THE IMAGE OF THE BLACK IN WESTERN ART

David Bindman and Henry Louis Gates, Jr.

GENERAL EDITORS

David Bindman and Henry Louis Gates, Jr.
GENERAL EDITORS

Karen C. C. Dalton
ASSOCIATE EDITOR

The Belknap Press of

Harvard University Press

Cambridge, Massachusetts

London, England 2014

In collaboration with the

W. E. B. Du Bois Institute

for African and African

American Research and

The Menil Collection

The Image of the Black in Western Art

THE TWENTIETH CENTURY

The Impact of Africa

Library of Congress Cataloging-in-Publication Data

The image of the Black in western art/David Bindman and Henry Louis Gates, Jr., general editors.—New ed.

 p. cm.—(Image of the Black in Western Art)

 Includes bibliographical references and index.

 Contents: v. I. From the pharaohs to the fall of the Roman empire. v. II. From the early Christian era to the "age of discovery": pt. 1. From the demonic threat to the incarnation of sainthood; pt. 2. Africans in the Christian ordinance of the world. v. III. From the "age of discovery" to the age of abolition: pt. 1. Artists of the Renaissance and Baroque; pt. 2. Europe and the world beyond; pt. 3. The eighteenth century. v. IV. From the American Revolution to World War I: pt. 1. Slaves and liberators; pt. 2. Black models and white myths. v. V. The twentieth century: pt. 1. The impact of Africa.

 1. Blacks in art. I. Bindman, David, 1940– II. Gates, Henry Louis.

 N8232.I46 2010

 704.9′49305896—dc22 2010019047

 ISBN 978-0-674-05271-0 (v. I) (cloth: alk. paper)

 ISBN 978-0-674-05256-7 (v. II, pt. 1) (cloth: alk. paper)

 ISBN 978-0-674-05258-1 (v. II, pt. 2) (cloth: alk. paper)

 ISBN 978-0-674-05261-1 (v. III, pt. 1) (cloth: alk. paper)

 ISBN 978-0-674-05262-8 (v. III, pt. 2) (cloth: alk. paper)

 ISBN 978-0-674-05263-5 (v. III, pt. 3) (cloth: alk. paper)

 ISBN 978-0-674-05259-8 (v. IV, pt. 1) (cloth: alk. paper)

 ISBN 978-0-674-05260-4 (v. IV, pt. 2) (cloth: alk. paper)

 ISBN 978-0-674-05267-3 (v. V, pt. 1) (cloth: alk. paper)

CONTENTS

PREFACE TO *THE IMAGE OF THE BLACK IN WESTERN ART*

DAVID BINDMAN AND HENRY LOUIS GATES, JR.

The Image of the Black in Western Art was conceived by the late Dominique Schlumberger de Menil (1908–1997) and her husband, John (1904–1973), fifty years ago. The de Menils were known internationally for their patronage of artists such as René Magritte and Max Ernst as early as the 1930s, and eventually for the size and range of their art collection. Their passion for art led them to set up, among many other things, the Menil Collection and the Rothko Chapel in Houston. They also were widely respected for their commitment to human rights. Dominique de Menil originated the idea of collecting images of persons of African descent in Western art at the height of the civil rights movement in the United States as a subtle bulwark and living testimony against antiblack racism. She also viewed this project as a way to counter, implicitly, the legion of all-too-familiar racist and stereotypical images of black people in American and European popular art by unveiling the fact that for centuries—indeed, millennia—canonical Western artists had included black figures in positive, sometimes realistic, and often celebratory ways in virtually every medium.

In launching this extraordinary project, the de Menils knitted two strands of their family's passionate interests together into one unusual form. Dominique de Menil once said that she assumed the entire project would take about a year or so to complete, since no one at the time could have had any idea of the sheer scope and as-

tonishing range of the presence of black images in the Western artistic tradition. A half century later, the project exists in the form of a photographic archive initially established in Houston by the Menil Foundation but now located in almost identical form at the W. E. B. Du Bois Institute for African and African American Research, Harvard University, and at the Warburg Institute, University of London. These twin archives remain the bedrock of the project and contain more than 30,000 images, far more than can be reproduced in a series of published volumes.[1] And the search for even more images of blacks in Western art continues.

The de Menils' idea in launching this project was based on their belief in the benevolent—indeed, transforming—power of art and their alarm at the stubborn persistence of racial segregation in the United States, to which they had both immigrated from France during World War II. It is no accident that the project was born in the heart of the South. After John de Menil's death, Dominique de Menil became even more actively involved in supervising the research and eventual publication of the initial volumes. In her preface to the first edition of Volume I, reprinted in the Appendix to that volume, she argues that works of art by master artists can reveal the common humanity of all people beyond the limits of conventional racial and social assumptions. Widely disseminated knowledge of and access to the beauty and range of these images

could, she and her husband believed, be a source of pride and self-respect for Africans and African Americans, and might simultaneously promote greater tolerance and understanding of black people among white people. Art, in other words, could be drawn upon as another weapon in the fight against antiblack racism, both in America and throughout Europe. Black figures in great works of Western art might provide a window onto times in the past when, as Dominique de Menil put it a little wistfully, "ideals of fraternity blossomed" between Europeans and Africans, a time before the start of the African slave trade to Europe and the New World, a time when race-based slavery and Jim Crow segregation were not the basis of the dominant socioeconomic relationship between them or of the ways in which black people were "seen" and represented in Western culture. It was a noble idea, if perhaps characteristic of a more optimistic era than our own.

The de Menils were not the first to take a systematic interest in the representation of persons of African descent in European art. Grace Hadley Beardsley published a standard work, *The Negro in Greek and Roman Civilization: A Study of the Ethiopian Type,* in 1929, and she had noted that "the earliest important work on the subject" was J. Löwenherz's *Die Aethiopen der altclassischen Kunst,* published in 1861, "an important year in negro history."[2] Beardsley makes the salient point that Löwenherz's study was undertaken precisely at the height of the abolition movement in the United States, in the first year of the Civil War. Similarly, publication of *The Image of the Black* was initiated at a turbulent time in the history of American race relations. Nonetheless, there is nothing explicit in the work of Löwenherz or Beardsley arguing that studying this subject might play a part in counteracting segregation or racial prejudice. At the other end of the scale from such works of scholarship were popular books like J. A. Rogers's *Sex and Race* (three volumes, 1940–1944), which used representations of blacks in the history of Western art as evidence, as its subtitle, *Negro-Caucasian Mixing in All Ages and All Lands,* indicates, to argue against current theories of racial essentialism. Regardless of the intentions of these authors, it had become clear by the Harlem Renaissance in the 1920s that representations of black people in Western art could be drawn upon both as another front in the war against racism and to make the case for the inherent equality of freed slaves and their descendants.

The idea that a study of European images of blacks in art could be an antidote to prejudice was first adumbrated in its most sophisticated form by the great African American scholar and critic Alain LeRoy Locke (1886–1954) in *The Negro in Art* of 1940.[3] Locke, upon graduating from Harvard College, became the first black Rhodes Scholar. After studying at Oxford University, he eventually returned to Harvard to become the first black person to earn a Ph.D. in philosophy there, in 1918. One of his areas of philosophical interest and expertise was aesthetics. He often wrote about art and its social uses, especially during the Harlem Renaissance, a cultural movement in part created by the massive anthology *The New Negro,* which he edited and published in 1925. In several of his own essays, in essays by others, such as the American inventor and art collector Alfred C. Barnes, and in lavish illustrations, many in color, Locke stressed the nature and function of art in society and its potential role in what he termed a necessary "reassessment" of the Negro, which he argued the Harlem Renaissance might effect. He brought various lines of his thought into a theory of art, race, and racial relations in *The Negro in Art,* the culmination of his thinking about Negro art and the Negro in art in the twenty years since he had completed his doctoral dissertation.

In this seminal book, Locke deepened his brief for the role of the

arts in the Negro's attempt to gain social equality and equal treatment before the law, arguing that "the deep and sustained interest of artists generally in the Negro subject, amounting in some instances to preoccupation with this theme, runs counter to the barriers and limitations of social and racial prejudice, and evidences appreciative insights which, if better known, might prove one of the strongest antidotes for prejudice." Locke's claim rests on a belief in the artist as vanguard, the artist's superior aesthetic powers within the social hierarchy, and her or his ability to see beyond ordinary perceptions: "Here in this field, as in others, the eye of the artist vindicates its reputation for having in most instances broader, clearer and deeper vision than ordinary." On the other hand, Locke argues, art could naturalize racial prejudice at the same time as mitigating it: "This is not to gainsay that art, too, has its limiting formula, or that in still other instances art reflects and even caters to its contemporary social conventions. But even in so doing, the net effect of art is to reveal the bias rather than to conceal it, while the usual course of the best art is to transcend it with a freshly original point of view."[4] In artistic depictions of black figures throughout the Western tradition, Locke was spurred by the formally transforming uses of African art by the cubists to create bold new ways of representing the human form, starting with Picasso's studies for Les Demoiselles d'Avignon. Locke maintained that ammunition could be found for deployment in the battle against antiblack racism where it had never occurred to anyone to look before: in the visual arts. As he had argued in *The New Negro,* if European artists could so fundamentally affect the world's attitudes toward and regard for traditionally benighted African masks, for example, just think of the implications of the creation of a truly resonant American Negro artistic tradition, and of the adoption of the Negro as a subject for art made by white Americans and Euro-

peans. This is exemplified by the drawings of the German immigrant artist Winold Reiss that pepper the text of his canonical anthology. It was a complex argument, and a subtle one, uniquely Locke's own.

For Alain Locke, the sheer variety of physical types of blacks in European art acted as a solvent for the prevalent stereotypes that obtained in American society. He drew attention to the crucial importance of the fact that one of the Three Magi who visited the baby Jesus had since the late Middle Ages often been represented as a black man in paintings of *The Adoration of the Magi.* He pointed to paintings of blacks by Rembrandt, Velázquez, and Rubens, in which he discerned "a degree of virtuosity in technical expression and a penetration of emotional understanding." He also argued, in a sign that even he was embedded in and valorized certain racialist ideas of his time, that "they caught, in addition to the particular model, that indefinable but tangible something we feel as race." He saw something almost charming or engaging in paintings in which a great European gentleman or lady is accompanied by an adoring black slave: "Even the late 17th and 18th Century tradition of the Negro page attendant, though grounded in slavery, still preserved something of the glamor of the exotic, investing that frequent figure with gaiety and charm."[5] While art could penetrate the superficial appearance of even a black person's social station or status, suggesting the universal human core beneath, he seemed unaware that it also had the potential to invest slavery with a certain glamour: a two-edged sword.

The de Menils certainly would have known Locke's book, if not Locke himself. However, there were more immediate influences on the generation of this research project, in particular the well-known Polish-French author and novelist Jean Malaquais (1908–1998), born Wladimir Malacki in Warsaw, who had been André

Gide's secretary and who moved between Paris and the United States, where he held several academic posts. Malaquais, like Locke, had strong views about the efficacy of art to effect social change. The de Menils also knew the work of the African American scholar Frank M. Snowden, Jr. (1911–2007), like Locke a Harvard Ph.D. (in classics) and a colleague of Locke's at Howard University. Snowden's *Blacks in Antiquity: Ethiopians in the Greco-Roman Experience* (1970) and subsequent books on this topic made him an obvious choice as one of the authors for the first volume in this multivolume work, on black images in the ancient world.

The de Menils were insistent that the proposed volumes (initially three were envisaged, covering works of art from European antiquity to the early twentieth century) should contain illustrations of exceptional quality, for which they commissioned a number of campaigns by outstanding photographers. They also employed as director of the archive and editor of the proposed volumes a young Paris-trained art historian, Ladislas Bugner, who produced a detailed chronological scheme for the volumes, which has remained the basis for the choice of images in the published books. Some of the volumes would be published in two large parts, and all were originally produced in both English and French editions, a nod to the increasingly troubled politics of race on both sides of the Atlantic, to the provenance of so much of the art being reproduced, and, of course, to the de Menils' native land. For various reasons, the volumes were not published in chronological order, leaving important historical gaps in the series' first incarnation. That unfortunate fact, combined with the two-part structure of two of the published volumes, often led to confusion among readers about the scope and organization of the project. The first volume, titled *From the Pharaohs to the Fall of the Roman Empire,* was published in 1976. Volume II, *From the Early Christian Era to*

the "Age of Discovery," was published in two parts in 1979, while Volume IV, *From the American Revolution to World War I,* came out, also in two parts, in 1989. Reviews of these publications were uniformly enthusiastic and unstintingly full of praise. We are pleased that we have published in 2010 and 2011, in three parts, the third chronological volume, *From the "Age of Discovery" to the Age of Abolition.*[6]

Sometime after the death of Dominique de Menil on the last day of 1997—but not before Harvard honored her with an honorary doctorate—the Menil Foundation decided to discontinue the publication of *The Image of the Black,* though authors had already been commissioned for the remaining volumes. Almost immediately, the director of the Du Bois Institute assumed responsibility for completing the project and fulfilling Dominique de Menil's original plan. In 1993 Madame de Menil had transferred the archive, under the direction of Karen C. C. Dalton, to the W. E. B. Du Bois Institute for African and African American Research at Harvard, where it was endowed through donations made by the Menil Foundation and various donors recruited by President Neil Rudenstine and by Henry Louis Gates, Jr. In 2005 the Du Bois Institute formally agreed to undertake the publication of the remaining volumes and to republish the existing volumes in the series, under the editorship of David Bindman and Professor Gates and the assistant editorship of Karen Dalton. This essay inaugurates this new series, which includes texts written by a mixture of the original and newly commissioned authors. In addition to the original publishing scheme and the present volume covering the twentieth century, a companion volume on the Image of the Black in African and Asian art is part of the Du Bois Institute's project.

This long gestation period has only served to increase the reputation of the published volumes, now extremely difficult to find,

and often shockingly expensive when they are available on the rare-book market. It has also served to make the appearance of the volumes covering the Renaissance and the Enlightenment in Europe and America, from the sixteenth through the eighteenth centuries, all the more desirable and urgent, given the considerable amount of scholarship that has been published over the past two decades by historians and literary scholars on race, slavery, and the presence of historical black figures in European society during those centuries. The volumes already published have become seminal works in the field. They have had a wide influence on scholarship and, though it is difficult to quantify, on racial relations as well, and even in some cases on the creation of art itself. Much has developed subsequently in the scholarship of each field, a great deal of which was stimulated by the impact of the scholarly essays in the volumes themselves. For this reason, in addition to completing the intended scope of this multivolume work and publishing new editions of the previous volumes with an increased number of color plates, we decided to add critical introductions by contemporary scholars, reflecting on the way the study of the subject has advanced since the initial publication. This has enabled Jeremy Tanner to evaluate the impact of the highly controversial "Black Athena" theory of Martin Bernal on the representation of blacks in the classical world, Paul Kaplan to cast new light on the sources of the presence of blacks in visual culture from the thirteenth century onward, and David Bindman to raise more fully the context of popular imagery in the nineteenth century as a necessary preface and transition to the present volume dealing with the explosion of images of black people in the Western art of the twentieth century.

The volumes covering the sixteenth, seventeenth, and eighteenth centuries have inevitably been affected by the interest among art historians in recent years in questions of "representa-tion," especially the representation of "others," and by a much more critical approach to the traditional boundaries of the history of art and the historical contexts in which works of art were created. Every noun and adjective in the title of these books, which seemed unproblematic when the series was first mooted in the 1960s, is now subject to contestation or qualification. *Image* no longer appears to be a neutral term but begs the question of the context and ideological standpoint of each representation. An image is no longer assumed to be "artistic" but can be anything from an allegorical painting or a portrait to an inn sign, an ornament, an engraved tobacco wrapper, or a household object like an Aunt Jemima image on a box of pancake mix. Where once these images were thought best hidden or, at worst, destroyed, today many African Americans themselves and scholars of all nationalities have become collectors of these widely disseminated—and relentlessly racist—images of blacks in American and European popular culture. One can find examples of such images as early as the late eighteenth century and all throughout the nineteenth, but they really exploded onto the market at the turn of the twentieth century as the visual manifestation of Jim Crow. The determination of scholars and collectors (especially African Americans) to gather these seemingly limitless and endlessly demeaning images and make them available for analysis and deconstruction is one of the most exciting developments in this field since the publication of the first edition of these volumes.

From the sixteenth to the eighteenth century, there are a few works that depict real black individuals, but the vast majority of images of blacks are purely fictive, playing a part in court, religious, or city life as representations of, say, Africa or the non-Christian world. The latter may be found in wall and ceiling paintings and in ornaments, as part of a fanciful setting paying tribute to the glory

of princes or to the spread of Christianity throughout the world, or as signboards or elements of heraldry. Somewhere in between the individual portrait and the personification of Africa is the black page in grand-manner portraiture, acting as an extravagantly dressed foil to his owner, his servitude sometimes emphasized by a silver slave collar around his neck or a silver ring in his ear. In a similar category are the black figures who appear as performers and musicians in pageants and ceremonies. In all cases, these images evoke a world as far removed as possible from the reality of the slave plantation in the New World, even though nearly all of the people on whom they are based were transported as slaves directly from the ports in West and Central Africa documented by the Trans-Atlantic Slave Trade Database.[7]

The role blacks played in such artistic fantasies derived from and reinforced European attitudes toward Africans in general—Africans who lived among them as well as their ideas of Africa and the human beings who lived there. The scholar Barbara Johnson memorably defined a stereotype as "an already read text."[8] Indeed, many of the significations attached to the "blackness" of black people preceded familiarity with actual people of African descent, upon whom was imposed a range of imagined attributes and associations: diabolical darkness; propensity to religious enthusiasm, intense piety, magic, and witchcraft; ancient wisdom; primitive innocence; savage ignobility or nobility; childlike wonder; irrationality; and a primeval and insatiable animal-like sexuality. Blacks were the other side of Reason, representing not only the very superstitions that the Enlightenment sought to obliterate but also sometimes the innocence that mankind had lost in its pursuit of material gain. Africans, like South Sea Islanders, could sometimes be Europe's noble savages, but far more often they served as Europe's ultimate ideal of ignobility.

In the nineteenth century, with the invention of lithography, photography, and other mass-reproduction techniques, images in general increased exponentially in the form of advertisements and popular illustrations. The visual world of Europeans and Americans, in myriad forms of popular culture, was flooded well into the twentieth century with deeply demeaning stereotypical images of blacks that showed them as infantile and bestial, often foolishly aping the ways of their "betters" or ostensible social superiors, people whom they could mimic but never become, never fundamentally be "like" or of a kind with. These images had an incalculable, and often subconscious, effect on the spread of the poisonous ideology of racism developed by scientists in the period. (In fact, science often willingly played the role of handmaiden to a larger discourse of racism.) Such images, reinforced by stereotypes of African "savages," and in spite of the modernists' bold new formal uses of African art, also appeared in some twentieth-century works of art as something to be incorporated and exorcised. This occurred implicitly in the work of African American artists as early as the Harlem Renaissance and explicitly in the work of a plethora of contemporary black artists, such as Michael Ray Charles, Kara Walker, Rotimi Fani-Kayode, Robert Colescott, Carrie Mae Weems, Yinka Shonibare, Glenn Ligon, Lorna Simpson, Adrian Piper, Chris Ofili, and Betye Saar, among many others.

Since the publication of the first edition of *The Image of the Black in Western Art,* scholars and critics have increasingly questioned the very boundaries of what constitutes "Western" art. The absolute separation of the "West" from other geographical and cultural entities has been challenged by studies of the correspondences and intertextuality of both writings by black authors and representations of blacks in art and literature in Europe and America during the Enlightenment and throughout the antislavery period, which

Henry Louis Gates, Jr., has analyzed extensively, and by theories of "hybridity" and the idea of "the Black Atlantic," in which Paul Gilroy condemns "absolutist conceptions of cultural difference" and argues, for example, that British culture has long been essentially fluid and negotiated through maritime traffic across the Atlantic.[9] The two-way traffic of black artists between America and Europe, and between Europe and Africa, at least since the late nineteenth century, helps to explain not only the emphasis that black artists and writers place on the African roots of their art but why they rightfully sometimes object to being characterized as solely Western. A number of African artists have pursued their art in the United States or Europe, and formal exchanges between black artists and writers in Europe and America have been occurring, we now know, on a regular basis since the colonial period.[10]

The idea of "art" as a discrete category has also become increasingly problematic. At least since the mid-nineteenth century, many artists have incorporated the iconography and the language of popular culture into their works rather than basing their imagery on the "art of the museums." The eighteenth-century science of aesthetics came to be applied to art precisely to create acceptable limits and social boundaries. Only the great works of classical antiquity, a few works of the Italian Renaissance, and those of a small number of modern emulators were deemed to be works of ideal beauty. Art that sought a truth-effect, such as Dutch painting, was for the most part thought to be beneath aesthetic notice. "Western art" became gradually more inclusive in the nineteenth century, but it is still conceived of broadly in accordance with criteria established in the early part of that century in the great national painting galleries. The National Gallery in London, for example, exhibits much that would have been regarded as outside the bounds of true art before the nineteenth century: Dutch painting, portraiture,

landscape, still life, and the contemporary life painting of William Hogarth. If art in the past one hundred years has enormously expanded its boundaries, this is in reaction to earlier attempts to purge it of all extraneous elements in order to clarify its metaphysical essence.

Yet since the beginning of the printing of images in fifteenth-century Europe, an imperfect distinction has been made between luxury images for the elite in sculptural, painted, or printed form and popular images—usually in woodcuts—that could be distributed in large numbers and copied seemingly endlessly. From the eighteenth century onward, as we have seen, developments in printing technology made it possible to produce caricatures for a large market and to lithograph advertisements for mass markets. There is in practice, however, an unbroken continuum from "high art" to the mass-produced image. It is in the latter that, as the African slave trade came under challenge in the late eighteenth century, caricatures and racist stereotypes of blacks begin to predominate and seriously reinforce or influence popular perceptions and even social policies. Do such egregiously distasteful works belong in volumes such as these? We believe that to omit them entirely would deny their enormous impact in reinforcing racial prejudices in European and American society, both in the era of slavery and especially with the rise of Jim Crow segregation in the United States after 1890. Further, by omitting these astonishingly numerous and deeply offensive images, we would lose an essential part of the meaning that they had for twentieth-century white and black artists as they went about the enormously difficult process of redefining the image of blacks in their own work against the backdrop of such imagery.

Needless to say, "the black" as a distinct category is now highly contentious in its use of the singular to represent the general. *Black*

as a noun is now perhaps the most commonly used word to identify persons of African descent. However, though it was often used in earlier centuries, the forms *Negro* in English (from the Latin *niger,* meaning "black"), *Nègre* in French, and *Neger* in German were at least as common. *Moor* was also used, as in Shakespeare's *Othello,* though often attached to the Muslim peoples of North Africa, as were *Ethiopian, blackamoor,* and *African.* As Christopher Miller put it, "The etymologies of Africanist names would . . . seem to be drawn toward meanings of darkness and otherness."[11] Before the modern period, *Ethiopian,* from the Greek for "burned face," was commonly used to describe black Africans, a practice often leading to great confusion among scholars, who mistakenly identify it with the people who live in present-day Ethiopia, the former Abyssinia. *Guinea* also was widely used to signify sub-Saharan Africa, and possibly derives from Berber words that mean "land of the blacks." *Sudan* means "the blacks" in Arabic, while *Zanzibar* derives from *zengi* or *zengj,* meaning "black," and the Arabic *barr,* meaning "coast." *Africa* has a less clear etymology, though it appears to be Roman in origin and was only relatively recently applied to the whole continent. Miller notes ten different hypotheses of its etymology: among others, *Afri* was the name given to several people who lived in North Africa, but Isidore of Seville suggested a derivation from the Latin word *aprica,* meaning "sunny,"[12] while the *Encyclopaedia Britannica* thought it derived from the Greek word *aphrike,* meaning "without cold."[13] Designations of sub-Saharan or black African origins tended to be clearer before the onset of slavery in the New World and the establishment of settled communities in colonial countries. *Black* (or lowercase *black,* as is used here), which in the mid-1960s replaced the universally used word *Negro,* is now an unavoidable shorthand term despite its literal descriptive inaccuracy and its tendentious opposition to *white,* signifying European descent. Of the two, *black* has a longer history; *white* became current, curiously enough, only in the late seventeenth century.[14]

In the early years of the twenty-first century, we now want to challenge the implicit primacy of Western art by taking a wider view of the non-European world. On the other hand, though the intellectual framework of this series might seem unfashionably Eurocentric, we believe that it is flexible enough to provide essential materials for further debate on issues that have become more rather than less topical since it was initiated. As the editors and authors have insisted from the beginning of the project, it is a preliminary study of an enormous field, with ramifications that can in some cases only be touched upon even in the most carefully researched and edited volumes. We hope these will be developed by other scholars, using the Image of the Black Archives at Harvard and at the Warburg Institute in London.

An obvious question undoubtedly arises: what then defines a black person in the context of these volumes? Because so many images, especially in the earlier periods, lack external documentation, the answer is usually that of appearance: a person or persons who *look* as if they are of black African descent. Many are simply identifiable by the black or brown pigment applied to the representation of face or body with varying degrees of precision. They are also identifiable even in objects of white marble and terracotta from stereotypical features, such as thick protruding lips, flared nostrils, and kinky hair, that can be traced through European art history over thousands of years and that have been identified by repetition, though they may have little correspondence to the appearance of actual African human beings. These features are summed up in Sir Joshua Reynolds's eighteenth-century description as "thick lips, flat nose, and woolly hair,"[15] and the first and last of those features

might be deemed sufficient for identification. In certain examples, such as the kantharos in the form of conjoined heads in the Museum of Fine Arts, Boston (Vol. I, fig. 160), the head is not only painted black but has stereotypical facial features, and furthermore is contrasted with a head of a "white" woman. In other cases, the features may be much less emphatic or even quite ambiguous, in conformity with the widely varying physical characteristics of actual sub-Saharan African people.

It goes without saying that very few of the many thousands of representations of blacks throughout the ages are of "real" people. In the first place, only in limited periods has art concerned itself with depicting observable reality, and even then artists have only rarely chosen to focus on representing real black people. Only a tiny number of images from the whole of antiquity can be tied to identifiable contemporary people, though realistic portrait sculpture was practiced in certain periods. Moreover, in the Middle Ages there were almost none, except perhaps the obviously schematic representation of the legendary king of Ethiopia, Prester John (Vol. II, pt. 2, fig. 59), and Mansa Musa, the fabulously wealthy king of Mali (Vol. II, pt. 2, figs. 93–95), who famously made the pilgrimage to Mecca with a vast entourage, dispensing enough gold to depress the world's gold market for several years. Yet there are examples of art from all historical periods that show an acute awareness of black African physiognomies. Medieval representations of the early Christian saint Maurice as a black warrior in soldier's garb are obviously fictitious or idealized recreations, but it is inconceivable that, for example, the great sculpture at Magdeburg (Vol. II, pt. 1, figs. 114–16) could have been made without some experience of black physiognomies or the use of a black model. With the exception of the second-century Roman bust of Memnon (Vol. I, figs. 336–38) and fanciful images of African rulers, we re-

ally have to wait until 1521 for Albrecht Dürer's wonderful portrait drawing of Katharina (Vol. II, pt. 2, fig. 263) to be able to put a name to a carefully delineated black face. Actual formal portraits of blacks—an implicit recognition of social status—are very rare before the eighteenth century and not especially common afterward. One should, however, note that in India there were several contemporary portraits of Malik Ambar (1549–1626), an Ethiopian who rose to be the effective and highly creative ruler of Ahmednagar.[16]

Given the sorry history of the North African, Middle Eastern, and European enslavement of blacks and the persistence of racism toward them well beyond abolition, does the art of the past give evidence of times when relationships between Europeans and Africans were based on mutual respect, as Dominique de Menil so ardently hoped? Art historians are naturally circumspect about drawing general historical conclusions from images that might have had little to do with the actual appearance of blacks or the circumstances in which they lived, though it would appear that some black persons were almost always a part of European society—throughout ancient Egypt, of course, but also in ancient Greece. The Sahara Desert, the Red Sea, and the Indian Ocean have often been represented in the works of European historians as insurmountable barriers to black African communication and interaction with the larger world, especially the world of Europeans. Africans, we have been told, were too unenlightened to think of intercontinental travel, doomed to wait to be "discovered." But we now know that these natural barriers were highways or avenues of communication, commerce, and the exchange of cultures and ideas between black Africans and the northern and eastern worlds. Black figures and Africa appear in both the Old Testament and the New Testament. Important references to blackness are the fa-

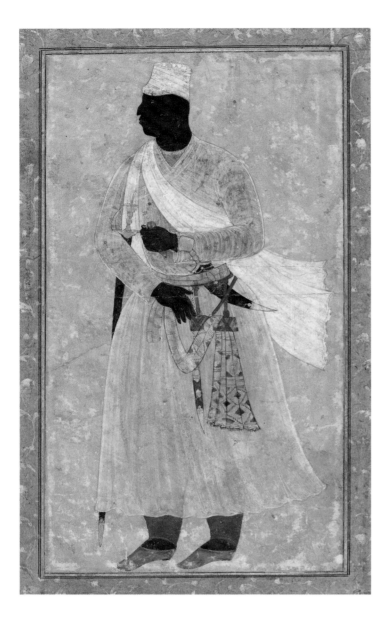

P.1 Anonymous. Portrait of Malik Ambar. Southern India (Dekkan, Amednagara), 1610-1620. Boston, Museum of Fine Arts.

mous one of Solomon's lover in the Song of Solomon—"I am black, but comely, O ye daughters of Jerusalem, as the tents of Kedar, as the curtains of Solomon" (1:5)—and the less well known case of Moses' Ethiopian wife, mentioned in Numbers 12:1,[17] who was the subject of a rare and fascinating seventeenth-century painting by Jacob Jordaens (see Vol. III, pt. 2). The Nubian pharaoh Taharqa (who ruled Egypt's Twenty-fifth Dynasty between 690 and 664 B.C.) is mentioned in 2 Kings 19:9 and Isaiah 37:9, and the Ethiopian eunuch in Acts 8:26–38. Psalms 68:31's admonition that "Ethiopia shall soon stretch out her hands unto God" signifies an awareness of a distant land where black people lived. In addition to the many images of blacks in Greek and Roman art, writers as early as Homer identified Africa and Africans such as Memnon in their works, and the constellation Cassiopeia was named after the queen of Ethiopia, who was the mother of Andromeda. Homer reminds us in the *Iliad* of the high regard that Zeus and the gods bore for the sacrifices and reverence of the Ethiopians. As early as the first century A.D., a book called *The Periplus of the Erythraean Sea*[18] served as a practical guide to mariners for navigation from the Mediterranean down the Red Sea and through the Persian Gulf to the Indian Ocean, as far south as the coast of modern Tanzania. Moreover, the revolt of 500,000 black slaves called the Zanj in and around Basra between A.D. 869 and 883 attests to the large presence in the Middle East of black African slavery in the early Muslim world.[19] In fact, many historians estimate that the trans-Saharan Arab slave trade exported at least as many black Africans to North Africa, Europe, and the Middle East as the transatlantic slave trade did to the New World. The Afro-Indian community called

the Sidis, in the northwestern Indian state of Gujarat, almost bordering on Pakistan, is testament to early contact between India and sub-Saharan Africa, commencing approximately in the twelfth century. And the extended expedition by Admiral Zheng He (1371/75–1435) during the Ming Dynasty included contact with East Africa (modern Tanzania) in 1421–1422 on behalf of the Chinese Yongle emperor, demonstrating that black Africa was not unknown even to the Far East.[20] Also, while black Africans were enslaved by the Egyptians, Greeks, Romans, and Arabs, they were only a part, though often a prized part, of slave populations. Before the sixteenth century, it was the Slavic peoples who were widely enslaved, enough to give slavery its name. Until the rise of the African slave trade under Arab domination in the early Middle Ages, followed by its eventual European adoption in the fifteenth century, slaves were generally derived from the ranks of conquered enemies or of debtors of whatever ethnicity, which might include Christian Europeans. But contrary to popular belief, it is difficult to imagine a time since antiquity when parts of sub-Saharan Africa and its variety of black inhabitants remained unknown to some part of the larger European, Middle Eastern, and Asian worlds.

George M. Fredrickson has argued that most Africans during the early years of the West African slave trade were regarded as infidels, but were preferable to Jews and Muslims in being ignorant of Christianity rather than having rejected it.[21] This view is contradicted by the fact that prior to the rise of the West African trade, black Africans were linked to Islam and to the ancient Christian kingdom of Ethiopia, going back to the fourth century.[22] Though Africans were often associated with Satan because of their dark skin and Africa was thought of as the home of fantastic humanoid creatures, some at least were regarded with respect for recognizing the truth of Christianity, while others were notionally ripe for con-version. Of course, "Africa" itself was sometimes a rather vague concept, occasionally identified with or subsumed in India. But the emergence in art of St. Maurice as a black legionary and the identification of one of the Magi as a black king—departures created in the thirteenth and fourteenth centuries, respectively—show that blacks could be seen as actual or potential Christians in the lands outside Christian Europe.

The full European entry into the African slave trade, which lasted a little over three centuries, of course changed everything. It would be an exaggeration to say that slaves flooded into Europe. On the other hand, about 12.5 million were shipped directly from Africa to the colonies, and they most certainly flooded into the Middle East and North Africa early on through the trans-Saharan slave trade. But black people from the fifteenth century became an increasingly visible part of the urban scene throughout Europe, especially in port cities and at ruling courts. The European sense that Africans were not only different but inferior beings derives from the use of Africa as a source of slaves to be transported to work on plantations in the West Indies and America. Plantation slavery was irredeemably inhumane for two interconnected reasons: it involved the uprooting and separation of individuals from their own families, cultures, and societies, and it simultaneously represented their commodification—in Moses Finley's words, their reduction from "a person to a thing."[23] Yet there has been an increasing awareness among historians that slavery, as Hegel first put it, could involve negotiation between slave owner and slave.[24] Slaves were not solely victims of coercion but could in some circumstances possess a certain degree of agency on plantations as foremen, trusted supervisors, and even passively as laborers. As chattel or domestic slaves they could be the object of affectionate or humane treatment by individual masters or mistresses. Conditions were infinitely var-

ious, but there are many examples of mutual dependency and a slowly increasing recognition among some masters that treating slaves well and promising them eventual freedom could be the most efficient method of increasing production. Still, brutality and dehumanization ruled the world of the slaves, in spite of these exceptions. As Ehud Toledano has noted, "Slavery must be studied . . . as a *relationship* between master/mistress and slave, a relationship far more complex, mitigated and mutually dependent than a mere legal proprietary context can explain."[25] Yet one should be extremely wary of sentimentalizing the relations between master or mistress and slave. However affectionate the relationship might be, the slave still suffered forcible uprooting from ties of family and place, and what Orlando Patterson, after the former slave William Wells Brown, has called "social death."[26] The slave collar, inscribed with the name or coat of arms of the owner, was a response to the fact that slaves frequently attempted to run away.

Of course, not all blacks in Europe were slaves. There were honored visitors from African kingdoms to European courts, such as Antonio Manuel Ne Vunda (d. 1608), the Congolese ambassador to the Holy See at the beginning of the seventeenth century (Vol. III, pt. 1, figs. 81–85). There were also free blacks in Europe, people who had been freed from slavery or who were descendants of free blacks. Some even earned university degrees early in the eighteenth century; Jacobus Capitein in Holland (Vol. III, pt. 3, figs. 228 and 229) and Wilhelm Amo in Germany[27] both published books in Latin, and several other Africans, like Olaudah Equiano (Vol. III, pt. 3, fig. 183), published books in English and became active in the antislavery movement in the last quarter of the eighteenth century.

As we might expect, there were also immense numbers of children of mixed relationships, particularly in slave colonies, where women did not accompany men from the home countries. Mixed-race children in a slave-owning culture could find themselves in a profoundly vulnerable and highly ambiguous social and familial position. Sometimes they were treated as slaves, but in other cases they might be treated as family by their father but not allowed the social status of their white siblings. In the notorious case of Thomas Jefferson, who conceived five children with his slave Sally Hemings, the children were brought up as slaves and denied a role in the family but were treated differently from Jefferson's other slaves and given enhanced opportunities to become skilled craftspeople.[28] Dido Elizabeth Belle, the illegitimate daughter of a black woman and Sir John Lindsay, a nephew of the judge Lord Mansfield, had a position in the household as both servant and family member, but in the anonymous portrait formerly attributed to Zoffany of Lady Elizabeth Murray (Vol. III, pt. 3, fig. 154), though affection is expressed by Lady Elizabeth's outstretched hand, her formality and bookishness are contrasted with the wild and exotically turbaned "natural" figure of Dido.[29] Hierarchies based on degrees of color mixture tended to be an essential part of the social structure in slave colonies; this is recorded in a fascinating series of paintings by Brunias and the whole genre of *casta* painting that grew up in eighteenth-century Mexico (see Vol. III, pt. 3, figs. 263–70 and 243–48).

It did not follow, as is often assumed, that Africans in the age of slavery were always thought by Europeans to be less than human. It is true that there were writers in the eighteenth century, like David Hume and the West Indian slave owners' champion Edward Long, who in effect justified slavery on the grounds that "the White and the Negroe are two distinct species."[30] Nevertheless, the predominant European assumption well into the nineteenth century rested on monogenesis, the Christian belief that Adam and Eve were the original parents of all humanity, though that did not make

blacks equal in the political or social sense or save them from being openly bought and sold. Even though monogenesis had from earlier centuries created an undertow of ecclesiastical wariness, and sometimes direct rejection, of the institution of slavery, there were always clergymen, both Catholic and Protestant, ready to reassure slave owners that it was not un-Christian to own and exploit slaves. For reasons that are still debated, there emerged in the 1760s and 1770s, through the voices of blacks themselves and among English religious and political dissenters and French philosophes, a passionate call for the abolition of the slave trade. This call grew into a Europe-wide movement, achieving with the support of governments its aim of the total abolition of slavery in most countries in the course of the next century, first in the British colonies in 1838 and then, most famously, with the passage of the Thirteenth Amendment to the U.S. Constitution following the Civil War.

Yet the peculiar discourse of nineteenth-century racism, which lasted well into the twentieth century, based as it was on supposedly unimpeachable scientific data, only reinforced the stereotypes of the behavior and appearance of blacks. This is evident from the art of the century, even by artists sympathetic to abolition. Blacks were seen as inherently different from other races, and skull and bodily measurements were brought in to "prove" it. Stereotypes were now given enormous authority and dominated artistic representations of blacks, who were seen as one link in the physiognomic great chain of being from ape to European, and according to some scientists much nearer to the former than the latter. While all European nations produced deeply demeaning images of blacks in the nineteenth century, the Jim Crow era in the United States used improvements in the technology of reproduction to produce floods of offensive images of blacks, to the extent, in Henry Louis Gates, Jr.'s words, that "to begin to escape, each black person would have to dig himself or herself out from under the codified racist debris of centuries of representations of blackness as absence, as nothingness, as deformity and depravity."[31]

Racial hierarchy was inadvertently reinforced by Darwin, who believed in human evolution from the savage to the most civilized, though he was himself fervently opposed to slavery, and by Darwin's bastard child, social Darwinism, which argued that "inferior" races were a demographic threat to the Anglo-Saxon race's natural supremacy. The effects of this dichotomy between "civilized" and "savage" can be seen in art in a concern with the distinctiveness of black physiognomy and a growing emphasis on the "primitive" nature of Africans, expressed often in a prurient concern with black sexuality, even in the avant-garde art of the early twentieth century, and in art created by artists during the Harlem Renaissance. Yet the twentieth century also saw the gradual emergence of black artists who were able to take charge of their own representations. And it is for this reason that we now present a further volume for this project, of images of blacks most of which were created by black artists themselves—a fitting and perhaps ironic conclusion to a marvelously diverse history of the representation of persons of African descent in the art of the Western countries in more than four and one-half millennia.

ACKNOWLEDGMENTS

This volume consisting of two books was not part of the original plan for *The Image of the Black in Western Art,* which was finally completed in four volumes (eight books) in 2012. When Dominique and Jean de Menil conceived the series in the 1960s they did not envisage it going beyond the early years of the twentieth century. The idea of the present volume came out of discussions among ourselves and above all with Sharmila Sen, for whose enthusiasm we are extremely grateful. Unlike the previous volumes which all had their origins in the Paris office of the project, under Ladislas Bugner, this volume originated entirely at Harvard, in a collaboration between the W. E. B. Du Bois Institute for African and African American Research and Harvard University Press.

We owe a great debt first of all to the contributors, who have all carried out their tasks with imagination, collegiality, and the highest degree of professionalism. It has been a pleasure and a privilege to work with them and with our colleagues at the Du Bois Institute, especially Sheldon Cheek, Vera Grant, Krishna Lewis, Amy Gosdanian, and Abby Wolf. Other fellows of the Du Bois Institute have played an important part, and we are grateful especially to Paul Kaplan, Marial Iglesias Utset, and Adrienne Childs.

As ever we would like to thank Dean Rosovsky for establishing the conditions under which the image archive could be housed at the Du Bois Institute at Harvard, and President Neil Rudenstine for fulfilling those conditions and overseeing the moving of the archive from the Menil Foundation in Houston to Cambridge. We would also like to thank President Lawrence Summers for the generous space in which the archive and its library are housed within the Du Bois Institute in Harvard Square; Glenn Hutchins, the chair of the National Advisory Board of the Du Bois Institute; and Renée Mussai of Autograph ABP.

Once again we have found it a huge pleasure working with Sharmila Sen and her wonderful colleagues at Harvard University Press—Heather Hughes, Annamarie Why, Jill Breitbarth, Eric Mulder, Adriana Cloud, and Abby Mumford, as well as Cheryl Lincoln, Ken Krugh, and Kevin Krugh at Technologies 'N Typography—who have worked to match and even surpass the high level of production set by the earlier volumes.

We have enjoyed working with Richard Philpott and Cristina Lombardo of Zooid Pictures Ltd., who had the enormous task of gathering the photographs for the volumes and obtaining permissions, which they carried out in an exemplary fashion.

DAVID BINDMAN, KAREN C. C. DALTON,
AND HENRY LOUIS GATES, JR.

The Impact of Africa

INTRODUCTION

DAVID BINDMAN

From its conception in the 1960s, *The Image of the Black in Western Art* project was guided by Dominique and Jean de Menil's passionate concern with the struggle for civil rights for African Americans and by a deep respect for the past. One of the series' original purposes was to demonstrate that relations between Europeans and Africans had not always been under the dark shadow of slavery. There were times when Africans had been treated with respect, and even during slavery's three-hundred-year reign, artists of superior insight were able to depict the humanity of Africans with warmth and sympathy. Dominique de Menil had a particular desire to show the humane possibilities within the classical and Christian tradition, despite the abiding European shame of African slavery. She wished to highlight heartening episodes that were given compelling artistic form, such as the sculptural creation of a black St. Maurice in thirteenth-century Magdeburg,[1] and the pope's embrace and commemoration of the dying Kongolese ambassador in 1608.[2]

Volume V of *The Image of the Black in Western Art* consists of two books: this one, *The Impact of Africa;* and the second, *The Rise of Black Artists.* The series was originally intended to be in three volumes and to end with the late eighteenth century,[3] but Hugh Honour was recruited to write a fourth volume to deal with the nineteenth century. That volume, which appeared in 1989,[4] in fact covered events up to around 1920. The twentieth century had, of course, many years to run when the nineteenth-century volume was conceived, but one of the unintended consequences of the terminal date of 1920 was to leave very little space for discussion of the work of black artists themselves. There are only passing mentions in Volume IV of such artists as Edmonia Lewis or Henry Ossawa Tanner, who had already produced significant works relevant to the image of the black within the time frame of the volume.

The subject of *The Impact of Africa* is broadly the change in consciousness in Europe and its colonies toward Africa itself. Africans and African objects from the first decade of the twentieth century become a vibrant presence in many of the great cities of Europe, especially Paris; Africa ceased to be the Dark Continent of imperial legend. African art first became important between 1905 and 1910, especially among the avant-garde in France and Germany. African art became at the same time the epitome of the "primitive" and of the "modern." The paradoxical character of an art, and implicitly of Africa itself, that represented both the precivilized state of humanity and the most advanced European industrial urbanism is the defining trope imposed on the image of the black throughout the whole of the century that followed. The idea of the primitive had been reinforced in the nineteenth century by Charles Darwin, who saw, as did many others, his own nation, culture, and class as

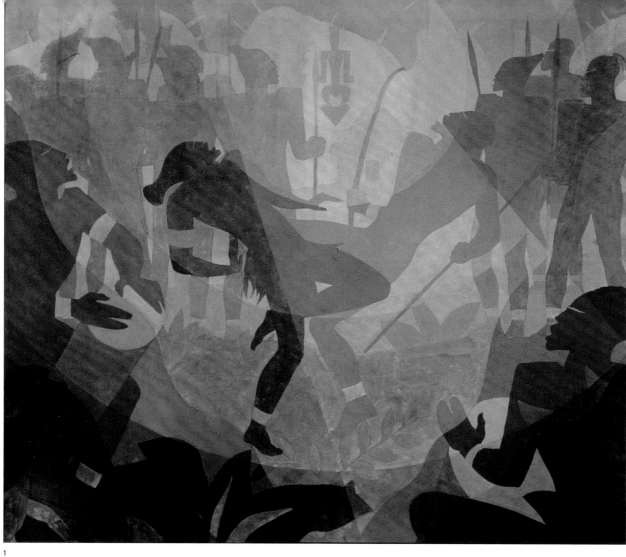

1 Aaron Douglas. *Aspects of Negro Life, The Negro in an African Setting*. 1934–1935. New York, Schomburg Center, New York Public Library.

2 Aaron Douglas. *Aspects of Negro Life, An Idyll of the Deep South*. 1934–1935. New York, Schomburg Center, New York Public Library.

3 Aaron Douglas. *Aspects of Negro Life, From Slavery Through Reconstruction*. 1934–1935. New York, Schomburg Center, New York Public Library.

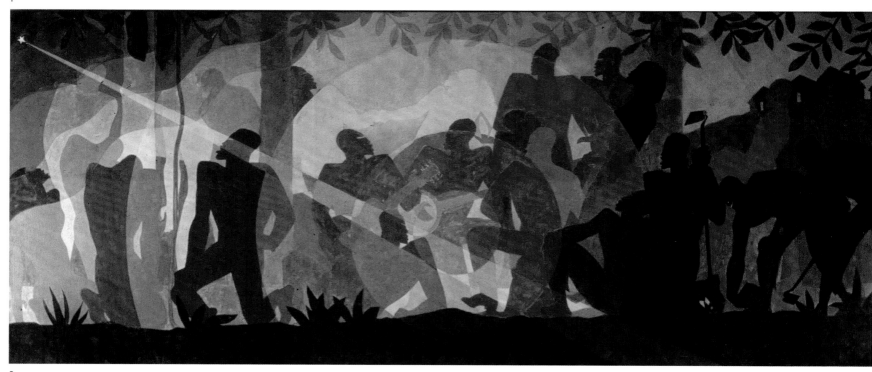

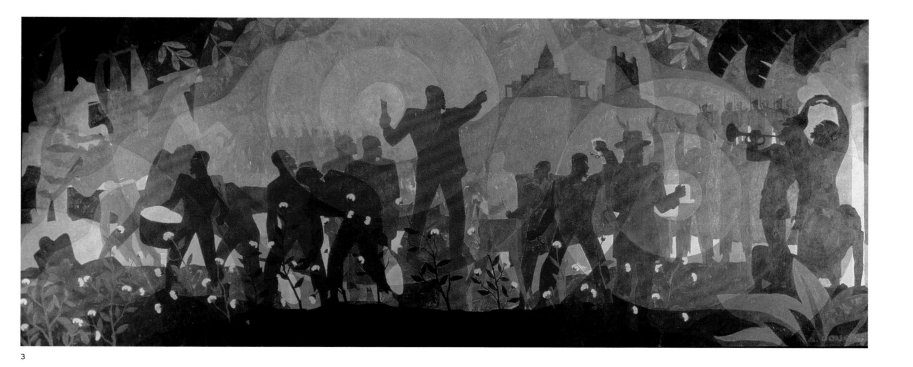

3

the highest outcome of an evolution from the primeval state in which many peoples on earth, most notably in Africa, were thought still to remain. But for such artists as Picasso, discontented with an increasingly industrialized society, so-called primitive peoples had retained more natural feelings and relationships than had his materialistic and class-bound contemporaries. Atavism was a positive and invigorating force that could counteract the decadence of academic art and the urban institutions that supported it.

Jazz, that great African American invention, is equally paradoxical. It is rooted in the rural oppression of slaves in the American South, but it became the sound track of the industrialization and urbanization of the United States. Aaron Douglas's great series of four monumental paintings—the Sistine Chapel of African American art—*Aspects of Negro Life,* 1934–1935, in the Schomburg Cen-

4 ter in Harlem,[5] culminates in the *Song of the Towers,* which shows a jazz musician with a saxophone as a defiant spirit among the skyscrapers of a great city. This urban "idyll" is reached by three stages.

1 The first, *The Negro in an African Setting,* shows an African ceremony with the central figures dancing with wild abandon to a drum, surrounded by hieratic Egyptian-style warriors, as the ancestral prelude to African American history. The second painting,

2 ironically titled *An Idyll of the Deep South,* shows in a rural setting groups of slaves witnessing a lynching, working in the fields, and playing and singing the blues. The third, *From Slavery Through Re-*

3 *construction,* represents the move of the liberated slaves in the pe-

riod of Reconstruction from the Southern plantations to the cities of the Midwest and the East.

This is in its essential form the African American story. The primitivism-modernism nexus in Europe is framed more by a binary tension between the African primitive and the commercial city and less by slavery, which, despite its huge economic effect on Europe, had taken place predominantly in the colonies and not at home. European experience of Africans, aside from those few who had been to Africa or the colonies, was based largely on their actual presence in cities as domestic servants and craftsmen of all kinds, but attitudes toward them were usually conditioned by a simplistic and formulaic view of Africa. This is expressed most completely in the spectacularly paradoxical figure of Josephine Baker,[6] an African American from St. Louis, Missouri. Baker's scanty dance costume, made of imitation bananas, invoked the most reductive and erotic clichés of the African jungle, yet her dances were highly artistic and adored by sophisticated Parisian audiences. As Count Harry Kessler remarked, "They are a cross between primeval forests and skyscrapers; likewise their music, jazz, in its color and rhythms. Ultramodern and ultraprimitive."[7] African American jazz and popular musicians and dancers were a feature of urban entertainment in major European cities throughout the century and frequently appear in the art of the 1920s and '30s.

The subjects of the two books that make up Volume V, *The Impact of Africa* and *The Rise of Black Artists,* are not sequential but

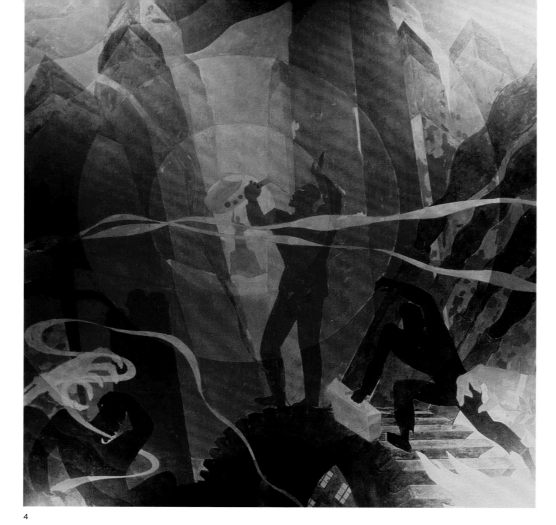

4 Aaron Douglas. *Aspects of Negro Life, Song of the Towers*. 1934–1935. New York, Schomburg Center, New York Public Library.

4

coterminous, at least for the first half of the century. The effect of Africans and African art on the work of European artists came into its own broadly in the same period that artists of African descent began to confront the practical and intellectual difficulties of being an artist of ambition in a white-dominated world. Both narratives are determined by different countries' particular inheritance of slavery. Individual slaves and servants had been from the sixteenth century a conspicuous and decorative feature of court and of aristocratic and later bourgeois life in Europe, but wealth-generating plantation slavery always took place at a great distance, in the American and Caribbean colonies. North America had organized slave labor from the sixteenth century in the Spanish and from 1619[8] in the English colonies; the slave population grew by direct imports from Africa all the way up to the 1820s and beyond. This led to the deliberate, brutal, and incomplete alienation of African slaves from their rich African cultures, but it also led to among other things the development of a wholly original African American music, in the distinctively twentieth-century form of jazz.

Though there have been communities of Africans going back to early times in Spain and in English ports like Liverpool and London, until the second half of the twentieth century most black people in Europe belonged to a more recent Diaspora, either from Africa itself or from the Caribbean or Latin America. So African American or Caribbean art can be seen more readily as a discrete entity or a "school," but there is less coherence in such centers as London or Paris, where in addition to artists born in the country, African and Caribbean artists sometimes settled or stayed for limited periods and then returned to their native countries. For this reason the second book of Volume V is largely about the United States, though in the final section Deborah Willis and Kobena Mercer range more widely across the Diaspora to reveal the increasing globalization of the twenty-first-century art world.

While South America with its large former slave populations, imported from Africa under Spanish and Portuguese rule, produced, as Dawn Ades discusses, a number of important representations of blacks and in more recent times artists conscious of their African heritage, other Caribbean islands produced schools or groups of black artists for whom blackness or "negritude" was an unavoidable part of their artistic identity. The art of the coun-

tries of Latin America is diverse, but they all share a heritage of Spanish and Portuguese rule, whereas the Caribbean is made up of former French and British colonies as well.

The first part of the present book, "Photography, Anthropology, Racial Theory, and Popular Imagery," is intended to provide a discussion of subjects that represent some of the underlying conditions behind works of art discussed in the second book of Volume V as well. The first essay, Deborah Willis's account of relevant nineteenth-century photography, makes up for the omission of photography in the previous volume of *The Image of the Black in Western Art*. But it also introduces the important idea that much of the photography and the art produced by black artists was framed by a conscious desire to counteract and provide alternatives to the overwhelming presence in all Western countries of demeaning images of black people. These images, a representative group of which are discussed in essays by Tanya Sheehan and Henry Louis Gates, Jr., and Vera Grant, contributed in their omnipresence an immense amount to antiblack racism, but they reverberate throughout twentieth-century art in Europe and the Americas, and, repellent though they are, are indispensable to a serious study of the subject. An essay by Elizabeth Edwards looks at the way photographs of Africans can be understood in light of anthropological theory, and my own essay looks at the application of racial theory to the representation of Africans in the very popular displays in natural history museums of the "Races of Man," current from the mid-nineteenth century to the 1940s.

Part 2 of this book, "Europe and the Construction of the 'Primitive,'" begins with Suzanne Blier's account of Picasso's "discovery" of African art but sets it in the wider context of theories of physical anthropology of the period. She reveals the *Demoiselles d'Avignon* to be at one level a History painting in the great Renaissance tradition, concerned with the major theme of the division of humanity

into different types. Christian Weikop looks at other French images of Africans, but his concern is to bring to the fore the richness of German as well as French primitivism in the years before 1918. Petrine Archer uses Josephine Baker as a case study of the intersection of jazz, Negrophilia, urbanism, and primitivism in 1920s Paris. Weikop recounts the story of German and Swiss attitudes toward Africans into the 1930s, and Esther Schreuder looks at Holland in the first half of the twentieth century, revealing an unexpectedly rich response to Africans, largely through Dutch colonial connections.

Part 3, "Beyond Europe: The Caribbean and Latin America," concludes the book. Dawn Ades explores the complexities of race relations in Latin America, with the dominant Spanish settlers, the native population, and the very large numbers of descendants of the African slaves brought over from the sixteenth century onward. The depiction by white artists of "picturesque" people of African descent gives way to the emergence of artists of African descent intent on representing their mixed heritage in their art. Petrine Archer's account of the complexities of the art of the Caribbean islands, with their inheritance of British, French, and Spanish slavery, shows that ideas of "blackness" were essential and unavoidable to virtually all the artists at work there. And finally there is my essay on *Négritude* and the relations between one of the founders of the movement, the poet Aimé Césaire, and two illustrators of his work, Pablo Picasso and Wifredo Lam.

The second book of Volume V, *The Rise of Black Artists,* represents a major break with *The Impact of Africa,* as it does with all the previous volumes, not only in bringing the story right up to the present day with its exploitation of new media, but in shifting the story toward the representation of blacks *by* blacks. This process began mainly in the United States before the beginning of the twentieth century with black photographers, and the question of

black identity remains to this day at the forefront of black artists' concerns.

Though there had been artists of African birth or ancestry before the twentieth century, like Juan de Pareja in seventeenth-century Spain, Guillaume Lethière in early nineteenth-century France, a handful of landscape painters, and one female sculptor, Edmonia Lewis, in the United States, Henry Ossawa Tanner, as Jacqueline Francis argues in her essay in book 2, was the first painter in a succession reaching into the present day fully to confront in his art the problem of black identity.

The importance of this change can hardly be overestimated in terms of the trajectory of this series of volumes, which reaches back into Egyptian and Greek antiquity and passes through the Middle Ages, Renaissance, Enlightenment, and nineteenth century. The original assumption behind the series—enshrined in its very title—was that it was about images imposed on Africans and those of African descent by artists of European culture and descent. This still holds largely true in the first book of this volume, with the exception of the Caribbean, but the second book tells a dramatically different story. All but a few of the artists were and are blacks for whom blackness is in different ways a central part of their artistic identity. Issues of representation are thus no longer imposed on persons defined by difference, but are negotiated by a free subject acting on her or his own behalf. If the black person in previous art is only rarely the central focus of the work and is usually subordinate to the main action or even literally a face in the crowd, in the twentieth century the negotiation of her or his personal identity might well be the raison d'être of the entire work.

But this apparent liberation brought with it serious issues concerning race and ethnicity, created essentially by a lack of self-awareness on the part of art institutions that still took certain values for granted, serving to alienate black artists from the mainstream. Some of these issues are to a degree common to all artists, whether black or otherwise, and they apply with different emphases in different periods:

How could an artist express a "black identity" within the framework of (Western) artistic traditions going back to antiquity?

And (essentially the same question) to what extent did artistic assertions of black identity question aesthetic criteria that were assumed to have universal validity?

Could European traditions be avoided by looking to African art and traditions or to the specifically African American tradition represented by jazz?

How could an art that raises social questions be modern when for a large part of the century modernism was defined by abstraction?

In periods of turmoil over civil rights, or at any time, does an artist have a duty to confront and counteract racism and, if so, how?

And to bring the discussion into more current preoccupations, does cultural hybridity or a mixture of cultures open up new possibilities rather than lead to the betrayal or abandonment of one's own culture?

These issues were in essence unprecedented for black artists before the late nineteenth century and are still extremely challenging, yet the way they have been taken up in the United States and other countries since the beginning of the century has created, and continues to create, a large body of work that is original, stimulating, and of enormous range. Questions about the nature of black identity are as much at the forefront of African American art and the art of the Diaspora in, say, the work of Glenn Ligon (*The Image of the Black in Western Art,* Vol. V, pt. 2) and Kara Walker (also in the

second book of Vol. V), as they were with Tanner's early work (Vol. V, pt. 2). But, as the volume reveals, they are framed differently in each generation according to the point of view of each artist.

see 2, 3

The first section of the second book of Volume V follows broadly a distinction made by Aaron Douglas in two of the paintings, *Aspects of Negro Life*. This distinction is between the rural life of blacks in the earlier part of the century, discussed in an essay by Jacqueline Francis, and the move to the city, described by Richard J. Powell in terms of the rise of Harlem as the "capital" of black America, both of which are complemented by Deborah Willis's essay on the photography of the period. Adrienne Childs takes on the period of the struggle over civil rights and the Black Arts Movement, which presented artists with the question of activism and how their art could contribute to social change. This question was particularly pressing for artists leaning toward abstraction, and what was for many artists an internal debate is discussed by Ruth Fine in an analysis of the work of Norman Lewis, who was the African American artist closest to the first generation of Abstract Expressionists.

The final two essays, especially that by Kobena Mercer, on contemporary art, expand the American focus of the book toward the wider African Diaspora in the age of globalization. In addition to the rise of London and Paris, there is movement between London and New York and between both cities and the Caribbean, and of course the presence in all centers of artists from Africa itself. There is also the question of new technologies and media, and black artists have been at the forefront of video and performance art in all their ramifications. Even more significant for book 2 has been the shift in conceptions of black artistic identity to what has been called "Post-black," a term first coined by Thelma Golden in conversation with Glenn Ligon,[9] which she describes as shorthand for "post-black art," though the term has often been applied more broadly. Golden claims "it was characterized by artists who were adamant about not being labeled as 'black' artists, though their work was steeped, in fact deeply interested, in redefining complex notions of blackness." Such artists have tended to embrace a less monolithic and more hybrid sense of blackness, often emphasizing their sexuality and nationality as much as their ethnicity.

Though a volume on the twentieth century was not part of the original plan for the series, Volume V respects the Menils' desire that it should go beyond a commentary on the works illustrated to consist of discursive essays by the best scholars available, usually art historians, reflecting on the issues presented by those works. No uniformity of style has been imposed on the authors, nor have they been rigidly confined to the bounds of their topics. Sometimes works or topics are discussed by more than one author from a different viewpoint, as in the case of Josephine Baker and the German/South African artist Irma Stern. However, I would hope that few major figures or work of arts with something to contribute to the subject have been omitted, though there will always be differences of opinion on that matter.

I hope that readers will recognize not only the high quality of the essays in the volume but also a sense of dialogue among them. If they do so, that can be ascribed in part to the contributors' response to a workshop held in April 2012 at Harvard, in which they (with only two exceptions) gathered to discuss their contributions and to look particularly at the borders between them. In editing the texts I have seen clear evidence of such a conversation among contributors, some of which continued after the workshop. At the workshop I showed a number of images of works of exceptional interest that I thought might slip between the cracks and not fit in any of the essays. In the end they were all taken up by contributors, but subsequently I was shown two paintings by the British artist Glyn Philpot of great sensitivity, that appear to have no obvious

5, 6

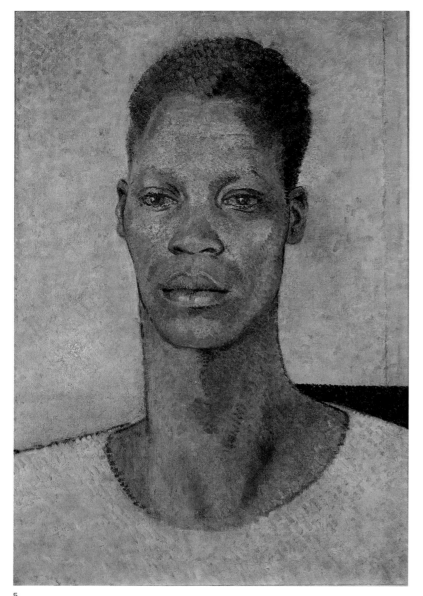

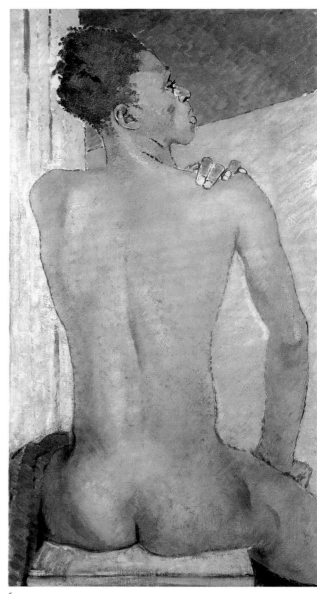

5

6

5 Glyn Philpot. *Portrait of Henry Thomas*. 1930s. London, Daniel Katz Collection.

6 Glyn Philpot. *Naked Figure from Behind*. 1930s. London, Daniel Katz Collection.

place in the volume. The portrait is certainly, and the figure seen from the back probably, of Henry Thomas, Philpot's servant and frequent model in the 1930s. Philpot exhibited a strong sexual attraction to black males and frequently represented them in his paintings. His biographer notes that "What makes Glyn unique was that black men became a major theme in his paintings done in London and Paris, and the inspiration of some of his best work."[10]

Such paintings make the point that there are twentieth-century realist representations of individual black people of real quality and interest—one might also mention Augustus John here—that do not fit within the framework of Volume V, which generally priv-

ileges works of a modernist tendency. But then this volume makes no claims to include all types of art; it discusses only a small selection of the many twentieth-century works that represent in one form or another the image of the black, but in a way that is designed to stimulate further inquiry.

This book is dedicated to the memory of one of its major contributors, Petrine Archer[11] (1956–2012), who tragically died after she had handed in the text of her two essays. She will be much missed by all who knew her and admired her work.

I

Photography, Popular Imagery,
Anthropology, and Racial Theory

1

COUNTERACTING THE STEREOTYPE: PHOTOGRAPHY IN THE NINETEENTH CENTURY

DEBORAH WILLIS

Picturing Africa America in Early Photography

Images of the black subject, whether artistic, documentary, or anthropological, are forever fixed in the popular imagination through photography. From the medium's beginning, race and gender have shaped and controlled the reception of photographic portraits, both politically and aesthetically. Frenchman Louis J. M. Daguerre (1787–1851)[1] made such images possible with his invention of the daguerreotype, the process of fixing an image on metal, in Paris. In August 1839, Daguerre published his description of the process. Within weeks, news of his invention had spread throughout France, and within months Americans were experimenting with the process. The *Great Western,* one of the fastest transatlantic steamers of the period, arrived in New York on September 10, 1839; it is remembered today because it carried French and English newspapers with descriptions of the daguerreotype process.

Daguerre was not the only one experimenting with what would become photography. A few years earlier in England, William Henry Fox Talbot also conducted experiments in photography. In 1834, he sensitized paper in an attempt to fix an image. By 1840, he had introduced the calotype—later renamed the Talbotype. In 1843, Fox Talbot began the mass production of photographic prints, and the following year he published the first book illustrated with photographs, *The Pencil of Nature.*

These new processes helped to shape the way in which we consider photography today. As Ewen and Ewen assert,

Bragging rights can be claimed in both directions. Talbot's techniques, creating negatives that could generate multiple positives, provided a foundation for the advance of modern photography and, later, cinema. On the other hand, Daguerre's one-of-a-kind images, though they required special conditions for viewing, were much sharper and more detailed than Talbot's.[2]

By 1850, photography had expanded to the use of printing on albumen paper, a process introduced by Louis-Desire Blanquart-Evrard, which became the most popular way of looking at images for the next forty years. Thus, Daguerreans and photographers working in the nineteenth century—who included everyone from artists to businessmen to enthusiasts—produced a wide variety of results on metal, glass, tin, and paper, offering new ways of looking at the world and its people. Photographic portraits and landscapes were accessible to most classes of American society, unlike the painted miniature portraits that had been popular in the 1830s. Images of black people—free and enslaved—attracted growing in-

7 Joseph T. Zealy. Portrait of Jack (Driver), Guinea, Plantation of B. F. Taylor, Esq. 1850. Cambridge, Mass., Peabody Museum of Archaeology and Ethnology, Harvard University.

8 Joseph T. Zealy. Portrait of Drana, country born, daughter of Jack. 1850. Cambridge, Mass., Peabody Museum of Archaeology and Ethnology, Harvard University.

9 Joseph T. Zealy. Portrait of Jem. 1850. Cambridge, Mass., Peabody Museum of Archaeology and Ethnology, Harvard University.

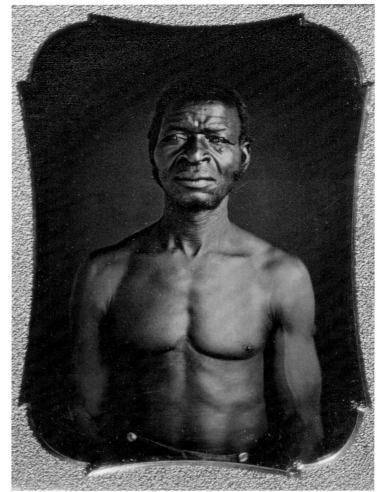

7

terest, and such photographs circulated within families black and white. They were reproduced as evidence of humanity and family ideals but also to promote ideologies that undermined their subjects.

This chapter features photographs produced by artists and photographers during the medium's early years. It investigates how racial identity was presented in photography in America and Europe at a time when debates about black people were the focus of scientific, aesthetic, and popular discussions. From the 1840s through the 1860s, photographic studios owned by white and black Americans recorded social and political events and made portraits of enslaved peoples, slave owners, free black families, and leaders in their respective communities.

During slavery, photographs of enslaved and free black men and women both changed and supported idealized racist scientific theories that rested on a belief in black inferiority. Louis Agassiz (1807–1873), the Harvard University natural scientist and zoolo-

gist, found photography the ideal medium for his studies. Initially, he was simply impressed by the portraits of white male leaders on display in Mathew Brady's photography gallery in New York. Then in the mid-1850s, he visited a colleague, Dr. Robert W. Gibbes in Columbia, South Carolina, while attending a conference. There, Agassiz observed the enslaved men and women living on B. F. Taylor's Edgehill Plantation and the properties of Wade Hampton II. He asked Gibbes to hire someone to photograph them.

J. T. Zealy, a popular South Carolina Daguerrean, claimed to have the first "truly established gallery in the capital city."[3] He advertised that he had "new and beautiful [Daguerreotype] cases, a skylight [in his studio] and up-to-date equipment."[4] A portrait session's exposure time could take up to twenty minutes and he had built-in skylights to support that process. Gibbes hired Zealy to make portrait studies of African- and American-born black men and women and possibly children. The group included Ebo, Foulah, Gullah, Guinea, Coromantee, Mandingo, and Congo, named

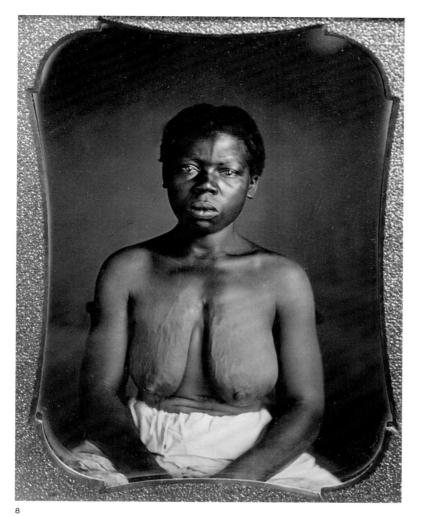

8

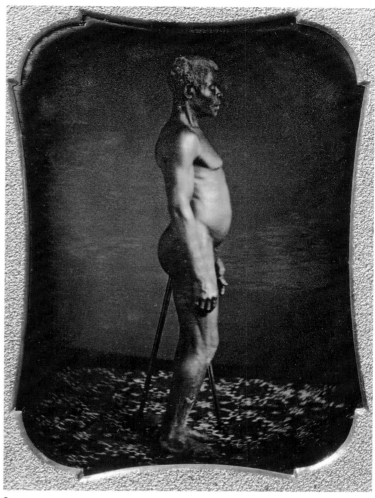

9

in carefully handwritten labels that accompanied the portraits that identified the subject's occupation, country of origin, and plantation owner. One example: "Jack (driver) *Guinea,* Plantation of B. F. Taylor, Esq. Columbia, S.C." Such classifications were especially essential for Agassiz's research. Posed nude or partially dressed, the black body became both muse and curiosity to Zealy and Agassiz. In addition to Jack, Renty, Alfred, Fassena, Drana, Delia, and Jem, among others, were taken into Zealy's studio. In 1975, these daguerreotypes were found in an attic on Harvard University's campus.

Photography curator Brian Wallis writes, "The daguerreotypes . . . had two purposes, one nominally scientific, the other frankly political."[5] They confront the complexity of photography and ethnology; by taking profile and frontal portraits, Zealy and Agassiz marked the images as representative of black bodies in general. Posed through the lens of race and desire, the black body is rendered sexualized and compliant; viewed as human property, it is represented as labor. All of the subjects were photographed and examined with these factors in mind. The white male gaze of both photographer and ethnographer dominate through the placement of each subject, whether sitting in a chair or standing on a patterned carpet. The visual narrative informs us that both subjects and images are objects to be handled. Such perspectives encourage a discourse that views the black body as inferior and at the same time desirable, based on the full-frontal nude poses revealing the penises of the men and the breasts of the women.

In the hands of Zealy and Agassiz, the bodies became the evidence that supported their political arguments of inferiority. Drana's full breasts suggest that she bore and breast-fed her own babies and possibly those of others. And as Suzanne Schneider argues, Jem's unclothed image is cloaked in "the scientific 'cover story' [that is] meant to veil the shocking nakedness of these black 'specimens' . . . [which] points to a much more troubling collapse of the distinctions that would delimit taxonomer from voyeur, empirics

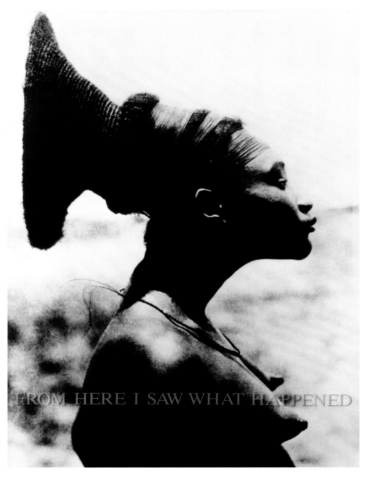
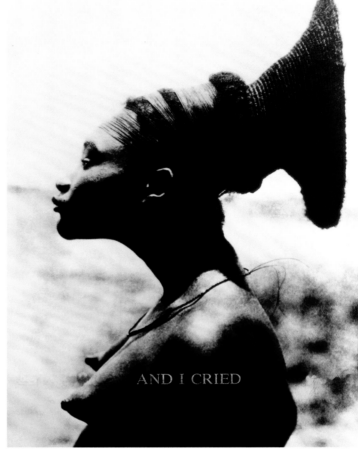

10

10 Carrie Mae Weems. *From Here I Saw What Happened and I Cried:* 1. "From Here I Saw What Happened and I Cried." 1995–1996. New York, Museum of Modern Art.

11 Carrie Mae Weems. *From Here I Saw What Happened and I Cried:* 2. "You Became a Scientific Profile." 1995–1996. New York, Museum of Modern Art.

12 Carrie Mae Weems. *From Here I Saw What Happened and I Cried:* 3. "A Negroid Type." 1995–1996. New York, Museum of Modern Art.

13 Carrie Mae Weems. *From Here I Saw What Happened and I Cried:* 4. "An Anthropological Debate." 1995–1996. New York, Museum of Modern Art.

14 Carrie Mae Weems. *From Here I Saw What Happened and I Cried:* 5. "& A Photographic Subject." 1995–1996. New York, Museum of Modern Art.

from erotics, and Agassiz as ethnographer from Agassiz as por-
9 nographer."[6]

Carrie Mae Weems (born 1953) is an activist and artist-photographer known for her photographic series relating to family, history, beauty, and memory. Concerned about iconography and the creation of icons, she has constructed a series of works questioning black women's presence in popular culture and art history. In 1992, she explored how the Zealy/Agassiz images were viewed then and how they are viewed now. She reimagined the experiences of some of the subjects, using slave narratives to help her re-

purpose the images. The resulting series, *From Here I Saw What Happened and I Cried*, is a text-and-image installation of large framed photographs printed with a red tint, possibly to signify the lifeblood still flowing through the memory of the subjects' enslaved experience. Weems layers a descriptive phrase or word on each photograph to further signify that experience. *From Here I Saw* visually retells the life stories of Delia, Renty, Drana, and Jack, with Weems serving as artist, scholar, and interpreter. Delia's profile is mounted in a circular frame covered with etched glass. The text reads: "You Became a Scientific Profile." Renty's frontal pose is captioned "A Negroid Type"; Jack's, "An Anthropological Debate";

10–14

11

12, 13

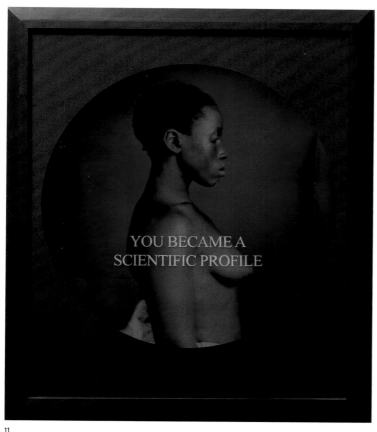

11

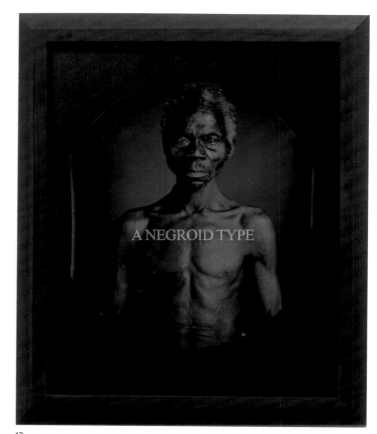

12

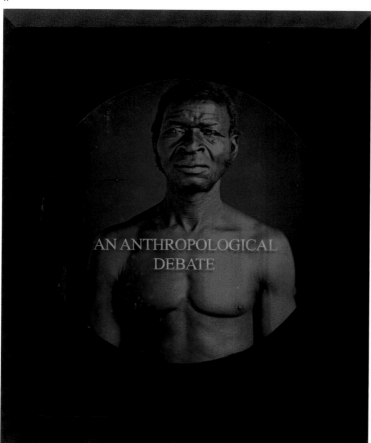

13

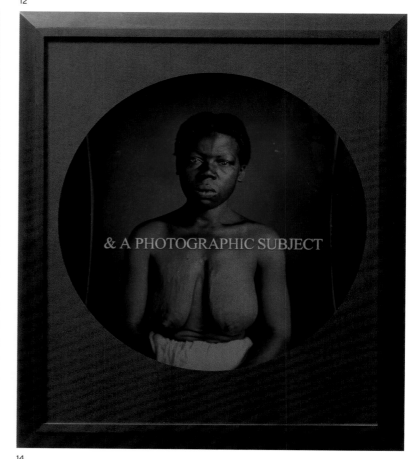

14

and Drana's, "& A Photographic Subject." By typecasting these images, Weems reframes their histories; tells their story "from here," that is, from a late-twentieth-century viewpoint; and becomes narrator and storyteller.

As Kellie Jones writes, "Trained also as a folklorist, Carrie Mae Weems has often directly engaged what Henry Louis Gates Jr. has called the 'speakerly' tradition, whether signifying racist jokes, or incorporating traditional wisdom or song. Her language runs from the vernacular to the poetic."[7] Weems's series is both a political and aesthetic response to the Zealy-Agassiz collaboration. She has restaged the troubling historic representation of the black body and explains, "The photographs were made for very, very different reasons originally. They were intended to undercut the humanity of Africans and of African Americans in particular."[8] Her appropriated photographs use color to evoke empathy for the subjects and to recall the abuse they suffered in their lives as well as through the forced photographic act.

During the period popularly known as Daguerreomania, 1840 to 1845, exhibitions of daguerreotypes and advertisements abounded. In Europe and America, photographers displayed their artistry. Despite the second-class status and living conditions of African Americans, most of whom were still enslaved, numerous free black men established themselves as daguerreotypists and photographers. The first publicized exhibition by a photographer of color was held on March 15, 1840, in the Hall of the St. Charles Museum in New Orleans. The exhibition, which drew a large crowd, was organized and sponsored by the Daguerrean himself, Jules Lion, who was also a lithographer. Other African Americans who practiced the art and business of photography between 1840 and 1850 included James Presley Ball and Augustus Washington. They worked as Daguerreans, documentarians, artists, and stu-

dio photographers, recording white families, celebrities, scholars, writers, singers, businessmen, artists, and other free blacks. They gained recognition locally and nationally and, in Augustus Washington's case, in Liberia, on the west coast of Africa.

In the early 1850s, Washington advertised that his Daguerreian [sic] Gallery on Main Street was a few doors north of the Centre Church in Hartford, Connecticut. His witty advertisement included a caricature of a photographer and his subject, aimed at attracting a variety of clients, and noted his location in the heart of downtown Hartford. Another ad stated, "Washington is at home daily executing beautiful and correct Miniatures, equal to any in this country, at his uncommonly cheap prices."[9] A few years earlier, he had lived in New Hampshire, where he studied at Dartmouth and became interested in photography, taking portraits primarily of white families. An antislavery activist, Washington closed his Hartford studio in 1853 to immigrate to Monrovia, the capital of Liberia. He believed that leaving the United States was the best way to reform the practice of slavery and the only way he could live freely. He gave his perspective in the *New-York Daily Tribune* on July 3, 1851:

I have been unable to get rid of a conviction, long since entertained and often expressed, that if the colored people of this country ever find a home on earth for the development of their manhood and intellect, it will first be in Liberia or some other parts of Africa. A continent larger than North America is lying waste for want of the hand of science and industry.

Strange as it may appear, whatever may be a colored man's natural capacity and literary attainments, I believe that, as soon as he leaves the academic halls to mingle in the only society he can find in the United States, unless he be a minister

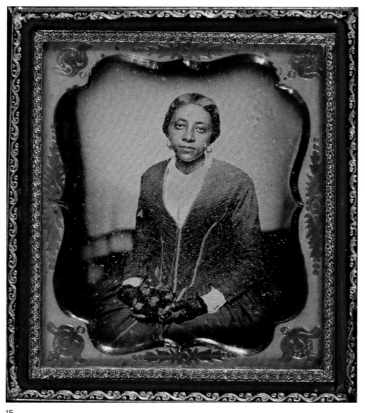

15

15 Augustus Washington. Unidentified woman, believed to be Sarah McGill Russwurm, sister of Urias A. McGill and widow of John Russwurm. 1854. Washington, D.C., Library of Congress.

or lecturer, he must and will retrograde. And for the same reason, just in proportion as he increases in knowledge, will he become the more miserable. He who would not rather live anywhere on earth in freedom than in this country in social and political degradation has not attained half the dignity of his manhood.[10]

While in Monrovia, Washington continued his daguerreotype business, carrying over chemicals, plates, and cases in order to continue to make poetic portraits of black Americans living in Liberia. "I love Africa," he said in a letter, "because I can see no other spot on earth where we can enjoy so much freedom. . . . I believe that I shall do a thousand times more good for Africa, and add to our force intelligent men."[11] And when we consider his political assessments of black America and Liberia, his portrait photography becomes evidence of the "dignity of [the] manhood" described in his editorial.

Washington's portrait business was an immediate success. He sold roughly $500 worth of portraits during his first five weeks of business in Liberia. Prices for his daguerreotypes started at $3. Washington made between $20 and $40 per day from his pictures. News of Washington's photo studio spread by word of mouth, and

he hired young boys to go out into the community and attract customers.[12]

In the short time that Washington lived in Liberia, he made an impressive number of portrait studies. In 1854, he photographed the McGill family, and his surviving portraits include one of a woman, possibly Sarah McGill, although it has been catalogued as an unidentified woman, probably a member of the Urias McGill family. Sarah McGill was married to John Brown Russwurm, who with Samuel Cornish founded *Freedom's Journal,* the first African American newspaper, in 1827. Russwurm was an early proponent of emancipation and was concerned about the misidentification that could occur through racial typecasting. He and Cornish wrote, "We wish to plead our cause. Too long have others spoken for us. Too long has the publick been deceived by misrepresentations, which concern us dearly. . . . It shall ever be our duty to vindicate our brethren."[13] Sarah McGill was the only daughter of George McGill, a minister, merchant, and teacher, and his wife, Angelina. In 1830, when Sarah was a child, the McGills moved from Baltimore, Maryland, to Liberia. According to historian Winston James, she married the older Russwurm when she was a young woman. Little is known about her except that she was well educated and a businesswoman; she and her husband imported beef, pork, mack-

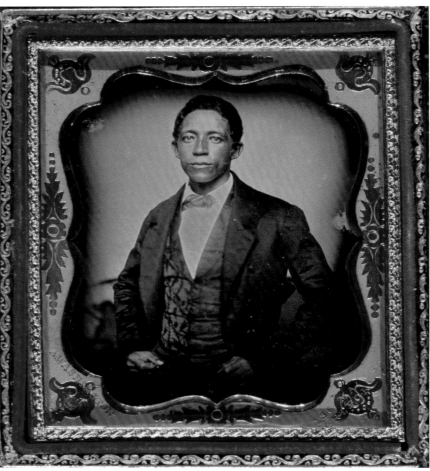

16

erel, tobacco, nails, and soap. She worked side by side with her husband, "at his elbow."[14]

Washington photographed her in his Liberian studio a few years after her husband's death. She appears mournful as she holds a daguerreotype[15] case between her open-fingered lace gloves and looks longingly into the camera. Her gaze is fixed, as if she is recalling the loss of her husband and business partner. This daguerreotype was in a double-sided case with a portrait of Urias Africanus McGill, her brother, and was found among the papers (now in the Library of Congress) of the American Colonization Society, founded in 1817 to resettle African Americans in Liberia.

The unique portrait must have given a strong impression in its day. Sarah McGill's clothing indicates her class and status in society. "The family-based albums of the nineteenth century are those of prosperous dynasties whose members had both the leisure and the money to take up photography, as well as to purchase commercially produced images."[16] Undoubtedly, Washington was commissioned by the McGill family, which was known for its philanthropy and concern for the black families who immigrated to Liberia in the 1850s. Sarah McGill's portrait stands

in sharp contrast to Zealy's portraits, taken around the same time.

In his groundbreaking book on the life of John Russwurm, Winston James describes the McGills as one of the "most distinguished families in the Colony [Liberia]."[17] Urias Africanus McGill (ca. 1823–1866) was photographed by Washington in 1854, the year he moved to Africa. This three-quarter-length, hand-colored portrait depicts him as an honorable, self-assured, well-dressed man, his hands placed firmly at his sides as he holds the hem of his jacket. Like Jack and Renty, he gazes into the camera, but here it is with a sense of prosperity. The year this daguerreotype was made, Urias and his brother James established a shipping and mercantile business that served West Africa, Europe, and across the Atlantic. They soon recruited their brothers, Samuel and R. S., and relaunched their company as McGill Brothers.[18] "Embracing both transatlantic and African coastal trade," writes Ann Shumard, "as well as a thriving commission business with numerous stores and warehouses, the McGill Brothers firm played a principal role in Liberia's early commercial history and earned a handsome fortune for its partners."[19]

Miles Orvell argues that the "portrait in the private realm sought to convey the individuality of the subject; the portrait of the public personage created an image that resonated with the popular imagination; but in this 'scientific' mode the photographer was seeking to record 'objectively' a subject who must be made to conform to a social type."[20] Viewed through the lens of Zealy and Agassiz, African Americans were seen as oddities and scientific specimens. Through Washington's lens, they were citizens and human beings. The Zealy and Washington daguerreotypes each affirmed an image of black people. One was manipulated to present the "primitive" that had been captured in the imagination of "darkest Africa"; the other presented an intelligent, ambitious, and prosperous family who chose to live in Africa. These were two well-established photographers, one white, the other black, who defined, under instruction from their patrons, how their subjects ought to look as they gazed into the camera. The unclothed body read "savage," the clothed body "civilized."

Creating a Likeness

Throughout early years of American photography, portraits of African American families, preachers, soldiers, writers, and other prominent and lesser-known individuals were produced regularly in galleries and studios. They were as popular as calling cards, and photography was increasingly the medium chosen for creating these likenesses. Most nineteenth-century photographs were not intended for publication or public presentation unless they were of celebrities, lecturers, and other prominent citizens. However, a few African American men and women thought it was important to distribute their likenesses to their contemporaries and sometimes preserve them for posterity.

Frederick Douglass's writings about photography and the notion of "self" radically transformed ideas about the perception of the black body in art and photography. In portraits of himself, Douglass heightened his viewers' awareness of the dignity and humanity of the black subject. He expressed in his writings and his posed portraits a dignity that scientific racism attempted to refute through the study of phrenology. His deep commitment to combating such efforts can be found in the large number of photographs of him in collections around the world. Zoe Trodd claims that he was "the most photographed American"[21] in the nineteenth century. According to Laura Wexler, "During slavery, Douglass heard in the click of the shutter a promise of the shackle's release." She surmises that "if black people could appropriate by means of the camera the power of objectification that slavery wielded, Douglass perceived that photography would become an agent of radical social change."[22] His portraits embody his position that slavery was inhumane and unconscionable.

Douglass, who was more than six feet tall, was considered one of the handsomest men of the nineteenth century, and his as-yet-unidentified photographer draws the viewer's attention to his subject's striking face, full head of hair, and shaved visage with a slight beard cradling his chin. While in Cincinnati, Douglass met the noted nineteenth-century spiritualist Margaret Fox, who described him this way: "Frederick is as fine looking as Ever. . . . I think he is the finest looking gentleman I have seen since I have been in Cincinnati," adding that beholding Douglass "would set the people Crazy."[23] Douglass's furrowed brow raises a question as he gazes directly into the camera. Colin Westerbeck comments that Douglass's portraits have "a powerful and unsettling effect on us today because he really became the prophet of his people that he felt destiny had chosen him to be."[24]

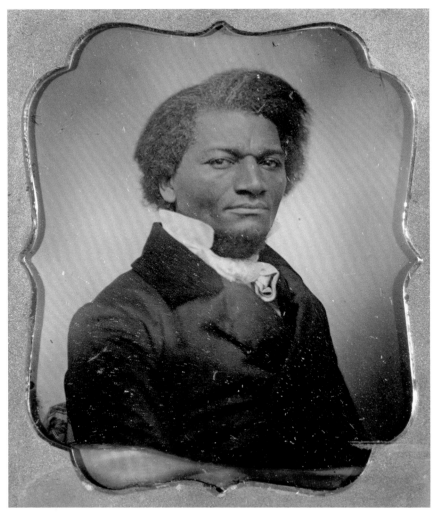

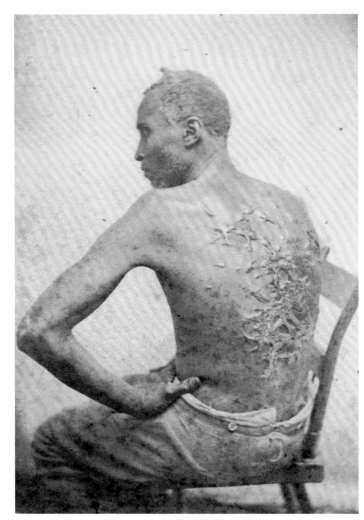

17

18

Douglass was about thirty-eight when the photograph of him reproduced here was taken. He had delivered one of the most famous speeches on slavery just three years before in Rochester, New York, on July 5, 1852:

What have I, or those I represent to do with your national independence? Are the great principles of political freedom and of natural justice embodied in that Declaration of Independence extended to us? . . . What, to the American slave, is your Fourth of July? I answer: a day that reveals to him more than all other days in the year, the gross injustice and cruelty to which he is a constant victim.[25]

In the photograph, Douglass is well coiffed; his high, starched collar, double-breasted jacket with velvet collar, and wide white necktie suggest his awareness of the fashion of the period. His public persona is that of a dapper gentleman, his distinctive full head of

hair swept to the side, creating a dashing and imposing portrait. Richard J. Powell writes:

As early as 1844, the soon-to-be published Douglass understood the broader implications of his own image, a realization that made the routine procedure of sitting for a daguerreotype or painted likeness a significant, political tactic. Forever the disaffected insurgent, Douglass unleashed his oversized ego in front of cameras and easels with the sense that what was at stake was not only his character and renown, but the reputations and claims to equality of all people of African descent.[26]

Douglass was motivated by the proliferation of stereotypes that portrayed blacks as buffoons. And so this portrait is a metaphor for the character of a "man," specifically Douglass himself, moved to grasp the concept of freedom through visual culture. He resisted

the labels placed on black people, and he saw photography as a vehicle for creating an identity, whether constructed or realized. The camera angle, lighting, and clothing caught the attention of his viewers. As Ginger Hill argues, "It is the lens of the viewer him- or herself that creates what is seen."[27]

Curators, art historians, historians, and cultural critics have written about Douglass's images for decades. About this image in particular, Malcolm Daniel wrote, "Although the photographer is unknown, this majestic portrait reveals a man whose dignified posture, forceful gaze, and determined expression, along with the passion and eloquence of his words, proved the merits of his cause."[28] At the time, Douglass was known for his philosophical lectures and writing on photography. Indeed, he helped to shape photography's reception in the early years. In 1870, he wrote about a chromolithographic reproduction of Senator Hiram Revels of Mississippi, which had been created from a photograph by Mathew Brady:

> We colored men so often see ourselves described and painted as monkeys, that we think it a great piece of good fortune to find an exception in this general rule . . . Pictures come not with slavery and oppression and destitution, but with liberty, fair play, leisure and refinement. These conditions are now possible to colored American citizens, and I think the walls of their houses will soon begin to bear evidence of their altered relations to the people about them. This portrait is . . . an historical picture. It marks, with almost startling emphasis, the point dividing our new and old condition.[29]

Nineteenth-century African Americans presented themselves to the camera in a manner that projected their desired status. As Eric Foner writes, "For Douglass, the term representation had both a political and pictorial meaning, and if the Civil War's promise of equality was to be realized, those meanings had to merge. Revels's realistic portrait embodied the myriad hopes, obstacles, and possibilities comprising Reconstruction."[30]

Portraits of black Civil War soldiers reimagined the black male desire to fight for his own freedom. During the war years, 1861–1865, soldiers posed in studios and in tents and wagons. Backdrop scenes included landscapes, flags, and bunkers, and each soldier held a weapon—a firearm or a sword—that suggested he was in control of his own manhood and freedom. A different case is that of the Civil War–era carte de visite of a self-emancipated man known only as Gordon, which circulated widely. This was taken by McPherson & Oliver of New Orleans, possibly in that city. Gordon escaped from his Mississippi master by rubbing himself with onions to throw off the bloodhounds. He took refuge with the Union Army at Baton Rouge and at that point posed for a photograph. Private Gordon is seated sideways on a wooden chair, his hand placed delicately on his hip. His shirtless body shows the evidence of beatings and whippings, which have formed keloid scars. To the abolitionists who sold the image, those horrific scars were evidence of slavery's cruelties. Text printed on the verso read, "The net proceeds from the sale of these photographs will be devoted to the education of colored people."

Cartes de visite were published under a few studio names, including Mathew Brady's New York and McAllister & Brothers, Philadelphia. Private Gordon's photograph was also known as "The Scourged Back" and was circulated by doctors and abolitionists. The photograph offered two opposing interpretations of Private Gordon. Nicholas Mirzoeff suggests that to abolitionists, "it was intended to highlight the evils of enforced labor and hu-

18

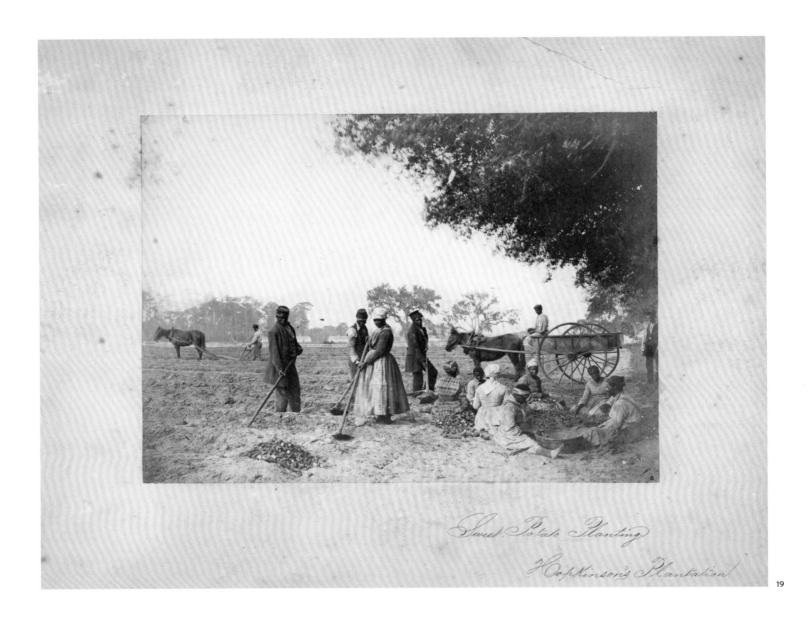

Sweet Potato Planting

Hopkinson's Plantation

19

man bondage, made visible as the scars of whipping(s) inflicted by a cruel slave-owner. In the plantation world-view, The Scourged Back was simply evidence of a crime committed and properly punished."[31] *The New York Independent* commented, "This Card Photograph should be multiplied by the 100,000 and scattered over the states. It tells the story in a way that even Mrs. Stowe [Harriet Beecher Stowe, author of *Uncle Tom's Cabin*] cannot approach, because it tells the story to the eye."

In 1863, three engraved portraits were printed in *Harper's Weekly* showing Gordon "as he underwent the surgical examination previous to being mustered into the service—his back furrowed and scarred with the traces of a whipping administered on

Christmas Day last."[32] The back of the card included comments of S. K. Towle, surgeon, Thirtieth Regiment, Massachusetts Volunteers: "Few sensation writers ever depicted worse punishments than this man must have received, though nothing in his appearance indicates any unusual viciousness—but on the contrary, he seems intelligent and well behaved."

Black Americans in the South during the Civil War fascinated photographers, who traveled the country documenting aspects of plantation life, battlefields, and campsites. New Hampshire photographer Henry Moore took one of the most iconic photographs of the period, depicting agricultural workers who labored under the hot sun harvesting crops. Calling the photograph *Sweet Po-*

19 *tato Planting—Hopkinson's Plantation,* Moore provided a view of slave culture from planting crops to style of dress. He included the types of baskets and farming tools used by the laborers. It is an idyllic scene of life on a Southern plantation, located on Edisto Island off South Carolina. On Edisto Island, Union troops administered the properties left by slave owners who had fled further south to Georgia or Mississippi and developed a taste for and interest in southern foods. As Frederick Douglass Opie writes, sweet potatoes, sweetmeats, cornbread, and pork "represented the most requested foods among Southern troops, both black and white."[33]

This photograph depicts carefully dressed men, women, and children, a rarely presented view of enslaved men and women. Only one of the women, wearing a head wrap and apron, holds a hoe as she mimics the proper gesture for harvesting the crop. Three men stand nearby—two in Union jackets and caps, the other in a vest and shirt—and also hold planting tools. The scene romanticized the laboring black body and the production of crops as the South tried to prepare for an unimaginable future. Seven seated figures fill sweetgrass woven baskets with the harvested crops; a single male figure stands by a tree in the distance as if he is guarding the crop and observing the laborers. A cart with driver is positioned nearby, and another man plows through the field with a horse. This photograph characterized the construction of a desirable vision of the South for some Northerners.

Gesture and clothing offer a subtext to reading this photograph; the multigenerational group, possibly a family, has become part of the landscape. Wide plaid skirts, white head scarves, and soldier caps and jackets identify them as laborers and tie them to Union soldiers, who may have given them the clothing. They were concerned about their appearance. The photographer's narrative ex-

plains that the women made their own clothing and that those who were oppressed retained in their memories African containers such as the sweetgrass baskets[34] that carried the crops. Moore clearly visualized this confined outdoor space on Hopkinson's plantation as a link to an African past. Moore became aware of the popularity of this type of imagery when the *Philadelphia Photographer* magazine acquired one of his negatives and reproduced prints of it. A reporter wrote: "No technology yet existed to print photographs in publications, so distribution of individually made prints remained the primary means of mass circulation. . . . This gave Moore's work national, and even international, exposure . . . [and his] pictures nevertheless were presented to the public as realistic."[35]

Over the course of some thirty years, photography became a commodity. Portraits became increasingly important to black people because they represented a reality that they recognized. In thousands of small and large photography studios, photographers catered to black clients who valued and sought to convey their dignity and freedom. These were carefully composed works that presented their subjects as noble and self-aware.

Abolitionist and women's rights advocate Sojourner Truth (1797–1883) was born Isabella Baumfree in upstate New York. It is believed that she was the first black woman to use photography to communicate her goal to abolish slavery. Truth sold portraits of herself mounted on sturdy board for 35 cents and 50 cents each. "I am living on my shadow," she wrote. Truth's image has been engraved on our public conscience since the 1860s, and she used photography to express and promote her political concerns and describe her life story. Carla Peterson observes that for Truth, "the photograph came to function as a form of autobiography, of recorded testimony, of a signature both singular and reproducible,

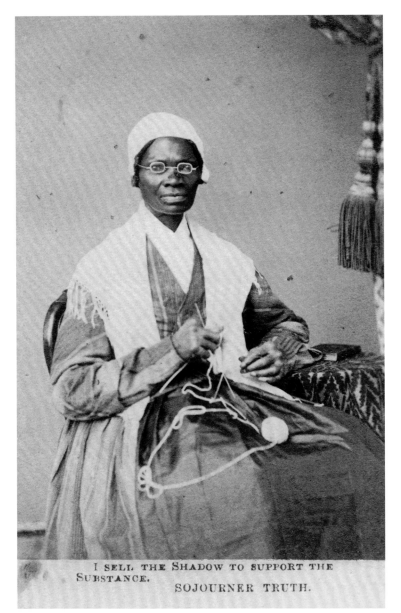

I SELL THE SHADOW TO SUPPORT THE SUBSTANCE.
SOJOURNER TRUTH.

20

20 Unidentified Photographer. Sojourner Truth (1797–1883). "I Sell the Shadow to Support the Substance." 1864. New York, International Center of Photography.

through which she . . . hoped in some measure to enter the culture of writing."[36]

20 In the carte de visite reproduced here, Truth is seated in a studio, wearing a cap and shawl and holding knitting needles and yarn in her lap. It is a picture of femininity and gentility. By staging the act of knitting and placing her arm on a studio table, she replicates a relaxed home environment. The studio's other props suggest class, leisure time, and concern for education; note the book on the side table. The portrait supports her role as a woman of the time, when femininity was of high importance; her hair is covered with a small white cap. During her often cited lecture, "Ar'n't I a Woman?" a man asked Truth to show her breasts to prove that she was not a man. As Deborah Gray White notes:

Many of the women in the audience were appalled by the demand, but Truth herself appeared undaunted. She told the man that her breasts had suckled many a white babe, to the exclusion of her own offspring. . . . Truth's experience serves as a metaphor for the slave woman's general experience. . . . Slave women were the only women in America who were sexually exploited with impunity, stripped and whipped with a lash, and worked like oxen. In the nineteenth century when the nation was preoccupied with keeping women in the home

and protecting them, only slave women were so totally unprotected by men or by law. Only black women had their womanhood so totally denied.[37]

Truth is also wearing eyeglasses, an indication of her concern for literacy and health care. Her shawl symbolizes her concern for style and also was essential for keeping the body warm. Truth defined and revised a woman's space/place with her photographs. In New York City in 1867, while lecturing about voting rights, she commented:

There is a great stir about colored men getting their rights, but not a word about the colored women; and if colored men get their rights, and not colored women theirs, you see the colored men will be masters over the women, and it will be just as it was before. So I am for keeping the thing going while things are stirring.[38]

Truth's images were distributed during her lectures, and she earned income by selling her "shadow." She acknowledged that the public was curious about her and desired to collect her likeness. Impressed by some of the photographs but dissatisfied with the quality of others, she wrote to a friend, "I wanted to send you the best. I enclose you three all in different positions—they say here that they are much better than my old ones."[39] Truth printed the following words on more than ten of the portraits: "I Sell the Shadow [the photograph] to support the Substance [her body, her cause]." Consumers of the image were left to ponder the poetics of the phrasing as they held it or placed it in a frame in their homes. A visionary and a spiritualist, Truth presented a message of "self-awareness." I would argue that she was as complicit in the making of her image as she was in renaming herself from Baumfree to Truth.

During the last half of the nineteenth century, despite the pervasive racial discrimination that existed throughout the United States, hundreds of men and women of color visually defined a group identity and the nationalistic ideals of their black leaders. They supported, for example, W. E. B. Du Bois's proclamation, "The duty of the Americans of Negro descent, as a body, [is] to maintain their race identity,"[40] and Booker T. Washington's philosophy that "a cultural education could be and should be a kind of education that helps us to awaken, enlighten, and inspire interest, enthusiasm, and faith in one's self, in one's race and in mankind."[41]

Artistic and commercial photographers opened studios in their local neighborhoods, teaching and taking courses, honing their craft to create imagery that projected dignity and documented black men and women as achievers, not "the savages" depicted in the larger culture. But caricatures of African Americans became more prevalent during this period. Historian Michael Bieze argues:

Racism in photography extended beyond entertainment into the new science of anthropology and the old science of phrenology, both of which used photographs to legitimize inferiority. If Blacks were not the butt of some joke in stereographs, they were ethnographically categorized and displayed in science and popular culture journals as types.[42]

Dramatic and exaggerated posing presented black children as undesirable, and these same images were used as product advertisements for soap and food. Black children depicted as alligator bait, as lazy, and eating chicken or watermelon while scratching see 25

their heads, became a craze. Large commercial publishing houses produced stereographic views of black Americans, sold under such titles as "Scenic views of the southern states." Photographers participated in the dissemination of these images at every level; some were published in newspapers, journals, cards, and books and were purchased by white families, but not by the subjects or their families. Black people purchased their photographs directly from studios that reflected their hope for a new life removed from derogatory stereotypes.

Images taken by artistic photographers, both black and white, attracted the attention of a significantly different consumer. These self-conscious images often were created for private families or were of celebrated figures, such as entertainers, boxers, or writers. These photographers and their subjects were composing visual narratives on beauty, masculinity, and prosperity that expanded the commonly known "typed" imagery of the late nineteenth and early twentieth century. In other words, the photograph was used as a form of resistance by the black subject and consumer. Conventional images and stereotypical photographs both valued and devalued black bodies. Black commercial studios, and some owned by white photographers, assisted their black sitters in revising the popular imagery that depicted black Americans as racially inferior. Racist white photographers profited from creating prejudicial and disturbing photographs of black subjects, including the tortured and lynched bodies of both men and women; they objectified black subjects and viewed them as subhuman, contributing to a system of power that gave credibility to the theories of Agassiz and others.

Today, nineteenth-century stereotype genre photographs, including those of African American men, women, and children, enjoy more popularity with collectors and segments of the general public than do many other images of the day. Southern scenes of black people—groups posing on plantations, servant children, laborers, chimney sweeps—were the ones most frequently mass-produced and distributed. As a result, when we imagine nineteenth-century black America, we often think of such stereotypical images, as well as of minstrel performers in blackface.

2

MARKETING RACISM: POPULAR IMAGERY IN THE UNITED STATES AND EUROPE

TANYA SHEEHAN AND HENRY LOUIS GATES, JR.

An astonishing number of images of black people that circulated widely in the United States and Europe from the middle of the nineteenth century through the twentieth objectified and caricatured them, propagating degrading stereotypes about the supposedly immutable *nature* of people of African descent. These images made visible deep and widespread anxieties about "racial" difference, and it is quite telling that they emerged most prolifically at key turning points in political history: the abolition of slavery in the Americas followed by Jim Crow segregation, European imperialism and its aftermath, and the globalization of Western capitalism. Perhaps the most significant fact is their mass popularity; why did a subjugated people, thought to be fundamentally different and unalterably inferior, elicit such a huge body of images from the white cultural imaginary, images whose function was to reinforce hostile beliefs and feelings? While other racial and ethnic groups were depicted in negative ways in American and European popular culture, the sheer volume of derogatory images of black people far exceeds that of any other group.

The purpose of this essay is not to provide a full account of this phenomenon, which requires a book-length treatment.[1] We have chosen instead to concentrate on a small number of images that provide a background to the representation of blacks in the art of the twentieth century. Deeply shocking and brutally racist images are still produced today, but black artists have tended to respond to more insidious forms of imagery. These images can be superficially comforting, like those of Aunt Jemima, which might evoke warmth and nostalgia for a nonexistent past; they can also be crudely humorous and trivialize the prejudice they embody.

The discussion that follows shows how particular ideas and feelings about "blackness" found expression in virtually every form of popular visual culture, including illustrated children's books, toys, magazines, advertisements, packaging, posters, postcards, decorative arts, vernacular photographs, and other collectible objects. While these images no doubt were meant to confirm the social order in which black people were relegated to subservient status and to stimulate pleasure at the sight of their imagined physical and social foibles and intellectual inferiority, artists of the African Diaspora responded to such images in the second half of the twentieth century by appropriating and undermining their antiblack messages. Artists thus signified upon these images by retrieving them from history and subverting them through pastiche, parody, and satire—all forms of repetition but with a pointed, political difference.

It was not uncommon at the turn of the twentieth century for derogatory images of black people to migrate between popular literature and commercial culture as well as across media and na-

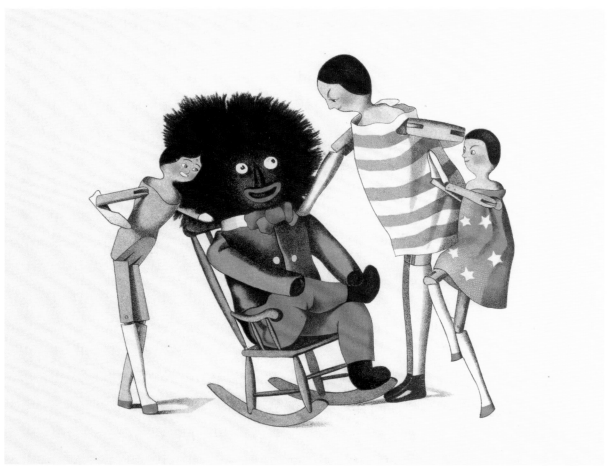

21

tional discourses. Exemplifying this cross-cultural migration is the figure of the golliwog. The American-born author Florence Upton, assisted by her English mother, Bertha Upton, invented a character named the "Golliwogg" for their children's book *The Adventures of Two Dutch Dolls*. First published in London in 1895, the book begins with two wooden dolls, Peggy Deutchland and Sarah Jane, coming to life on Christmas Eve and seeking the "liberty" to walk, dance, and escape the toy store that confines them. After making dresses for themselves out of an American flag—an unsubtly nationalist gesture—the pair encounter other toys that join them in their play; they include a doll with jet-black skin, thick red lips, and a head of frizzy hair that Florence Upton had based on "Negro minstrel" characters from her childhood in the United States. While initially frightened by the "horrid sight" of this "blackest gnome," the Dutch dolls are reassured by the golliwog's "kindly smile," his gentlemanly suit and bow tie, and his respectable demeanor. As their play ensues, however, the white dolls' agency is contrasted with the golliwog's captivity and victimization, as he falls into icy water, gets pelted with snowballs, and ultimately must be carried back to the toy store as a limp rag.

The golliwog character survived for another day, to be featured in many more adventures written by the Uptons and in popular literature, sheet music, postcards, and children's toys, especially dolls.[2] Today the caricature is best known in the United Kingdom, Australia, and other former British colonies thanks to the efforts of James Robertson & Sons, a British company that introduced the golliwog as the trademark for its mass-produced jams and preserves around 1910. Found on jam jars, badges, pendant chains, playing cards, aprons, and much more, Robertson's "Golly" understandably came under attack between the 1960s and '80s, when black political activists in the United Kingdom and the United States campaigned to remove grotesque racial caricatures from mass circulation. Remarkably, Robertson's trademark remained in commercial use until 2002, and golliwog dolls continued to be manufactured and sold in the United Kingdom, reportedly on the royal estate in Norfolk, as late as 2009.[3]

The golliwog belongs to a collection of racist caricatures that imagined black bodies as different from those of white people. This difference was essentialized through the blackness of their skin, which had long been associated in Western culture with filth

21 Page from Florence Upton, *The Adventures of Two Dutch Dolls and a Golliwogg*. 1895. Cambridge, Mass., Houghton Library, Harvard University.

and disease and represented as a pollution of whiteness. Such associations find their origins in ancient fables about leopards and spots and about "Ethiops" and their dark skin. In one much-recited tale, a man attempts to scrub his servant white and clean, assuming his blackness to be the result of neglect on the part of a former master. The notion of washing an "Ethiop" or "blackamoor" white served as a figure of sheer impossibility and miraculous rebirth from ancient Greece and the early Christian era, through early modern Europe.[4] These associations would have been familiar to middle-class consumers in Europe and the United States, whose anxieties about white racial purity informed the advertising campaigns of many household products in the late nineteenth and early twentieth centuries.[5]

The British company A. & F. Pears Limited is well known for proclaiming that its soap could make any material white, especially the "hands and complexion." A Pears advertisement makes this claim through a pair of before-and-after illustrations. In the top register, a rosy-cheeked red-haired girl stands with a bar of soap in hand over a bathtub in which a dark-complexioned boy soaks. In the bottom register, the girl holds up a mirror so that the boy can see the apparently miraculous results of the cleansing: from the neck down, his body has been bleached white, taking on the rosy glow of the cherubic white children in the round frames below. Through the seemingly innocent figure of the white female child, Pears thus expressed a serious political investment in the black body as a commodity that could be made docile, fit, and clean—in a word, "civilized"—in order to claim or earn its value within a white social and political economy.

Bound up with that investment were anxious concerns to maintain the perceived differences between the races. Pears addressed such concerns by leaving the boy's face black, a choice that encour-

aged consumers to laugh at the advertisement and buy Pears soap rather than perceive it as a threat to the immutability of white dominance. A similar logic informed the marketing of American domestic products—from Gold Dust washing powder, whose ads featured black twins washing each other in a tub, to J & P Coats thread, which compared its ability "never [to] fade" to the color of a dark-skinned boy.

Commercial advertising that imagined blackness as something that could be put on and removed for humorous effect was undoubtedly influenced by the minstrel show, which began in the United States in the 1830s and '40s and enjoyed international popularity through the mid-twentieth century. This form of theatrical entertainment featured white (and later black) actors performing black caricatures with faces darkened with burned cork in comic songs, dialect speeches, and sketches. They also mimicked a stereotypically "black" voice and used verbal malapropisms and homophonic puns that suggested inept attempts at replicating white speech and manners.[6] References to the stock characters and tropes of blackface minstrelsy infiltrated popular visual culture on both sides of the Atlantic, as many of the examples in this chapter demonstrate. Minstrelsy also cultivated a prolific visual culture of its own, from illustrated sheet music, posters, and advertisements, to a body of racist imagery that included many thousands of condescending images.

Among the racist stereotypes that minstrel images perpetuated was that of the "coon," which represented black men as lazy, stupid, shiftless, and generally good-for-nothing. There was the country coon, who was prone to eating watermelon, stealing chickens, and sleeping on the job. In the city, the image took on the guise of "Zip Coon," a descendant of and a riff upon the "Jim Crow" minstrel character fabricated by Thomas "Daddy" Rice in 1828. Zip Coon

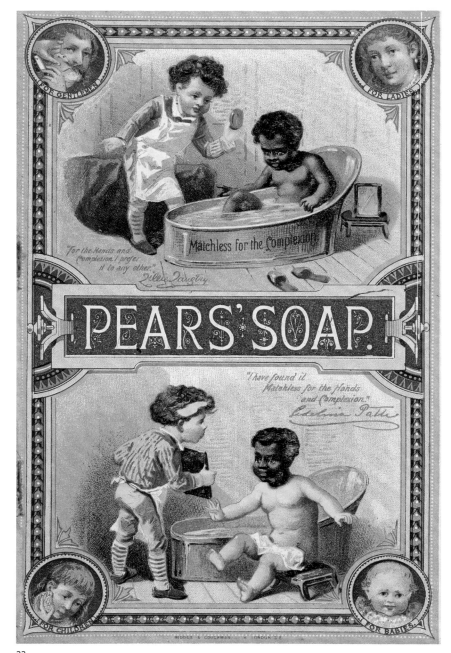

22

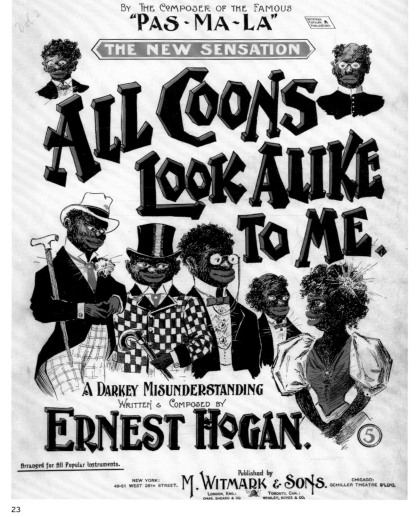

23

exhibited airs beyond his lowly status, dressed as a dandy, and mangled standard English, revealing, it was assumed, the innate intellectual inferiority of all black people. Such attitudes had found visual expression in the series of fourteen colored etchings titled *Life in Philadelphia* by the British artist Edward Williams Clay in 1828–1830. (See *The Image of the Black in Western Art,* Vol. IV, pt. 2, fig. 41.)

At the turn of the twentieth century—precisely when black political gains during Reconstruction were being buried by the "Redemption" of former Confederates and the formalization of Jim Crow practices into U.S. laws—the coon became the subject of its

own musical form, the popular "coon song," which joined blackface minstrelsy to vaudeville. We show the cover illustration for one of the most famous of these songs, composed in 1896 by Ernest Hogan. The lyrics tell the story of a young black woman who is so enamored of her boyfriend that she can no longer see the attraction of other men. With the exception of her boyfriend, "all coons look alike" to her. The cover gives visual form to this resonant phrase and thus to the idea that the African American community was a homogenous group that shared the characteristics of idleness, laziness, lasciviousness, and stupidity.

Although the illustrated figures appear sophisticated through

22 A. & F. Pears Limited. Advertisement for Pears' Soap, British. Ca. 1880s. London, Wellcome Library.

23 Illustrated sheet music cover for *All Coons Look Alike to Me*. 1896. Providence, Brown University Library.

dandified dress, their mimicry of white middle-class styles is always inept. Black people themselves played with this form of mimicry for humorous effect under slavery and later through such carnivalesque rituals as Pinkster Festivals and the Cake Walk. But the type of image epitomized by this cover illustration is at the expense of the black subject. All the figures are pictured with the same jet-black skin, kinky hair, bulging white eyes, and bloated red lips—including the song's female subject. That Hogan was himself African American adds another layer of complexity, and even tragedy, to the cover's gross caricatures and the song title's apparent light-heartedness.

While famous black composers and performers like Hogan, Bert Williams, and George Walker did much to establish the genre of black musical theater in the United States, their relationship to the minstrel stage and its predominantly white audiences not only influenced but often determined their reproduction of these loathsome caricatures and stereotypes. Usually they did so without the signifying irony with which black artists approach this storehouse of racist representation today. At the time that Booker T. Washington, W. E. B. Du Bois and other African Americans were calling for a "New Negro," such images continued to dominate the representation of black people and the popular vaudeville music created by many blacks.[7]

The figure of the black child, as a synecdoche for the entire race on the scale of evolution and as a metaphor for the arrested intellectual and moral development of black adults, became a widely used device through which to articulate popular conceptions of blacks as helpless and dependent on whites. The children's book *Ten Little Niggers,* an illustrated children's story based on counting rhymes, was first published in London and New York in 1869 and underwent numerous editions and translations into the twentieth

century. Clumsy, naughty, gluttonous, and lazy, one by one the black boys in the story are killed off. In an early American edition, their deaths result from being burned by the sun, suffocated by a bear, and consumed by a "red herring"; others choke at a banquet or cut themselves in half. Only the tenth boy escapes death through marriage; a scene of his future happiness concludes the counting lesson.[8]

That some editions of *Ten Little Niggers* replaced the "red herring" with a crocodile brings to mind the fantasies of African American children as "alligator bait" that were disturbingly common in the 1890s, when the codification of Jim Crow laws was accompanied by a surge in representations of violence against black people. In 1897—just a year after the infamous Plessy v. Ferguson "separate but equal" Supreme Court decision—the Tennessee photographic studio of McCrary and Branson printed for mass circulation a picture of nine naked black babies arranged in a horizontal row against a white backdrop. The caption at the bottom of the photograph—"Alligator Bait"—crudely disrupts the sweetness of the scene with the possibility that these innocent-looking figures might become lunch for an alligator. This photograph was recycled in many forms in the decades that followed. One commercial postcard dating to the 1920s incorporated four babies from the original composition, heavily redrew their figures, and placed them in an outdoor scene reminiscent of Floridian swampland. The children are stereotyped as "pickaninnies." With neither parents nor civilization to tame them, pickaninnies were endlessly causing and getting into trouble. Being eaten by an alligator, then, served as a fitting punishment for their insolence in the racist imagination.[9]

The representation of blacks as savages, however, was not always framed as a laughing matter. Images of black men as menacing brutes proliferated in popular visual culture during Reconstruc-

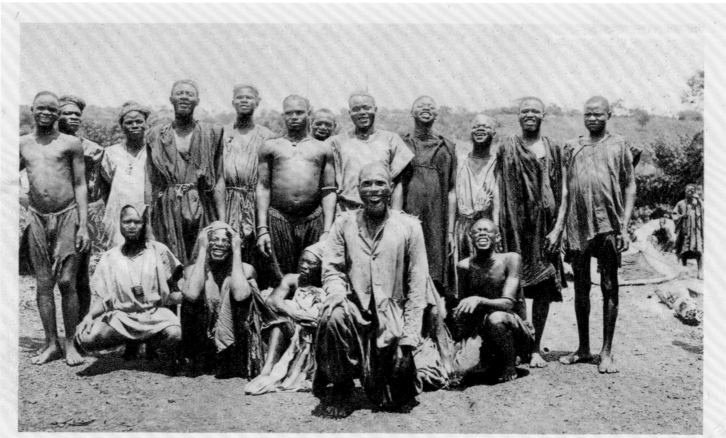

Types africains. - Concours de sourires

24

tion (1865–1877) and through the Progressive era, provoking white fear and outrage, just as black men were being systematically disenfranchised throughout the former Confederate states. In illustrated literature and in such early films as D. W. Griffith's *Birth of a Nation* (1915), "the Negro" was depicted as physically and sexually aggressive, threatening the safety of white women and the "purity" of the white race. Such images lent support to the violence against blacks that had become widespread across the United States and was documented by horrifying lynching postcards and photographs (see Vol. V, pt. 2).

A similar process was at work in representations of Africa. The many photographic postcards picturing colonial Africa in the first decades of the twentieth century imagined blacks as collectively Other. Mass-produced chiefly for European tourists and military personnel in the colonies, but with a larger circulation throughout the globe, these images presented bodies and scenes from African life as foreign and exotic. Captions reduced Africans to racial and ethnic types. For example, a dark-skinned Senegalese woman and the young son she is holding were stripped of their individual identities to become "Madame Sénégal et son fils," "Types Sénégalais,"

or simply "Types noirs." Scantily clothed African women with local hairstyles and adornments were sexualized for Western male viewers as "belles négresses," while men in similar states of undress were labeled "très primitifs."[10]

The French postcard illustrated here, captioned "Concours de sourires" (competition of smiles), also reduces Africans to generic types. The commercial photographer who created this image clearly invited the men before him to smile broadly in order to stage a Western fantasy of black Africans as essentially happy. They are presented as simple, childlike beings, naive about the realities of modern life and conditioned to endure without complaint the harshest labor and living conditions. For centuries, the caricatured black smile and images of the "happy darkey" served to justify slavery, apartheid, and colonialism. That several figures in the postcard refuse to bare their teeth for the camera, however, reminds us that such a refusal developed into deliberate resistance in the twentieth century as people across the African Diaspora challenged white assumptions about black feelings.[11]

The Belgian artist Georges Remi (pen name Hergé) famously incorporated stereotypes of colonial Africans as both uncivilized and

24

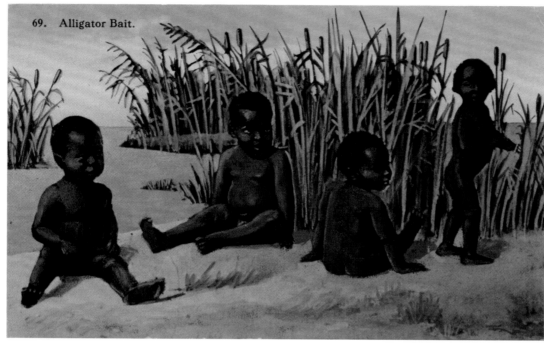

69. Alligator Bait.

24 *Types africains. Concours de sourires,* French. Ca. 1920. New York, New York Public Library.

25 *Alligator Bait.* Postcard, American. Ca. 1920. Private collection.

25

unthreatening into his internationally best-selling comic book series, *The Adventures of Tintin*. For the second book in the series, first published in 1931, Hergé's editor reportedly asked him to bring the fearless boy reporter (Tintin) and his canine companion (Snowy) to the Congo in order to support a larger national effort to celebrate the effects of Belgian colonialism in the region.[12] Absent, of course, from *Tintin in the Congo* is any mention of the atrocities inflicted on the native population that accompanied King Leopold II's rule over Congo (1885–1908). In their place, Hergé created a vision of the Belgian colony that followed Leopold's rule (1908–1960) as bringing white "civilization" to black "savages." It was this vision and its articulation through grotesque black caricature that evidently led to Hergé's own apology for *Tintin in the Congo* and the comic book's partial revision in 1946. Controversy over its illustrations resurfaced in 2007, when the Commission for Racial Equality in the United Kingdom supported its removal from British bookstores. It is a sign of the continued sensitivity surrounding the book that Hergé's heirs and publishers refused permission for any of it to be reproduced in the present volume, though the 1946 edition repeats some of the stereotypes that caused offense in the first place.

A survey of the illustrations in *Tintin in the Congo* reveals a potpourri of period stereotypes as grinning blacks appear to be irrationally fearful and both confused and fascinated by Western civilization. In one early scene, an automobile carrying Tintin, Snowy, and his Congolese servant-boy Coco crashes into an aged locomotive full of African passengers. Readers are invited to find humor in black bodies in ridiculous forms of Western dress and in their misplaced belief that their decrepit train is a fine example of modern technology. When Tintin orders the Africans to get their train back on its tracks, they proclaim in broken English their aversion to work and their fears of getting dirty, evoking old jokes about black laziness.

However, these passengers eventually become deferential and grateful to Tintin. Their view of white men as saviors or gods is repeated in several scenes: first, when Tintin shows the Africans a movie, which they fail to recognize as a visual representation and attack with spears; and second, when Tintin is saved from hungry crocodiles by a white priest, who shows him the school and chapel he built for the natives. Popular photographs illustrating such scenes circulated widely in the early twentieth century. Missionary photographs, for example, were commonly found both in ethnographic studies and on postcards, often presenting black subjects in Western clothing and poses, reading and writing in nonindigenous languages, playing European musical instruments, and engaging in other "white" activities. Many of these photographs depicted black children (or infantilized adults) standing beside their white benefactors, all looking proud of the light and order that Western education had brought to dark, benighted, and chaotic Africa.[13]

Europeans could also envision black men as brutes in the context of struggles for power in African colonies and in international military conflicts. During the Second World War, for example, the Fascist government in Italy commissioned posters and flyers that

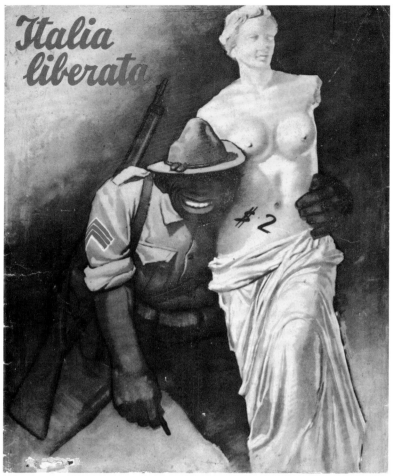

26

27

depicted the Allied soldiers as African savages. Gino Boccasile's *Italia liberata* commented on the seemingly unstoppable movement of American and British troops through Italy and France in 1944 by pairing a grotesquely featured African or African American soldier with one of the Louvre Museum's cultural icons: the Venus de Milo. With splayed legs, hunched back, apelike hands, and broad grin, the bestial black figure grips the white classical sculpture tightly, pushing his face toward its breast. The juxtaposition was meant to invite the Italian public to associate the Allied campaign with rape and violation, sexualized political violence, and cultural defilement. The phallic crayon dangling suggestively from the soldier's right hand further indicates that it was he who inscribed "$2" onto the torso of the Venus—a crude depiction of America's presumed materialism in the face of European culture, and the desire of lustful black men to violate the purity and integrity of the white female body.[14]

Italy and other nations had, however, produced popular images of the black long before their involvement with Ethiopia. In Venice there was a tradition that flourished particularly in the eighteenth century, of incorporating "blackamoor" figures into interior architecture, furniture, and decorative objects, such as candelabra and serving bowls (see the works of Brustolon in *The Image of the Black in Western Art,* Vol. III, pt. 3, figs. 29–30). Arranged in poses of servitude and often holding up other objects, these sculptural figures gave material form to black labor in wealthy European homes and throughout the colonies. With their elaborate gilding and hand-painted polychrome finish, they functioned as symbols of exoticism, luxury, and refinement for wealthy Venetians and others.[15]

Blackamoor figures dating to the late nineteenth and early twentieth centuries were products of the rococo revival in Italy. By the end of the twentieth century, they were appearing in more public spaces, including hotels throughout Venice. These wall brackets, lamp stands, and side tables drew the attention of African American artist Fred Wilson, who incorporated them into his installation in the U.S. Pavilion at the 2003 Venice Biennale. Wilson's appropriation of the sculptures and their recontextualization in an international art exhibition in Italy served as a double signifying mo-

26 Gino Boccasile. *Italia liberata,* Italian poster. 1944. Berlin, Deutsches Historisches Museum.

27 Blackmoor figures, Italian. Late 19th century. Houston, Museum of Fine Arts.

28 Advertisement for Aunt Jemima Pancakes, American. Ca. 1951.

ment, ensuring that this generation of Italians and visitors to Venice would for the first time become conscious of such images.[16]

Through the work of African American fine artists, filmmakers, and collectors in the final quarter of the twentieth century, Americans in general became more aware of their country's mass production and dissemination of racist material culture over the previous 150 years. This has led to the recuperation of what we can call "Sambo Art," or what is euphemistically known as "black memorabilia."[17] In 1889, the Quaker Oats Company adopted the Aunt Jemima or "mammy" stereotype as its now infamous trademark.[18] Named after a black minstrel song ("Old Aunt Jemima") written by Billy Kersands and sung by a blackface performer in drag, Aunt Jemima became a stock figure in later minstrel shows. The Quaker Oats' Aunt Jemima began its life in the form of a matronly black woman whose comforting and invitingly warm smile, apron, and head kerchief could be seen to engender nostalgia for an ideal of domestic servitude rooted in fantasies of loyalty and faithfulness on long-gone southern slave plantations. The purpose of this icon—whose motto was "My Aunt Jemima Old South Recipe gives you the lightest pancakes you can bake!"—was to bolster the product's claim to authenticity. It was accompanied by a range of other kinds of "mammy" objects, from cookie jars to memo pads.[19] Rather than treating the mammy as a historical figure to despise and forget, Betye Saar's *The Liberation of Aunt Jemima* (1972) (see *Image of the Black,* Vol. V, pt. 2)[20] and Renee Cox's *Liberation of Lady J and UB* (1998) reconfigured it as a disconcerting image to express revolutionary ideas about black female agency.

A cast-iron mechanical toy was first marketed in the United States and Britain in the late nineteenth century, branded with the words "Jolly Nigger Bank," in the shape of a coon stereotype. The

28

29-30

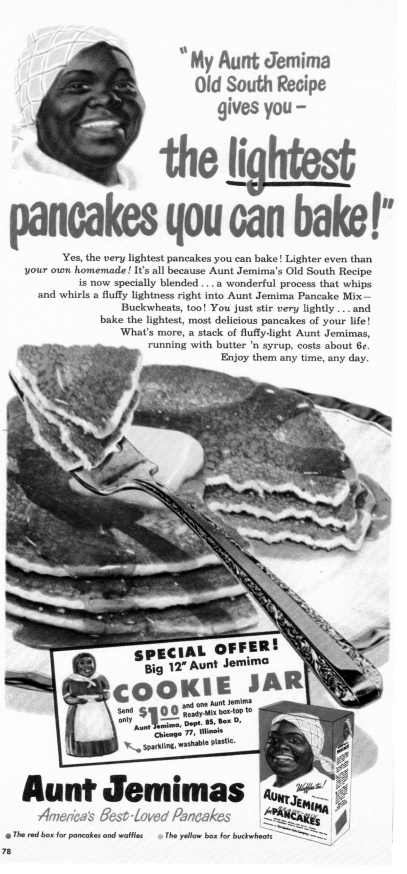

28

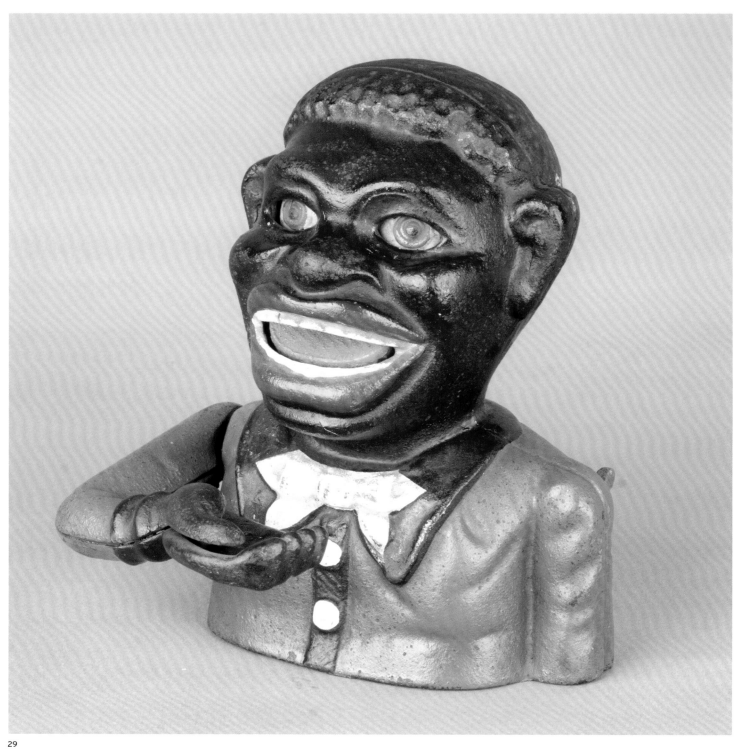

29

29, 30 J. E. Stevens. *Jolly Nigger Bank*, American. 1896. Collection of
Henry Louis Gates, Jr.

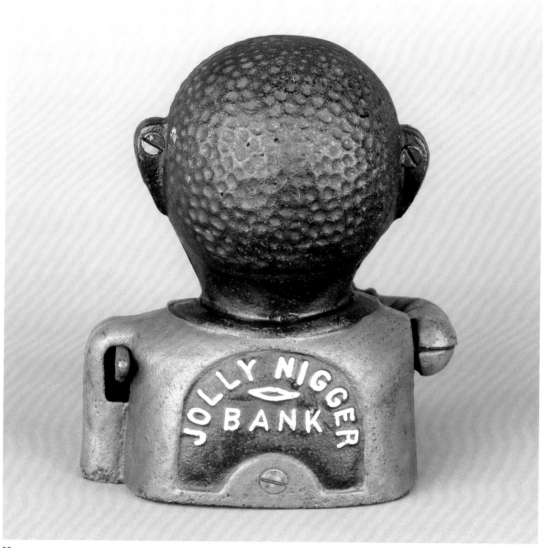

30

user of the bank would place a coin in the figure's hand and then press a lever on its back that would push the coin into the red-lipped mouth. Blacks were thus represented as "eating" money, as mindless consumers rather than producers. In a series of provocative paintings and prints from the 1990s, artist Michael Ray Charles (see *Image of the Black,* Vol. V, pt. 2) adopted the iconography and symbolism of the Jolly Nigger Bank to comment on the dehumanization and commodification of black bodies. His *Forever Free* series (1997) sets grotesquely smiling black heads against white crossed bones, conjuring the stereotype that black men are dangerous, even deadly, and fusing the image of the brute with the fool. The coin slots that Charles carved into these heads, like the copper penny he used as a signature and leitmotif throughout his oeuvre, connects his figures to the mechanical bank and more generally to racist fantasies of the American past. The titles in

the *Forever Free* series also address more contemporary white fears, as in *Hello, I'm Your New Neighbor* and *Can I Be of Any Assistance.*[21]

For Charles, as for the filmmaker Spike Lee, what is alarming about racial stereotypes is not only that they persisted into late-twentieth-century popular culture, but that they could also be propagated by blacks themselves. Lee's controversial film *Bamboozled* (2000) brought these fears to life through the character of Pierre Delacroix (played by Daman Wayans), a Harvard-educated television producer who, to salvage his career, created *The New Millennium Minstrel Show* with an all-black cast; it included a tap-dancing duo named Mantan and Sleep n' Eat with a chorus composed of Sambo, Aunt Jemima, Topsy, and many more. As the show became a wild success among black and white audiences alike, the black memorabilia that filled Delacroix's office began to

haunt and taunt him; chief among these was a *Jolly Nigger Bank,* which began to feed itself.[22]

In the 1960s and '70s, the advertisements for Aunt Jemima Pancake Mix and the many other domestic products that relied on black stereotypes were condemned by activist groups in the United States who called for their revision or removal. In the 1980s and '90s, as the size of the black middle class grew, some commercial advertising in the United States and Europe began to offer images of racial diversity to appeal to a broader range of consumers. Black subjects began to populate advertisements for makeup, clothing, and housewares more than ever before, in mainstream magazines, television commercials, and billboards. Their presence across these media framed the products as suitable not just for white consumers, but for everybody, whatever their color. The most controversial effort to bring racial diversity to commercial advertising was launched by the Italian clothing company Benetton in 1984, when it hired photographer Oliviero Toscani to manage its media presence. At first, Toscani paired Benetton's distinctively colorful clothing line with a multiracial and multinational group of models to convey ideas about racial harmony and world peace.[23] Around 1990, however, Toscani removed clothing from the ads altogether and began attaching the Benetton logo to provocative photographs.

These pictures incorporated black bodies into a commentary on famine, epidemic disease, violent crime, and a host of late-twentieth-century political conflicts. Among the campaign's racially charged images were photographs that juxtaposed black and white bodies: a black woman breast-feeding a white baby; a black hand and a white hand cuffed together; and two children playing the roles of (white) angel and (black) devil. The first of these photographs appeared in seventy-seven countries around the world but was banned from magazines in the United States and United Kingdom, which saw it as reminiscent of the wet nurse and mammy stereotypes. It also suggested that black children were made to go hungry while white mouths were fed by the labor of the black female body, a discomfiting idea that some of the American press did not want to see associated with the sale of consumer products.[24] This is not to say that images of black poverty and famine did not have a place in the popular media; such subjects were commonly circulated in international photojournalism of the 1980s and '90s. Throughout this period, the covers of *Time, Newsweek,* and other widely distributed magazines regularly equated starving black bodies with Africa, while the continent itself was presented to readers as a generic signifier for poverty, famine, and disease. Photographs of Ethiopians were particularly popular, reducing the entire Horn of Africa to brown skeletal bodies with faces full of desperation and despair.[25] The mass circulation and commercialization of such images incorporated the suffering of many African people into the Western cultural imagination, arousing sympathy for their plight and raising money for relief efforts. Yet any positive work that such strategies might accomplish must also be weighed against their framing of suffering as an essentially "African" problem and their failure to specify the temporal moments and physical spaces in which that problem might exist.[26]

Scholars have made this criticism of many photojournalistic images, but none of these pictures has attracted more attention than Kevin Carter's *Famine in Sudan.* The South African photographer traveled to southern Sudan in 1993 to document the rebellion taking place there. Carter submitted to the *New York Times* a horrifying image that the newspaper published on March 26, 1993, of a Sudanese child attempting to crawl to the nearest food station while a vulture stood watch over her naked and emaciated body,

31

32

ostensibly waiting for her to die. The *New York Times* called the picture an "icon of starvation," as the child remained nameless and the context of the photograph's production was undisclosed; it could have been taken anywhere as long as it was in Africa. The circumstances of its making evidently weighed heavily on Carter, who claimed that he watched the child whimper and pant for twenty minutes, waiting for the vulture to spread its wings, before leaving the child to continue the struggle on her own. Some commentators have speculated that the moral and ethical questions the photograph raised contributed to Kevin Carter's suicide, which came just two months after it won a Pulitzer Prize.[27]

Such images of African starvation can be seen as another way in which demeaning ideas about Africans and people of African descent have been propagated. Though very different in intention and effect than the overtly racist images that have been so prevalent over the past 150 years, they can retain troubling assumptions about black people as in need of white leadership and salvation. They have in a certain sense supplanted the grotesque caricatures that proliferated at the turn of the nineteenth century and that danced and sang to amuse the consumers of the staged culture of blackface minstrelsy. And yet a visit to the Jim Crow Museum of Racist Memorabilia will attest, these visual images are not merely relics; rather, they are very much with us, all too readily available for downloading in a veritable i-cloud of antiblack imagery. We saw this in the cottage industry of racist depictions of candidate and then president Barack Obama, and we see it in the curious way in which old images are being recycled afresh on web sites and all sorts of consumer products, including household goods, clocks, and fishing lures.[28]

3

VISUAL CULTURE AND THE OCCUPATION OF THE RHINELAND

VERA INGRID GRANT

Most popular images of Africans in twentieth-century Germany followed the pattern in other countries, placing them in humorous contexts mocking their supposedly childlike or savage nature. The depictions exhibited in commercial and entertainment venues reflected an exoticism of the foreign body within Germany as well as the derogatory position prescribed for blacks in the German colonial space. Actual experiences with blacks residing in Germany were quite limited. The small black German population originated through Germany's diplomatic ties to Africa in the nineteenth century or the brief period of German colonial adventures (1890–1918) that began at the end of the century. The German colonial experience *within* Africa and also *within* Germany was intense and provocative. We may consider the atrocities by German colonial troops in the 1904 massacre of three-quarters of the Herero population in South-West Africa (present-day Namibia) as the outer edge of German colonial encounters. German military actions in the colonies were shadowed by the supposed innocence or naïveté of comical and ferocious popular images of the black in popular circulation. The significance of German colonial possessions extended deeply into the German homeland's daily life through a constant stream of popular mass culture on the colonies: "experts, explorers, colonial heroes, [and] missionaries" competed with "dime novels, wax museums, and panorama."[1] The images blended a gen-

eral fascination with blackness with surging scientific expositions of colonial life. In other words, "currents of knowledge and magic flowed, paradoxically, together."[2] An episode of propaganda and politics in the aftermath of the First World War, however, gives a distinctive harshness to a number of images produced when the world suddenly seemed upside down. The French army of occupation in the Rhineland deployed black colonial troops, bringing about "the first large-scale Black presence in Germany."[3] In April 1920, following an outbreak of unrest in the Ruhr region, and when the French army subsequently moved into Frankfurt, violence ensued when French Moroccan troops fired upon and injured German civilians. Suddenly, the French black "occupation" troops drew international attention. An article appeared in the *London Daily Herald* on April 10, 1920, that claimed sexual misbehavior on the part of the black troops: "Black Scourge in Europe: Sexual Horror Let Loose by France on the Rhine."[4] It marked the beginning of the international "Black Horror on the Rhine" campaign that would both capture the public imagination and incite private fears.

Images circulated in Germany that claimed that black rapists presented a threat to German biological purity and *Kultur*. The early twentieth century witnessed an explosion of spectacular visual culture marked by the collective consumption of visuality, a new synergy between written and visual texts, and representations

33 *Simplicissimus*. Cover from 27 Nr. 45 page 629, Simplicissimus from 5.2.1923. Weimar, Klassik Stiftung Weimar.

34 Josef Steiner. *50 Wilde Kongoweiber Männer und Kinder in Ihrem Aufgebauten Kongodorfe*. 1913. Berlin, Deutsches Historisches Museum.

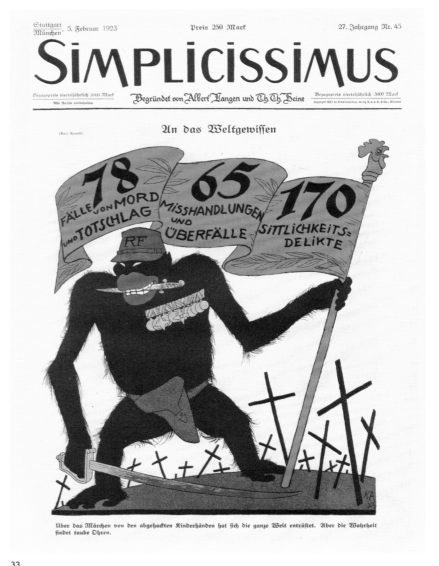

33

of reality as spectacle. Within this milieu the graphic and cinematic representations of the propaganda campaign fed on sensationalized passions.[5] "Importantly, the black figures in the visual propaganda were all highly racialized, often to the point of making the figure almost nonhuman. In some cases these figures featured in lurid sexual scenes."[6] The eye of the visual storm centered on notorious "highly sexualized imagery of vicious, subhuman Africans raping young German maidens."[7] Lora Wildenthal notes that the presence of masses of black troops in Germany "was associated with defeat, humiliation, and powerlessness. Interracial desire, which colonialists had admitted and sometimes even praised before the First World War, was now denied and reinterpreted as rape."[8] Rape scares and narratives of sexual victimhood inside Germany also generated evidentiary materials needed for Germany to protest the Versailles Treaty.

One example among many comes from *Simplicissimus,* an insurgent new magazine with a provocative style. It depicts an African soldier as a gigantic ape, with medals pinned to his chest and knife held within his teeth, carrying a bloody sword.[9] The "Black Horror on the Rhine" campaign was unstoppable and included occasional prurient highlights, such as the public publication of "love letters," improbable brothel logistics, and distorted venereal disease statistics. It reached a climax in 1921. 33

This was not, however, the whole story in Germany. There were also displays of popular anthropology, represented by Josef Steiner's 1913 poster *50 Wilde Kongoweiber Männer und Kinder in Ihrem Aufgebauten Kongodorfe (50 Savage Women, Men, and Children from the Congo in Their Reconstructed Congo Village),* which suggest knowledge of German Expressionism in the extraordinary range of colors used to represent the African woman. As Jill Lloyd 34

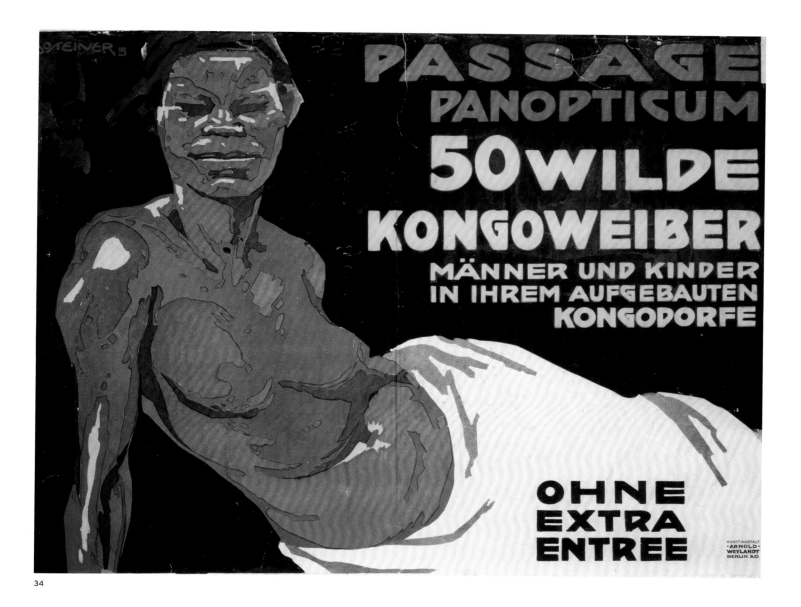

34

argues, German Expressionist artists' engagement with the city led them to paint colorful cabaret and circus scenes as well as lonely, alienating Berlin streets.[10] The setting for the show the poster advertised was the Panopticum, a commercial space that "fed from and fed into the public's desire to see for themselves the freakish, and the outlandish, presented in dioramas, wax displays, and live shows."[11] When anthropologists "captured" colonial bodies through their mechanical and indexical film and photographic archives, they also sought to document "scene setting" and verify an "authoritative anthropological realism."[12] In the short-lived German Colonial Museum, for example, gathered ethnographic products and materials were then shared with the public in "the most modern techniques of spectacular display, bringing together a mosaic of panoramic settings with photographs and life-groupings, and an ongoing series of lectures and slide shows."[13] In borrowings

from both the techniques and theoretical approaches of anthropology, German Expressionists brought these exhibition elements to their graphic designs: "Precisely because their primitivism had a conceptual basis which went beyond questions of formal influence, exoticism was an important constituent. It provided a rich meeting ground for elements of the 'primitive' and the modern, which involved subjects as well as styles, and a network of shifting relationships between the two."[14]

Karl Goetz's cast bronze medal *Die Wacht am Rhein/Die Schwarze Schande* (The Watch on the Rhine/The Black Shame), 1920, is among the most extreme of the images produced at the time to address the presence of the colonial troops. Goetz's visual imagery draws upon discourses of degeneration and racial hygiene, with their specters of racial mixture. He was a sculptor renowned for his satirical medals produced during and after the First

35

35 Karl Goetz. *Die Wacht am Rhein/Die Schwarze Schande*. 1920. K262 obverse and reverse. Henry Scott Goodman collection.

36 Karl Goetz. *Die Wacht am Rhein/Die Schwarze Schande*. 1920. K262a reverse; *Die Schwarze Schmach*. 1920. K263 reverse. Henry Scott Goodman collection.

37 Karl Goetz. *Die Wacht am Rhein/Die Schwarze Schande*. 1920. K264 reverse. Henry Scott Goodman collection.

World War, especially for his 1915 medal that commemorated the sinking of the *Lusitania,* an act that triggered the American entry into the war. His medals are notable for a cartoonist's immediacy, chronicling the escalating social discontent in Germany in the immediate aftermath of the First World War, and the inflation, poverty, and political violence in the Weimar period. Cora Lee Gilliland suggests that we should place Goetz within the artistic milieu of the Expressionists and the art community of Munich.[15] She compares him with George Grosz and links him to the *Blaue Reiter* group, with connections to Kathe Kollwitz, Emil Nolde, and Otto Dix.

On the obverse of the *Die Wacht am Rhein* medal, a grotesquely stereotyped African colonial soldier in profile leers brutally, his lower jaw extended. A large earring hangs from his ear, his hooded eye and woolly hair topped off by a helmet, with a French Revolutionary rosette. The inscription reads: *"Die Wacht am Rhein!!"* and "Liberte, Égalité, Fraternité" on the obverse, the former referencing a patriotic anti-French song popular during the Franco-Prussian War of 1870, the latter a facetious comment on the French Revolutionary national motto, implicitly attributing the presence of the black troops to the ruinous and lasting effect of the French Revolution on the French nation.

On the reverse, however, is a more startling image. Goetz produced four versions of the "Black Shame" medals; the first striking in 1920 depicted a disembodied and unabashed giant phallus with the inscription: *"Die Schwarze Schande"* (The Black Shame). In the next version, the phallus was barely transformed for the censors into a tree with a branch added in the upper part of the trunk and roots added to the base, the testicles now covered with long grass. Goetz then prepared the third version, in which the phallus and tree are fully replaced by an obelisk with an altered inscription.

A naked German woman—symbolizing victimized Germany and any white German woman who engaged in an intimate relationship with a colonial soldier, whether willingly or not—is bound to the obelisk, topped by a French helmet with a writhing baby at its base. The woman's broken lyre symbolizes the destruction of civilization. The eye in the triangle, an emblem of the French Revolution, illustrates the imposition of French "enlightenment" on German *Kultur*. The inscription reads: *"Die Schwarze Schmach"* (The Black Disgrace).

In the fourth, and final, edition, Goetz returned back to the penis shaft image on the reverse, but with an exclamatory doubly struck inscription, or *screaming* text, framing the rim. The subtle shadow-carved figure, hands, and markings indicate movement—thus amplifying the sensational message of this moving "image-text" struck in metal.

The medals' overall imagery fits within a larger intertextual image family—a discursive continuum of popular culture ranging from "Negrophilia" to "Negrophobia" prevalent in Germany and other countries in this period, where the medals clearly inhabit the extreme end of the later category. The classic sculptural form of the whole German woman juxtaposed to the disembodied phallus in effect exaggerates the sculptor's breaking apart of the body; signaling the accelerating trajectory and dissemination of nineteenth century scientific notions of race[16] and prefiguring the future "disintegration of the human body witnessed in Cubist and Surrealist works."[17] Goetz's Black Shame Medals also induce a unique script of interactive visuality, seriality, and materiality. "As an *intimate sculpture* in a double-sided relief format, medals have always been something to hold and turn in the hand—personal objects for aesthetic and intellectual contemplation."[18] The eye moves between the obverse and reverse of the Goetz medals, and the holder is

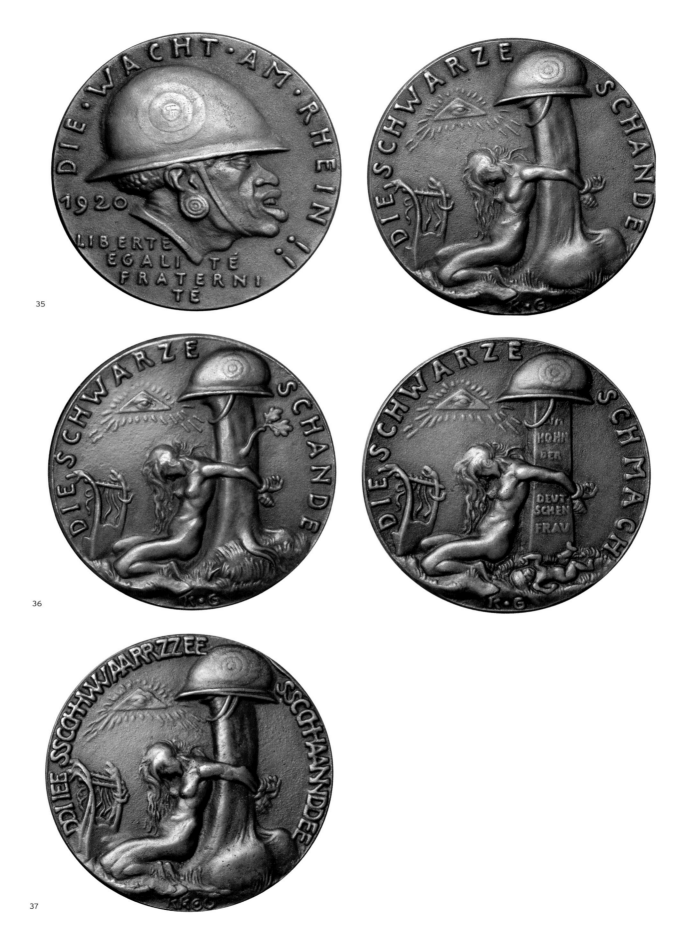

35

36

37

caught in a *microcinematic* moment; the grotesqued racist figurations reinscribe their visual and haptic affects with each medal's rotation within the hand—amplifying their visual message along a material channel. Upon numerous chronicle viewings, the spectator physically absorbs a provocative narrative of their multiple productions.

The reverse of the Goetz medal is one of the most shocking images of the twentieth century, linking Africans with unrestrained sexual aggression, but it has another historical importance. Its blatant racism, expressed in such a powerful graphic form, and the success of the racial propaganda campaign against the French occupation of the Rhineland were a lesson well learned by the Nazis and were to have unimaginable consequences in the years that followed. The Goetz medals illuminate and articulate the junctures of art and medals and of race and fantasy in the wake of world war.

4

ANTHROPOLOGY AND PHOTOGRAPHY (1910-1940)

ELIZABETH EDWARDS

The relationship between anthropology, photography, and the representation of people of Africa and of African descent is a difficult one, defined through concepts of race, culture, and hierarchy and by power, exploitation, and objectification. I shall argue in this piece that while these formative elements resonate through photographic and anthropological practice, by the mid-twentieth century acts of both anthropology and photography operated in sets of relationships that complicate these monolithic political and analytical categories. In order to understand both the profound shift and the profound problematic of these images it is necessary to consider both the anthropological and the colonial as unstable and critical categories, for neither can be seen in simple terms. They have a bearing on what the photographs are doing, and indeed might do, and complicate the homogenized categories which have deadened the analysis of photographs of anthropological making and their potential performances in broader histories of African peoples.

These questions intersect with the recodability of photographs that can create simultaneously different accounts of African cultures. I am going to consider the dominant form of "ethnographic naturalism" as part of a changing academic anthropological focus. I frame this, first, by a brief account of nineteenth-century legacies in the photographic representation of African peoples and, second, by a brief consideration of two very different intersections with photographic style, those of the "ethnographic picturesque" and of "ethnographic surrealism," which engaged anthropological photography in an eclectic representational dynamic of African cultures. For anthropological photography does not assume a comfortable teleological trajectory, nor is it a "pure form"; it is entangled with other representational practices and their ideological framings.

A Nineteenth-century Legacy

Even with changed technologies, changed anthropological concerns, and changing relationships with Africa itself, the legacy of nineteenth-century photographic practices lingered, overlapped, and were reformulated within later photography. The most pervasive nineteenth- and early-twentieth-century form was not the dehumanizing anthropometric images, which have so fascinated commentators, but the "portrait type" produced both in anthropology itself and within the wider visual economy. Anthropometric styles of photography can be traced back, in science, to anatomical drawing of earlier centuries. With its pairing of full-face and profile views, one of its earliest photographic manifestations is in the overtly racialist daguerreotypes of enslaved people made for

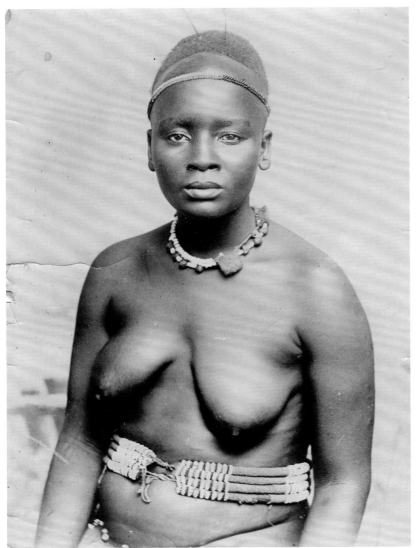

38

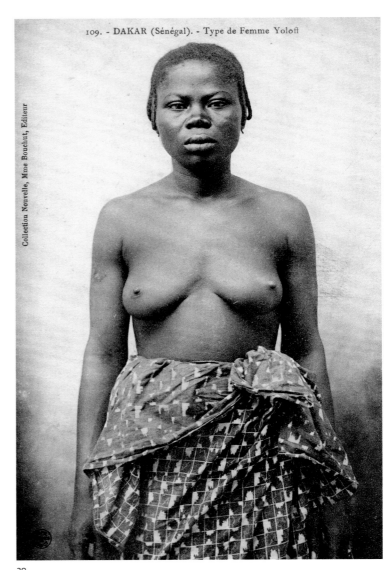

109. - DAKAR (Sénégal). - Type de Femme Yolofi

Collection Nouvelle, Mme Bouchut, Editeur

39

see 7-9
the Swiss American polygenist scientist Louis Agassiz by Joseph Zealy in the 1850s. Such photographs became the stylistic point of reference for the representation of non-European origin and indeed those of the "European margins" over a wide range of scientific and popular discourses.

Like anthropometric photographs, the studio-produced "portrait-type" photographs focused on the body, which filled the visual field with quasi-quantifiable data. Both direct markers of racial difference (nakedness, skin tone, skull shape, hairiness) and material cultural accoutrements (animal skins, spears, body paint, elaborate ornaments), intentionally signifying the primitive, permeate these images in conflations of race and culture. Much of this photography was not made within scientific anthropology itself but, rather, was informed and legitimated by it. Cir-

38

culating in a saturating colonial and imperial rhetoric, the photographs claimed their validity through a generalized rubric of racial and cultural "otherness" enmeshed in assumed hierarchies. Widely available photographs of African peoples, whether scientific, touristic, stereotypical, derogatory, or romantic, or intersections of those tropes, circulated across these various but conceptually overlapping visual regimes. Indeed, the description used by contemporaries, "portrait type," itself points to a confusion of both categorical and epistemological status, as the images merged the aesthetic styles of European portraiture with iconographical rhetorics and value systems drawn from science. These photographs constitute a form of antiportrait in that they have all the appearances of a portrait but are at once honorific and repressive.[1] In this "double system of representation," such photographs

38 J. E. Middlebrook (?). Portrait, Zulu woman, South Africa. Ca. 1890. Oxford, Pitt Rivers Museum, University of Oxford.

39 Anonymous postcard. Senegal. Ca. 1905. Oxford, Pitt Rivers Museum, University of Oxford.

filled the imaginative space of the primitive and the exotic in a multitude of travelers' albums and scientific collections. "Portrait type" photographs circulated in vast numbers as cartes de visite and photographic prints of all sorts. By the late nineteenth and early twentieth centuries they had also become the stock images of the postcard trade in the exotic, bearing, like the earlier photographs from which they were derived, generalizing and appropriative captions redolent with discourses of race and gender, such as "A Native Warrior," "A Village Dandy," or an "African Belle."[2]

These photographs not only produced a popular sense of the generic exotic African body but were also absorbed into scientific archives of anthropology itself, which had contributed so forcefully to the iconography of the "portrait type," as evidence of race and culture. The portrait types produced by J. E. Middlebrook or the Mariannhill Mission in southern Africa, for instance, were distributed widely to scientific collections that accepted material from travelers and bought from lists of commercial photographs within a global image market in order to build banks of "ethnographic" information.[3] The contemporary term used of such images, "of anthropological interest," marks the work of the disciplinary eye, which privileged certain forms of image information while calculating to suppress the disruptive "noise" of photographs. Such disciplined viewing, in both senses of the word, "transformed the commodities and curiosities of the metropolis, even pornography, into scientific evidence."[4] Thus, at one level, within science the formal qualities of the image and its content were effectively secondary to acts of viewing, as these photographs became anthropological through the patterns of their consumption, while at the same time having been informed by an emergent anthropology.

Ethnographic Naturalism

At the beginning of the twentieth century the residue of these older anthropological paradigms and their imaging practices were still in circulation, based in ideas of evolution, diffusion, and cultural salvage that had sustained notions of the primitive and the savage of Western fantasy and imagination. Popular representations continued to be saturated in the discourses of the primitive and the exotic, as demonstrated in the representation of African peoples in the expanding postcard trade and popular magazines of travel, exploration, and colonial endeavor. Within anthropology itself, however, by the early twentieth century there was a declining influence of the historically grounded scientific modes of evolution and diffusion. The visual tropes that supported these concepts largely disappeared as overt forms within anthropology itself. Shifts in anthropological thinking and anthropology's speedy adoption of new photographic technologies demanded more of photographs.

The early years of the twentieth century saw a radical change in the nature of anthropological theory and practice in its emerging modern and professionalized form. As I have suggested, anthropological photography is not a comfortable linear narrative, and earlier practices of physical and cultural anthropology did not entirely disappear, as exemplified, for example, in C. S. Seligman's photographs of racial classification in Sudan, taken in 1909–1924. However, increasingly the conceptual shifts in anthropological method, combined with technological changes in photography itself, had a profound effect on the kind and purpose of photographs made, how and why they were circulated, and under what conditions.[5] The more extensive photographing of African peoples for the purposes of anthropological understanding itself was part of a slow shift from the distantly observed bodies of people to the closely

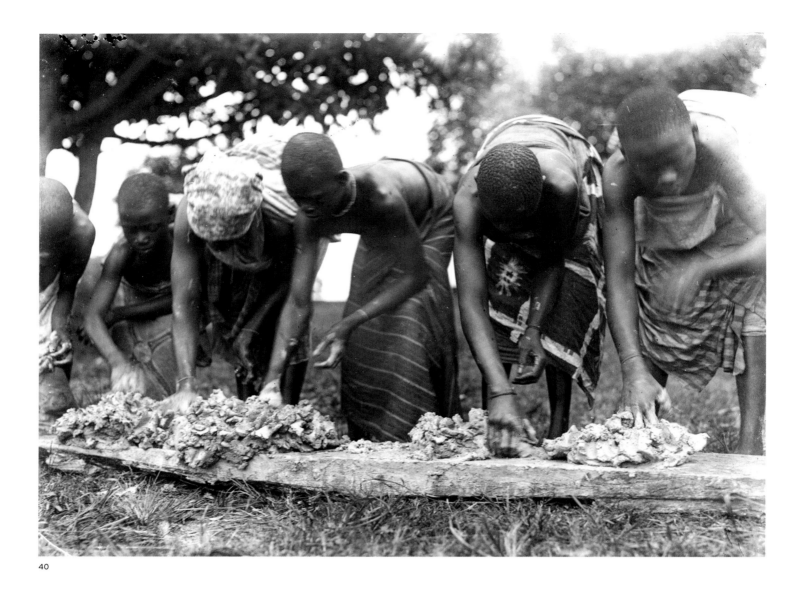

40

observed and experienced cultural practices of people. The photographic response might be termed "ethnographic naturalism." This sense of "naturalism," immediacy and unmediated inscription, belongs both to a style of anthropology and a style of photography, and the interplay between the two.

40

This newly figured relationship between photography and anthropology in the emergence of an ethnographic naturalism had a profound effect on the representation of African cultures in this period. Shot through with an ambivalence, anthropological photography in the first three decades of the twentieth century was both inflected with the assumptions of cultural hierarchy, yet at the same time anthropologists respected African cultures and sought to understand them on their own terms, through the latter's own categories, even if that understanding remained, to an extent, mediated through those hierarchies. Consequently these photographs resist reductive analysis.

Crucial to understanding the potential of the photographs of African cultures was the emerging "functionalist" paradigm in anthropology. While there were different forms and intensities of its application, broadly "functionalist" approaches attempted to understand societies through a sense of total immersion into interconnected cultural wholes. As both a field method and analytical position, functionalist approaches therefore presented African cultures as synchronic totalities that demonstrated social systems. This anthropology was realized through the practice of long-term participatory methodologies, which embedded anthropologists within communities, positioning the anthropologist as both outsider and insider. This integral and inclusive model of social existence, methodology, and explanation could be demonstrated photographically through "ethnographic naturalism," as a straight and unmediated style merged with the camera as an extension of the eye of the anthropologist.

40 R. S. Rattray. Women preparing pottery clay. Asante, Ghana. 1921-1932. Oxford, Pitt Rivers Museum, University of Oxford.

Photography as a medium is characterized by its random inclusiveness, the photograph being an indiscriminate quotation from appearances that exceeds the intention of the photographer. What characterized these expansive visualizations was a shift from the control of this photographic excess in the visualization of the object of study to an engagement with the scientific potential of the messiness of everyday human existence, a valorization of abundance as the site of both cultural and disciplinary significance.[6] Photographs were an integral part of the demonstration of this significance.

Addressing the immediate, the everyday and the experienced, rather than the typical and typifying, anthropological photographs also drew an increasing authority from the claims of humanist documentary realism in photography. Like documentary, anthropological photography aimed to achieve an equitable record, a representation and interpretation of the truth of people's experience in its translation across different spaces. While the truth claims of photographs and the politics of humanist documentary have, of course, been theoretically challenged—what are the "realities" that photographs produce in relation to their ideological framing?—the inscriptive power of the camera merged with the immediacy of anthropological observation to legitimate ethnographic naturalism as a coherent and credible statement about culture.

The naturalism of photographic style was emphasized by practices of seriality—an almost quasi-filmic use of the camera to record and demonstrate not solitary moments of the exotic Other but connected and connecting moments of experience as dynamic narratives. This is perhaps most clearly demonstrated in a spatial analysis of Evans-Pritchard's series of twelve quarter-plate photographs of Zande initiation into the corporation of witch doctors.[7] The photographs demonstrate the clear interaction not only of the subjects of the photographs, but the relationship of the photographer to unfolding events. These photographs suggest the subjectivities and experiences of all participants, including the anthropologist. They mark a desire to understand events from within, in which the photographs might become, in effect, a form of vernacular text.

It is not possible to address anthropological photographs, however, without a consideration of the colonial dynamics of anthropology, and this, of course, relates to questions of appropriation and objectification. The shifts in anthropological method and anthropological photography happen at a moment of colonial expansion and consolidation in Africa. Indeed I have, in this section, purposely addressed British anthropology because of its particular focus on Africa in this context.[8] But again, a more complex politics of the image can be argued. At one level, anthropological photographs encompass the colonial gaze in that inflections of race, hierarchy, and the primitive resonate through the underlying premising of such images as they open their content to the scrutiny of the viewer. But such images also challenge such a reading; their inclusiveness, and indeed their contexts, embed points of fracture and traces of indigenous experience that challenge reductive readings.

It has been analytically assumed that photographs automatically bolstered colonial regimes. They undoubtedly fulfill this role in many particulars and in formulating the broader "habitus" of colonial endeavor, whether this meant infrastructural support for academic anthropologists in the field or the employment of government anthropologists to enhance colonial knowledge of local populations, for instance, the political structures engaged within the policy of indirect rule. Many of these government anthropologists, who had links to academic anthropology through their training, made photographs in the course of their work. These photo-

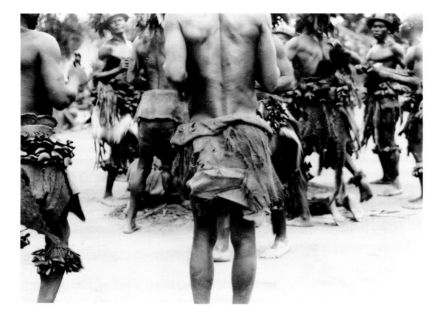

41 E. Evans-Pritchard. Sequence from witch doctor *(abinza)* initiation series. 1927–1930. Oxford, Pitt Rivers Museum, University of Oxford.

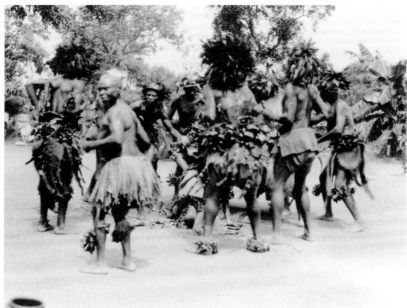

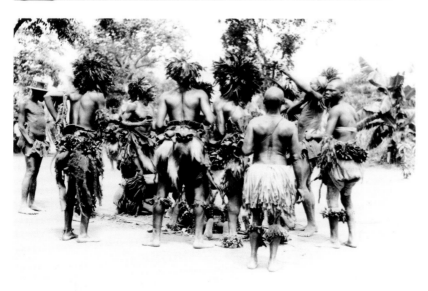

graphs vary greatly in style, reflecting the photographer's interests and response to local administrative requirements. For instance, R. S. Rattray's photographs from Ghana display a naturalistic style, whereas those of C. K. Meek in northeastern Nigeria have more in common with "type" photographs, often single figures placed centrally in the frame.

However, at the same time, by the interwar period, in terms of realpolitik, colonial authorities were highly suspicious of academically trained anthropologists, who had left-leaning politics that were often critical of the colonial enterprise, or who made unrealistic demands of colonial administration in the name of "traditional government." Anthropology, and thus its image-making practices, was integrally entangled with the structures of colonial enterprise, yet it was also emerging as a potential counternarrative to the colonial. Thus one cannot assume necessarily a simple anthropological alignment with colonial structures even if anthropology was simultaneously embedded in those structures.[9] The ambivalence of anthropological photographs, their seriality and their excess, is grounded in their potential for multiple readings, as on the one hand a reifying of a traditional perceived culture (a point to which I shall return), denied its own temporal dynamic, within and in service of those structures, and on the other hand, a counternarrative to the taxonomies of colonialism.

This is exemplified in the photographs of South African anthropologist Isaac Schapera, who was trained in the British functionalist school. Working in colonial Bechuanaland, he too saw the camera as an extension of the ethnographer's eye, a visual notebook to document as comprehensively as possible. His resulting photographs have been described by commentators as having "extraordinary interest, aesthetic value and . . . ethnographic acuity."[10] The ethnographic naturalism of his photography accorded with his de-tailed and careful ethnographic observation and belief in a "fastidious ethnographic realism."[11] He believed strongly that anthropologists should address the lived realities of peoples caught in the dynamics of social and cultural change and colonial government, as "sensate human beings, with their material circumstances, their mundane practices and passions,"[12] and should not attempt to construct a timeless, imagined traditional culture. Thus his photographs include the contemporary face of traditional practices, including colonial entanglements, for instance his photograph of Chief Molefi at the Kgatla royal court (kgotla).[13] Yet he also uses the camera to express the aesthetics of the sensual affective tone of local lives and of anthropological experience, such as his photograph of women threshing corn or that of a small girl playing in mud.

42-43

Further, beneath the colonial, Western, scientific gazes, another energy is at work. The participatory forms of fieldwork that dominated anthropological method by the interwar period were exactly that. Anthropological endeavor was often enabled through interchange, including photographic exchange, with local elites, and the work of local assistants. In African terms, subordination, and even oppression, does not mean passivity or a lack of agenda.[14] Indeed one of the colonial fears of an anthropology that went beyond a surface description of "customs and practices," as a class of colonial information often photographically defined, was that in its valorization of traditional culture, its collectivities and its power structures, anthropology would stimulate nationalist activity.[15] Whatever the asymmetries of power relations, the act of photography was participatory and intersubjective by definition. This resonates with Ariella Azoulay's argument that "every photograph of others bears the traces of the meeting between the photographed persons and the photographer, neither of whom can, on their own, determine how this meeting will be inscribed on the resulting image."[16]

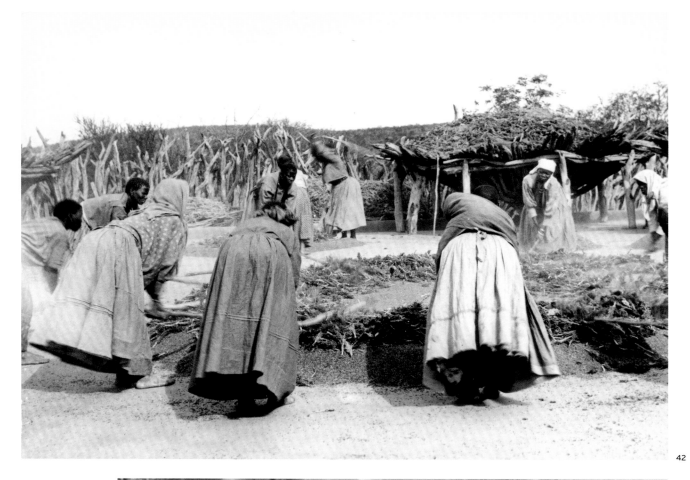

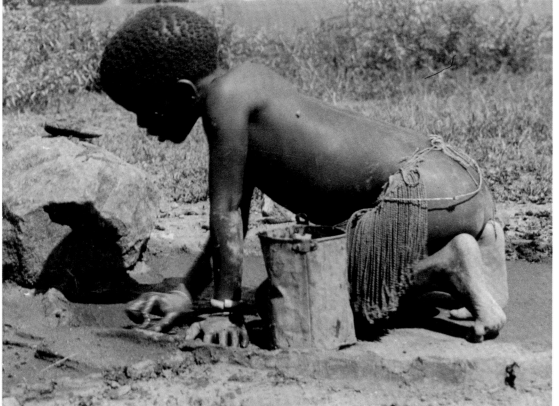

42 Isaac Schapera. Women threshing corn, Kgatleng, Botswana. 1920-1930. London, Royal Anthropological Institute of Great Britain and Ireland.

43 Isaac Schapera. Small girl at play, building a miniature house. Kgatleng, Botswana. 1920-1930. London, Royal Anthropological Institute of Great Britain and Ireland.

While such subjectivities were politically embedded within the colonial, it can be argued that a rethinking of the photographic trace beyond the merely appropriative to the intersubjective allows for the possibility of thinking about photographs as moments of experience that real people actually lived through.

Therefore, arguably, colonial and anthropological photography, and thus its archive, is patterned by African responses to the camera itself, buried within the traces and under the noise of the colonial. While this sense of dynamic encounter is palpable in Schapera's photographs, it can also be extrapolated from the photographs of other anthropologists, taken in very different political and social contexts. For instance Evans-Prichard's photographs of Nuer people of Sudan are very different from those he took of the Zande people on the borders of Sudan and what was then Congo. This difference cannot be explained by different intentions by the anthropologist in photographic accounts, because in anthropological terms the photographer's intentions were largely similar in both cases, to document and account for belief systems and their social manifestations. Rather, the different patterning of the photographic inscription emerges from different sets of subjective and social relationships in making the photographs.[17] Further, photographs became a site of social exchange between anthropologists and local people. The archives of anthropologists such as Evans-Pritchard and Schapera are full of photographs of their friends and local African assistants and their families, though these significantly seldom appear in their anthropological monographs. These photographs are not types but are of named individuals who influenced the making of their own images.

The seductive hermeneutic lure of reductive forms and categories of analysis of these photographs, at the intersection of the anthropological and the colonial, actively obscures the way in which photographs might be a trace of African social being, and might add positively to a sum of traces of African experience within those photographs. What marks these photographs is that whatever the power relations and the specifics of their making, the makers of these photographs took African societies seriously. Through the abundance of photography and the promise of the capture of the direct cultural moment, they have also opened the space for subsequent histories of African peoples. Photographs of anthropological making and consumption have been increasingly activated in reclaimed histories in Africa itself. An example is the work undertaken by historian and archeologist Gilbert Oteyo on colonial and anthropological photographs of Luo people in Kenya,[18] such as those taken by administrator Charles Hobley in the early twentieth century. Similarly, Schapera's photographs feature in local museums and in local communities in Botswana.[19]

Yet there is another side to this photographic legacy. Interestingly, such photographs remain stubbornly marginalized and problematic in the larger debate on narratives of African history and its Diaspora. The focus on "traditional cultures" in largely rural environments rather than on energetic modernities means that there lurks within these photographs a negatively inflected lack of dynamic, a sense of the culturally authentic, a conflation of purity and of pastness, that James Clifford has described as an ethnographic pastorale.[20] This sense of the authentic also becomes a visual language of appropriation, an anthropological illusionism that can efface agency. Tensioned in both production and consumption, these photographs present complex and competing values that are played out through photographic style, coded to signal, in their different ways, the natural, the simple, and the authentic but fail to speak to the political moment.[21]

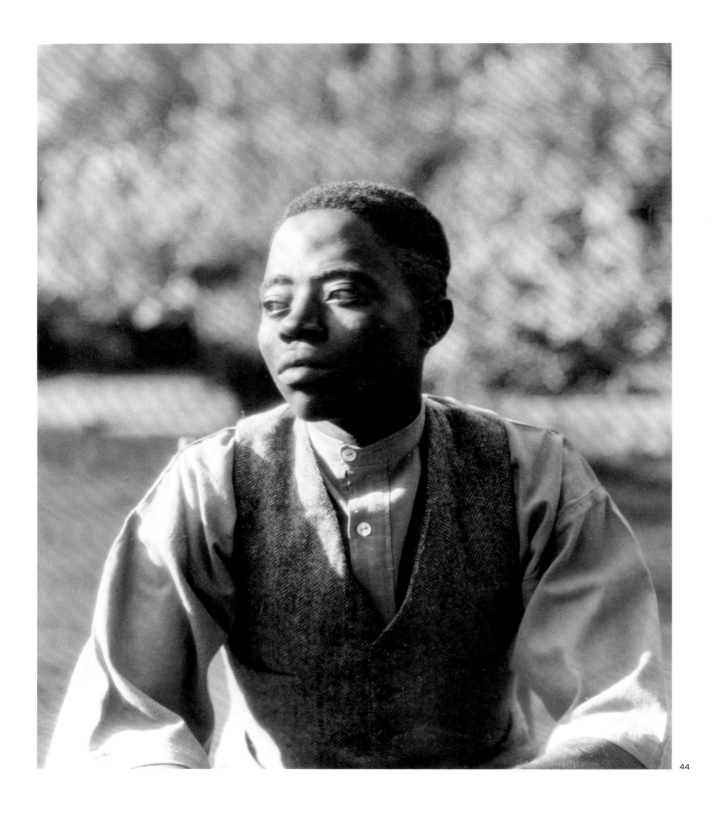

44

44 E. Evans-Pritchard. Mekana, son of elite local man, Ongosi, and Evans-Pritchard's Zande servant. Yambio region, Southern Sudan. 1927–1930.
Oxford, Pitt Rivers Museum, University of Oxford.

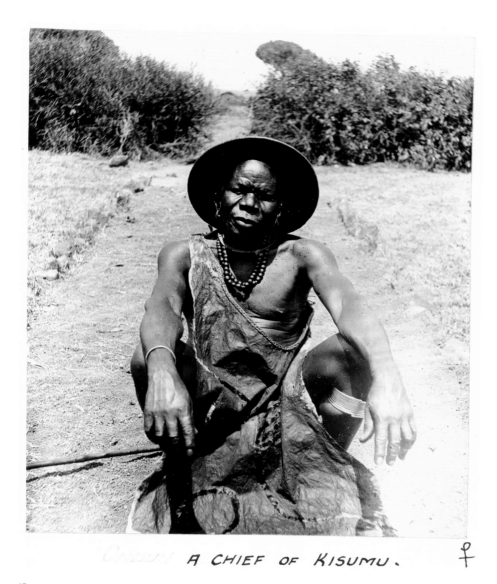

45 Charles W. Hobley. Man, possibly Ondun, chief of the Kaiulu Luo clan. Kisumu, Kenya. 1902. Oxford, Pitt Rivers Museum, University of Oxford.

A CHIEF OF KISUMU.

45

Neo-Exotics: Ethnographic Picturesque and Surrealist Fantasies

Despite the emergence of a strong disciplinary identity for anthropology in the first half of the twentieth century, as I have suggested, anthropological photography is in no way a pure form. If ethnographic naturalism emerged at the same time as a self-conscious humanist documentary photography and shared its convictions of a dynamic and equitable representation of human experience, there were other aesthetic crossovers in both photographic style and photographic consumption. I want to look briefly at two very different examples, the romantic "ethnographic picturesque" of Alfred Duggan-Cronin, who photographed southern Africa in the 1920s and 1930s, and the photographic interplay between anthropology and Surrealism in France because they too

suggest a location of the residual reticence toward anthropological photographs in broader global historical narratives of African peoples.

Duggan-Cronin, a De Beers diamond mine employee turned photographer/ethnographer, undertook an extensive photographic survey of the different groups of southern Africa, including Zulu, Bavenda, Swazi, Matabele, and Xhosa. A selection of the photographs was published, organized by population groups, as *The Bantu Tribes of South Africa* by Cambridge University Press in eleven volumes of high-quality photogravures between 1928 and 1954. It is a work of monumental salvage ethnography, which assumed the disappearance of "real" traditional African culture. As such it is work based not only in a broad sense of the colonial picturesque, but also discursively in salvage paradigms of late-nineteenth- and early-twentieth-century anthropology responding

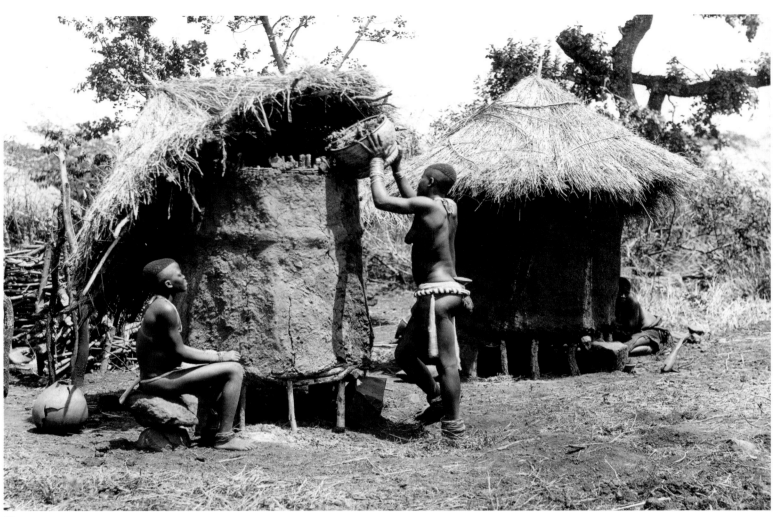

46

to the perceived evolutionary inevitability of cultural disappearance, inflected with the romance of the premodern.

Iconographically and stylistically, Duggan-Cronin's photographs merge the discourses of the "portrait type," painterly pictorial style, and picturesque sentiments of photography of the period. Although crisper in style and focus, his work had much in common with Edward Sheriff Curtis's rendering of Native American peoples, as he used an "ethnographic picturesque" to create an idealized rural vision of traditional African culture. It was a vision that rendered African people timeless, for, as Clifford has argued, the salvage paradigm constituted "a relentless placement of others in a present-becoming-past."[22] Despite their claims to naturalism, Duggan-Cronin's images are careful exercises in the control of informational excess. Carefully posed, furnished with traditional objects and carefully lit, often statuesque figures against a skyline, and distanced, through the outsider's imaginary, the photographs produced a rhetoric of the "typical" that simultaneously romanticized and exoticized while claiming evidential status.[23]

However, Duggan-Cronin's photographs, while they formed an idyllic visual counternarrative for Western consumption to the exploitative experience of many black South Africans, were at the same time closely entangled with the establishment of a southern African national identity, its emerging legal structures and the status of black South Africans at that period. Duggan-Cronin's photographs, his project funded by the Carnegie Foundation, were taken up by physical anthropologists in South Africa. It is significant too that, despite receiving advice from Schapera, who rejected the conceit of recording the surface of an imagined precontact authentic society,[24] Duggan-Cronin's engagement was largely, as his photographic style suggests, with the residue of older anthropological paradigms of physical anthropology and descriptive ethnography rather than the new sociologically-based anthropology. For all their picturesque quality, his portrait types were absorbed into discourses of racial type, the language of anthropometrics, and the management of racial identity in southern Africa.[25] The tensions in both the making and consumption of Duggan-Cronin's photo-

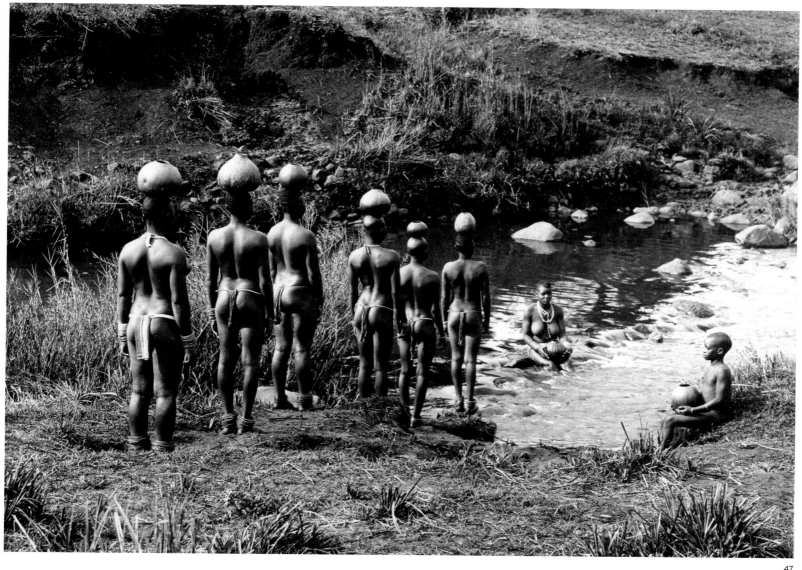

46 A. M. Duggan-Cronin. Venda girls filling granaries. Southern Africa. Ca. 1920. Kimberley, A. M. Duggan-Cronin/McGregor Museum.

47 A. M. Duggan-Cronin. Venda women going to draw water at the Mutshindudi River. Southern Africa. Ca. 1920. Kimberley, A. M. Duggan-Cronin/McGregor Museum.

graphs demonstrates the slippages and overlapping discourses in which photographs of African peoples were entangled.

As I have argued, the lure of the primitive lurked within the documentary-style "naturalistic" expression of African cultures and its embrace of excess. If Duggan-Cronin's photographs counter this position through their carefully controlled romanticism and ethnographic picturesque, my second brief excursion, Surrealism, gave this embrace of excess a new dimension within an alternative form of cultural recognition and explication. Surrealist approaches constituted a cultural activity through which the eth-

nographic could "again become something unfamiliar," yet resonate with visual, and thus cultural, correspondences through its self-conscious appropriation into artistic and literary discourses.[26] This was especially so in France, where institutionalized anthropology and Surrealism as sets of ideas emerged at the same time. The pattern of French anthropology had its own particular character and structure, which demanded a very different set of visual relations. Its scientific base was strongly rooted in medical and physical anthropology, premised on the anthropometrics of Paul Broca and Paul Topinard. By the early decades of the twentieth

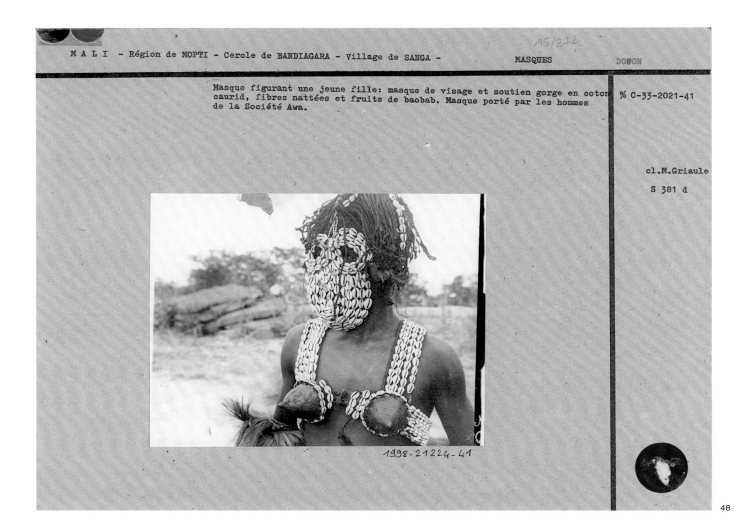

MALI - Région de MOPTI - Cercle de BANDIAGARA - Village de SANGA - MASQUES DOGON

Masque figurant une jeune fille: masque de visage et soutien gorge en coton cauris, fibres nattées et fruits de baobab. Masque porté par les hommes de la Société Awa.

% C-33-2021-41

cl.M.Griaule

S 381 d

1998-21224-41

century, as elsewhere, the model of a biologically determined vision of culture gave way to a "science of civilizations" and highly theorized sociological explanations under Marcel Mauss, Arnold Van Gennep, Emile Durkheim, and, later, Claude Lévi-Strauss. However, if "ethnology" more broadly was seen as the social science of colonial service, and the biological definitions of race continued to resonate through popular practices, such as the "human zoos,"[27] simultaneously, a new intellectual environment emerged. In this environment a highly racialized anthropology and ethnology was entangled with art, literature, and questions of culture both conceptually and in terms of personnel.[28]

see 57 This was especially marked in the photographic production of the Mission Dakar-Djibouti (1931–1933), an interdisciplinary expedition across central Africa, which was valorized through connections to Georges Bataille, André Breton, and key arts publications with Surrealist interests. If, as I have argued, the random excess of photographs, mediated through the disciplinary eye, enabled a sense of cultural coherence grounded in the ordinary to emerge, conversely that excess could be absorbed into, as Clifford

puts it, an "aesthetic that values fragments, curious collections, unexpected juxtapositions—that works to provoke the manifestation of extraordinary realities drawn from the domains of the erotic, the exotic, and the unconscious."[29]

Entangled in the broader fashion for negritude and a search for an account of cultural expression and meaning in response to the fracturing experiences of the First World War, everyday realities of African culture became translated into prisms for the exotic, erotic, and subconscious which sought both a disconnect and a correspondence with the ethnographic realities delineated through both observation and photography.[30] This was not the holistic and coherent society of a serial ethnographic naturalism, but the photograph as a self-conscious point of disjuncture in the "composing and discomposing of culture's 'natural' hierarchies and relationships."[31]

Yet at the same time, both ethnographic naturalism and ethnographic surrealism emerged from a deep engagement with the charge of the everyday and with a sense of an anthropology emerging from "within" a culture of participatory practices.[32] Just as eth-

nographic truth was no longer necessarily premised on surface realities of the photographic trace, Surrealist thinking offered a break with the norms and categories of conventional analysis, especially those legacies of the reductive realisms of the nineteenth century, such as the "portrait type." So while, for the expedition's anthropologist Marcel Griaule, the photography was part of the ethnographic naturalism of direct observation (as evidenced by his publications and museum displays of objects collected by the Mission Dakar-Djibouti), the photographs were also important players in the expedition's intersection with the artistic avant-garde.[33] They were reproduced in key art publications such as Bataille's *Minotaure* and the Surrealist-influenced *Document*. However, the Surrealist absorption of the ethnographic naturalism of the expedition privileged the fragment and meant that, at the same time, photography became not only an explication of cultural wholes as such, whether through the conventions of ethnographic naturalism or ethnographic picturesque, but also, as Clifford argues, "it studies, and is part of, the invention of interruption of meaningful wholes in works of cultural import-export."[34] Both the ethnographic picturesque of Duggan-Cronin and the engagement with Surrealist ideas was ultimately premised on the recodability and reframing of the photograph in an uneasy relationship between art, photography, and anthropology, working within both conservative and experimental environments.

Closing Thoughts

I have outlined the complex and competing strands of photographic usage and the construction of photographic meaning to address the "affective register of suspicion" that has informed the general concept of anthropological photography and the way in which it has been used to both address and consume African culture.[35] Photographs operated in a space that addressed a range of scientific and aesthetic concerns that clustered around the ambiguities of, on the one hand, the surface insistence of photographs to delineate race and culture in reductive and appropriative terms and, on the other hand, engaged attempts to capture equitably and cogently the defining yet intangible qualities of culture and social organization. While photographic production was no longer informed by the overt "reification, racialization and temporal distancing" of people that marks its nineteenth-century and popular legacies,[36] at the same time there lurks within these photographs, in their attempt to translate culture visually, a sense of the culturally authentic—a sense of pastness. There remains perhaps a slippage at the point where the "realisms" of the ethnographic naturalism, ethnographic picturesque, and the ethnographic surreal intersect to play out the values of the authentic and the natural through photographic style.[37]

These ambiguities and uncertainties have historiographical implications. This representational matrix coupled to the normative force of the assumed homology of anthropology, racialism, and colonialism in nineteenth-century forms, within established modes of critique, have closed down other ways of thinking about these images.[38] Not only is anthropology not allowed its own dynamic or indeed dilemma as it encounters and addresses its colonialist and racialist past, but, more important, it elides subjectivities and closes down the revitalization of complex histories inscribed in these photographs that might be reclaimed within wider interconnections and wider discourses about the shifting axis of the representation of African peoples. It is these concerns that are leading to an ongoing reassessment of photographs and their potential multivocality, from the products of anthropology

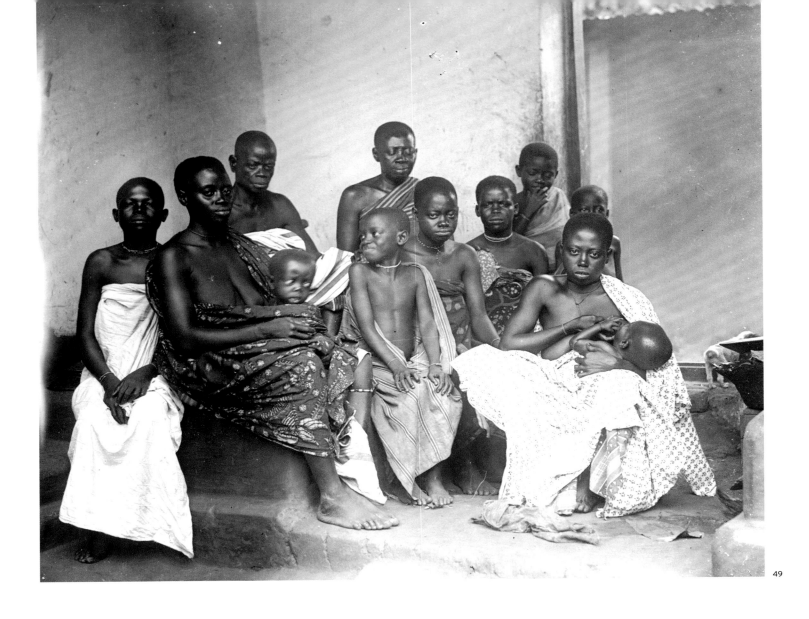

49 R. S. Rattray. Group portrait of the Queen Mother of Tafu and her family. Asante, Ghana. Ca. 1927. Oxford, Pitt Rivers Museum, University of Oxford.

and colonial administration to those of Duggan-Cronin in South Africa.[39]

Underlying these questions is one of photographic translation and recodability. Like linguistic translation as described by Benjamin in his wonderful analogy, photography "envelopes its content like a royal robe with ample folds."[40] Caught in the folds of these images, sympathetic direct renderings of a coherent African daily experience and its structures as understood by mid-twentieth-century anthropologists, are concepts of race, of the authentic, of the primitive, that can fall out and scatter at any moment. So the

marginalization of, and reticence toward, anthropological photographs has much to do, perhaps, with the powerful haunting of the colonial structuring within the folds of these photographs that can perhaps never be politically or discursively superseded. But likewise, other possible histories are folded within the photographic robe, and these, coupled to a destabilizing of both the anthropological and colonial as monolithic categories, are increasingly engaged with, connecting anthropological photographs to more complex representational narratives and a dynamic past in the present.

5

AFRICAN TAXONOMIES: DISPLAYING AND CLASSIFYING RACE

DAVID BINDMAN

The Chauncey Keep Memorial Hall of the Races of Mankind in the Field Museum in Chicago opened in 1933. It displayed about one hundred bronze and stone figures and busts by Malvina Hoffman, and it belonged to an age when "race" was a fully accepted scientific category in European intellectual circles, as it had been from the second half of the eighteenth century until the rise of Nazism destroyed its respectability. The concept's scientific standing in the nineteenth and the first half of the twentieth century rested on the assumption that there was a measurable biological difference between peoples variously and inconsistently defined as racial entities. The length and angle of physiognomic and bodily features had been tabulated since the late eighteenth century in comparative hierarchies that continued to be adapted by most—though not all—physical anthropologists to denote the stage of civilization and intelligence of individuals and groups. Yet the efforts of hundreds of researchers in all the great universities and natural history museums of the Western world to analyze immense amounts of observed data failed to achieve a consensus of the races that made up humanity or of what constituted a race as opposed to a nationality or ethnicity. Though some scientists argued for a cultural rather than a biological basis for racial difference, the very uncertainty of racial definitions had the effect of stimulating efforts to find the key to the ra-

cial taxonomy of mankind by ever more refined methods of analysis.

Linnaeus first formulated a structure for human taxonomy as a development from his botanical and zoological taxonomies, and it was given a comparative form by the Dutch physician Pieter Camper, who placed measurable skulls in a hierarchy from apes through Africans and Europeans to the Apollo Belvedere.[1] In the natural history museums that opened in European cities in the mid-nineteenth century, human specimens were as much part of the educational display as plants and animals, either as skeletons and preserved bodies or in the form of casts or replicas.

What role did artists have in such displays? This was never definitively decided, though Charles Cordier (1827–1905), who all his life was a professional decorative and portrait sculptor, was involved from the beginning in 1852 in supplying bronzes, sometimes with polychromatic additions, of racial types for the "gallery of the principal human types" in the Muséum national d'histoire naturelle in the Jardin des Plantes in Paris.[2]

For Cordier, there was no contradiction in seeing his work as both scientific and artistic. He obtained a grant from the French state to go to Algeria "to study the various types of indigenous peoples from the standpoint of art," and he deliberately sought the most beautiful or noblest representatives of each race. Though he

exhibited a group of his sculptures in Paris, London, and elsewhere as an Ethnographic Gallery, he sold them freely to collectors as works of art. He was a pioneer in the use of colored marbles and other materials, and this coloration both established his busts' authenticity as accurate representations and increased their aesthetic appeal to his patrons. It was the public success of his first four African busts in 1850 that led him to create a gallery of busts of racial types, a success, as the sculptor himself claimed, stimulated by the abolition of slavery in France and its colonies in 1848.[3] Cordier was a member of the Society for Anthropology, but his gallery was a self-generated project that had no fixed location despite his efforts. A few of his busts, including the *African Venus,* were bought for and exhibited in the anthropology gallery at the museum, but among a grisly group of real severed heads and casts of living beings, including the "Hottentot Venus." In reality, their impact was greater through their dissemination in art exhibitions and the art market.

Cordier's ethnographic sculptures are both taxonomic and spectacular because, as Laure de Margerie has pointed out, he flourished in an age of public exhibitions in which native peoples from outside Europe were displayed in reconstructed villages in the form of "living dioramas," mainly in Berlin, London, and Paris, as they continued to be into the 1930s.[4] This concern with public spectacle in ethnographic displays remained a powerful factor in their realization. It is not coincidental that the Races of Mankind in the Field Museum was to be opened as part of the Chicago World's Fair of 1933.

Cordier took his responsibility to achieve scientific precision seriously, and in a talk to the Paris Society of Anthropology he countered the preference for making casts of living subjects, which he saw as dulling the body and weakening the flesh, by advocating geometric measurement in the tradition of the late-eighteenth-century Dutch physician Pieter Camper, which allowed for the exact comparison between skull types of different peoples. Cordier argued that as an artist he was able to bring out the distinctive beauty of each race, and by focusing on a beautiful individual it was possible, for example, to express "the essential moral and intellectual character of the Ethiopian race."[5] This unqualified attribution of beauty to Africans—expressed also in the seductive form and title of his *African Venus*—anticipates his repudiation of Comte de Gobineau's theory of the inequality of races, published in 1853–1855.[6]

The English sculptor Herbert Ward is also an important figure in the representation of racial sculpture in natural history museums, but his project was ethnographic, not taxonomic.[7] His focus was entirely on the Congo, where he had spent 1887–1889 as part of H. M. Stanley's expedition and later, an experience he wrote about in the unfortunately titled *Five Years with the Congo Cannibals* (1896). His Congolese sculptures were all made within a ten-year period (1902–1912), and they are characterized by human sympathy and a powerful emotional charge that shows the influence of Rodin, whose work he would have seen in Paris. This is especially the case with the figure of *Distress*, which is clearly derived from Rodin's *Adam after the Fall,* and suggests an association between present-day Congolese and the earliest state of mankind.

At one level, Ward was a classic imperialist, who believed that the Congolese were in a state of "arrested development."[8] But he also expressed a deep if patronizing admiration for them and their achievements in making objects, which he collected voraciously. His bronze sculptures, which barely add up to a dozen altogether, are divided between those that commemorate Congolese customs

50

and crafts and those that highlight the tragic situation of the Congolese under the brutal rule of the Belgian king Leopold.[9]

Ward's American widow left a complete set of his sculptures and his collection of Congolese artifacts to the newly founded Smithsonian Museum of Natural History in Washington, D.C., where they were initially displayed together, but in a more rational arrangement than in the sculptor's Paris studio.[10] The Ward sculptures became a touchstone for the artistic representation of non-European peoples, to the extent that when the Field Museum first contemplated a display of the Races of Mankind in the late 1920s,

the president of the museum, Stanley Field, suggested telephoning the sculptor, not realizing he had died some ten years earlier!

The origination of the Field Museum's display of the Races of Mankind was claimed by both Henry Field and Berthold Laufer, curators of anthropology at the museum. Field recalls a conversation in the late 1920s in his autobiography: "'I have two dreams,' I told Dr. Laufer. 'I would like to see the Story of Man portrayed in two adjoining exhibition halls, one dealing with prehistoric men of the Stone Age, and the other with all the races of mankind.'"[11] Laufer, however, claimed to have had an idea for the latter exhibit

51 Herbert Ward. *Distress*. Washington, D.C., Smithsonian National Museum of Natural History.

51

since 1915, but in his proposal it was to be based on a mixed display of skulls, skeletons, photographs, and plaster casts, on the model of Ales Hrdlička's then canonical display in the San Diego Museum.[12]

Henry Field was a cousin through his mother of the Chicago store-owning Field family, including Marshall and Stanley, but his real surname was Gibson; he was descended from an eighteenth-century family of free blacks who had gradually shed their racial origins to become plantation owners in the South.[13] His mother, after divorcing his father, had married an English landowner, Algy Burnaby, a friend of Edward VIII, and Henry had been sent to Eton and Oxford. Despite his excellent connections he was unclear in his professional direction, and though he called himself an an-

thropologist, he seems to have been more interested in Middle Eastern archeology.[14]

Berthold Laufer had a completely different background. He was born and studied in Germany, and he attracted the attention of the great German-born anthropologist Franz Boas, who brought him over to Columbia University in 1898, where he studied Asian languages and cultures.[15] He remained close to Boas and edited a volume of essays dedicated to him in 1906, and in 1907 he was appointed to the Field Museum. Boas, as is well known, stood firmly on the side of a cultural rather than a biological explanation of race. Though not immune to some of the biological assumptions behind physical anthropology,[16] he argued that there were no pure races—differences between races were in any case slight—and that

the so-called problem of the Negro was caused by white prejudice. This position is clearly reflected in Laufer's preface to the pamphlet produced to explain the display of the Races of Mankind on its opening in 1933. Laufer disputes strongly the existence of the Aryan race, no doubt with an eye to Hitler's assumption of power in Germany in the same year, and he states unequivocally that "the behavior of a nation is not determined by its biological origin, but by its cultural traditions."[17] He also saw the Races of Mankind project as a means of fighting racial prejudice.

Henry Field, though like Laufer not strictly a physical anthropologist, was particularly admiring of a British approach to the subject associated with Dudley Buxton, by whom he had been taught at Oxford, and Alfred Haddon of Cambridge, the author of *The Races of Man and Their Distribution* of 1925. These two were both consulted, but the main influence on the project was the Scottish anatomist Sir Arthur Keith, whom Field described as "the greatest living anthropologist, who was to become a lifelong friend."[18] Keith was a firm believer in the central historical importance of race, and in a book he published in 1931, titled *Ethnos; or, The Problem of Race Considered from a New Point of View,* he argued that "the further back we go the greater do we find the degree of racial divergence to be."[19] As a fervent Darwinian, he saw racial divergence and prejudice as an evolutionary mechanism: "It was, and still is, Nature's way of evolving higher types; for success there must be rivalry and competition. . . . I regard race-feeling as part of the evolutionary machinery which safeguards the purity of a race."[20] He believed in eugenics, and that at the present critical point of danger it was necessary for the white race and other races to retain their ancient tribal instincts. But he also saw races as in process of evolution, always in different stages of differentiation. Keith argued that races were divided into those "superior" races who had the potential to evolve, and primitive races who were static and thus likely to die out in time, a very common argument from the late nineteenth century onward. Furthermore, Keith was opposed to skull measurement and the use of statistical data. In his view everyone was an anthropologist by nature; racial difference could be observed with certainty even by ordinary people.[21]

Though all the well-known authorities on race were consulted by the museum—even Boas, who had publicly attacked Keith in 1931 for precisely the beliefs stated above—Keith remained the dominant intellectual presence in the Races of Mankind project and was consulted in detail at every stage. But if Keith and Haddon both believed in the biological reality of race, they differed over the relationship between process and taxonomy. Haddon was essentially a taxonomist, but Keith, as we have seen, shared with Boas, despite their differences, a belief in race as a process of evolution.

How did these ideas influence the display of the races of mankind? First there was the inevitable question of whether the display should follow a "realistic" or "artistic" model. There seems to be initially a desire to use the method already applied to the Hall of Prehistoric Man of employing figures that were as lifelike as possible by casting them in plasteline, a kind of plaster, tinting them in imitation of human skin, putting real hair on their heads, and setting them in realistically painted dioramas.[22] This was the method preferred initially by all parties.

So why did they end up with a professional sculptor like Malvina Hoffman and a series of bronzes that could not accurately replicate skin color—though she did claim to be able to vary it in each case —or the real texture of the human body? A short but superficial answer would be the force of her personality, for she was determined to make them in a traditional artistic medium. She laid siege to Keith, and he admitted he had been nearly swept off his

feet by her.[23] She was by the late 1920s a considerable force in the world of sculpture. She had been one of Rodin's last pupils in Paris and had achieved an international reputation for her sculptures of Anna Pavlova and other dancing figures, as well as the huge, double-figure stone group, *The Friendship of English-speaking Peoples,* high up on the facade of Bush House in London. She had already shown an interest in racial physiognomy on her visit to Africa in 1926, and she had excellent contacts.

She was able to convince a group heavily invested in scientific truth that bronze was a permanent material that would preserve forever even races that faced extinction and would demonstrate the stability of the concept of race and a belief in progress—the theme of the 1933 Chicago World's Fair—in the face of widespread threats of civil disorder and fear of economic and moral decline.[24] "Artistic" representations of physiognomy were appropriate in this case because they could invoke the traditional idea that they could reveal the soul of the person represented. This idea had a history that long preceded Cordier, even going back to antiquity. It was revived by the Swiss clergyman Johann Kaspar Lavater, who in the late eighteenth century wrote a large and influential treatise in which he analyzed hundreds of facial types, correlating their relative beauty or ugliness with the person's inner moral condition.[25] But the application of such an idea in the Hall of the Races of Mankind developed beyond Lavater's theory. It was not the *soul* of the individual represented that was to be captured, but her or his racial characteristics. Hoffman claimed that "I chose the moment at which I felt each one represented something characteristic of his race and no other," and demanded "artistic freedom to select . . . the best possible representative of a race and not the ugliest."[26]

This emphasis on the moment suggests another divergence from Lavater, and also from Camper, for Hoffman, following Keith, did not represent race in terms of fixed structures of the skull, which could be measured comparatively, but of movement, action, and gesture. It was claimed in a draft press release of 1933 that every detail "conform[ed] to actual attitudes which would be assumed as a natural part of some typical activity in the life of a man or woman of the race portrayed."[27] Hence many of Hoffman's sculptures show figures in movement, with an emphasis on characteristic gestures and facial expressions rather than the shape of the skull.

Everyone working on the project, especially Henry Field, was aware of the work of Herbert Ward. Field claimed that it was his admiration for the English sculptor that gave him the idea of finding a sculptor who could make portraits that were realistic but with an artistic flair: "Herbert Ward . . . possessed the eyes of a great artist, eyes which revealed the innermost feelings and thoughts. He expressed the real character and true spirit of the African native in his clay figures, which were later cast in bronze. The thought came that this was the method to employ in our hall of races of mankind."[28]

Ward's figures, as we have seen, often represented occupations rather than physiological types, but Ward still claimed that they "must have the spirit of Africa in its broad sense, and at the same time fill the requirements of the art of sculpture."[29] Ward would certainly have got the job had he still been alive, and Hoffman had to convince the museum that even though she was a woman, she had enough physical stamina to take on the task.

Once Hoffman had started work, the anthropologists tried to keep tight control of her work, providing her with a long bibliography, reference materials, and forms she was supposed to fill out in each case, though she refused to do so with some asperity.[30] She was frequently described as having traveled the world to make sculptures of peoples in their original habitat, but in reality she

went on only one expedition in connection with the project, to Asia, including China and India. In fact the images of Africans in the series, which are both full-length figures and busts, were not made in Africa, though she had visited the continent only a few years before she became involved in the project. Even then she seems only to have visited North Africa. She is vague in her autobiographical accounts about her actual travels, moving seamlessly from an account of her time in North Africa into a discussion of the African subjects in the Hall of the Races of Mankind, which in reality were entirely sculpted from people she had encountered in Paris, where they were brought for the Exposition Coloniale in 1931, or from photographs taken in Africa.[31]

The Hall of the Races of Mankind was dominated by a central sculptural group, also by Hoffman, consisting of three ideal and heroic statues, each "embodying the highest physical qualities of his race," of a white or Caucasian, a yellow or Mongolian, and a black or African man, a figure of a Masai warrior. Each carries a different weapon (respectively, sword, axe, and spear), though Hoffman's original idea was for the white man to hold a book. This division into three races was Keith's idea, and he claimed that "the recognition of these three prevailing types and the perception of the differences which separate them as well as the similarities which unite them, represent the central crux of modern anthropology."[32] The central group is symbolic and hieratic, contrasting with the naturalism of the other sculptures in the hall.

Hoffman made a total of sixteen sculptures of Africans, of which five are full-size figures or groups. This is about the same number as Oceania and Australia, considerably fewer than Asia (thirty), but many more than Europe (six). Africa, as can be seen from the plan printed in the 1933 handbook, is in Hall A, paired with Oceania, which suggests the grouping together of the most "primitive"

societies, while Asia is in Hall C and contains twice as many sculptures, perhaps in tribute to the relatively more "advanced" societies of China and India. But Europe's six sculptures are placed in the central hall in two of the corners with representatives of America and Asia in the other two, around the central edifice of the Three Great Races. According to Henry Field, writing under the influence of Arthur Keith, Europe is divided into three basic stocks—the Mediterranean, Alpine, and Nordic—but in its centrality in the main hall and the paucity of actual representatives Europe takes on its traditional role of the "unmarked" category, the norm against which others are measured. Typical for its period, the Hall of the Races of Mankind is more about exotic and "primitive" than "civilized" peoples.

The 1933 handbook that accompanies the display, written largely by Henry Field, divides Africa between the "True Negroes" of West Africa, and those who are racially mixed. The handbook claims that the Hamites, a Caucasian people from the north now settled in Ethiopia, mixed with "true Negroes" to form the Nilotic type and the Kenyan type, characterized by a "European" refinement of features. Hottentots were supposedly a mixture of Bushmen and Negroes, and the origin of Pygmies was unknown. There is then an implicit racial hierarchy *within* Africa in the choice of sculptures, which places the Hamites from Abyssinia toward the top of the continent and the Bushmen, Hottentots, and Pygmies at the bottom and farthest from Europe. That hierarchy is not reflected in the relative size of the sculptures, for the two African whole-figure groups are of Bushmen and Pygmies.

In almost all the African sculptures the figure or bust is caught at the moment the individual supposedly enacts race in its essential form. Hoffman sought out distinctive physical attitudes, most notably the famous *Shilluk Warrior,* from the Upper White Nile,

FIELD MUSEUM OF NATURAL HISTORY

Anthropometric Form.

Observer **H.F.**

Place and Date **Field Museum. July 27, 1929**

No. _____ Sex **male** Race **Bushman**

Age **?** Date of Birth _____ Birthplace **Kalahari Desert**

Occupation **Employed in Ringling Barnum and Bailey's Circus**

Nationality, Tribe, and Clan of Father _____

Nationality, Tribe, and Clan of Mother _____

Married? **no** How long? _____ Outside tribe? _____ Age at Marriage

How many children? _____ Boys _____ Living? _____ Dead? _____

_____ Girls _____

Infant Mortality _____ Twins _____ Cripples or otherwise unfit _____

No. of Brothers **3** Living? **3** Dead? _____

No. of Sisters **1** Living? _____ Dead? **1**

Tattooing, ornamental scars, etc. **none**

General observations _____

Underscore following if data have been obtained:

Photographs: Frontal, profile; hair sample, mouth cast, blood sample, face cast,
foot-print, hand-print, finger-prints.

Physiological

Temperature _____ Pulse **71** Weight **81 ½ lbs.** Skin Color No. **18-20**

MEASUREMENTS

				INDICES
1. Standing height	1280	11. Head length	177	2/1 Relative shoulder height
2. Acromion to sole	1007	12. Head breadth	128	4/1 Relative shoulder breadth
3. Dactylion to sole	440	13. Head height		10/1 Relative sitting height
4. Biacromial	120	14. Min. frontal diam.	101	12/11 Cephalic
5. Bi-iliac	260	15. Bizygomatic	113	14/12 Fronto-parietal
6. Chest breadth		16. Bigonial breadth	92	17/15 Total facial
7. Chest depth		17. Total facial height	98	18/15 Upper facial
8. Circumference of chest	73	18. Upper facial height	61	20/19 Nasal
Inhalation	76	19. Nasal height	48	
9. Circumference of chest		20. Nasal breadth	39	
Exhalation	73	21. Ear length	29 right 28 left	
10. Sitting height	704	22. Ear breadth	54 right 51 left	

Pathological _____

Anomalies _____

53

whose extraordinary one-legged stance had been depicted by Max Slevogt in a painting of 1912,[33] and the *Ubangi Woman* with the "duck bill" created by the progressive insertion of pieces of wood into her mouth.

The results in such cases owe little to unmediated observation, and in some cases are not at all what they appear to be. For instance, the full-size figure originally called *Negro Dancing Girl of the Sara Tribe* is derived, as Marianne Kinkel has demonstrated, from a photograph in Hoffman's possession, taken from the Haardt expedition, which shows two women conversing on a tennis court. The Sara girl is not dancing at all but gesturing toward or greeting another person seated on the ground. The figure was intended to be paired with the *Senegalese Drummer*; according to the handbook: "These two statues . . . are shown in poses characteristic of the rhythmic movements associated with Negro music. The vivacious and graceful figure of the girl in dancing posture strikingly contrasts with the dreamy expression of the drummer."[34] As Kinkel also suggests, it refers to the assumption of anthropologists that dance was closely associated with the racial temperament of Africans. The famous *Mangbetu Woman* is also taken from a photograph from the same 1925 expedition to Central Africa, and there is no doubt from the photographs commissioned by Georges-Marie Haardt that he gave to Hoffman that she used them directly and exclusively in making the sculptures.

The original Mangbetu woman played an important part in the Haardt expedition of 1925, known as "La Croisière Noire" or the Black Expedition, in which the length of Africa was crossed by twelve purpose-built armored vehicles called *Autochénilles*

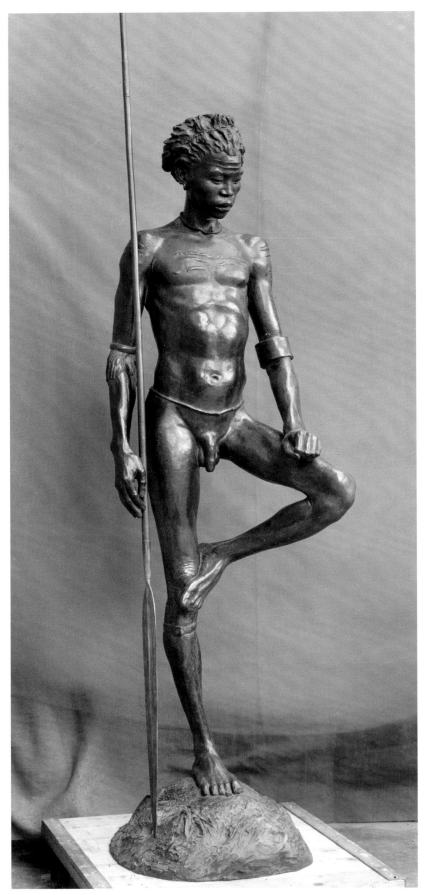

54

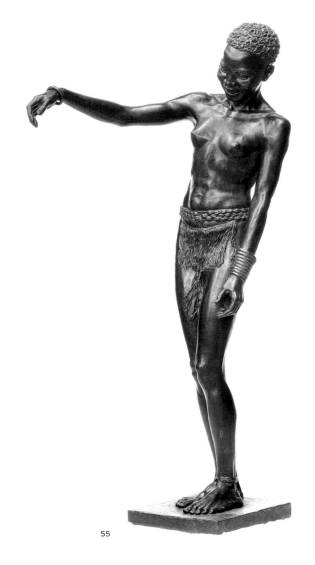

55

("caterpillar-tractors"), provided by the Citroën motor company, for which Haardt worked.[35] The expedition was carried out with maximum publicity before and after, and it included an artist, photographer, filmmaker, geologist, and taxidermist; its return was celebrated in Paris and elsewhere by a successful film and many magazine articles.

The Mangbetu woman was the principal "trophy" of the expedition because, with her mysterious aura and contrived shape, she called into question the assumption that all sub-Saharan Africans were essentially "primitive" or close to nature. She seemed aristocratic, even decadent, with a hieratic, Egyptian-type appearance, perhaps denoting Egyptian ancestry, accentuated by the deliberate deformation of the head. A photograph from the expedition shows a group of Mangbetu women in profile, lined up like an Egyptian

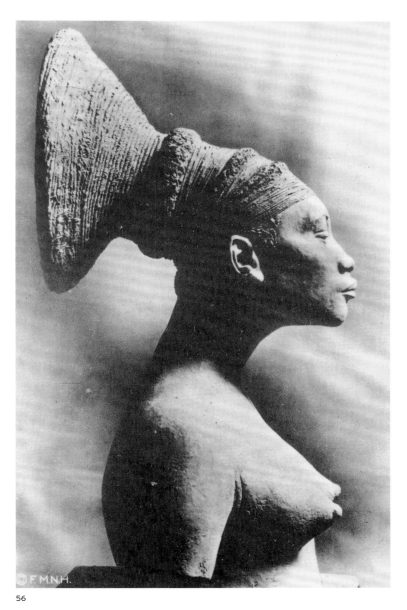

56

54 Malvina Hoffman. *Shilluk Warrior from the Upper White Nile*. Chicago, Field Museum of Natural History.

55 Malvina Hoffman. *Negro Dancing Girl of the Sara Tribe*. Chicago, Field Museum of Natural History.

56 Malvina Hoffman. *Mangbetu Woman*. Photograph of bronze in the Chicago Field Museum of Natural History. Cambridge, Mass., Du Bois Institute, Harvard University.

wall painting. Haardt's fascination with the Mangbetu woman extended to making her a radiator mascot on his car,[36] and Aaron Douglas adapted her profile on more than one occasion (see the reproduction in *The Image of the Black in Western Art,* Vol. V, pt. 2). Henry Field's account of Hoffman's bust of her also reflects the woman's supposed racial ambiguity: "The Mangbetu of the northeast Congo region are primarily a true Negro type; but the light brown skin of the aristocratic class suggests some Hamitic mixture."[37] But he also remarks on the deformation of the head caused by binding it tightly with bandages in childhood, placing the Mangbetu woman in a similar "primitive" category to the Ubangi duck-billed girl, also sculpted by Hoffman, whose lower lip was progressively extended and had to be supported by her hand.

The choice of such exotic subjects as the Mangbetu and Ubangi women perhaps has more to do with colonial romance and the lure of the exotic than physical anthropology, but they undoubtedly helped to make the display of the Races of Mankind a huge success when it opened in the Field Museum in Chicago in 1933. It attracted crowds of visitors and glowing reports in newspapers, making Malvina Hoffman an even bigger celebrity. But by 1944 the Field Museum itself was becoming disillusioned with its racial taxonomies. In the words of the museum's chief curator of anthropology: "We have inherited a vast and clumsy system of nomenclature that is now antiquated and incorrect and yet is firmly entrenched in the literature. The job was further complicated by two facts. One is that some of the types in our Hall of the Races of Mankind are not strictly typical in that they do not represent the average for a given group. . . . The second fact is that there is no

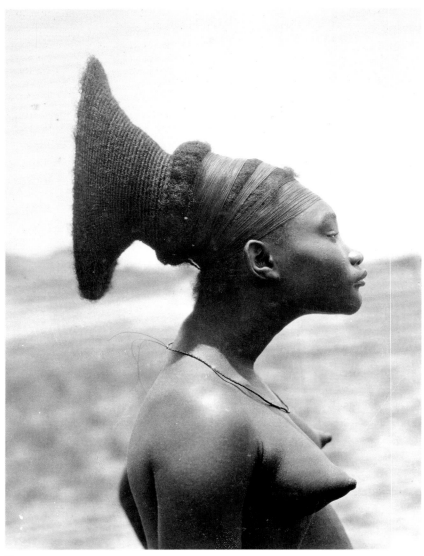

57 Anonymous. Photograph of Mangbetu woman, taken on the Haardt expedition. 1925. Los Angeles, Getty Research Institute.

standard agreement on racial terms, and, depending on whether one is an anthropologist with ethnological interests or one with genetical background, many kinds of terms are in vogue—social, religious, geographical, and racial."[38]

For the last fifty years the display has been completely discredited, and only a few of the sculptures are still on public view in isolation from each other. From the point of view of the twenty-first century, the concept of such a display and the values it represents are so alien that it is hard to believe that it was created within the lifetime of many people today. Though Hoffman had undoubtedly absorbed some of the racial essentialism of the time, and her writings are full of patronizing admiration for the human qualities of "savages," the sculptures are redeemed to a degree by the vitality and realism of their execution. But more to the point, the Hall of the Races of Mankind opens a window onto the complex and contradictory racial assumptions that provide a background to all of the images of the first half of the twentieth century in this volume.

II

Europe and the Construction of the "Primitive"

6

AFRICA AND PARIS: THE ART OF PICASSO AND HIS CIRCLE

SUZANNE PRESTON BLIER

African art, evolution, racial aesthetics, colonialism, and world fairs were among the common threads that helped to shape the image of the black in France in the first decade of the twentieth century. For Picasso and some in his circle, Africa (and Africans) represented a combination of creativity, curiosity, social concern, sexual provocation, philosophical interest, and extended family ties. Pablo Picasso's first encounter with African art, which led to his initial studies for his famous 1907 painting *Les Demoiselles d'Avignon,* in many ways begins with a small Vili "idol" figure from the Congo, a sculpture that Matisse also would include in his late 1906 *Still Life with African Sculpture.* Matisse's unfinished watercolor painting of the Vili figure is a still life that also depicts three vases and a glass goblet. It is a canvas that focuses attention on the Congo sculpture in it, one whose very figural primacy adds a sense of animation and humanity to the whole. This watercolor also speaks to the important visual play between surface volumes and voids, European artifacts and a work from Africa.[1] But the main story here is the significance of this African sculpture to Picasso's important 1906–1907 painting and changes in it.

While some of the details of the story have been forgotten, there is no doubt that this same Vili sculpture had an indelible influence on Picasso. The event in question took place in the autumn of 1906 soon after Picasso had completed the portrait of Gertrude Stein.[2]

The first to discuss this encounter is the artist's close friend Max Jacob, a poet and art critic. The setting, Jacob notes, was a dinner at the home of Paris's then more celebrated painter Henri Matisse. Two of Picasso's other good friends, Guillaume Apollinaire and André Salmon, also were present.

At some point, Matisse took from a table a statuette in black wood and showed it to Picasso. It was the first African sculpture. . . . Picasso held it in his hand the entire evening. The next morning when I arrived at the studio, the floor was strewn with sheets of Ingres paper. On each sheet was a large drawing, every one almost the same: a three-quarters view of a woman's face with but a single eye, a too-long nose mixed up with the mouth, a lock of hair on the shoulder. Cubism had been born.[3]

While for most art historians key Cubist works would only be created in 1908 and subsequent years, there is little doubt about the importance of Picasso's 1906 engagement with African art in works leading up to this period. It was this event, insist both Salmon and Jacob, that led directly to Picasso's Africanizing changes in the right-hand figures of *Les Demoiselles.*

Another possible and in many ways complementary source for

58
59
60

61, 63

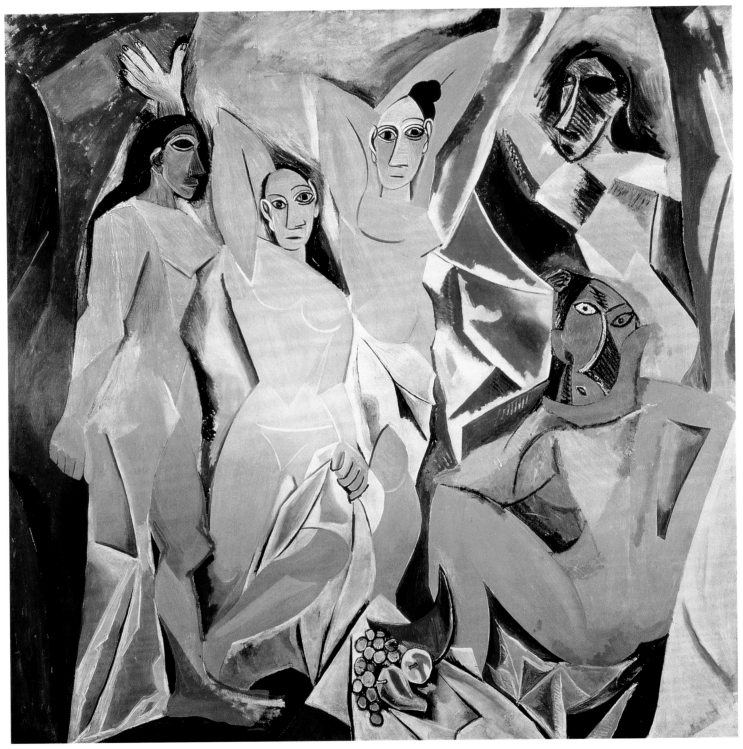

58

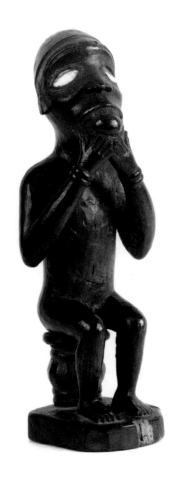

59

60

61

58 Pablo Picasso. *Les Demoiselles d'Avignon*. 1907. New York, Museum of Modern Art.

59 Vili figure. Republic of Congo. 19th century. France, private collection.

60 Henri Matisse. *Still Life with African Sculpture*. 1906. Private collection.

61 Pablo Picasso. Study for *Les Demoiselles d'Avignon*. 1906. Paris, Musée Picasso.

Tab. II A.XIV.

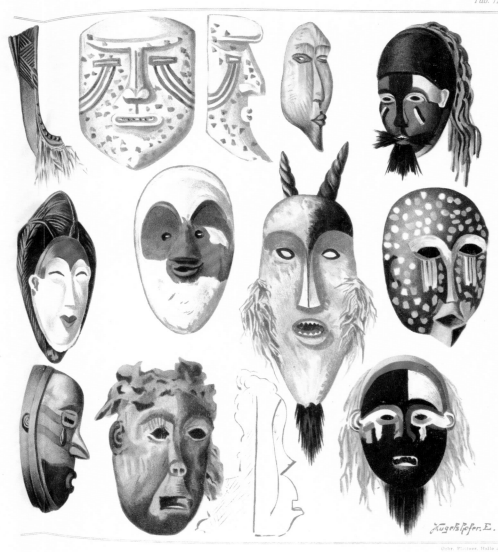

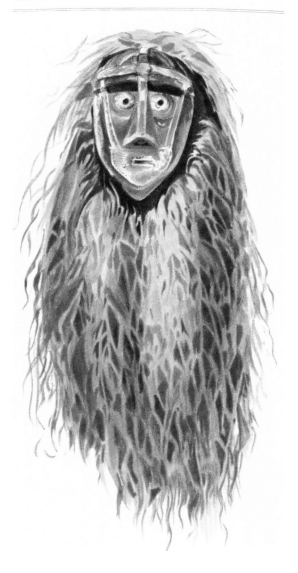

62

Picasso may have been Leo Frobenius's 1898 volume on African masks, *Die Masken und Geheimbünde Afrikas* (African masks and secret societies). This work featured black-and-white and color illustrations of key masks that plausibly left an impact on the artist's rendering of the masklike African faces in *Les Demoiselles,* particularly those works not available in the Trocadéro or elsewhere in Paris at this time, since many of the images it included were not available as actual objects in Paris in this era. There are striking resemblances between some of these masks, not only vis-à-vis the figures that seem to reference Africans in Picasso's *Demoiselles d'Avignon* and related studies (compare the right-hand figures of fig. 58 with the right-hand and bottom figures of fig. 61), but also a number of other works in this 1907–1908 era. (See fig. 63 and compare it with the color mask second from the left in the bottom row where we see not only shared physiognomic elements—curving noses, concave faces, and asymmetrical features—but also complementary color hues and brushstrokes.) The Africanized women in *Les Demoiselles* thus also appear to owe their form in part to mask typologies found in a book on African masks, one that also addresses the importance of ancestor worship in these cultures. This source suggests that Picasso's painting of prostitutes references them not only as sexual objects but also as ancestors (i.e., the mothers) of the diverse human races, an idea consistent with both the racial diversity of these women and the cavelike setting in which they appear.

Another likely inspiration for Picasso's *Les Demoiselles d'Avignon* is a photograph of six near-naked African women from Dahomey, women warriors (Amazons) appearing in wildly popular perfor-

64

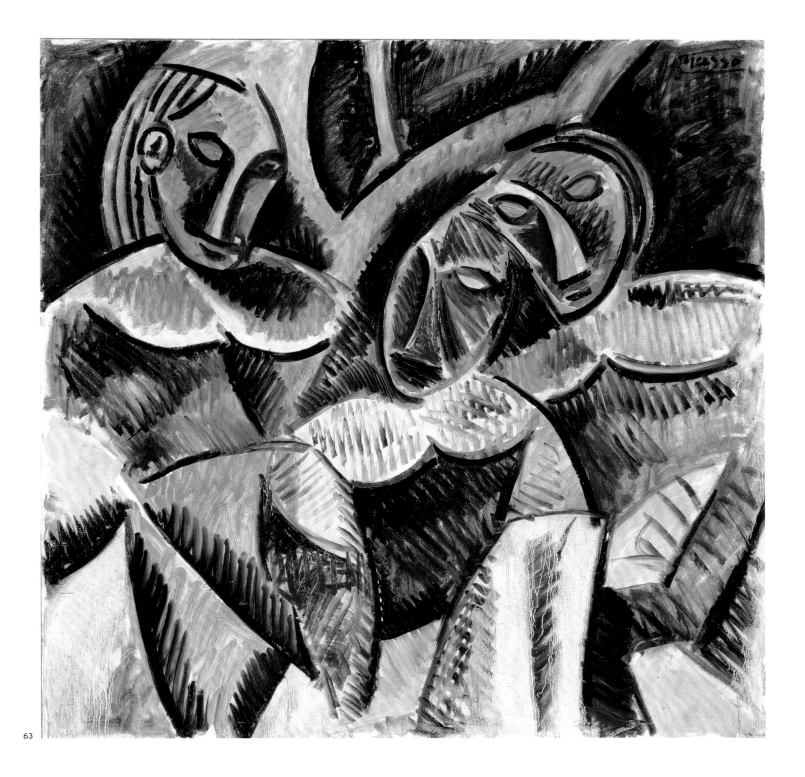

63

62 Composite of images of African masks from Leo Frobenius's *Die Masken und Geheimbünde Afrikas*. 1898. London, British Library.

63 Pablo Picasso. *Three Figures Under a Tree*. 1907.

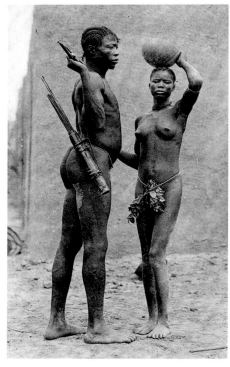
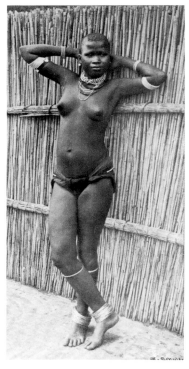
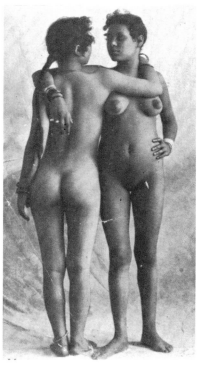

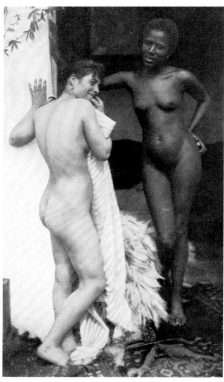
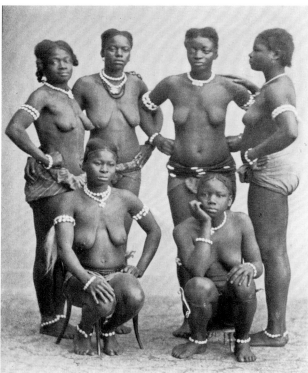
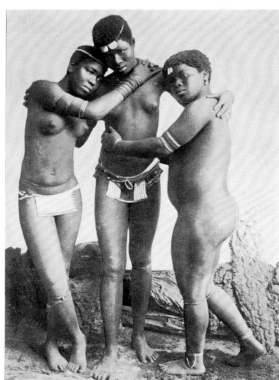

64

64 Photographs of Africans. Top row left: Edmond Fortier. "Les Bobos." Postcard. 1906. Paris. Top row, center: Basuto Woman. From Carl Heinrich Stratz, *Die Rassenschönheit des Weibes* (1906), p. 138 and fig. 76. Top row, right: "Deux jeunes filles Targui" (Two Targui women). Photograph clipped from the review *L'Humanité féminine* (5 January 1907) by Henri Matisse. Paris, Henri Matisse Archives. Bottom row, left: "Helle und Dunkle" (Light and Dark Skin). From Carl Heinrich Stratz, *Die Rassenschönheit des Weibes* 1911 (1921), p. 29 and fig. 14. Bottom row, center: from Carl Heinrich Stratz, *Die Rassenschönheit des Weibes* (1907), p. 148; p. 83 "Ashanti." Bottom row, right: "Zulu Girls." From Stratz (1907), p. 132 and fig. 73.

mances in Europe and America between ca. 1890 and 1900. The photograph, taken by Karl Guenther, shows us the women while on tour in Germany. It is not clear that any of these performing Amazons were part of the famous Dahomey female military, but some of this group, whom the king must have agreed to let tour abroad, may have been refugees or one-time prisoners in the wars. While their story is a fascinating one, it is not germane to Picasso's work except that he may have seen this image and others from the volumes in which it appeared. The photograph, misidentified as Ashanti women, was published in a richly illustrated book brought out by Carl Heinrich Stratz titled *Die Rassenschönheit des Weibes*[4] (The racial beauty of woman), a compendium of photographs of naked or near-naked women from around the globe intended for a broad audience. After an initial volume published in 1901, the Stratz book appeared in twenty editions, each larger than the last with more pages and photographs. As noted by Michael Hau: "Carl Heinrich Stratz [was] the most important racial aesthete of the period."[5] He also published a number of related volumes, each emphasizing the merging of science (anatomical study), aesthetics, and the erotic. A 1900 French edition includes this same photograph. In this photograph we see a group of African women, four standing with hands on their hips and two seated on short stools in front. Short panties and beads (barely) cover their genitals. White cowrie shells decorating ankle bands, armbands, bracelets, and necklaces highlight the deep blackness of their skin while also suggesting the idea of restraint.

Could the image taken ca. 1893 and published as early as 1901 also have been a source for Picasso's *Demoiselles d'Avignon*? Six women are shown here, rather than the five in Picasso's 1906–1907 canvas, but some of his early studies had more figures (several of whom were men). Although the gestures are different, the

tightly composed group of women shown in an array of poses—front, side, three-quarters, sitting low to the ground, and standing—with the whole shot from below to enhance their seeming power has a certain compositional similarity, particularly when coupled with Picasso's fascination with Dahomey Amazons and Amazons in general. This interest can be seen in Picasso's appropriation of an African Amazon from Richard Burton's account of Dahomey, in his 1905 "La Danse barbare." In both the Amazon photograph and Picasso's 1907 canvas, it is clear how the low point of view makes the women seem even larger than life, more dominant and imposing than they might be otherwise. Their near-nude portrayals and the variety of positions and poses (the latter a key feature of established photographic practices in the new field of physical anthropology) serve, as with women posturing in a brothel, in some ways to remove their humanity, by transforming them into complementary specimens of science and sexual desire.

see 66, 67

As one looks more closely at the photographs and diagrams of women in the Stratz volumes (among these fig. 64, top row, center, and bottom row), it is clear there are also a number of others that shared qualities with the figures in Picasso's various studies for his 1907 masterpiece. The potential importance of photography to Picasso's oeuvre in the period of *Les Demoiselles* has been addressed by several researchers, among these Michael Leja, who documents[6] the complementary nature of photographs of bordello interiors, and the workers therein, to the artist's work, images that were quite widespread in the early twentieth century. David Lomas, in pointing to the general importance of the field of physical anthropology in this era,[7] introduces photographs depicting the facial anomalies of prostitutes and others suffering from the disfigurement of disease. Scholars have pointed to colonial agendas and issues of alter-

ity framed around photographs, and what Allan Sekula has called the "mythic aura of neutrality."[8]

In several books and articles, Anne Baldassari, while not taking up the likely importance of Stratz, has made a point of highlighting the potential impact of photographic sources—in particular ethnographic images—to Picasso in the 1906–1907 period and later. *Les Demoiselles d'Avignon* has been a subject of special interest to Baldassari and in particular several postcards by the famous Dakar-linked photographer Edmond Fortier dating from 1905–1906 that were in the artist's collection. The date when Picasso acquired these postcards or was given them is not known, and this relatively small grouping of forty colonial-era Fortier postcards is a small part of about two hundred colonial examples, itself part of some fifteen thousand photographs Picasso had accumulated over his life that are now housed in the Picasso Museum.[9] Even if several photographs among this group were important to the artist as he was conceptualizing his 1907 canvas and related studies, Baldassari is correct to insist[10] that Picasso no more painted "from (after) photographs" than he did "from life" or "from models." Instead she points to the importance of such photographic sources in contextualizing for him visually this colonial moment becoming an "ontological vector" that functioned as indices enabling him to conceptualize a kind of "primitive scene." She also argues that photography played a decisive role in advancing Picasso's pictorial imagination and engagement in the critical proto-Cubist period between 1907 and 1909.

see 64 One of these postcards, "Les Bobos," was taken in what is today Burkina Faso, where Fortier was documenting people, buildings, and life between the last months of 1905 and the first months of 1906.[11] This photograph of a Bobo couple depicts a nearly naked man and woman in conversation, a pose that suggests a certain fit with Picasso's *Two Nudes* (fall 1906) and studies for both *Les Demoiselles d'Avignon* and this work. Another postcard that Baldassari highlights is a market scene in Bamako, Mali, showing the now standard Fortier theme of "types de femmes."[12] In this horizontal composition set in a rural village savanna with earthen thatched houses in the background, we see nine women, six standing, three of whom hold calabash containers on their heads or shoulders. In front sit or kneel three other women, each positioning toward us large calabash halves containing what appears to be grain.

Like many of the photographs of nude women that appear in Stratz, and various illustrated journals for artists from this period *(Mes Modèles, L'Humanité Féminine)* (fig. 64, top row, right), most of Fortier's women appear with their chests bare, most wearing bold horizontally striped textiles around their waists. In addition, like Picasso's standing African demoiselle, three of the standing Bobo women are shown with their arms angled out and upward (behind or atop the head, or holding aloft a vessel), a pose intended in part to accentuate the breasts.

It is important to emphasize that very rarely did Picasso ever copy from a single source, without adding others in elaborating his unique visual style. Moreover, as Baldassari points out, through these photographs "these women are there, contemporaries of Picasso as he looks at them. At the moment when he paints them, the artist knows that in their own countries, these same bodies live, move, display gestural attitudes."[13] Their very "'Africanness'— physical, cultural, social," she adds, is superimposed on, yet distinguishable from, the importance of the African sculptural works that Picasso discovered through Matisse in the autumn of 1906, see 59 about the same time he seems to have discovered the photo documents.

Picasso most likely acquired the Fortier postcards in 1906 (the year they were printed), Baldassari argues,[14] possibly in conjunction with the "Senegalese village" display at the Grand Palais, Paris's smaller complement to the Marseille Exposition Coloniale. The latter was attended by Picasso's artist friends Derain and Matisse. Whatever their source, the Fortier photograph of "types de femmes" discussed by Baldassari clearly has key details in common with the Stratz photograph of the Ashanti (Dahomey) women featured in figure 64 (lower center). While the Fortier photograph includes the raised-arm gesture of the "African" *Demoiselle,* which none of the Stratz women in this image shows, the latter image's far tighter composition, the low focal point of the camera lens, and the bold stares of these women make the Stratz image particularly noteworthy.

The title of Baldassari's chapter in her 1997 *Picasso and Photography: The Dark Mirror,* namely, "'L'Humanité féminine': Une source africaine des *Demoiselles d'Avignon*" (pp. 69–115), reveals the additional importance of photograph-rich journals such as *L'Humanité féminine* published by Amédée Vignola (who also edited two other of the era's widely used illustrated journals, *Mes Modèles* and *L'Etude académique,* featuring the naked female). The twenty-three weekly issues of *L'Humanité féminine* issued from 1 December 1906 to 4 May 1907 (with a special emphasis on the critical period between 1 December and 23 March), took its readers on a whirlwind tour each week, from Africa to Europe to the Middle East, with no apparent order except to present photographs of women, many of whom are shown devoid of clothes (fig. 64, top row, right). Each sixteen-page issue features generally one photograph on each page as well as a cover image, a mix of full body, torso, and head shots, taken indoors and outside, clothed and naked bodies in an array of poses, gestures, and expressions.

The effect of these journals rich in photos, like the volumes by Stratz, is that of a whirlwind sexual tour over the publication's history: first stop Andalusia, second stop North Africa, third stop Italy, fourth stop Dahomey and Congo (this on 29 December), before heading back to North Africa, then Germany, returning to North Africa, back to Austria, then Egypt, turning eastward to Palestine, Syria, and Turkey, back south and westward to Senegal, and so forth. In Picasso's eye and creative mind, he may have decided to provide a visual forum in which to bring all the women together in one place to meet each other—and himself, the man and artist—as well as his band of poet/artist friends, and us, the viewers of his painting.

Equally interesting in these weekly journal excursions into global sexual fantasy is the timing of the Dahomey and Congo stop (two African locales whose sculptures clearly intrigued and influenced Picasso); the number of photographs (particularly Berber and Congo) showing body markings, consistent with changes Picasso made to the face of the "African" *Demoiselle*; and the fact that the very first issue featured women from Andalusia, Picasso's home. In a way, *L'Humanité féminine* nurtured and advanced Picasso's own personal and artistic story. He did not need the photographs as models, but they may well have been a factor in his decision to reimagine each of the five women in his 1907 canvas as being part of a global conversation.

One of the visual impacts of a close reading of the diverse issues of *L'Humanité féminine* is the sense one gets that most women, despite their different cultures and geographies, look quite similar (with breasts, vaginas, hair, toes, noses). Yes, age, height, weight, skin color, and coiffure make a difference, but these features are far less definitive as markers of cultural difference than are clothing and hairstyle. Once Picasso had decided to create a unity of these

women, how would he go about visually referencing core differences between them? He seems to have re-created each demoiselle in the type of dress, coiffure, posture, and style of artistic rendering that serves to identify the women living in these diverse areas, similar to the portrayals in *L'Humanité féminine.*

There is no doubt that Picasso, like other artists, knew of these volumes, single sheets of which also were available for purchase. Indeed on the back of a card mailed to him by Leo Stein in February 1909, Picasso wrote "L'Humanite feminine: la femme d'afrique" as part of a longer list of things he needed to acquire for work (along with pencils, paint, a camera) when he left for Horta de Ebro.[15] Because, as Baldassari points out,[16] this trip would be seminal to the "birth of cubism," it is important that, in Picasso's mind (and preparation), Africa would also be part of this artistic journey. Indicated also by this is that Picasso most likely owned the magazine(s) in question. Moreover, one of the photographs from the 5 January 1907 issue (two Targui women in friendly embrace; p. 40. See fig. 64, top row, right) is documented photographically to have been in Matisse's study when he was at work on his sculptures *Two Negresses* and *La Vie.*[17]

It is quite possible, as McBreen notes,[18] that Picasso also was aware that Matisse had used the photograph of the Targui women for his 1908 sculpture. Having studied the various photographs that appear here, I do not see any that seem to be obvious sources for Picasso's work. In a sense the images were for him probably both too staid and readily available. However, leaving the specific images to the side, I can easily see a broader impact of the issues, taken more as a whole, as a sort of "virtual bordello" or "philosophical bordello"—one of the canvas's early titles—providing safe sexual pleasure in the age of syphilis (much like Stratz). Picasso may

well have been coupling together these female bodies, sites, and scenes in his mind, during the critical December 1906 to March 1907 era in which he was working on *Les Demoiselles d'Avignon.*

Baldassari also points[19] to the racial cross currency being promoted in other illustrated artist reviews at this time, such as *Mes Modèles,* where one of the plates presents "two studies of French and Sudanese women in nearly similar attitudes that serve to underscore the anatomical differences of white and black women." Clearly as McBreen observes: "Matisse used these documents against the grain of their well-articulated intentions of several additional levels."[20] The same is true of Picasso. Moreover, as Baldassari points out, the business of selling colonialist views around sexual mores promoted through photography (including titillating lesbian pairings) went hand in hand with the larger "primitivist project." Although the journal was expressly intended for painters and sculptors, it drew attention in other quarters. It would soon come under the scrutiny of French censors, beginning with the requirement that its covers be "closed," and eventually the magazine's demise.

While at present we have no clear evidence that Picasso saw these journals or the Frobenius and Stratz volumes, or for that matter any of the other books whose imagery I discuss here, during the time he was working on his various 1906–1908 projects, the same also holds true for other photographic sources that have been explored by Picasso researchers interested in this question. However, further support for photography's role in Picasso's oeuvre in the 1906–1907 era can be seen in the complementary importance of such images for Picasso's friend, competitor, and contemporary Henri Matisse. Among Matisse's works that have been linked to possible photographic sources are several from this period, most

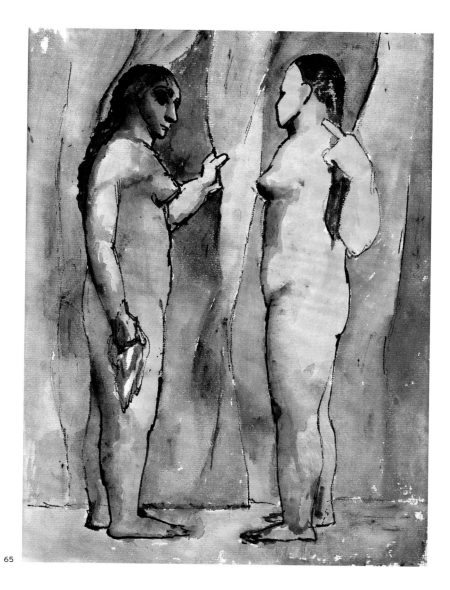

65

important of which are his 1906 *Standing Nude* and 1907 *Blue Nude, Souvenir of Biskra.*

Another Stratz photograph may be important to this discussion (fig. 64, lower left). In this image, which I have so far been able to find only in a 1911 edition of Stratz, though it may well have been circulating earlier, we see two smiling women, one black and one white, in conversation. The black woman faces us directly; the white woman has her back toward us, her head turned to the side. Suggested here is the evident pleasure she is about to have in a lesbian romp. The two are photographed at a portal as the white woman pulls down a fluffy and fringed cloth which serves to separate the two symbolically and visually. While vines have been hung in the upper left to suggest the out-of-doors, the carpet under foot reveals indeed that they are part of an interior. Important to this scene is the relationship between the two women, both of whom appear to be modeling for the gaze and pleasure of the photographer, who stands before them in an implied ménage à trois, here in a notable setting of pornographic polygamy—a theme otherwise rarely explored in more public photographs. That the two women of different races are shown together here is also significant in that the pages of books such as these are often the only contexts outside of brothels in which women of different races in Europe and elsewhere in this era occupied the same space in a context of relative equality. As is clear from the set of photographs from Stratz's volumes, the interest of the photographer, editor, and viewer (here clearly a more apt term than reader) resided not only in the comparability of women's bodies around the world, but also in their sexual desires, both individually and with respect to each other.

Several early studies for Picasso's *Demoiselles d'Avignon* display two women in conversation with each other at a door enhanced with draperies (see among other studies, one that specifically positions a black woman with a white woman in a comparable setting). 65

The study is also the source for a 1906 painting of two women in a similar milieu, although in this one the racial differences are less apparent. Moreover, as both Rubin[21] and Richardson[22] have noted, Picasso's first sketch for *Les Demoiselles* can be seen on the reverse of the notebook 2 sheet (p. 32). The recto of this page features a horizontal composition depicting a crowded, seven-person study for *Les Demoiselles,* showing not only the five women but also the two men who later are removed from this canvas. To the left of the drawing is a standing doctor holding a book, and in the center a predominantly forward-facing, seated sailor. On the verso of this same page, now turned vertically, is a study of two nude women in a curtained setting depicting, on the left, a seated woman with a cloth draped over her lap. Her head is canted upward and to the right, toward the head of a standing woman shown in three-quarters view, her head toward the rear, and her left arm and index finger at shoulder height pointing toward her. Much as the seven-person composition is an important early study for *Les Demoiselles d'Avignon,* the drawing of the two nudes of different races is a key study for both this work and the fall 1906 painting *Two Women* that is clearly seminal to it.

The paired recto-verso study[23] offers important evidence that Picasso was exploring both subjects in the same time period, and works like the photograph published by Stratz may have contributed in important ways to each. Significantly, as noted above, one of the many studies from the fall of 1906, *Two Women* (the last major work before *Les Demoiselles d'Avignon*) presents this meeting as including both a black woman and a white woman. Since one woman is black (or mulatto) and the other is white, any idea of reciprocal mirroring seems also to carry a certain racial engagement as well, complementarities that also have parallels in the women of different ethnicities depicted in *Les Demoiselles.* As Leo Steinberg

points out,[24] *Two Women* evokes "the threshold of an encounter," with the curtain marking both the coming together and the separation.

Picasso's *Demoiselles,* much like *Two Women* and the illustration-rich volume, focused on women around the world, largely naked and in provocative poses with raised, bent arms, a virtual bordello featuring women from various locales. Picasso's large canvas, originally titled by the artist *My Bordello,* also showcases women from a variety of geographic settings brought together and displaying their largely naked bodies for a larger, anonymous audience, in a context largely free of danger.[25] Discussing the raised bent-arm pose in African postcards featuring naked African women, Raymond Corbey observes the primacy of this pose, which highlights the breasts, a gesture that was a common convention in nineteenth-century European painting and photography. A photographer's request that the model assume this pose, as Corbey notes, conveys ideas of sexual interest. Specifically referencing the African works, he adds that "the message is one of availability for male European purposes, as the whole colony was taken to be available."[26] As evidenced in an array of related studies and canvases, Picasso simultaneously seems both to have drawn from and subverted these forms.

Equally striking in Stratz's 1901 volume was the emphasis accorded to ideas of evolution, complete with charts and maps, extending even to the order in which the photographs themselves were presented. In this book, as in his *Naturgeschichte des Menschen: Grundriss der somatischen Anthropologie* of 1904, the bringing together of African and European women, as well as women from the world over, in a context that would allow for and indeed encourage comparison was key. The map and charts furnished by Stratz (created after Fischei and several other illustrators) include

the assumed earliest world populations: the "Aboriginal" Khoikhoi (Bushman), Australian, and Papuan (New Guinea). From this "root" group there are seen to emerge three branches, leading via "intermediary" populations (Melanesian, then Oceanic, American Indian, followed by Eskimo and Malaysian) to the "Gold Race": Asian populations. In another "stem" Stratz sees the "Aboriginal" as leading from the Khoikhoi (Bushman) to the Akka, and finally the "Black Race." The centermost stem, in contrast, moves directly through the Aino to the "White Race," the latter in turn being divided into two subgroups, "the Mittelaender" Roman and the "Nordlaender" Germanic culture. In this same chart Stratz includes several "mixed" races seen to have emerged through the intermarriage of groups from the three dominant stems, among these the Libyan and Ethiopian populations (representing a mixture of black and white) and Slavic, Turkish, and Indonesian (gold and white). In short, what this chart illustrates are the assumed five dominant branches of humankind: Aboriginal, Gold (Asian), Black (African), Southern European (Roman), and Northern European (German).

These five culture areas/races also suggest complements with the five women in Picasso's 1907 painting, specifically, the dark-faced, African-like crouching figure in the lower right, who evokes the Aboriginal (i.e., the African Khoikhoi and Pygmy) populations, along with Papuan New Guinea and indigenous Australian. The standing "African" figure behind this crouching woman references in turn the "Black Race." The two centermost and frontally positioned white women suggest Southern and Northern Europe, while the standing profile figure on the left evokes Stratz's Gold Race (Asia, as well as various "mixed race" populations, Indonesian and Egyptian). The large scale of the *Demoiselles* canvas, its unusual proportions, extensive revisions, and numerous studies

are consistent with Picasso's engagement with a theme of difficulty and importance, such as evolution may well have been.

For Picasso, as for many in Paris at this time, the issues of evolution and origins were not only of philosophical interest (evoked in part by one of the original titles of this canvas, *Le Bordel Philosophique*), but also of personal concern. Picasso's maternal grandfather, Francisco Picasso Guardeño, had gone to Cuba, leaving his wife and four children (among these Pablo's mother, Maria), and with his black mistress, Serra, had fathered a new family, four children, whom he named after the children he had earlier had in Spain. He died in Cuba in 1888, before his planned return trip to Spain could take place. The Picasso family in Spain knew of this liaison and of their relatives in Cuba, a fact that adds another layer to the already complex dimensions of this canvas. Returning to the study and painting of two women of different races meeting in the see 65 liminal zone of a doorway, one that served as a partial model for *Les Demoiselles,* it is tempting to see this in part as an imaginary meeting created by Picasso that serves to introduce his Spanish maternal grandmother to his maternal grandfather's black lover in Cuba.

Picasso's 1907 *Demoiselles d'Avignon* was not the first time the artist explored the theme of Africa in his art. In his 1905 study for *Salomé and Herod,* cited earlier, he includes the figure of a black 66 servant girl, taken from an unusual source, a reimagining of an illustration of a Dahomey Amazon from Richard Burton's famous 1863 travelogue, *King of Dahome,* and/or another similar illustration by the same English artist, John Wood. The first of the works 67 depicts two well-muscled, simian-jawed women who resemble hags searching for enemy prey. Their hooded eyes, low-angled foreheads, thick cheekbones, broad fleshy lips, and unkempt hair create a certain bestial aspect and danger that is heightened by

66

their physiognomies starkly profiled against the brightly lit sky. Captured from below (as if by a fallen foe), their gigantic size seems to empower their villainous behavior even more.

The women's barely human features reinforce highly derisive Western views of Africans in this era; their features are more ape-like than human, consistent with social evolutionary theories of this period. These attributes are counterbalanced, if only slightly, by their long-barreled weapons and strangely elegant white hair ribbons tied tightly around the hairline and draping down the back. The second illustration depicts a notably similar simian-faced woman, shown in a deep, squatting posture atop a short, three-footed stool. She has a thick bullet pouch around her waist and her rifle rests in her hands as she surveys the landscape while a group of fellow Amazons stands at attention in the distance.

In Picasso's study for *Salomé and Herod*, he renders the black girl as a servant with a dish of fruit. He has flip-flopped the Dahomey Amazon left to right, while retaining her dominant profile view. Many of Picasso's other appropriations of book images are similarly reversed. Here Picasso also has chosen to sever the Amazon model at the midriff, repositioning her limbs into a ground-hugging squat. He also has removed her roughly textured blouse, retaining the rear-keening shoulders and replacing her rifle with a

bowl of fruit. Inching this fruit-filled vessel forward on long uplifted fingers toward the recumbent Salomé lying with Herod on a bed, Picasso has reimagined this scene into a still more famous historic referent, Edouard Manet's iconic 1863 painting of Olympia. In the original Manet version, a neatly coiffed white female lies nude and semi-recumbent on a thickly cushioned divan. She stares boldly out toward the viewer as a uniformed black girl enters the room from the rear to present her a large bouquet of flowers wrapped in elegant paper, a gift, seemingly, from her lover.

As with Manet's *Olympia*, Picasso highlights here the rich and deeply contrasting skin tones of the African woman, distinctions further reinforced by the differential stylistic modes in the rendering of this black servant. A deep rich charcoal is smeared thickly over the epidermis of the African woman's hard-muscled body, a striking contrast in both sensory engagement and stylistic approach to the light-skinned (chalky white color applied almost transparently in some places), giving the faces a near-ghostly countenance in contradistinction to the strongly earthbound physicality of the African. Here, too, Picasso has invited us in to watch in almost voyeuristic fashion the chance meeting of not only key exotic figures of the past, but also notable femmes fatales of different races and times (deadly women in both mythological and

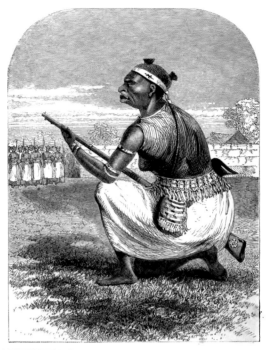

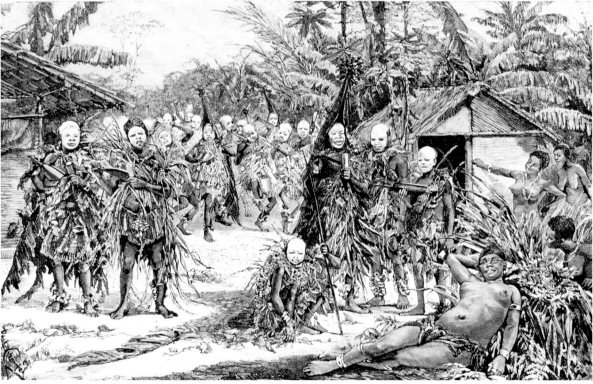

67

67 Composite. Top row left: Dahomey Amazon in Rev. R. J. Wood, *The Uncivilized Races, or Natural History of Man* (London, 1870), p. 637. Top row right: "The Amazon." Frontispiece for Richard Francis Burton, *A Mission to Gelele, King of Dahome*, vol. 1 (London, 1863). Bottom row: Mme Crampel. "Aduma [Gabon] Tamtam." From Harry Alis, "Pays des Fans," *Tour du Monde* (1890), p. 323.

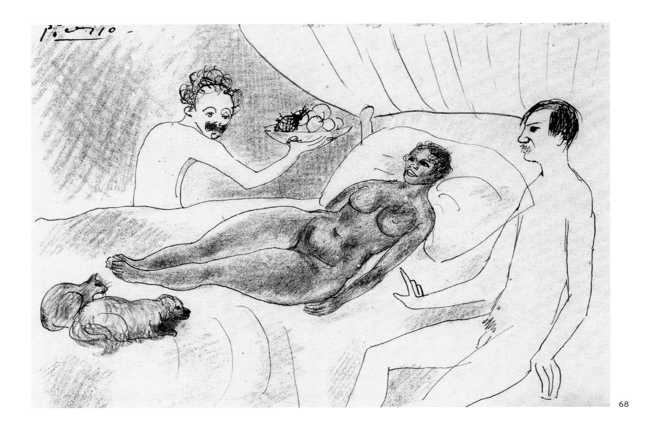

68 Pablo Picasso. *Parody of Olympia*. Self-portrait with Sebastià Junyer and nude. 1901–1903. Paris, private collection.

69 Vallotton. *Le Blanche et la noire*. 1913. Winterthur, Villa Flora.

ontological terms). The squatting coal black servant *cum* woman warrior is carefully positioned in three-quarters back yet profile facial view. This representation is clearly one source for the unusual squatting black female in the front right corner of *Les Demoiselles*. In the latter case, Picasso has again flip-flopped the female model back to her original left-facing profile, three-quarters back view.

The story of Salomé is an interesting one for Picasso to have taken up in this context. She was the subject of a popular Oscar Wilde play of 1896 that many in Picasso's circle would have seen, most important among these the poet-playwright Guillaume Apollinaire. Interestingly, in his rendering of the scene, Picasso utilizes Apollinaire's body shape and anatomical features in the figuration of Salomé's father, King Herod. The play's heroine-villain, Salomé, famously had been instrumental in causing the execution of John

the Baptist when he declined her advances. This dangerous and specifically death-causing woman, as femme fatale, references the complex nature of fruits of desire as objects of both danger and pleasure. Explored here at the same time is the larger subtheme of an exotic woman (women) on display before a curious audience. Here the black Salomé becomes the focus of even greater curiosity because of her (Ethiopian?) race. A rather similar cross-racial encounter of historic women drawn in distinctively separate styles, seemingly unfinished in effect, but in truth differentially drawn, also is a distinctive feature of Picasso's *Demoiselles d'Avignon*. In Picasso's *Salomé and Herod,* we thus find early clues as to what makes his famous 1906–1907 canvas so revolutionary.

Picasso explored key aspects of Manet's *Olympia* in one of his still earlier drawings as well, a somewhat whimsical pencil and

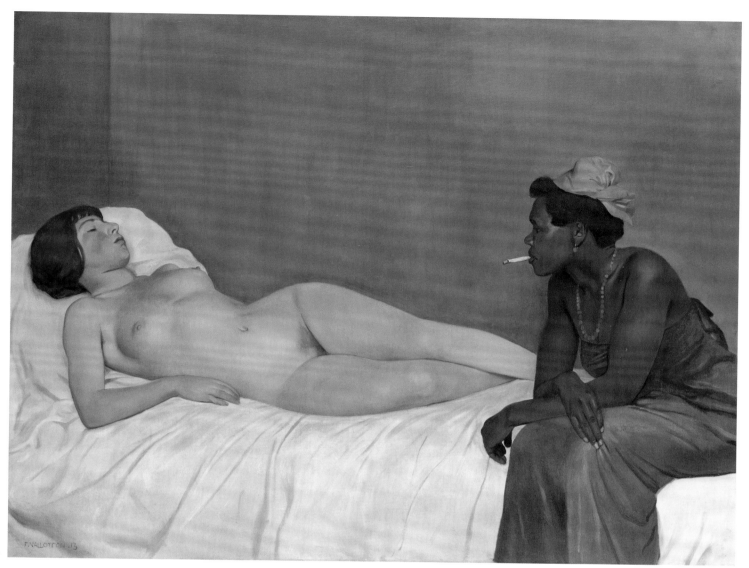

69

see 62

68 color crayon self-portrait with his friend Sebastià Junyer Vidal, a work of unknown date but attributed to the period of 1901–1903 soon after Picasso arrived in Paris.[27] Witness here the round-bodied figure of a blue nude (an ironic prefiguration of Matisse's much later reclining *Blue Nude* of 1906). The full breasts, belly, and thighs of this royal blue (black) woman are picked up again in the blue pelting of a thick-furred dog and cat who stare up at the supine nude whose body and features are set off strikingly from the white bed covering and pillow. Both men, who also are nude, sit demurely on stools on either side of the wood-framed bed. Junyer, whose curly hair and mustache are marked with the same deep blue crayon as the woman and animals (evoking the more animal-istic impulses?), here plays the role of fruit-carrying servant girl, although he seems not to dare to enter her space to convey it to her.

The nude Picasso, shown in the foreground on the right, seems bi-zarrely uninterested in the woman displayed before him (in nota-ble contrast to the wide-eyed, staring Junyer), but he surrepti-tiously inches his outstretched right index finger toward her, as if to touch her velvety skin without her knowledge.

There were other important engagements with Manet's *Olympia* involving portrayals of blacks in this period, among these Vallot-ton's *La Blanche et la noire* of 1913. Here the figure of the black servant has been changed to what appears to be an African setting in which a naked white woman sleeps on a bed in a stark, green-hued room, as an African woman wearing a native blue cloth wrapper, red beads, and a bright orange hat boldly stares at her body and flushed face as she sits on the rumpled bed linen smok-ing a cigarette. In an earlier example of this same *Olympia* genre,

70 Pablo Picasso. *Child Beside a Hut with Palm Tree*. 1905. Marina Picasso collection.

71 Pablo Picasso. *Seated Negro*. 1906. Zurich, Bollag collection.

70

this one dated to 1890 and republished in 1898 by Leo Frobenius in his *Die Masken und Geheimbünde Afrikas,*[28] we see a group of Adouma (Gabon) natives in chalk-white face paint staring at a young African maiden in the forest.

Voluptuous women were not the only figures invoking Africa that Picasso would portray in this period. Two drawings, one from 1905 and the other from 1906, figure in this discussion. The first, depicting a child beside a hut with palm tree, could well be a re-imagining of the scene at the Dahomey pavilion at the 1900 Exposition Universelle, which Picasso attended, here showing native-style architecture alongside a lake with a pirogue. The scrawny child, a stick-figure silhouette in the blaze of the noonday sun, stands akimbo with his hands hooked around his too thin waist. Picasso, evoking the hunger he knew that Africans sometimes faced, seems also to be referring to his own difficult circumstances, when, up until the summer of 1906, he would sometimes go to bed at night without having eaten because he had no money for food.

A somewhat similar theme is evoked in the very different ink sketch from 1906 of a tall, well-muscled, middle-aged African, shown naked and seated, his knees wide on the ground with an

70

71

72

(empty?) cooking pot beside him. In some way this African figure of poverty and hunger also had a certain resonance for Picasso and the fear (and pain) he was experiencing in this era. The figure, though male, also has a certain fit with the crouching African woman in the lower right corner of the *Demoiselles* canvas. In a third example—a 1906–1907 study of a stylishly dressed and coiffed Parisian along with a dark-faced Egyptian woman (in Egyptian-style profile view) and a haggard old woman in frontal view whose face is rendered in wrinkles that recall African facial markings—Picasso touches on another theme that is addressed in his large 1906–1907 canvas, namely, the shared qualities of sexuality (age and motherhood?) of women around the globe and throughout time. This early study also may offer key insight into what Picasso was exploring in *Les Demoiselles.*

72

Jump forward to late 1906 and early 1907 when Picasso is working on *Les Demoiselles d'Avignon.* Once again he is addressing some of the incongruities of time and place, specifically as they relate to Africa and Europe. Among his studies is a pen-and-ink drawing related to both the standing African figure in the *Demoiselles* and his 1908 painting, *Nude in Profile, Arms Raised.* Particularly striking in this study in pencil, pen, and red ink is the large lettered term *Málaga* that is written to the right of the figure. This, of course, is the name of Picasso's Spanish hometown, a place of some consequence in light of both its close ties to Africa and Picasso's thinking at this time. The female shown here, who seems at once to possess both African and European attributes, suggests the predominance of cultural and physical hybridity in this southern port city. Málaga had long been one of the main points of passage be-

73

72 Pablo Picasso. *La Parisienne and Exotic Figures.* 1906–1907. Paris, Musée Picasso.

73 Pablo Picasso. *Standing Figure with Raised Arms.* 1906–1907.

73

tween Africa and Europe, a place that until the city's fall to the Christians in 1487, and the fall of the larger Granada province in 1492, was an important Berber Islamic center.

The woman shown here elicits that same kind of powerful hybridity and north–south global engagement that was evoked in Picasso's most important canvas that preceded this, *Les Demoiselles d'Avignon*. In key respects, this female also encapsulates Picasso's own cultural identity as well. Gertrude Stein's remark[29] that African art seemed "natural" and "civilized" to Picasso in part because he was "a Spaniard" is noteworthy in this regard. If these works also complement the figure of a Malinke woman depicted in much see 64 the same pose in one of Fortier's photographs, as suggested in Anne Baldassari's writings on Picasso and photography,[30] this conveys in equally striking ways how important this co-joining of

Africa and Europe was to him, serving both as a reference to a specific cultural past and as an example of the ways in which Europe, to members of his circle, can best be understood as a mirror of Africa. In this vein, through Picasso's eyes, when stripped down to the essential elements, we are similar, and in some respects perceived African models of conduct and character (sexual among these) represent a certain normative ideal. If the fluidity and strength of the partially cursive Málaga referent in this painting conveys a potent emotional pull—memories of his childhood—it also conveys something of the void (and lack) that Paris and its critics had bathed him with in the aftermath of his radical and challenging painting *Les Demoiselles d'Avignon*.

The unusual form of the *Nude in Profile* canvas, partially effaced by ink in the lower right of his study, may be another clue, for it

seems to draw inspiration in part from the plate of fruit and related studies of a plate with watermelon slices that seems to link this drawing even more to the large 1906–1907 canvas. With daily ferries to transport people back and forth between Africa and Europe via Málaga, the ties remained strong. So did the heavily salted fish, after which the port city had been named; this provided sustenance for the Mediterranean journey north and south, east and west from here. While discussing the larger context of Picasso's connections with Africa from the vantage of his Spanish roots, Natasha Staller cites an 1887 Málaga text to the point that "all Moroccans carry Spanish blood in their veins, and all Spaniards carry Moroccan blood in their veins."[31] She also addresses the important complementarity between the figure of an African woman pulling back the curtain on the right of Delacroix's painting, *Women of Algiers* (1834), and the females parting the curtain in *Les Demoiselles d'Avignon.*[32]

Other hints as to what Picasso and his friends were thinking about these issues can be discerned in the popular figure of Père Ubu, who was largely a product of a play and serial written by Alfred Jarry. Appearing initially in 1896 in the play *Ubu Roi,* this personage would reappear in different contexts (and descriptive elements). Jarry was the leader of a group of avant-garde authors who used satire to point out the problematic colonial effort. One of the most important of the group of related publications was the illustrated 1901 "Ubu colonial" *(Almanach illustré du père Ubu),* which highlights colonial self-interest in stunningly bare terms, including its racial stereotyping, through bitingly comedic drawings. The wit, parody, and cruel play addressed here in terms of cross-cultural encounters is perhaps also in play in Picasso's *Les Demoiselles d'Avignon.* In the Père Ubu illustrations, not only are the belligerent engagements of the colonials in Africa and similar contexts addressed, but so also are issues of race, color, and the sometimes strange taxonomic questions of both, as in figure 64, bottom, where we are presented with the situation of Africans who turn from black to red on hearing a colonial song. The striking lithographs by Pierre Bonnard that accompany the text, in a style that is at once crisp, fluid, and modern while also suggesting the sort of animated cartoonlike renderings that were appearing in popular print productions such as those from *Images d'Epinal,* are at once childlike and "primitive." In *Ubu colonial,* a series of animals is used to show the sometimes ludicrous relationships between the colonial (here through the character of the huge-bellied Père Ubu with his crocodile-like muzzle) and native subjects (the ostriches) in the former's attempt to control various forms of native behavior. When Ambroise Vollard brought out another edition of this volume in 1932 with illustrations by Georges Rouault, the new approach and imagery affected the viewer very differently. The primitivized abstractions allowed less space for the reader to contemplate the sometimes cruel and dangerous conditions of Africa's inhabitants during the colonial era. Similar issues were among the many concerns that figured in other portrayals of Africans in this era.

7

ENCOUNTERS WITH THE IMAGE OF THE BLACK: THE GERMAN AND FRENCH AVANT-GARDE (1905–1920)

CHRISTIAN WEIKOP

In 1931, in the catalogue for his exhibition *German Painting and Sculpture,* Alfred H. Barr, Jr., the first director of the Museum of Modern Art in New York (MoMA), considered the discovery of so-called "primitive art" by two principal figures of two important European avant-garde manifestations, both formed in 1905. He pitched Ernst Ludwig Kirchner, the self-styled leader of the first German Expressionist group, known as the "Brücke" (Bridge), against Maurice de Vlaminck, an artist associated with a loose group of primarily French painters known as the "Fauves" (wild beasts), who similarly explored the expressive potential of form and color. Barr stated: "It seems probable that Kirchner's discovery of African and Polynesian art in the Dresden Ethnological Museum in 1904 definitely precedes Vlaminck's discovery of Negro sculpture in Paris. What is more important is the fact that as soon as they had come upon primitive art the Germans did not turn it into a formal exercise such as cubism."[1]

Although more than eighty years have passed since Barr made this claim, the statement is still an intriguing starting point, as it counters later and more established narratives on "primitivism"[2] by suggesting that a process of creative interaction with African and Oceanic art might have been independently initiated by German artists, preceding the French avant-garde. This chapter will reinvestigate this claim on early discoveries, but it will go beyond a dis-

cussion of the avant-garde response to African masks, sculptures, and caryatid objects to consider also the direct response of artists to "flesh-and-blood" black models, a response that was particularly evident in the art of the German Brücke group and far less present in the French avant-garde. As will be demonstrated, encounters and interactions with the "image of the black" had more profound implications for the art of German figurative Expressionism than for French Fauvism or Cubism.

In *German Painting and Sculpture,* Barr included most of the artists connected to the Brücke and three from the Blaue Reiter, a coterie of Expressionist artists formed in Munich in 1911. But as Rose-Carol Washton Long has observed, just five years later in the catalogue for MoMA's important 1936 exhibition, *Cubism and Abstract Art,* Barr shifted his focus of interest, making no reference to the Brücke at all.[3] Significantly, only "Abstract Expressionism" (1911 Munich) was included in his oft-reproduced chart outlining the progression of modern art toward abstraction, where it is seen as being directly informed by Redon, Near Eastern art, and Fauvism, but not Negro sculpture, which is directly linked to Fauvism and Cubism. It seems that this exhibition, rather than Barr's earlier 1931 show, influenced the way in which Anglo-American art historians in particular subsequently interpreted the "discovery" of African art by the avant-garde as an essentially Paris-based phe-

74 Cover of the exhibition catalogue *Cubism and Abstract Art,* showing Alfred H. Barr, Jr.'s chart of the progression of modernism. 1936. New York, Museum of Modern Art.

75 Pablo Picasso. *Bust of a Man.* 1908. New York, Metropolitan Museum of Art.

nomenon that then migrated to other European and North American cities. This view has subsequently become pervasive and was reinforced by MoMA's much later (1985) major exhibition and two-volume catalogue *Primitivism in 20th Century Art.*[4] Even Sieglinde Lemke in *Primitivist Modernism,* published in 1998, corroborated this view: "What started in Paris was soon to spread to modern artists in other European countries. German Expressionists such as Erich [sic] Nolde and Paul Klee became interested in *Negerkunst.*"[5] The assumption is not strictly incorrect, for the African-inspired art of Pablo Picasso, Henri Matisse, and their artist friends was of course highly influential outside of France. However, the historical case should be reinvestigated bearing in mind Barr's understanding (in 1931 at least) that German artists, and specifically the founding Brücke member, Kirchner, may have got there first. The case, however, is more complicated than merely verifying the chronology of events and claims. Processes of cultural transfer between Germany and France need to be considered, processes that occur in exchanges among ethnographers, collectors, dealers, and art historians as well as artists. The conceptual dynamics that existed among these interacting circles are fascinating.

Early Encounters with African Artifacts

It has often been related that Vlaminck, in his own somewhat romanticized account in *Portraits avant décès* (1943), claimed that in 1905 he was the first of the Parisian avant-garde really to understand the true artistic significance of African sculpture, not in a dusty museum but in the more intoxicating setting of an Argenteuil bistro:

While sipping my white wine and seltzer, I noticed, on the shelf behind the bar, between the bottles of Pernod, anisette, and curaçao, three Negro sculptures. Two were statuettes from Dahomey, daubed in red ochre, yellow ochre, and white, and the third, from the Ivory Coast, was completely black. . . . I intuitively sensed their power. They revealed Negro Art to me.[6]

Vlaminck went on to claim that along with André Derain he had explored these "barbarous fetishes" in the Paris Trocadéro several times, but on those occasions the idea that these were "the expressions of an instinctive art" had eluded them.[7] Again according to his own story, after considerable persistence, Vlaminck acquired the "Negro sculptures" from the bar owner and shortly afterward supplemented his small collection with a powerful white Fang mask given to him by a friend of his father's. The mask so captivated Derain that he felt compelled to offer Vlaminck 50 francs so he could hang it in his own study on the Rue Tourlaque, where "Picasso and Matisse saw it" and were equally "thunderstruck."[8] While Vlaminck may have attempted to mythologize various aspects of his account, he did not attempt to take credit for being the first to respond *artistically* to the formal qualities of African and Oceanic sculpture; rather he praised Picasso for being the pioneer in deriving formalist lessons from the "sculptural conceptions" of tribal artifacts.

Jack Flam has reinvestigated the chronology of events concerning the discovery of African art and concluded that because of Derain's changes of studio, it was not possible for this event to have occurred in 1905, but that it actually took place in 1906.[9] Furthermore, he has argued that Derain's interest in the formal properties

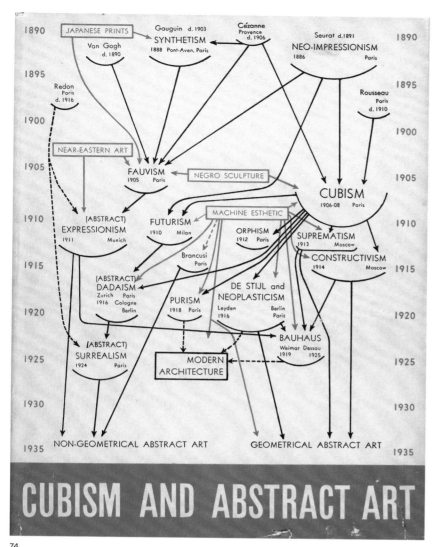

74

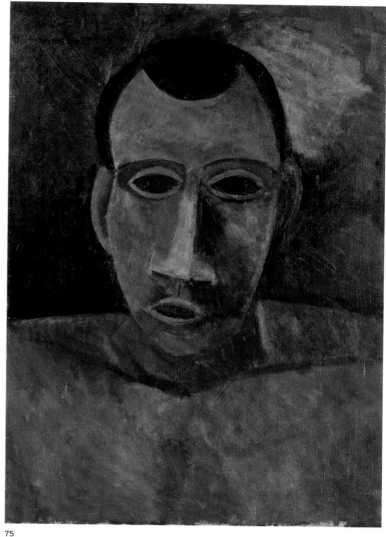

75

and potential of African sculpture as a source of inspiration for the Fauves preceded his acquisition of Vlaminck's mask, as evidenced by a letter that Derain sent to Vlaminck from the British Museum on 7 March 1906. Flam also related that Matisse first became interested in African sculpture, independently of Vlaminck and Derain, as a consequence of his first visit to North Africa in March 1906, and perhaps also in response to the public exhibitions in the Trocadéro that had been on display for more than two decades. Flam stressed that it was Matisse who introduced Picasso to African art that autumn, a point confirmed by Gertrude Stein, Picasso, and Matisse himself. Matisse said in a 1941 interview:

I came to [African sculpture] directly. I often used to pass through the Rue de Rennes in front of a curio shop called "Le Père Sauvage." . . . There was a whole corner of little wooden

statues of Negro origin. I was astonished to see how they were conceived from the point of view of sculptural language . . . these Negro statues were made in terms of their material, according to invented planes and proportions. . . . I went to Gertrude Stein's apartment on the Rue de Fleurus. I showed her the statue, then Picasso arrived. We chatted. It was then Picasso became aware of Negro sculpture. That's why Gertrude Stein speaks of it.[10]

Tracking who influenced whom in these much discussed narratives is one thing, but what has been less emphasized is that many of the collectors, gallerists, art historians, and supportive critics of the vanguard artists in France and Germany, who had begun to respond to African and Oceanic art, were in fact German and frequently German Jewish. Stein, who moved from the United States

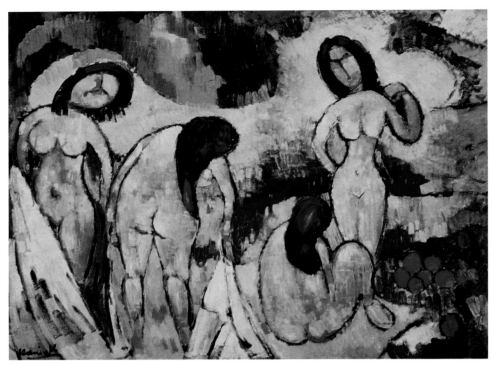

76 Maurice de Vlaminck. *Bathers*. 1908. Switzerland, private collection.

76

to Paris in 1903, where she remained for the rest of her life, was born to upper-class German Jewish parents. Daniel-Henry Kahnweiler, the young art dealer from Mannheim who established a small but critically important gallery in 1907 at twenty-eight, Rue Vignon Paris, where he would become a pioneering champion of the Fauvists and Cubists, was supported by his Jewish banker family. Kahnweiler's close friend Carl Einstein, the author of the seminal text *Negerplastik* (1915), who moved to Berlin in 1904 and became acquainted with the ethnographic collections of the Trocadéro, as well as many artists of Kahnweiler's circle on his trips to Paris from 1907 onward, grew up in a very religious Jewish family in Karlsruhe, although he later rebelled. And while he was not Jewish, the scholar and art dealer Wilhelm Uhde, who had moved to Paris in 1904 and aligned himself with the group of German intellectuals and artists meeting at the Café du Dôme, was among the earliest to recognize the importance of Picasso. Like Kahnweiler, he set up a gallery in Paris, while also maintaining contact with artistic developments in his native country by joining the *Sonderbund*, a Cologne group advocating Expressionism. A "primitivizing" Expressionism, or displays of the French avant-garde, could not have flourished in German cities without the support of an interacting network of publishers, publicists, dealers, and critics, such as Max Osborne, Paul and Bruno Cassirer, Paul Westheim, J. B. Neumann, Wolfgang Gurlitt, Ludwig Schames, Samuel Fischer, Kurt Wolff, Alfred Hess, Herwarth Walden, Else Lasker-Schüler, Alfred Flechtheim, and countless others, many of whom

were of Jewish descent. As will be discussed in chapter 9, German Jewish support for European avant-garde artists, especially those who registered the influence of African or Polynesian wood carving, would later be identified by the National Socialists as a conspiracy to encourage German artists to see the world through a prism of hybridization and miscegenation.

More discussion of early German-French connections and Barr's comment that German artists may have reached a similar "eureka" moment before the French is needed here. Certainly in 1948, Kahnweiler maintained that the Fauves had not been particularly influenced by African art: "Matisse, with his intelligence and acute sensibility, was capable of appreciating these sculptures at their true value; but neither his painting nor his sculpture shows any signs of this admiration."[11] Kahnweiler further argued that some of Derain's works may well have been inspired by Gauguin but had no connection to "the Negro artists," while he cautiously admitted that a few of Vlaminck's paintings, such as *Bathers* (1908), 76 demonstrated the "influence of the appearance of the African sculptures" (in this case an almost caricatural transposition of the features of the Fang mask to the faces of two of his female bathers), but nonetheless showed "not the slightest understanding of their spirit."[12] In a seminal *Burlington Magazine* article of 1968 titled "German Expressionism and Primitive Art," Leopold Ettlinger confirmed this perspective, stating: "It should also be stressed that Matisse and the Fauves, their enthusiasm apart, learned little if anything directly from African art as Guillaume Apollinaire

77 Henri Matisse. *Reclining Nude I*
(Aurora). 1907. Baltimore Museum of
Art.

pointed out as early as 1907."[13] In addition, John Elderfield observed that "Derain, though full of admiration for African sculpture, was unable fully to use its lessons in his work."[14] In conducting a much closer visual analysis of the evidence, Flam agreed that African art's influence on Vlaminck had been limited; he was able to only illustrate rather than assimilate the structural features of African sculpture into his paintings, and in 1907 Derain had a similar problem, Flam said.[15] However, he argued that by 1908, Derain was able to combine successfully "Cezanne and Negro art" in his *Bathers*.[16]

More important, Flam took issue with the common notion that the influence of African art was not really registered in Matisse's work; instead he proposed that "African-inspired formal structures" were clearly evident in the artist's creative handling of the human figure in painting and sculpture from late 1906 and early 1907 onward, and conducted a formal analysis of key works such as the painting *The Blue Nude (Souvenir of Biskra)* and the related sculpture *Reclining Nude I,* both of 1907, and representing, in his words, a modern "African Venus."[17] In many respects, these artworks represent an incongruous hybrid "primitivism," recalling the truncated forms of classical torsos and the tightly interlocking volumes of African sculpture. They were shown in a group of major works by the artist in Paul Cassirer's gallery in Berlin in Janu-

ary 1909, seen by the Brücke artists Max Pechstein and Kirchner, who responded to Matisse's work in various ways in their painting, sculpture, and graphic work from 1909 onward. In the case of Pechstein, this may have occurred even earlier, as he was already in contact with Fauvist artists in Paris on his sojourn there in 1907–1908. The Dresden-based Brücke artists were linked to the Parisian avant-garde through Pechstein and the more peripheral Brücke artists Franz Nölken, Cuno Amiet, and Kees van Dongen (the latter recruited by Pechstein while in Paris), all of whom were close to the circle of Matisse at various points before 1910.[18] This observation would seem to corroborate the commonly held view expressed by Lemke and others that what started in Paris soon migrated outward, but was this actually the situation? Was there any credence to Barr's time-honored notion that perhaps this may not have been the case?

Barr gives 1904 as the date of Kirchner's first discovery of African and Polynesian art. This date was most likely based on the incorrect dates of drawings supplied by Kirchner to Will Grohmann for a 1925 publication, *Zeichnungen von Ernst Ludwig Kirchners*. Kirchner dated these drawings, later described by Wilhelm Arntz as being created "after African and South Sea sculpture," to 1904, but they were actually from late 1909 or 1910.[19] Kirchner provided Grohmann with an even earlier date for his biographical mono-

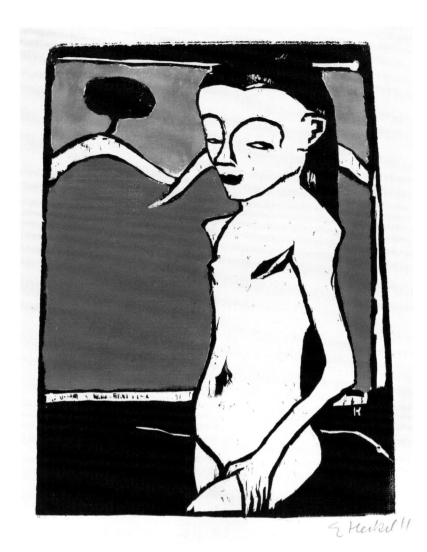

78 Erich Heckel. *Standing Child* (Stehendes Kind). 1910/1911. Los Angeles, Los Angeles County Museum of Art.

78

graph *Das Werk Ernst Ludwig Kirchners,* much manipulated by the artist and published a year later in 1926. He did this by directly supplying Grohmann with a self-penned essay designed to steer his biographer's account when he visited the artist in Switzerland in 1925: "In 1903 he [Kirchner] visited the Ethnographic Museum in Dresden where he discovered the carvings of the Negro and the pictorial representations of the Palau beams and recognized a highly expressive art in spite of the derision of some friends. In these works he felt there was a parallel to his own strivings."[20] Barr would have consulted Grohmann in preparation for his 1931 exhibition that included a number of Kirchner works.

Although the testimonies of both Kirchner and those in close contact with the artist have proved to be notoriously unreliable, it is still entirely possible that Kirchner did encounter and was stimulated by African and Oceanic art in the Ethnographic Museum as early as 1903. The Palau wood beams were installed in the museum in 1902, and by the end of the nineteenth century the museum al-

ready had a collection representing North, Northeast, West, East, Central, and South Africa. The largest part of the Benin collection (around 170 objects) was accessioned between 1898 and 1906, and the Togo and Cameroon collection started to grow after 1906 with more than fifty objects acquired in 1910 alone,[21] the same year that Kirchner really started his sculptural work in earnest. Peter Lasko has suggested that Kirchner's appreciation of these sources might well have been heightened as a result of his sojourn in 1903–1904 to Munich, where he studied in the progressive Arts and Crafts School founded by Hermann Obrist and Wilhelm von Debschitz.[22] Obrist's attitude toward creative processes as expressed in various essays and in his seminars often stressed the vitality of early and so-called "primitive cultures," promoted the virtues of "unself-conscious," "natural" artistic activity, such as was evident in Samoan beam carvings, and he favorably compared the art of children with "primitive" and "prehistoric peoples," and in a manner that was reinforced by publications of this period such as Theodor

Koch-Grünberg's *Anfänge der Kunst im Urwald: Indianer-Handzeichnen auf seinen Reisen in Brasilien gesammelt* (which was in Kirchner's library). The latter was published in 1905, the same year as Brücke's formation, and the same year that Edvard Munch created his powerful woodcut *Primitive Man,* which was later visually associated with the Brücke in a monograph on the expressive German woodcut by Paul Westheim.[23] In many ways, Obrist's theories anticipated the ideas of Wassily Kandinsky and Franz Marc as expressed in the *Blaue Reiter Almanac* (1912), and there might well have been a direct link given that Kandinsky's art school, Phalanx, was directly across the street from Obrist's institution in Schwabing.

As Ettlinger has indicated, during the Brücke's student years there is every chance that they came across Karl Woermann's widely read and influential "universal history of art" titled *Geschichte der Kunst aller Zeiten und Völker,* which devoted almost ninety pages to the section "Die Kunst der Ur-, Natur- und Halbkulturvölker" ("The Art of Primordial, Primitive, and Half-civilized Peoples").[24] Woermann, the director of the Dresden Gemäldegalerie and the Kupferstichkabinett, was an evolutionist who saw the art of African or South Sea Islanders as "primitive" in more than one sense. Many of the artifacts Woermann discussed came from Dresden's own ethnographic collection, and one color plate depicted the Palau wood beams that would become such an inspiration to Kirchner and Erich Heckel. Ettlinger also revealed that it was highly likely that in the pre-Brücke period, Kirchner and Fritz Bleyl would have come across a relevant article in the English arts and crafts magazine *Studio,* given that (according to Bleyl) they were voracious readers of that publication.[25] An article by C. Praetorius stressed associations among different forms of "primitive," innocent, and untainted expression, notably the idea of a kinship between the artistic vision of children and the crafts-

people of "tribal" cultures. Interestingly, a woodcut by Heckel from 1911 titled *Standing Child* appears to conflate a number of sources that had been identified as "primitive" by Praetorius and others. The woodcut, deploying Munch's jigsaw technique, depicts the child model Fränzi standing in front of a semiabstract mural of green hills under a red sky, a mural that is also represented in Kirchner's *Negro Couple* (1911). With respect to its flatness, coloration, and splintered angular forms, it owes much to Heckel's encounter with the Palau wood beams in the Dresden ethnographic museum, yet Fränzi's facial features have morphed and been simplified into the form of an African tribal mask, possibly a Fang mask judging by the wide, convex forehead, and the eyebrows that form arcs with the nose. However, it is clearly not an image of innocence, as Fränzi's gaze and the way she clasps her upper thigh suggest an awakened sexuality.

Irrespective of any encounters that Kirchner may have had before or around the time of the Brücke's formation, Donald Gordon argued that there was "no evidence to indicate Kirchner's creative interest in non-Western sculptural sources before the year 1909."[26] He repeated this assertion in his MoMA essay of 1984 and added the comment: "Suggestions that Kirchner's interest in Primitive art began as early as the Fauves must be rejected,"[27] by which he was referring to Barr's much earlier comment given at the beginning of this chapter. Gordon's view has held firm among German, Swiss, and Anglo-American scholars of Expressionism. However, in 2008, on the occasion of an exhibition titled *Ernst Ludwig Kirchner und die Kunst Kameruns* that was staged at the Museum Rietberg in Zurich, and set alongside the larger exhibition *Kamerun: Kunst der Könige,* a curatorial observation was made that may have important implications.

In 1884 Cameroon was declared a German colonial territory at

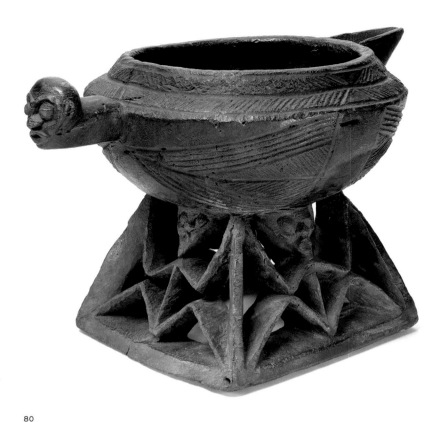

79

80

the Berlin Conference, and it remained so until the end of the colonial government in 1914. Between these years a large number of utilitarian objects, ceremonial carved figures, masks, and even thrones were accessioned to burgeoning ethnographic collections in major German cities such as Dresden and Berlin, where they would have been seen by the public as well as artists such as members of the Brücke. The highly expressive features of carved figures from Cameroon, more expressive and emotive perhaps than carved objects from other African regions, excited Kirchner in particular. In preparation for the two Cameroon exhibitions at the Museum Rietberg, Lorenz Homberger, the curator for African and Oceanic Art, informed Lucius Griesbach, the great Kirchner expert, that the embellishing forms that top and tail the primitivizing "Künstlergruppe" lettering of the woodcut title vignette of the Brücke manifesto of 1906, bore more than a passing resemblance to the supporting, crouching stick figures of a nineteenth-century decorative bowl from the Fungom region of Cameroon.[28] We know that Kirchner was fascinated by such caryatid objects and carved his own bowls and other utilitarian objects inspired by Cameroon exemplars from 1910 onward. Unfortunately, it cannot be proved where Kirchner might have seen this specific bowl or one like it. The one in question is currently in the Völkerkundemuseum of the University of Zurich, but its provenance history is unclear. Record-keeping in terms of the sale or exchange of objects between ethnographic museums or other parties before the Second World War was often rather informal by contemporary standards.

Accepting Homberger's observation and Grisebach's conviction that this analysis is correct, I would also suggest that the crouching motif of the bowl was actually carried over into the woodcut manifesto itself, for it forms, albeit in a slightly more abstracted manner, the illuminated carved letter "M" in the first line: "Mit dem Glauben an Entwicklung, an eine neue Generation der Schaffenden wie der Genießenden rufen wir alle Jugend zusammen" (With a belief in evolution, in a new generation of creators as well as appreciators, we call together all youth). Indeed, the lettering of all words in the Brücke manifesto was "primitivizing" from the illuminated "M" onward, to a degree not then seen until Karl Schmidt-Rottluff's woodcut lettering for the short-lived, utopian art journal *Kündung* (1920–1921). Zigzag forms (that could relate to both African and Oceanic carving) and *brut* lettering did characterize a great deal of their graphic output, especially in Brücke portfolios, annual reports, and exhibition catalogues. Peter Selz once suggested that Kirchner may have drawn inspiration for his manifesto from the Kelmscott Chaucer produced by William Morris's Kelm-

81

79 Ernst Ludwig Kirchner. *Program of the Künstlergruppe Brücke (Title vignette)*. 1906. Davos, Kirchner Museum Davos.

80 Workshop of the Fungom Region, Cameroon. *Bowl with figures (Schale mit Figuren)*. 19th century. Zurich, Völkerkundemuseum der Universität Zürich.

81 Ernst Ludwig Kirchner. *Program of the Künstlergruppe Brücke (manifesto text)*. 1906. New York, Museum of Modern Art.

scott Press.[29] However, on closer inspection this seems highly unlikely. While other Brücke insignia and letterheads do seem inspired by the Arts and Crafts movement generally, and perhaps the Wiener Werkstätte more specifically, the title vignette and manifesto suggest an alternative non-European source. It could be argued, in fact, that Kirchner was already starting to conflate his own take on a German and British Arts and Crafts aesthetic with carved objects from Africa and Oceania, unsurprising given what we know about his creative synthesizing approach to developing a vital antiacademic visual language. The importance of Homberger's observation, if correct, is that it demonstrates that a German avant-garde artist was creatively engaged with African sculptural sources independently of and contemporaneously with the French avant-garde from 1906 onward. And while French interest was very tentative in that year, more notable for the acquisition of key objects (particularly the Fang mask) than any creative response, Kirchner does seem to have engaged artistically with Cameroonian decorative forms, not just by scribbling in a sketchbook but in the very mission statement of the Brücke *Program,* rough cut into wood in 1906, thereby formally and materially emphasizing the antiacademic agenda of the manifesto content. It does have to be admitted, though, that there was then a hiatus of at least three years before Kirchner reengaged with African sources of inspiration.

Parallel Wood Cultures

In the first half of Kirchner's *Chronik der Brücke* (1913), a document whose self-aggrandizing tone and factual inaccuracies regarding the history of Brücke events were partially responsible for the dissolution of the group, the author, without ever being precise in terms of dates, discussed key occurrences from a pre-Brücke period up until 1907. He claimed: "From southern Germany Kirchner brought the woodcut, which he had revived under the inspiration of the old prints in Nürnberg. Heckel carved wooden figures. Kirchner enriched this technique with polychromy. . . . During this time, in Dresden, Kirchner continued to work in closed composition and in the ethnographic museum found a parallel to his own creation in African negro sculpture and in Oceanic beam carvings."[30]

While the dating of the woodcut Brücke *Program* is certain and would seem to corroborate his finding a "parallel" in African sculpture at this time, there is no evidence that Kirchner's own sculptural oeuvre in wood carving started before 1909/1910; it is therefore doubtful that he would have "enriched" Heckel's technique before this time. Heckel started producing wood sculptures approximately three years before Kirchner. The earliest known Brücke wood sculpture still extant, and a very rare example, is his

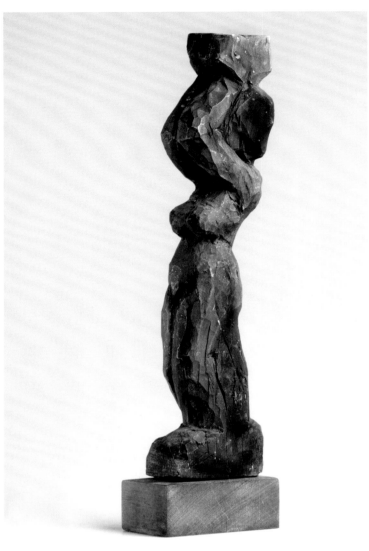

82

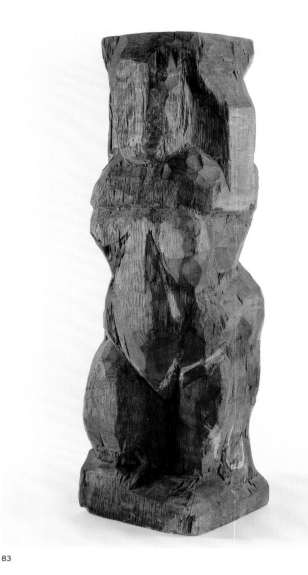

83

82 *Bearer* (1906). Until now, a certain mystery has surrounded this work as next to nothing is known about the circumstances of its creation. It is a painted alder wood caryatid figure that seems to refer to various and seemingly incongruous sculptural traditions and yoke them together. Wolfgang Henze has referred to the sculpture as representing a "symbiosis of barbaric strength and sensitive tenderness."[31] There is something "Gothic" about the attenuated verticality of the figure, and alder was a wood often used for carving in the Middle Ages. Furthermore, it is known that during the life span of the Brücke, Heckel created other wood sculptures that seem to have their models in Gothic sculpture.[32] Yet there is voluptuousness about the torso that is suggestive of the caryatid figures that form ceremonial stools or bowls in West and Central Africa, of which he might have seen an example firsthand at the ethnographic museum in Dresden or reproduced in a publication by a popular ethnographer such as Leo Frobenius. However, in an un-

published letter of 1958 that has only recently come to light, Heckel gave a strong hint of the source of inspiration. He wrote:

Around 1906, as painters of the Brücke, we discovered in the Ethnographic Museum of the Zwinger in Dresden many ethnographic figurative objects and the carved beams from the South Seas. I cannot remember whether African art was also represented with significant pieces. . . . For me, the first impression that corresponded with my own sculptural imagination was an Egyptian wooden sculpture that I saw in the Albertinum in Dresden about 1906. Here, carved out of the full trunk by using simple means was a figure full of sensuality and yet formally bound, not naturalistic but mysteriously worked out, in the same manner as South Sea and African sculpture, which seems to only increase the power of expression through changing proportions.[33]

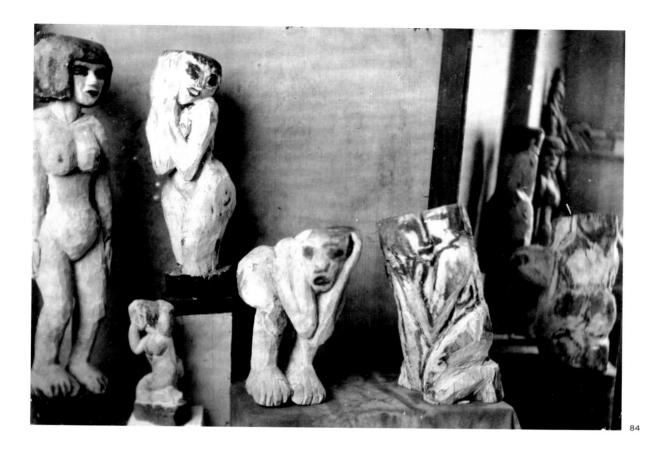

84

82 Erich Heckel. *Bearer* (Trägerin). 1906. Hamburg, Museum für Kunst und Gewerbe.

84 Ernst Ludwig Kirchner (?). Five wood sculptures by Erich Heckel. Ca. 1911. Hemmenhofen, Nachlaß Erich Heckel.

83 Pablo Picasso. *Caryatid*. 1907. Paris, Musée Picasso.

There is a hieratic stiffness about Heckel's sculpture, accentuated by the raised elbow gesture that partially covers the face, a figurative sculpture with a marked tendency toward abstraction, which does indeed suggest Egyptian wood carving as the primary source. The sculpture is far from an ethnographic copy though, and the very notion of copying was antithetical to Brücke's artistic creed. Creative conflation seems a more appropriate description, and in many respects Heckel's sculpture visually encapsulated what Wilhelm Worringer was working out theoretically at the Paris Trocadéro and elsewhere for his soon-to-be published thesis "Abstraktion und Einfühlung" (Abstraction and empathy; 1907); namely, that a tectonic, non-naturalistic urge to abstraction is what links ancient Egyptian, Byzantine, Gothic, and "primitive" art, formally and psychologically distinct from the empathic art (mimesis) of classical Greece, Rome, and also the Renaissance. Worringer privileged abstraction over empathy and effectively valorized the exploration of "primitive art" in a way that was meaningful especially

for Einstein's later *Negerplastik* (1915). "Abstraktion und Einfühlung" and his other publications, including *Lukas Cranach* (1908), *Formprobleme der Gotik* (1912), and *Die altdeutsche Buchillustration* (1912), would also have a tremendous influence on other avant-garde writers and artists, including members of the Brücke and the Blaue Reiter.

Most of Heckel's early sculptures are now missing, although photographs and correspondence reveal that his first wood sculptures were produced between 1906 and 1907,[34] a little less than a year before Picasso in Paris. There is one Picasso wood sculpture created in 1907 that does have an "expressionistic" quality, although there is hardly any possibility that he would have been aware of Heckel's wood carving or vice versa at this juncture. Picasso's sculpture is titled *Caryatid*, and Rubin confirmed that the source was "obviously African rather than classical," and possibly an Ivory Coast drum-support figure.[35] Picasso's *Caryatid* was axe-hewn, roughly executed, and only partially carved, but not

83

without an appealing *brut* quality. In this respect it bears some resemblance to an unfinished figurative wood sculpture of Heckel, clearly evident in a rare photograph of his studio space that shows

84 a cluster of nude figures, albeit Heckel's figures are more animated than Picasso's. They have the appearance of having emerged organically from a tree trunk, a form of what I have described as "Arboreal Expressionism."[36]

Picasso's wood carvings of 1907 have been discussed as a sign of his earlier engagement with African sculpture, but very few of them still exist, and two out of the three relate more closely to Iberian than African sources. Picasso was much more interested in sculptural ideas, as expressed particularly through drawing, than in sculptural practice. To illustrate this point, William Rubin discussed Picasso's second portrait of André Salmon (1907–1908)—a pen-and-ink portrait which goes through a series of preparatory sketch transformations from the caricatural to the "tribal"—citing Adam Gopnik's line that Salmon was the "imperturbable evangelist of primitivism." However, this project for a sculpture in wood was never realized.[37] Rubin argued that Picasso disliked "the effort that went into carving or otherwise realizing his ideas three dimensionally. Execution was an annoying and time-consuming matter that would eventually be largely left to others. By the standards of a Brancusi, Picasso was lazy—and little concerned with the nature of sculptural materials."[38] Picasso was much more successful in translating the sculptural ideas of African carving captured in his sketches into the medium of oil on canvas, as his earthy paintings of 1907–1908, such as *Nude with Raised Arms, Three Figures Under a Tree,* and *Dryad (Nude in the*

85 *Forest)* demonstrate. Picasso's paintings along with African sculpture would later be exhibited in Berlin (1913) and Dresden (1914) at the Neue Galerie and at the Kunstsalon E. Richter, respec-

tively, the latter also being the venue of two Brücke exhibitions in 1908/1909.

In his attitude toward carving, Picasso was quite different from the Brücke artists, who wholeheartedly adopted and adapted the tool processes and organic expressivity of direct carving in their woodcuts and wood sculptures, working with or against the resistance of the material. This practice was a means of conveying their group cultural identity, demonstrating a kinship to both an indigenous carving tradition going back to and before Tilman Riemenschneider and the limewood sculptors of the German Renaissance, and to the direct carving craft cultures of Africa and Oceania, which the Brücke understood as a form of instinctual *Urmensch* expression that accorded with their own artistic objectives. With respect to exploring some of the key differences between the German and French avant-garde in terms of "primitivizing" tendencies, choice of artistic material seems highly significant. These differences are revealed by the reluctance of Derain and Matisse to pursue what was pejoratively understood in academic terms as a "primitive" or at best "vernacular" material and technique. Despite drawing inspiration from Paul Gauguin's wood carving for his own decorated furniture, especially after the Gauguin exhibition at the Salon d'Automne in 1906, Derain carried out many of his carvings in the more resistant medium of stone. Flam has observed that Derain's "choice of stone was a conservative one, since for several millennia stone had been the preferred medium of European sculpture."[39] The Fauves did produce woodcuts, although Matisse would soon abandon this process and later use what Emil Nolde once referred to as the artificial "deadening" material of linoleum.[40] However, they were far more reticent about moving into the three dimensions of wood sculpture than were the Brücke. In his theoretical writings, the former Brücke artist Kirchner argued in favor

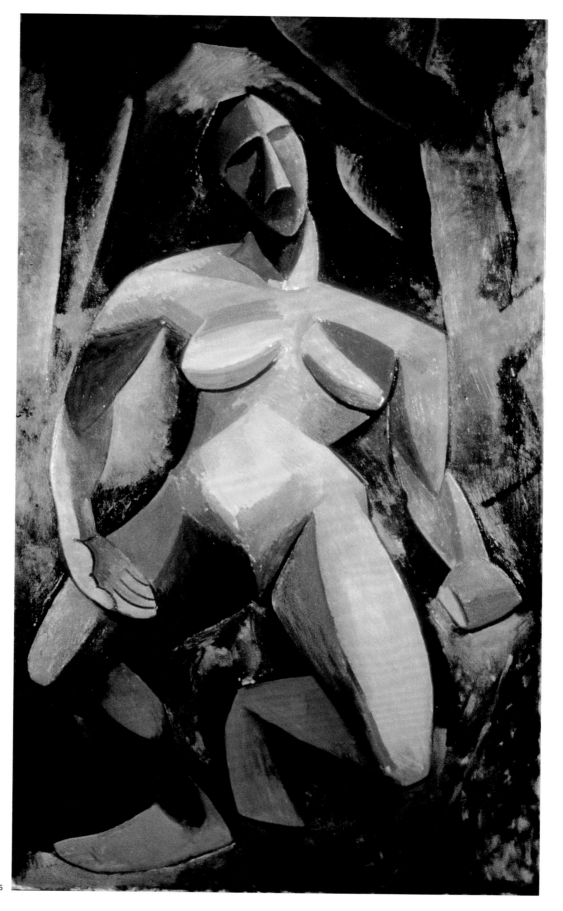

85

of direct carving as opposed to plaster or bronze casting, which lacked expressive organic immediacy.[41] Matisse, though he may have admired the "invented planes and proportions" of African wood carving, did not explore this organic material in his own work, preferring the additive rather than subtractive process of clay modeling to direct wood carving. Matisse's models were then sand cast to create bronze sculpture, which of course along with marble sculpture was and still is considered to be a "high-art" medium, unlike the "poor" and readily available material of wood, thought of at the time in European art academies as a material of "low craft."

In Germany, especially after 1905, wood was deliberately used and celebrated by Expressionist artists and key figures of the Arts and Crafts movement as a means of challenging both academic hierarchies and the dehumanizing drive of industrialization in Wilhelmine society. Use of this "primitive" arboreal material also transported ideas about tracing the primal roots of cultural ancestral memory. The excursions of the Brücke and Blaue Reiter artists to remote villages on the Baltic coast or in Bavaria in search of authenticity of expression was therefore a desire for "organic" community *(Gemeinschaft)*, something they felt was lost in the societal atomization *(Gesellschaft)* of the metropolis. The German noun *Stamm* has multiple meanings, including "root," "trunk," and "tribe," all of which are relevant when considering the semantic implications of the act of wood carving. Clearly, the incessant Expressionist search for *Urnatur* led to an engagement with both "domestic primitivism" (an exploration of indigenous peasant life and craft) and an "exotic primitivism" (a professed admiration for non-European tribal societies that had not lost a feeling for the soil of their own culture). Donald E. Gordon has related how Heckel

hoped to travel to Africa, like his brother Manfred, to inhabit "primordial nature."[42]

Through Expressionist art and theory (and especially Worringer's writings), an aesthetic synthesis or an alliance of sorts appears to have been forged among the new German art, the vernacular *völkisch* woodcraft of peasant communities, the wood carving of Dürer and Riemenschneider, the emergence of the modern woodcut evinced by Edvard Munch and Paul Gauguin, and the tribal and court arts of Africa, Asia, and Oceania, in a romanticizing celebration of the creative craftsmanship of pre- and nonindustrial societies. The practice of carving wood, the means by which both Cameroon tribesmen and Palau islanders would visually define the life and mythologies of their communities, and a form of folk expression in central and eastern Europe, helped Expressionist groups such as the Brücke to create a cohesive aesthetic that conveyed their identity as a *Künstlergemeinschaft* ("artist community"). Kirchner was therefore willing to acknowledge some parallelism with the unknown wood-carvers of Africa and Oceania and to associate himself and the Brücke with German canonical art in his *Chronik* while vigorously disclaiming the possibility that his or the Brücke's work was influenced by contemporary artists or movements.

This "primitivism" might also be related to the myth of origins in the *Germania* (A.D. 98) of Tacitus, which led to a long-standing fascination with the subject of the "wild man" or "savage" in the forest. The etymological origin of *savage* derives from the attributes bestowed upon the Germanic tribesman by the Roman colonizers: *silvaticus*—of the woods—defined a violent barbarian who dwelt outside the perimeters of Roman civilization living off the land. But in Expressionist theory, in defiance of the Vasarian tradition of damning art "north of the Alps," the term "barbarian" (fol-

lowing Gauguin's example) was given a positive value and was a badge of honor. "Barbarian" was therefore an expression that would become celebrated by the German avant-garde in reference to both indigenous and exotic forms of "primitivism," something conveyed principally through the primitive material of wood, and the ideas of Germanic and African tribesmen of ancient forests, the former being mythic, the latter real. When considering Schmidt-Rottluff's use of wood carving in an early publication on the artist, Wilhelm Valentiner eulogized about the German feeling for this organic material (a *Holzgefühl*): "It is as if the structure of the rough trunk, with its knotty, misshapen form that nevertheless submits to the passionate carving knife, was especially suited to the half-barbaric, half-sentimental, self-sacrificing German character."[43] The Hamburg museum director Max Sauerlandt suggested that it was Brücke's "barbarian" carving method of nonconcealment, in which work processes were revealed rather than effaced, that was unique. He argued: "Every blow of the axe and every cut of the knife remains directly, sensually perceptible, touchable to the eye."[44] And it is true that while Brücke's figurative wood sculpture was crudely polychromatic, using color to accentuate sexual parts of the body, the organic quality of the surface was never camouflaged and only rarely polished. Beyond the accenting of erogenous zones through color, the crude crafting of woodblocks stood, as Colin Rhodes has pointed out, "as a metaphor for the 'naturalness' of the sexual act."[45]

In Gordon's article "Kirchner in Dresden," written in 1966 and still an essential reference point for considering Brücke's formative influences, the author rightly identified the Galerie Arnold's Gauguin exhibition (1910) as a catalyst for Kirchner's heightened artistic responses to a range of sources from Africa, Asia, and Oceania:

Before the Gauguin exhibition, the primitive works in the Dresden Ethnographical Museum were objects of aesthetic appreciation, curiosities whose "otherness" was provocative in suggesting decor for studio appointments and stylizations for a drawing shorthand. After the Gauguin exhibition, non-Western sources became for Kirchner the essential raw material for the ultimate attainment of personal style.[46]

The Gauguin retrospective of twenty-six paintings at the Galerie Arnold, shown simultaneously with a Brücke exhibition, was the first to take place in Dresden although it was not the first in eastern Germany. Gordon does not mention the Gauguin retrospective with a checklist of thirty-six works that opened in Weimar in July 1905, just a month after the formation of the Brücke in Dresden, though it is not known whether any of the Brücke artists saw this show.[47] Aside from being attracted to Gauguin's primitivizing canvases, his mythologizing of himself as the artist "barbarian" in the *Noa Noa* diary (translated and published in *Kunst und Künstler* and in book form by Bruno and Paul Cassirer in 1908), and later being drawn to follow in his wake to the South Seas, one key factor that must have attracted the Brücke artists was Gauguin's "arboreal primitivism." In a *Burlington Magazine* article of 1920, titled "Negro Art," André Salmon connected the "rustic" with the "savage": "When Gauguin, tired of Brittany left for Tahiti, he had already carved out of the wood of the forests of Finistère some of the rude but expressive figures which rank among the best of his work."[48] He then contrasted the "undisciplined," primitivizing art of the symbolist artist with "our" (meaning the Cubists) more "constructive values." In pursuing both a domestic and an exotic "primitivism" through the *arte povera* material of wood, Gauguin can be closely

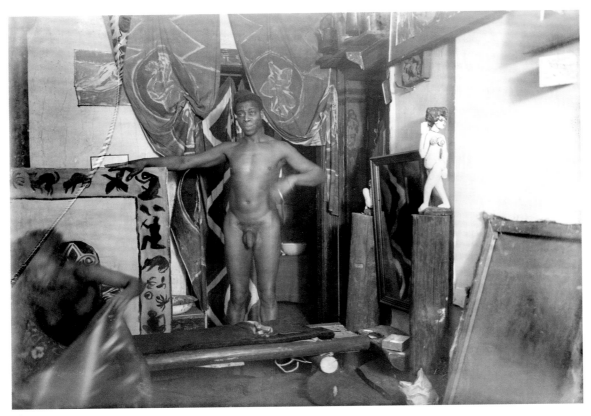

86

identified with Brücke's own wood-carving practices at "home" and "abroad." Carl Zigrosser argued in 1957 that Gauguin's experimentation in woodcutting "opened up new vistas," and was the direct result of his need to embody his "inner vision of Tahitian paradise."[49] The strong parallels between Gauguin's appreciation of wood as a vital, expressive material and Brücke's own rough-cut, "primitive" carving and printmaking must not be overlooked. It is another element that marks Gauguin as more significant for the Brücke than Matisse or Picasso. Kirchner's powerful dedicatory, one could say memorial, woodcut poster marking the Gauguin retrospective at the Galerie Arnold exhibition (1910) testifies to that significance. The fact that Gauguin had Iberian ancestry, married a Dane, and abandoned what he saw as the false civilization of Paris and Parisian art circles would only have made him more appealing to Kirchner, who, unlike Pechstein, was not particularly Francophile.

Flesh-and-Blood Models

The ethnographic museum was not the only place where the Expressionists encountered African culture. Elaborate reconstructions of model villages, often populated by natives shipped from Africa and other parts of the world for the instruction of the West-

ern public, formed part of world fairs. Circuses and zoos frequently featured exotic tribal acts and displays for their entertainment value. This trend can be traced back to Carl Hagenbeck, a German merchant of wild animals who supplied many European zoos, but who from the 1870s onward also exhibited human beings considered as "savages" in a "natural state" for his "Völkerschauen," elements of which became an essential part of the 1889 Paris World Exhibition. The ethnographic zoos that developed in the wake of Hagenbeck's insidious colonialist practice were often predicated on social Darwinism, unilinealism, and scientific racism, whereby indigenous peoples, particularly those of African descent, were placed on a scale between the great apes and humans of European extraction. From Paris to Berlin and beyond, these zoos were commonplace in European capitals by the early twentieth century, although the "nobility" of colonized indigenous communities was now often stressed in line with a burgeoning and mostly amateur interest in ethnography and ethnographic photography. The Brücke artists visited Dresden Zoo, which was particularly famous for its elaborate re-creations of Indian, Sudanese, African, and Samoan village life in the years before 1911, when they all moved to Berlin. Here, another key difference from Picasso and his circle in Paris should be stressed. While avant-garde artists based in the French metropolis had access to this superficial ethnological tour-

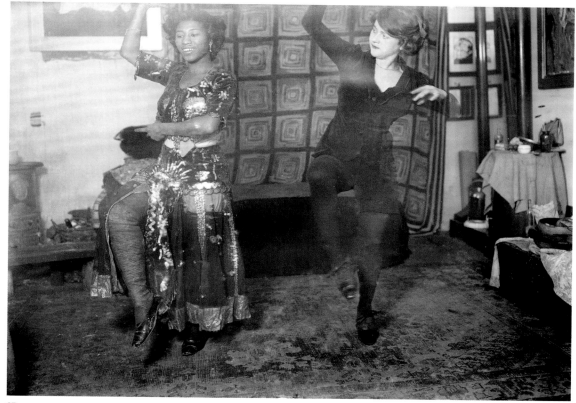

87

87 Ernst Ludwig Kirchner. *Nelly and Sidi Heckel (Riha) dancing in Erich Heckel's atelier, Dresden.* Ca. 1910/1911. Davos, Kirchner Museum Davos.

ism, their response to "flesh-and-blood" models rather than the tribal artifacts of masks and carved figures was limited. It is true that Matisse's travels to Algeria in 1906 and Morocco in 1912 and 1913 inspired a number of odalisque paintings, but his artistic response to these North African excursions was far from immediate, as most of these canvases were created only much later, in the 1920s, and were mainly of young European models in exotic attire. In works such as *Lucie and Her Dance Partner* (1911), Paris-based Brücke member and Fauvist Kees van Dongen did directly respond to Africans, not from the *Völkerschauen,* but from the cabarets and variety shows.[50]

It could well be that Picasso and others found ethnographic zoos to be distasteful, but his formalist response to material "tribal" objects led Robert Goldwater to refer to his (and therefore Cubist) practice as veering more toward "intellectual primitivism" than the "emotional primitivism" he aligned more closely with Expressionism.[51] However, Picasso's engagement with African art was more than just a formalist exercise as his impassioned 1937 interview with André Malraux revealed.[52] Postcolonial and feminist theory subsequently criticized Kirchner's direct artistic response to black models as sexually and racially "objectifying," especially as his models were occasionally juxtaposed with primitivizing wood sculpture, murals, batiks, and other textiles inspired by African,

Asian, and Oceanic sources, all markers of exoticizing studio spaces. On 31 March 1910, Kirchner wrote enthusiastically to Heckel, in a letter adorned by a lively sketch of a standing figure after a Congolese carving, that the "Samoans" and "negroes" were to be on display again in the zoological gardens that summer. In the same letter he commented with equal enthusiasm on the reopening of the ethnographical museum featuring "negro sculptures," and in so doing the artist conceptually slipped from people to objects.[53] It is a letter that exposes Kirchner's appetite for seeking out the exotic both in life and in artifacts. It is not clear that he prioritized or distinguished one rather than the other, hence the criticism. However, photographs taken by Kirchner of Heckel's studio at this time tell a slightly different story of the Brücke's relationship to their black models. Photographs of Heckel's partner, the dancer Sidi Riha, performing with Nelly are particularly joyful and relaxed, and show Sidi trying to imitate Nelly's moves in an image that speaks of friendship and equality rather than objectification.

86

87

During this Dresden period, after visiting the *Völkerschauen* Kirchner created two paintings titled *Negro Dancer (Die Negertänzerin)* of 1909/1910, although it is difficult to say with certainty whether these relate to Carl Marquardt's African village reconstruction of 1910 or his Sudanese village display of the previous spring. A postcard photograph from 1909 shows Sudanese women

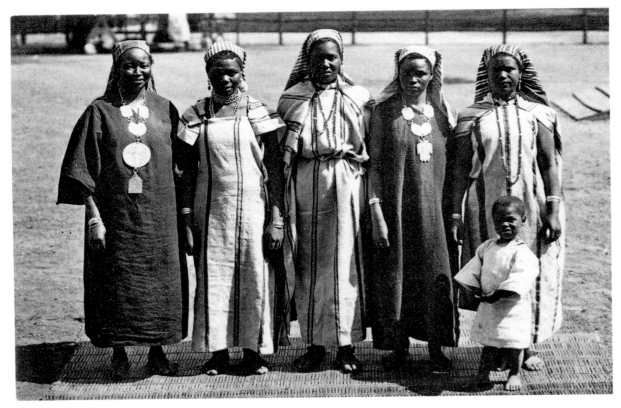

88

88 wearing the same type of head scarves as those worn by Kirchner's exotic dancers in the two paintings. It is possible that Kirchner saw the earlier show, although three of the women shown on the postcard of 1909 also appear on a promotional postcard of 1910. To make matters more confusing, Kirchner later antedated both paintings to 1905, a highly dubious practice (often combined with overpainting). This is a process he also undertook from the 1920s with his sculpture and graphic work for two reasons: first, it seems, to appear more pioneering in terms of his treatment of form and subject than his former Brücke colleagues (particularly Pechstein) and, second, to rebut claims of Fauvist influence and to outshine Matisse and others associated with the Parisian avant-garde. Another complexity of these works is that it is unclear whether Kirchner was responding to a real performance or whether he was concocting some Gauguinesque fantasy. The clothed performer of the *Negro Dancer* does appear as if she might have been painted in

89 response to a direct experience. However, the *Negro Dancer* in the Würth Collection could well be a product of Kirchner's fer-

90 tile imagination rather than a response to any performance he saw. In this painting, the dancer is depicted naked but for a chain around her waist, bangles on her arms, and her striped headdress. She gazes out seductively at the beholder, arching her dark-skinned body into an S-shape. The sexual charge of her dance performance is heightened by the representation of her female partner in a yellow dress that has slipped to expose her right breast and who, with her head tilted back, appears to be in a trance-like state brought about by the drummers sitting on the floor behind her.

Kirchner's images conform to a stereotype prevalent in this period and evident in other Brücke images of ecstatic dancers, particularly by Pechstein and Nolde, in which ethnic peoples from Africa and other non-European cultures were far less abashed and inhibited about tapping into their primal instincts and erotic energy and were far more in harmony with the natural world. In the case of the Brücke artists, this idea related to their Nietzschean understanding that the stultified refinements of European society had meant a loss of instinctual and vital Dionysian forces, a sentiment that earlier informed Gauguin's decision to travel to the South Seas, a move later followed by Pechstein and Nolde. African and Oceanic cultures were thereby romanticized as more authentic and uncorrupted. Dance scenes were often rendered in woodcut and wood carving as well as in paintings as the Brücke artists decided that a primitive medium was required for a "primitive" subject; the rough gouges and tactile forms expressed through organic material were seen as ways of heightening the ecstatic charge. With the loss of its colonies and the rise of other forms of entertainment in Weimar Germany and elsewhere in the 1920s, the *Völkerschauen* gradually disappeared from the European scene altogether, sup-

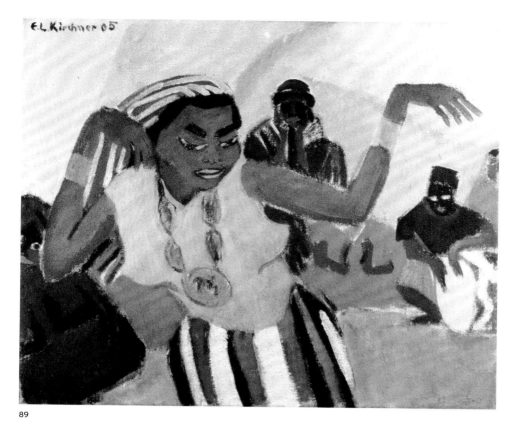

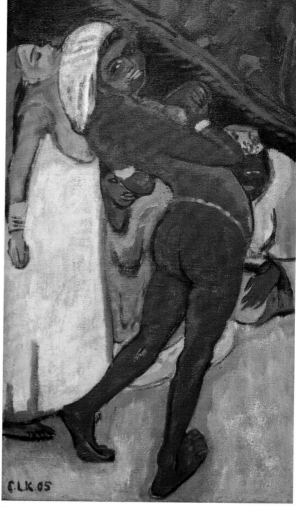

89 Ernst Ludwig Kirchner. *Negro Dancer* (Negertänzerin). 1909/1910. Bern, collection of Eberhard W. Kornfeld

90 Ernst Ludwig Kirchner. *Negro Dancer* (Negertänzerin). 1909/1910. Erstein, Musée Würth.

90

planted by the cabaret and theatrical performances of dancers such as Mary Wigman and Josephine Baker.

Sam, Milly, and Nelly

Heckel and Kirchner recruited their three famous black models—Sam, Milly, and Nelly—not from the *Völkerschauen* but from the Zirkus Schumann that toured Dresden in 1909 and 1910, in which they were worked as artistes. Documentation remains lacking however, and in considering Brücke art of this period there is some blurring of the distinction between "circus" and *Völkerschauen* in any case. Given that they were such important models for the Brücke, it is perhaps surprising that so little is known about them, although the same is true for Brücke's pubescent European models, Fränzi and Marzella, who are also usually referred to only by their first names. The use of child and "African" models corresponded to

Brücke's understanding of the uncorrupted, "primitive" type, informed by their reading of Praetorius and others, although Kirchner's artworks would also conjure up the stereotype of the voracious, black sexualized body. We do not know whether Sam, Milly, and Nelly were truly natives of Africa, African Americans, or even other multiracial citizens of the various European colonies. In all those cases, they would still have been classified as *schwarz* and as "primitive" generally, and while the names do have a definite American sound to them, they may be stage names.[54]

One lead to the origin of their "assumed" names would be the publications of Harriet Beecher Stowe, namely, *Uncle Tom's Cabin* (serialized in 1851 and published in book form in 1852) and the follow-up, *Dred: A Tale of the Great Dismal Swamp* (1856), both controversial abolitionist publications of their day. In the former, a "Sam" (or Sambo) appears as a carefree slave character. In the latter, a "Milly" embodies the loyalty of slaves and the femininity and

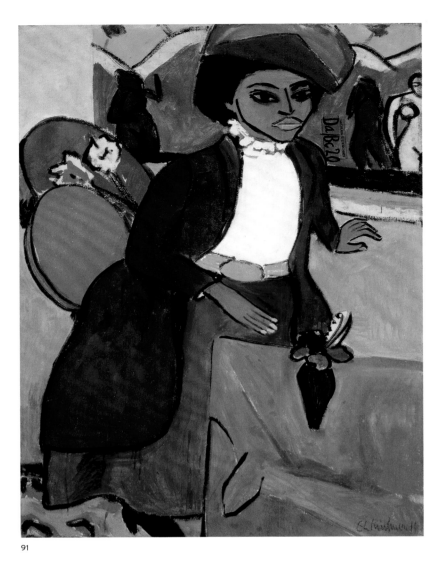

91

91 Ernst Ludwig Kirchner. *Portrait of a Woman* (Frauenbildnis). 1911. Buffalo, Albright Knox Art Gallery.

92 Ernst Ludwig Kirchner. *Milly Sleeping* (Milly schlafend). 1910–1911. Bremen, Kunsthalle.

grace of women. One of the first translations into German of *Uncle Tom's Cabin* as *Onkel Toms Hütte* was serialized in *Der Beobachter am Ohio* in 1853 by Louis Dembitz, and later book editions became incredibly popular in German-speaking parts of the U.S. Midwest and in Germany itself. As early as 1905, Heckel had created a woodcut titled *Negro (Sambo),* and it is likely that this was a response to *Onkel Toms Hütte,* given that many of Heckel's early woodcuts were responses to literary sources. A "Nelly" does not appear in either of Beecher Stowe's aforementioned publications, although she did have a character named "Nelly" in *We and Our Neighbours* (a society novel rather than an antislavery novel). Another more likely source for this "stage name," however, would be Stephen Foster's popular song "Nelly Was a Lady" (1849), made famous by the Christy Minstrels; it was written from a slave's perspective and the first known to insist on an African American woman as a "lady." The title "Nelly Was a Lady" could well be applied to a painting by Kirchner simply titled *Portrait of a Woman*

(1911), which depicts either Nelly or Milly (the identity is not certain) stylishly attired in modern Western clothing. The model sits in an ambiguous Fauvist-type setting, possibly a studio space, including a blue cloth, vase, and flowers, and a red chair. Behind her is a mural-like backdrop with nude figures in a landscape reminiscent of the work of Matisse. It is not clear whether Kirchner was attempting to subvert or accentuate through contrast the notion of "primitive" by having his black model attired in this manner. In some respects, it seems like a companion painting to *Milly Sleeping* (1910–1911), in which Kirchner releases the "primitive" body from its unnatural clothed state. Moreover, *Milly Sleeping* can be considered a response to the tradition of the reclining nude, a tradition initiated by the Venetian painter Giorgione, whose *Dresden Venus* of 1510 Kirchner would have known from the old master collection of his home city. It is a tradition that encompasses works by Titian, Rubens, Goya, Manet, and more pertinently for Kirchner, paintings by Cranach (*River Nymph at the Fountain,* 1518),

91

92

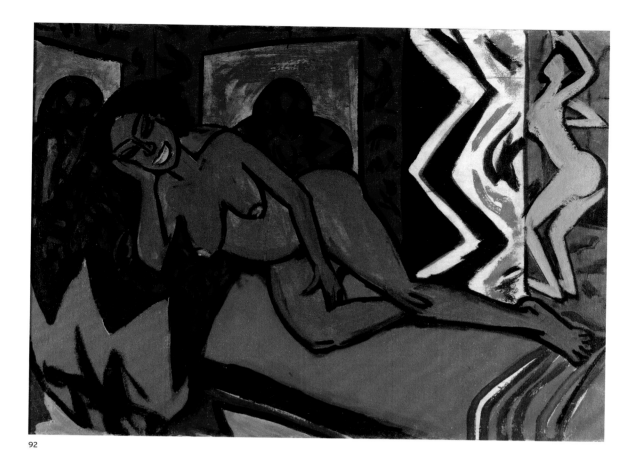

92

Gauguin (*Nevermore,* 1897), and Matisse (*Blue Nude—Souvenir of Biskra,* 1907).

The primitivizing paintings of Matisse and Gauguin would have been at the forefront of Kirchner's mind given his experience of the former at the Berlin Secession in 1909 (which included the *Biskra* painting), and his high regard for the latter, whose work had already been shown a few times in Dresden, including at the Galerie Arnold show in 1910, hosted by the same gallery and at the same time as a large Brücke exhibition. The Cranach connection may be most revealing through Kirchner's Worringer-inspired sense of the "Gothic" as akin to the "primitive." Reinhold Heller has vividly described *Milly Sleeping* in terms of a transformation of a "nymph reclining on red drapery in a Saxon landscape into a Baudelairean 'Black Venus' who is translated from her imagined 'natural' African or Oceanic surround into the Brücke studio in Dresden where alone she can again find repose."[55] It is clear that Kirchner enjoyed visually quoting and transforming paintings from Cranach's oeuvre, so that his own living models stood in for and made contemporary the heathen goddesses of the Wittenberg master. This is also what relates *Milly Sleeping* to another famous painting of Kirchner's Dresden period, *Standing Nude with a Hat* (1910), effectively a contemporary portrait of the unabashed sexuality of his

girlfriend Dodo, which paraphrased Cranach's standing nudes of Venus, but set Dodo against a backdrop of tribal zigzag forms.

In *Milly Sleeping,* Kirchner emphasized the sexuality of his model through the contrast of her pink lips and nipples against her dark skin, her left arm that extends down to touch her thigh in a gesture that only partially covers her pubic hair, and her elbow signaling her prominent buttocks that are mirrored by the background pose of a nude white female, who could be represented as a painting within this painting or live in the studio. The dominant positioning of black to white female here also subverts the racial power relations of Manet's *Olympia,* something of which Kirchner might well have been conscious. Rhodes has discussed Kirchner's use of "visual signs" that imply the "hypersexuality" of Brücke's black models in accordance with popular racial theory at this time.[56] In the painting *Negro Couple,* as has been pointed out in various publications on the Brücke, Kirchner deliberately exaggerated the length of Sam's penis (in the same way that he enlarged the already exaggerated sexual organs of figures represented on the Palau beams in his sketches). He also again stressed Milly's large buttocks that constitute a modified steatopygia, considered typical of black physiognomy, especially after the parading of Sarah "Saartjie" Baartman (the "Hottentot Venus") and other Khoikhoi

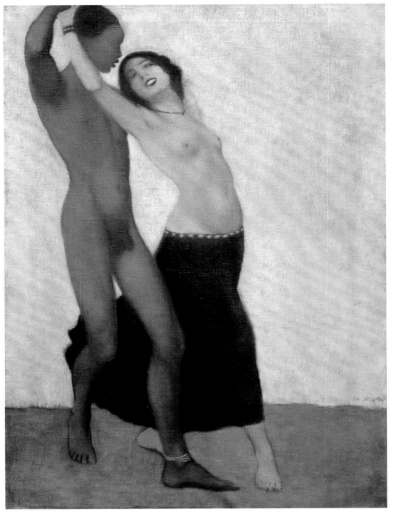

93

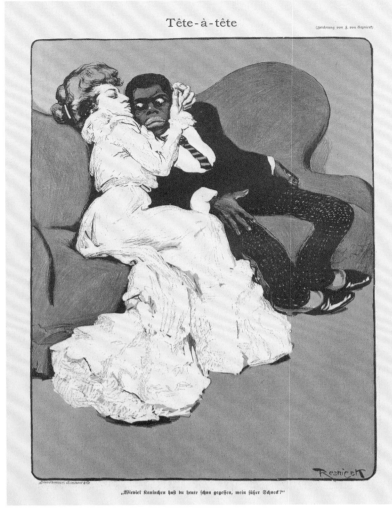

Tête-à-tête

„Wieviel Kaninchen haſt du heute ſchon gegeſſen, mein ſüßer Schneck?"

94

women who were exhibited and heavily publicized as freak-show attractions in nineteenth-century Europe. Furthermore, German curiosity about Khoikhoi women heightened after 1884, when the Germans colonized what is now Namibia.[57] There is no evidence that Milly was from this region of Africa, but this characteristic of the Khoikhoi was carried over into Kirchner's representations of Milly and Nelly. This body shape also relates to Kirchner's fascination with the famous Paleolithic "Venus of Willendorf," sometimes referred to as the "steatopygian Venus," excavated in Austria in 1908 and represented by Kirchner in a sketch of 1910. There is a sense in which the "prehistoric" also becomes assimilated into Kirchner's notion of "primitive" in his quest for anticlassical, pre-industrial, primal roots.

Heller has argued that Pechstein's interest in African models during this Dresden period was of a different order from the utopianism of Heckel and Kirchner, and was emotionally rather more detached.[58] Heller considers Pechstein's *Somali Dance* (1910) to

be a relatively static print, a curious observation of a staged scene that somewhat distances viewer engagement, unlike the imaginative transformation of pictorial spaces in Kirchner's work. This distance also applies to Pechstein's painting of *Nelly* (1910; San Francisco Museum of Modern Art), a head portrait that reveals in its use of color and application of paint his keen interest in the Fauvist work of Matisse and van Dongen, the latter of course also being a member of the Brücke. But Pechstein could be accused of racial stereotyping in this work in that he enlarges and rouges Nelly's lips that contrast with the whiteness of her teeth in the manner of "blackface" makeup.

Otto Mueller also depicted black models, and his *Artist Couple* (1910), rendered in distemper on burlap, relates to the year in which he joined the Brücke artists and became close friends with Kirchner in particular. It has been said that this work is a double portrait of Sam and Milly or Sam and Nelly.[59] This seems probable, although once again the identities are unclear. In this curious

93 Otto Mueller. *Negro with a Dancer* (Neger und Tänzerin). 1903. Private collection.

94 Ferdinand von Řezníček. *Tête-à-tête*. Illustration in *Simplicissimus* 5, no. 35 (1900): 280.

painting, the naked female model tightly and intimately embraces her darker-skinned male companion, who looks directly and almost defiantly at the viewer. The black male would also be naked if not for a flimsy, small loincloth, a garment that would have been viewed as a marker of a "primitive" person. There are no studio background details and the focus is on the bodies of the performers. This was not the first or last time that Mueller took on such subject matter. In 1903, some seven years before he joined the Brücke, he painted *Negro with a Dancer,* which is closer in spirit and style to the fin-de-siècle eroticism of artists like Hans Makart and Franz von Stuck than any Brücke canvas. It was a daring, interracial subject painted at a time when close physical contact between black men and white women was very much a societal taboo, and the possibility of such contact was sent up in satirical art magazines such as *Simplicissimus.* For instance, in the 1900 issue (vol. 5, no. 35) of the high-circulation Munich publication, a cartoon by Ferdinand von Řezníček titled *Tête-à-tête*—an image later turned into a popular postcard—the artist broke with the convention of representing the African male as a sexual predator, and instead the well-dressed male figure with stereotyped wide eyes and thick lips becomes the reluctant recipient of white female desire. This was created at a time when "mixed marriages" were forbidden in the German colonies and interracial relationships within Germany were considered to be rape. "Officially" such love affairs were not feasible. Mueller's work by contrast depicts a naked and youthful black male with a half-naked female dancer, who adopts an arching seductress pose reminiscent of another of Mueller's paintings from that year, *Dancer with a Veil,* based on a stage performance of Oscar Wilde's *Salome.* Mueller would return to the theme of black sexuality and sensuality in his *Two Negro Girls* of 1928, in which he set his female models against an abstract backdrop of an

exotic batik. More generally, he occasionally seems to Africanize the facial features of his Gypsy girls, so that they look more "black" than some of the lighter-skinned Romany types that he represented.

While provocative, Mueller's paintings were not as daring as those of Paula Modersohn-Becker, who, though she was a native of Dresden, was never a member of the Brücke, even though her work expressed certain stylistic similarities to theirs and their paintings were exhibited together with hers at the Kunsthalle Bern in 1948.[60] Her *Kneeling Mother and Child* (1906/1907) depicts a naked, black, breast-feeding mother and her white, blond-haired, suckling infant. This work was heavily influenced by Gauguin's primitivizing Tahitian paintings that she saw at the Paris memorial exhibition in 1906, an exhibition that also influenced the likes of Picasso and Derain. Unlike Gauguin's exotic females who also become symbols of fertility, Modersohn-Becker's nude is not an erotic object of male desire, but solely a life-giver or nurturer, although the lack of sexual connotation would not have made this work any less provocative for a German middle-class gallerygoer. It was only after Modersohn-Becker's death in 1907 that her work became known to wider audiences when the first exhibition of her work was held in Bremen in 1913. She was later condemned as a transgressive, "degenerate artist" by the National Socialists.

Exotic Studio Spaces

From 1909 to 1910 onward, during their last years in Dresden and up until the dissolution of the group in Berlin in 1913, the Brücke became more creatively engaged with ethnographic objects, particularly those from Cameroon. The reopening of the ethnographic museum in the Saxon capital early in 1910, which included

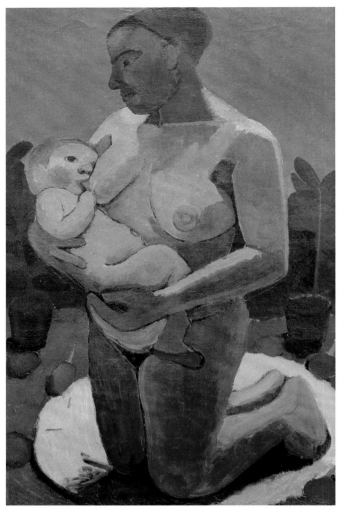

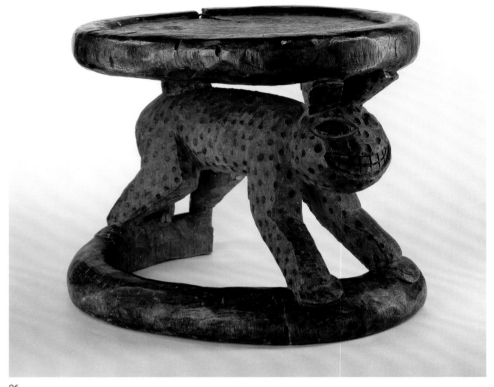

95

96

a greater number of objects from Cameroon, was a contributing factor. Another may have been Heckel's older brother Manfred, who was working as an engineer in German East Africa and who visited his brother and the other Brücke artists in Dresden in the summer of 1910. He brought with him African artifacts ranging from stools to textiles, including a textile depicting a frieze of an antelope that features in Kirchner's *Two Nudes on a Blue Sofa* (1910). One object that appears in numerous Brücke works from 1910 is the nineteenth-century leopard stool from the Babanki-Tungo region of Cameroon, which has gained near-mythic status as a "totem" of Expressionism rather in the same way that the Fang mask became associated with Fauvism and Cubism. This stool was allegedly a gift from Manfred to Kirchner,[61] although it is not clear how he acquired and transported such objects, particularly as he was working on the other side of the continent from the region of their production. Another link to Cameroon may have been estab-

96

lished through Hans Frisch, a passive member of the Brücke who was a close friend of Kirchner's and Heckel's and later became the brother-in-law of Schmidt-Rottluff and worked at the Völkerkundemuseum in Dresden from 1905. It has also been suggested that Kirchner might have been acquainted with a near contemporary who was based in Dresden around this time, the painter Ernst Vollbehr, who traveled to Cameroon in 1910 and is known to have sent three leopard stools as presents. The contact with Kirchner, however, has not been firmly established, so this is again conjectural.[62]

These authentic African artifacts divorced from their original function and context, and the carved furniture and wall decorations that the Brücke created under their inspiration, as well as those created under the influence of Asian and Polynesian art, were the essential objects that helped transform typical Berlin-Friedenau apartments into alternative *Gesamtkunstwerk* spaces.

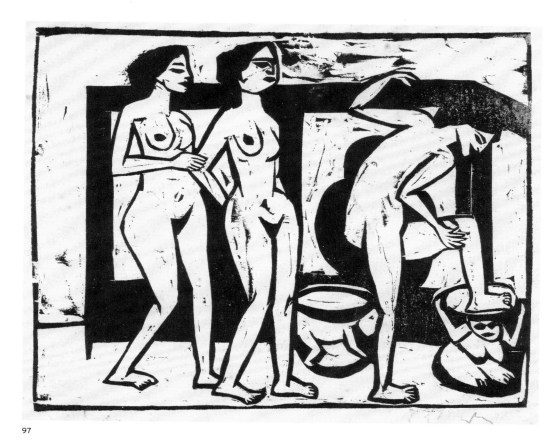

97

These studios in no way corresponded to anything found in academy studios; instead, they provided a "self-consciously constructed space within the city physically, but outside it metaphorically and morally."[63] These exoticizing studios satisfied Brücke's atavistic desires for a more "primitive" lifestyle and corroborated their Nietzschean idea of the relationship between artistic creation and sexual drive. Photographs of the Brücke artists' studios taken between 1910 and 1915, mostly by Kirchner, often show African artifacts and Brücke wood sculptures located among live models (such as Sam and Milly) and "framed" by the murals and batiks painted with explicit erotic subject matter, presenting a unity of participants and exotic craft.

A strong sense of the intimacy of a bohemian *Künstlergemeinschaft* pervades these images as well as those studio woodcuts, drawings, and paintings depicting the Brücke's models and girlfriends interacting with the various props of the studio space, images that blur the distinction between art and life and dissolve the distinction between art and craft. This is evident in a woodcut such as *Three Nudes* of 1911, in which the two female figures on the left side of the image appear to have just stirred to life from a static sculptural condition, whereas the naked figure on the right is treated more naturalistically, resting one foot on a caryatid foot-

stool and supporting her balance by holding on to a dressing screen. Kirchner cleverly conflates life and art by placing this figure between two carved but highly animated stools. The stool on which her foot rests is not the legendary leopard stool that also appears in profile in this work, directing the other girls in what appears to be a processional ritual. Rather, this is another, which could be a Yoruba (Nigeria) or Luba (Congo) stool that perhaps Kirchner "owned," or one carved by him after a West African example. He could have seen such examples in the ethnographic museums of Dresden or Berlin if he was not in possession of one. A very similar caryatid object, referred to as a "fruit bowl," was carved by Kirchner in 1911 and bears some resemblance to a caryatid bowl from Cameroon in the Berlin ethnographic museum, although Kirchner's carving is much rougher by comparison. The caryatid stool that is represented in *Three Nudes* also appears in an unusual painting of the same year, *Female Nude in Tub,* which depicts a female model with pure white skin who appears static, sculptural, and marmoreal diagonally in front of a caryatid stool that is vital, animated, and arboreal.

It seems that Kirchner was playing visual games rendering that which was animate inanimate and vice versa, a process enhanced by the multiple perspectives of the painting. Further interplay be-

98

99

98 Ernst Ludwig Kirchner. *Fruit Bowl* (Obstschale). 1911. Bern, collection of Eberhard W. Kornfeld.

99 Ernst Ludwig Kirchner. *Female Nude in Tub* (Weibliche Akt im Tub). 1911. Kiel, Kunsthalle zu Kiel.

tween living material and the objectified body is evident in an ink-and-pencil drawing titled *Interior II* (1911), which shows two female models relaxing in Kirchner's studio. One clothed model sits on the Cameroon leopard stool in front of a mirror; the other naked model reclines on what appears to be a deck chair, one hand clasping her knee while the other clasps her head. Her raised arm movement seems to echo the gesture of the nude represented in a painting on the wall and the *Crouching Woman* (1910) wood sculpture on a pedestal, one of two primitivizing sculptures by Kirchner, the other being *Female Dancer with Necklace* (1910), which flank the mirror that symbolizes the models' mirroring of the sculptures' animated poses (or vice versa). Gordon correctly suggested that while Kirchner's early figurative wood sculptures were an "unusual synthesis of Oceanic and African style characteristics,"[64] his work would become "increasingly volumetric" and more indebted to African sources, although this plasticity was also probably a response

to his appreciation of the voluptuous forms of Ajanta wall carvings that he came across in reproduction in 1911.

Ethnographic Colonialism, Hybridity, and Physiognomic Transformations

The Brücke artists, including former member Emil Nolde (a Brücke artist from 1906 to 1907), had all moved out of Dresden by 1911, and they visited the ethnographic museum in Berlin frequently thereafter. Nolde gained inspiration from different and more diverse sections of this museum than did Kirchner, but both artists were there at the same time. Nolde exhibited alongside the Brücke at the Berlin Neue Secession in 1910 and 1911, and he undertook prefatory work by drawing artifacts in the museum before his South Pacific trip in 1913, following Gauguin's example. Of the 120 or so study drawings that Nolde made at the Berlin Ethno-

100 Ernst Ludwig Kirchner. *Interior II* (Interieur II). 1911. Berlin, Brücke-Museum.

101 Ernst Ludwig Kirchner. *Crouching Woman* (Hockende). 1910. Stiftung Moritzburg, Sammlung Hermann Gerlinger.

graphic Museum, forty-five of them were used in paintings between the years of 1911 and 1913. Nolde saw in these ethnographic artifacts an expression of life in its simplest but most impressively raw form.

The Berlin Ethnographic Museum was still a relatively new building when the young German avant-garde sought inspiration from its exhibits. It opened in 1886 at the beginning of Germany's colonial conquests, and by 1910 the museum floor space was completely taken up by show cases and cabinets containing thousands of artifacts. Nolde and company must have sketched standing up in very cramped conditions, as the narrow passageways of the museum would have precluded the possibility of being able to sit down and work.[65] Although Nolde benefited enormously from the collecting and listing devotion of ethnographic scholars, he was antipathetic toward the scholastic, scientific approach to the study of "non-Western" cultures. Nolde's attitudes toward art and science echoed the pseudo-Nietzschean ideas of the cultural critic Julius Langbehn. According to Fritz Stern, "to worship art in Langbehn's manner was to go primitive, to return to some form of tribal fetishism."[66] Nolde's view paralleled Langbehn's in his loathing of the sterile, mechanistic approach to understanding mankind undertaken by positivist science. Nolde's respect for African and Oceanic cultures over the materialistic mores of Western civilization is well documented in his own autobiographical writing.[67] He was disgusted at the destructiveness of imperialism, and protested vehemently against the looting of cultural treasures from their indigenous lands carried out by colonial forces in the name of scientific inquiry even though he was a net beneficiary in terms of being able to explore new subject matter for his art. He wrote: "We 'educated people' have not moved so wondrously far ahead, as is often said. Our actions cut two ways. For centuries, we Europeans have treated the primitive peoples with an irresponsible voraciousness.

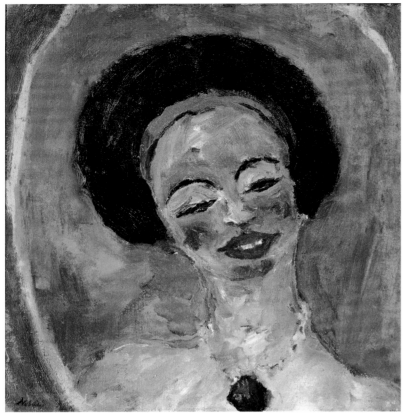

102

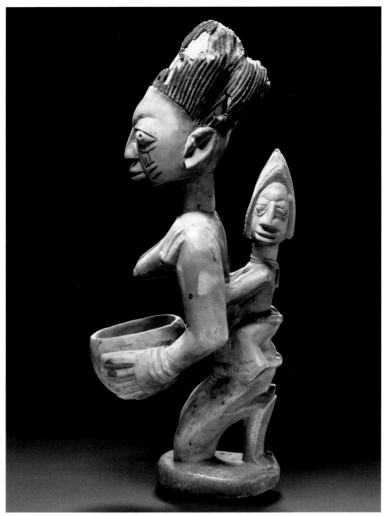

102 Emil Nolde. *Mulatto*. 1913. Cambridge, Mass., Harvard Art Museum, Busch-Reisinger Museum.

103 Mother and Child Figure, North Yoruba, Nigeria. 19th century. Berlin, Ethnologisches Museum, Staatliche Museen Preussischer Kulturbesitz.

103

We have annihilated people and races—and always under the hypocritical pretext of the best of intentions."[68] August Wiedmann has argued that Nolde "never preached the preordained superiority of one people over another. For him, each race possessed its own distinct strength and beauty."[69] His apparently "liberal" racial tolerance and his ethnographic inquisitiveness before embarking on his South Seas trip seem paradoxical when considering his later association with the National Socialist Party. It appears that Nolde bought into the "blood and soil" propaganda of the Nazi Party and believed in the rootedness of a people to their native land. It was this sense of "rootedness" that he claimed to admire in the art of African tribesmen and New Guinea aborigines, and he identified an affinity between the attachment to the earth felt by these indigenous peoples and his own commitment to the idea of a "healthy" German art. He was not a proponent of the cross-fertilization of

"race," however, and spoke out against those who painted "half-breeds, bastards and mulattoes."[70] This is ironic considering his *Mulatto* of 1913, a work that seems joyful rather than condemnatory.[71] Apparently, he saw no contradiction between his professed ideology and his artistic practice in this regard, which seemed precisely to form a hybrid "primitivism."

A good example of this hybridity and a painting that also expressed his contempt for colonialist forces is *The Missionary* of 1912, which refers to three quite different nineteenth-century ethnographic objects: a Bongo face mask from South Sudan, a Korean roadside idol (which stands for a Christian preacher), and a mother-child figure from North Yoruba (Nigeria) that Gordon assumed was lost but is in fact in the ethnographic museum collection in Berlin. Of this work Gordon wrote: "The African woman kneels, in a form of Christian prayer, before the missionary while

102

103

104

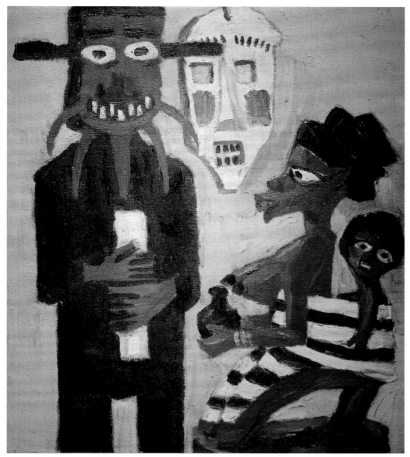

104

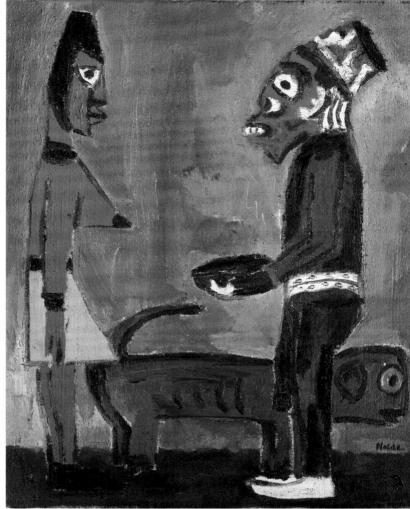

105

104 Emil Nolde. *The Missionary* (Der Missionar). 1912. Private collection.

105 Emil Nolde. *Man, Woman, and Cat* (Mann, Frau, und Katze). 1912. Neukirchen, Stiftung Seebüll Ada und Emil Nolde.

the disembodied mask, symbolizing her native religion, looks on in horror between them. By teaching the woman to give up her tribal religion in favour of Christianity, the preacher is fostering the extinction of tribal culture."[72]

In this and other artworks, Nolde did not create ethnographic copies in his representation of these objects. Rather he appropriated and adapted them to his painting, ignoring their sculptural qualities and flattening them into planes, emphasizing the distinctive physiognomy of his sculptural models for comic effect and stressing sexual features, decontextualizing and juxtaposing these objects to create narratives alien to their original function. Leaving aside the complex issue of juxtaposition, this caricatural aspect is problematic as it seems to push his work into the camp of racist stereotyping exemplified by much commercial advertising of this

period. However, if we compare a painting such as *Man, Woman, and Cat* of 1912 to one of the ethnographic objects that inspired its creation—the male figure relates to a figure on a king's throne from the Grasslands of northwestern Cameroon—then we can see that the original object is highly animated in itself, and Nolde has hardly embellished it for comic effect. However, in the same painting Nolde does emphasize the conical form and protrusive nipples of his sculptural female models, as he did in *The Missionary*.

The other Brücke members continued to explore African and Oceanic art in Berlin from 1911, although perhaps not with the same level of formal inventiveness as Kirchner and Nolde. As with Kirchner's art, Heckel's paintings, prints, and sculptures clearly register this interest. The same can be said for Pechstein, who also drew inspiration from Benin bronze reliefs and Cameroon wood

105

106

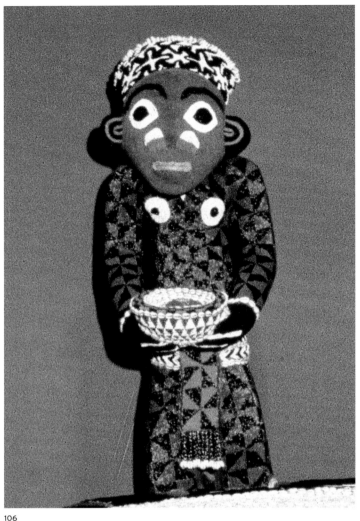

106

106 Detail of king's throne (Königsthron), Bamun, Cameroon. 19th century. Berlin, Ethnologisches Museum, Staatliche Museen Preussischer Kulturbesitz.

107 Karl Schmidt-Rottluff. *Four Evangelists: Matthew, Mark, Luke, and John* (Die vier Evangelisten). 1912. Berlin, Brücke Museum.

sculpture, particularly in woodcuts such as the *Killing of the Banquet Roast* (1911) and *The African* (1914). He would become a collector of tribal art and produce primitivizing wood sculpture and woodcuts in 1919 inspired by Cameroonian exemplars.

Particularly notable though is Schmidt-Rottluff's engagement with African ethnographic sources, which would become more significant after 1911, and especially after 1915 with the publication of Carl Einstein's *Negerplastik*. A striking Schmidt-Rottluff work that had considerable influence on the other group members was *Four Evangelists: Matthew, Mark, Luke, and John* of 1912, depicting the core Brücke artists, the source of which according to Gordon was a skin-covered dance headdress from the Ekoi tribe in northwest Cameroon that could be seen in the Berlin Ethnographic Museum in 1911.[73] More recently, another visual comparison has been established between this Schmidt-Rottluff work and a reliquary figure from Mindassa or Bawumbu tribes, which is a little more convincing in terms of its material quality—the brass and

wood materials used.[74] Schmidt-Rottluff's unusual relief in part inspired both Mueller and Kirchner, and significantly the latter's tetramorphic image for the woodcut cover of the *Chronik der Brücke* with the four artists again taking the place of the Four Evangelists and framed by rectangular forms. It is interesting to consider the "tribal primitivism" that unites the formative manifesto *Program* (1906) with the summative *Chronik* (1913) as it reveals a certain constant in a collaborative practice that was continually synthesizing a multitude of sources. On that point, Kirchner's *Chronik* cover also relates to the tradition of tetramorphic medieval illuminated manuscripts, such as the eleventh-century Bamberg Apocalypse, and in addition owes much to the *Blaue Reiter Almanac* of 1911–1912, which visually intercut Gothic carvings, African and Oceanic carvings, children's drawings, and naive or folk art, as examples of nonacademic, "authentic," artistic production. In the *Almanac*, "primitivism" was used to separate Expressionist art from the post-Renaissance tradition, includ-

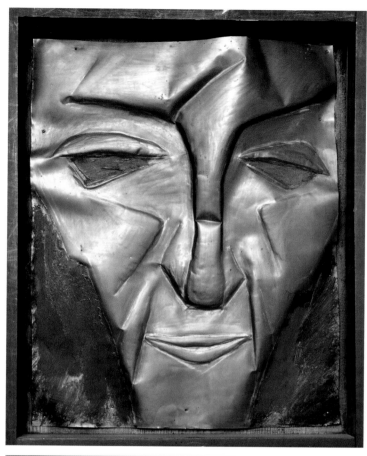

108

108 Ernst Ludwig Kirchner. Cover page of the *Chronicle of the Artists' Group Brücke*. 1913. Private collection.

109 Ernst Ludwig Kirchner. *The Drinker; Self-Portrait* (Der Trinker; Selbstbildnis). 1914–1915. Nuremberg, Germanisches National-museum.

110 Ernst Ludwig Kirchner. *Schlemihl in the Solitude of His Room* (Schlemihl in der Einsamkeit des Zimmers), Print IV of the Schlemihl cycle. 1915. Kiel, Kunsthalle zu Kiel.

ing nineteenth-century realism. This separation of a southern, Renaissance-inspired realist tradition from northern, "Gothic," and "tribal" art was a reverberation of Worringer's ideas, and Worringer's plates for his *Die altdeutsche Buchillustration* were even used in Kandinsky and Marc's influential compendium document. Worringer had considered what impelled both Gothic and tribal forms, and it is this identification of a nonclassical kinship that is expressed in Kirchner's woodcut *Chronik* cover. In the woodcut, following the example of Schmidt-Rottluff's relief, Kirchner starts to "Africanize" slightly the features of the represented Brücke artists (including himself), a process of transformation that he would explore to a greater extent in the post-Brücke years when Africanization symbolized his alienation from, rather than participation in, a tribal brotherhood.

From 1913 onward, Kirchner, like the Austrian Expressionist Egon Schiele, often represented himself in diverse roles as a means of characterizing his state of mind. Nowhere is this more striking

than in the painting titled *The Drinker; Self-Portrait* (1914–1915). 109 Of this work Norbert Wolf has written: "With emaciated, stark, masklike negroid features, the artist sits in front of a glass."[75] However, on closer inspection, Kirchner's unusual self-representation does not seem to relate to any mask, but rather his features resemble those of Sam, his black male model from his Dresden years. It appears that Kirchner somehow wanted to correlate his existential anxiety concerning military service and his sense of being marginalized from his former Brücke friends after their acrimonious breakup, with the alienation he believed that black Africans must feel, subordinated societally by a white ruling class. This sense of alienation is heightened by the way he depicts himself in an enclosed setting of multiple perspectives in which he appears to be sliding off the bar table. He also did something similar in his 1915 woodcut series, *The Amazing Tale of Peter Schlemihl*, which is of some formal and iconographic complexity, based on the Gothic story by the Romantic writer Adalbert von Chamisso first pub-

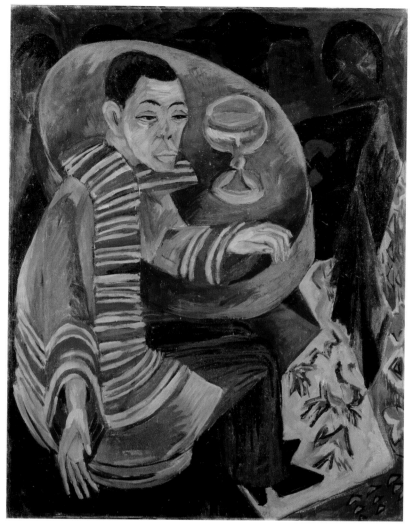

109

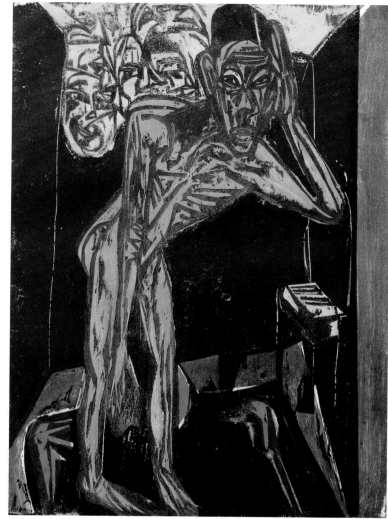

110

lished in 1814. In these woodcuts Kirchner visually alludes to the work of Van Gogh and Dürer and visualizes himself as the protagonist Schlemihl. In one print from the cycle he represents himself/ Schlemihl as a naked black man, again possibly Sam, who after being pursued by a mob is entrapped in a cramped dark chamber. Through warped perspective, Kirchner generates a sense of claustrophobia similar to that of *The Drinker,* and the schematic rendition of himself as both "negro" and existential "hero" appears to fuse two ideas: the Gothic-Romantic and the tribal African. Heckel also seemed to transform Kirchner's facial features into those of an African in his schematic portrait *Roquairol* of 1917, although he retained a white skin tone, which gives his subject the appearance of being an albino African. The implicit message here is that Kirchner was an outcast from society, and perhaps it is also a comment, given their estranged relations at this time, on Kirchner being an outcast from the Brücke community.

It should be reiterated that the Brücke did not regard their inter-

est in African cultures as having a diluting effect on their own sense of Germanness. Rather, they perceived these cultures as accrued to their own authentic Germanic ideology of vitality and free growth, the very adversary of rigid classical values. Joseph Masheck has even suggested that one of the indirect consequences of German colonial expansion, the enthusiastic collecting of examples of "tribal" art for German ethnographic museums, helped foster a cultural reevaluation of the medieval German Gothic as an "affirmation of primitive crudity."[76] This notion also went hand in hand with the inherited Romantic idea of the "noble savage" roughly carving wood, whether it was in Germanic or exotic African or South Sea forests. Much later, this idea was carried into the work of so-called neoexpressionist Georg Baselitz, who in many ways inherited Brücke's artistic legacy. Baselitz wanted to be a forester before he became an artist, and this desire was expressed in his crudely executed wood sculptures from 1979 onward, created with an axe and chain saw, and heavily influenced by the tribal ar-

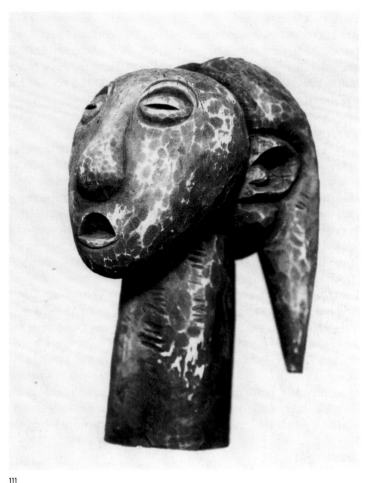

111

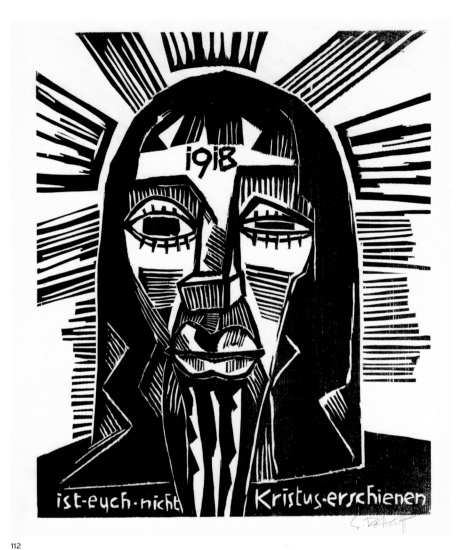

112

tifacts he was collecting at the time, such as African Lobi figures, as well as, of course, Brücke wood sculpture. Baselitz identified closely with Schmidt-Rottluff as a fellow Saxon artist, and perhaps because of their mutual interest in forests and tribal art.

In the short-lived and utopian Expressionist art journal *Kündung* (1921), Wilhelm Niemeyer even dedicated a forest song *(Waldlied)* to Schmidt-Rottluff, alluding to the importance of the tree and wood in his work. *Kündung* had a woodcut cover and crude woodcut lettering by the artist, which as Heather Hess has pointed out, "reflected the ecstatic tone and primitivist language of the text." Between 1911 and 1912 Schmidt-Rottluff also produced a few highly distinctive masklike wood reliefs of bearded men. These look vaguely "tribal" but are not as indebted to African and Oceanic prototypes as are some of his later three-dimensional head sculptures. On a military posting to Lithuania in 1916, Schmidt-Rottluff found himself surrounded by ancient forests. Here, he took his raw artistic material directly from its source. In Lithuania,

he deeply admired the use of wood as a craft material by the native population, although his work seems relatively uninfluenced by "local" wood carving. Instead, he produced many head sculptures (1916–1918) that appear to have been conceived from his appreciation of African prototypes to the degree that some of these works almost look like ethnographic copies, or echo Polynesian forms in that they often possess the appearance of scaled-down versions of giant Easter Island figures.

111

The reason for this disjunction between what he would have seen in Lithuania and what he actually produced is that like many vanguard artists working in Europe at this time, and particularly in Germany, he owned a copy of Einstein's seminal text *Negerplastik* (1915). Whether he traveled to the Baltic coast or rural Bavaria, Schmidt-Rottluff's immediate environment usually had an impact on his art, but such was the influence of *Negerplastik* that it totally conditioned his way of seeing and imagining. While in Lithuania, deprived of other artistic materials, he only produced woodcuts

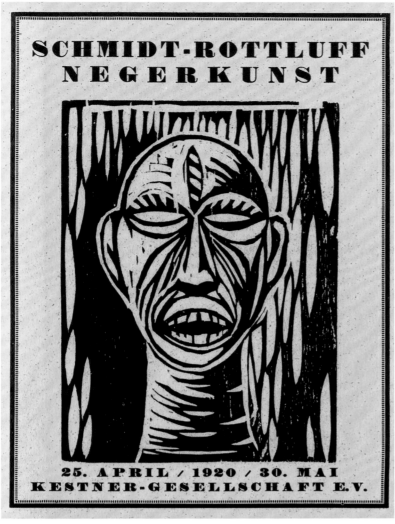

113

111 Karl Schmidt-Rottluff. *Blue Girl's Head with Hanging Braids* (Blauer Mädchenkopf mit hängenden Zöpfen). 1917. Whereabouts unknown. Image taken from Wilhelm Niemeyer, "Von Wesen und Wandlung der Plastik," *Genius; Zeitschrift für werdende und alte Kunst,* 1:1 (1919): 86.

112 Karl Schmidt-Rottluff. *Christ* (Kristus). 1918. Berlin, Brücke Museum.

113 Herbert Garvens. Title page to the exhibition catalogue *Schmidt-Rottluff Negerkunst.* 1920. Hannover, Kestner-Gesellschaft.

and wood sculpture, and as Gordon explored in some detail in the 1984 MoMA catalogue, the formal assimilation of the masks and figures of Ngumba, Luba, and Fang reproduced *in Negerplastik* is striking in his body of work at this time.[77] His woodcuts were particularly creative in terms of being transformative. Whether he represented the "local" population in prints such as *Girl from Kovno* (1918) or focused on Christian Biblical subject matter, Schmidt-Rottluff tended to "Africanize" facial features, developing what he had already started in his prewar graphic art. But unlike Kirchner's work, this process of "Africanization" was developed exclusively from ethnographic objects and photographic representation of such objects.

In the postwar period, Schmidt-Rottluff's artworks were occasionally juxtaposed to African carving, such as in the 1920 Hannover exhibition *Schmidt-Rottluff Negerkunst,* which evidently attempted to capitalize on the success of Einstein's book. This idea of juxtaposing ethnographic objects with displays of modern art orig-

inated with Karl Ernst Osthaus and his pioneering art museum the Folkwang in Hagen, which he founded in 1899. By 1902, Osthaus had acquired African objects for his museum, and ten years later, the museum guide described the display of European and non-European art as an attack on "classical-European prejudices" and an affirmation of the aesthetic worth of tribal art.[78] Katherine Kuenzli has discussed how Carl Einstein would oppose this model of comparative "interactive viewing" in *Negerplastik*. In terms of his photographic illustrations he treated ethnographic objects in isolation, including two objects from the Folkwang collection, lit against a neutral background to "focus attention on matters of sculptural form."[79] Einstein, following in the theoretical footsteps of Worringer and Frobenius, affirmed the aesthetic value of "primitive" art, but he did not make any aesthetic or ideological connection between African art and Expressionism, even though he was a regular contributor to Expressionist periodicals such as *Die Aktion* and had ample opportunities to do so. Instead, in *Negerplastik*

he alluded to the importance of the "French painters" (meaning Cubists) who "investigated the elements of viewing space, and the things that this viewing produces and dictates."[80] Through Kahnweiler, Einstein seems to have had better links to Picasso, Braque, Gris, and Leger than with German contemporaries, and although he does not mention the art movement by name, in *Negerplastik* he recognized the affective formal influence that African art had on Cubism rather than on the German avant-garde. In fact, Einstein was rather dismissive, one could say caustic, in his criticism of the achievements of the Brücke and Expressionism in general, and singled out only Kirchner as a truly original artist.[81] It was really the German interpreters of Einstein rather than Einstein himself who related Expressionism to a "primitive" African art. It was a view that did not correlate with Einstein's own as expressed in *Afrikanische Plastik* of 1921 that one should not attempt "to extrapolate from African sculptures the flimsy idea of a primitive art. A significant quantity of African works is anything but primitive."[82] Furthermore, as Charles Haxthausen has noted: "Even Einstein's earlier *Negerplastik* was, in part, a critique of a fashionable 'primitivism.'"[83]

It is curious that just a year before the publication of *Negerplastik* in Leipzig, a British avant-garde artist who invented Vorticism, and who was more than intrigued by European movements such as Futurism and Expressionism, wrote a review of an exhibition titled "Modern German Art" at the Twenty-One Gallery in London. This was the first exhibition devoted to Expressionist art to be seen in the United Kingdom, staged just three months before the outbreak of the First World War. His name, of course, was Wyndham Lewis, and he published his highly poetic review in the first issue of his magazine *Blast,* of which the following is a heavily abridged version:

At this miniature sculpture, the Woodcut, the Germans have always excelled. The black, nervous fluid of existence flows and forms into hard, stagnant masses in this white, luminous body. Or it is like a vivid sea pierced by rocks, on to the surface of which boned shapes rise and bask blackly. . . . It is African black. It is not black, invaded by colour. . . . But unvarying, vivid, harsh black of Africa. The quality of the woodcut is rough and brutal, surgery of the senses, cutting and not scratching. . . . Where the Germans are best—disciplined, blunt, thick and brutal, with a black simple skeleton outline of organic emotion—they best qualify for this form of art.[84]

Such a passage relates more closely to the critical perspective of those German commentators and curators of Expressionism, such as Niemeyer and Valentiner, who knew what they wanted from Einstein's writings but who were left somewhat shortchanged on Afro-German associations, a situation that led to rather selective interpretation of his work and a certain recourse to Worringer. But Einstein's *Negerplastik,* and the later *Afrikanische Plastik,* with which he claimed to launch a historical study of sub-Saharan African art, continued to influence the European avant-garde throughout the 1920s. Not long after the publication of *Die Kunst des 20. Jahrhunderts* (1926), generally regarded as the first survey of modern art, Einstein moved to Paris and cofounded the magazine *Documents* (1929–1931), an ethnographic Surrealist collaboration.

8

NEGROPHILIA, JOSEPHINE BAKER, AND 1920S PARIS

PETRINE ARCHER

When Josephine Baker performed opening night for *La Revue Nègre* at the Champs Elysées in 1925, her stardom was predictable. The audience erupted in screams of horror and appreciation. Many applauded robustly. With legs splayed in the air, she entered the stage on the back of black partner Joey Alex in "La Danse Sauvage," choreographed especially for her début. She dismounted with a cartwheel, landing center stage and standing, according to writer Janet Flanner, like "an unforgettable female ebony statue."[1] She appeared to be naked save for appropriately placed pink flamingo feathers.

Nude spectacle was not unknown in Paris's music halls. But when Baker began to move, her savage dance was like nothing Parisians had ever seen. It was a dance for aesthetes, divorced from ritual and created for its sexual appeal. Her stage gyrations fulfilled a long-held modernist vision: she was Charles Baudelaire's *Vénus noire* and Matisse's *Blue Nude* made flesh.[2]

Baker's black body did not move with the traditional, vertically aligned poise of European ballet. Her bouncing black bottom swayed, jutted, and jiggled, disrupting bourgeois notions of refinement and restraint. Fantasies of the black body had prefigured in the minds of writers and poets for centuries and had gained potency under colonialism. Thoughts of liberation and sexual freedom that her shapely body provoked signaled aspirations of avant-garde art, poetry, and performance, and concerns about decadence and degeneracy from naysayers. Her *derrière,* objectified in the title of the dance *Black Bottom,* would become the battleground for change and transformation that was at the root of the avant-garde's modernist project. It would also be indelibly marked in the racial imaginary of those artists who witnessed her dancing.[3]

Baker triggered an iconic craze in film, photography, fine art, and commercial memorabilia. Billboard posters harnessing mass print technologies, such as Paul Colin's *Revue Nègre au Music-hall des Champs-Elysées* (1925) or Michel Gyarmathy's *Josephine Baker at the Folies Bergère* (1927), became the popular art form that promoted her performances and the black aesthetic. The frenzy that accompanied her rise to fame has been labeled "Negrophilia," a term that represents the fluid and fantasy-driven variations of black artistic agency and white voyeurism. Collecting African-inspired art, listening to jazz, and dancing with black people became modern and rejuvenating.[4]

The bohemians who cultivated the shadowy world of jazz clubs called themselves Negrophiles. Unafraid of the negative historical implications of being called "nigger lovers," this vanguard, including the poet Guillaume Apollinaire, the art dealer Paul Guillaume, the shipping heiress turned publisher Nancy Cunard, and surrealist critic Michel Leiris used *négrophile* and *négrier* almost as

114

terms of endearment to establish their status outside "civilized" society's moral boundaries. Being called a Negrophile among the Parisian avant-garde affirmed their defiant craze for black culture. Blackness was a sign of their modernity, reflected in the African sculptures scattered about their rooms alongside abstract paintings.

The irony of Negrophilia is that it was not visually reflective of black people and their mundane realities in New World Diaspora communities or Africa. Rather, the images and the phenomenon's frivolous badinage were more often re-presentations of black people—like Man Ray's photographs of Marcel Duchamp, Cunard, or Kiki de Montparnasse—depicting white people "acting black" or fantasizing about blackness. Our challenge with the image of the black in a contemporary context is to articulate this role reversal and to find a means of expression that grapples with Negrophilia's highly charged forms, moving beyond its teasing banter and visual punning to reveal its populist and inherently racial signifiers. It is also important that we recognize the role of black performers in supporting the tropes of their race that circulated in Paris during this era. As strategies for their survival and success, many, like Baker, hyperbolized their Africanity, lacing their performances with popular "tam-tam" rhythms and minstrelsy to please audiences.

Although Negrophilia was a passion for black culture, the white avant-garde misappropriated that experience. Black people saw this vanguard's use of African idioms as a complement to their New Negro ideals, and contemporary African American expressions such as jazz were meant to counter racist stereotypes and position the expression of Diaspora Africans as modern. But the avant-garde's preoccupation with primitivism and atavistic transgression closed down this sense of modernity in favor of a black identity that was misunderstood and misrepresented. The principle underlying avant-garde admiration for black culture was a racist one that suggested that the white race had exhausted itself and needed a transfusion of blood and energy from a more primitive source. The ultimate crisis for African Americans in this era was the difficulty of articulating their very existence in Paris as part of a modern Diasporic experience.

Like the fused cultural sounds of syncopated jazz music, the image of black people in 1920s Paris was multilayered. Its altered states mirrored the multiple ways that French society perceived Diaspora blacks and the complex intersections among vanguard Cubism, Dadaism, and Surrealism that served to shape their image. Of necessity, black people had agency in this process of image building. With Josephine Baker, we see how their resourcefulness helped fashion their modern personas. But there was a catch: while blackness qualified them for modernity and the Negrophilia relationship, to participate they had to distort their identities to fit primitivist projections that better suited the vanguard's taste for vitality, sexual potency, and things African. Black social historian W. E. B. Du Bois recognized the problems of Negrophilia when he wrote, "We can go on stage; we can play all the sordid parts that America likes to assign to Negroes; but for anything else there is still small space for us."[5]

Jazz promoted the spread of Negrophilia in the 1920s. It was fast, raw, noisy, alien, and modern, with its origins in the southern United States. Its swing was a new sound born out of European forms and African music during the plantation era but popularized in Europe by marching bands of African American soldiers during the First World War.[6] In Paris, the avant-garde turned a deaf ear to jazz's New World origins. Like l'art nègre, it was appreciated for its African roots. Modern classical composers such as

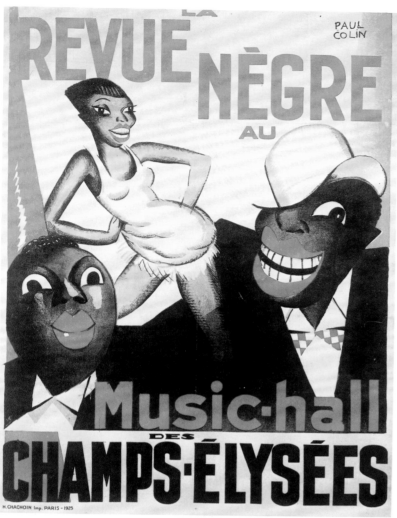

114 Paul Colin. *La Revue Nègre au Music-hall des Champs-Élysées.* 1925.

Antonín Dvořák (*Symphony No. 9—New World Symphony,* 1893), Claude Debussy (*Golliwogg's Cakewalk,* 1908, and *Minstrels,* 1910), Maurice Ravel (*L'Enfant et les sortileges,* 1925), and Igor Stravinsky (*Ragtime,* 1917) also adopted jazz derivatives such as syncopation, swing notes, polyrhythms, and blue notes and applied them to their essentially monorhythmic forms. For these composers, the multilayering of sounds in jazz met their need to reflect modern life's complexity.

In Picasso's program cover (1919) for Stravinsky's *Ragtime,* a score created immediately after the First World War, we see the influence of this new musical form.[7] Picasso's drawing delineates two musicians with a complex line that intertwines and loops back on itself repeatedly, as if referencing ragtime's energized, persistent, free-flowing rhythms. Stravinsky's melodic phrasing, dotted with sudden shifts and discordant beats, is mirrored in Picasso's use of this single line that halts, jerks but never breaks with the music's underlying rhythm. The artist's line defines the two musicians with

musical notation symbols, a treble clef forming the face of one and a bass clef becoming the ear of the other. Their bodies are open and fluid, moving and moved by the music they are playing.

The Parisian avant-garde first encountered Africa and black culture in their admiration for African sculptures that ended up in the hands of dealers and museums as a result of colonial trade and pillaging. Initially, these objets d'art went under the generic label *l'art nègre,* indicating a general ignorance of their origins, and *les fetishes,* suggesting a magical potency. These were the images that prefigured in Fauve, Cubist, and Expressionist paintings by artists such as Picasso, Derain, Vlaminck, and the German Brücke. Like the Dogon statue in E. L. Kirchner's *Seated Woman with African Wood Sculpture* (1912, Richmond, Va., Virginia Museum of Fine Arts), these painted forms were employed as a type of shorthand for spirituality, immediacy, and authentic, primeval expression. The avant-garde's admiration and borrowing of black forms satisfied their need for the magical and spiritual that had been lost in

115 Poster announcing the fight between Jack Johnson and Arthur Cravan in Madrid. 23 April 1916. London, the British Library.

their increasingly materialistic and mechanized society. Especially after the carnage of the First World War, the assimilation of black forms into Parisian subculture was revolutionary, remedial, and therapeutic.

Prewar encounters between Parisians and real Africans ensured that the latter's presence in Europe would be sensationalized. From the end of the nineteenth century, the promotion of *France d'Outre Mer* popularized by world's fairs and universal exhibitions went hand in hand with colonial exploration and conquest. African and other non-European peoples and exotic animals were showcased as curiosities. Initially, little distinction was made between continental Africans and their black Diaspora counterparts. Both groups entered French popular imaginations through theatrical re-enactments of colonial battles; minstrel shows, circuses, and sports were similarly sensationalized. Both groups were perceived as primitive, with black women being framed in terms of their sexuality and fecundity and the men in terms of their physical prowess and savagery.

Nowhere was this more apparent than in boxing, a sport in which the myth of black brutality could be confirmed and exploited. Despite its English origins, the revival of *la boxe,* as the French called it, came to Paris via America, and was associated with fairground and circus attractions. African American men who participated in boxing events were feted for their feats of strength and likened to their African brothers. Unlike America, Paris posed no restriction on their fighting with white men, and after 1900 many black boxers gravitated to the city in search of title fights.

Heavyweight champion Jack Johnson came to Paris in 1913 and participated in several boxing exhibitions organized by the Nouveau Cirque. Johnson was soon adopted by artists such as Peeka-boo, Blaise Cendrars, and Sonia and Robert Delaunay, and later the Dada performance artist and European boxing champion Arthur Cravan, with whom he fought an exhibition match in 1916 in Madrid. The fight poster in Spanish depicts both men in a clinch, their bodies barely distinguishable from each other, as if suggesting their equality and competitiveness inside the ring.[8]

Although racial difference provided the visible tensions for Johnson's fights, the political and sexual tensions that his male physicality established in the ring were equally potent. Outside the ring, and especially in America, his flamboyant character and penchant for white women roused white fears of violation and miscegenation. In Paris, a city proud of its liberal race policies, and without the same critical mass of black people to challenge the status quo, the sense of depredation was less acute. That said, the courtship of black culture by the Parisian avant-garde was an even greater slap in the face of bourgeois morals than a fistfight in the ring. Johnson was vilified by the French mainstream because his winning challenged its values; he was admired by the avant-garde for the same reason.

Jazz, African Americans, and New World urbanity presented artistic options that were innovative and fashionable. Avant-garde interest in black people rested on two opposing perceptions. First, they were viewed as "primordial" with all the exotic notions that primitive innocence implied. Second, they were viewed as being New Negroes with a pace that matched modern life. The two were not contradictory, particularly for the avant-garde who promoted the primitive condition as a useful model for postwar, modern man. This dichotomy was seen in the 1923 ballet *The Creation of the World,* a theatrical performance in which modern and primitivized forms blended easily.

The Creation of the World was a production by the Ballets Sué-

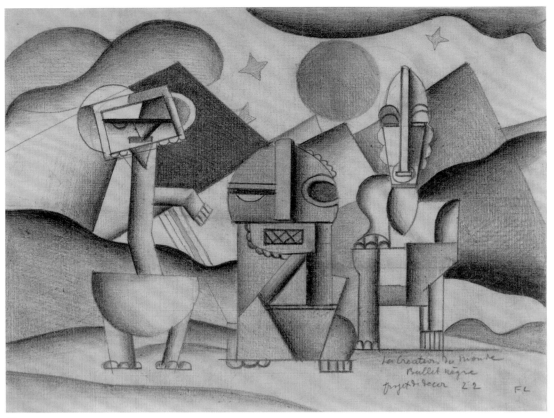

116

dois under the direction of Rolf De Maré and choreographer Jean Börlin that explored this new aesthetic and sensibility. African forms became a stylistic metaphor for origins and the avant-garde's aspirations for a rejuvenated and renewed modern society, especially after the First World War. Informed by *Anthologie Nègre,* Blaise Cendrars's translations of African mythology, the production attracted several artists renowned for their innovative thinking who were also taken with his more studied and ethnographic approach to African culture. Jean Börlin was the choreographer, Fernand Léger designed the set and costumes, and Darius Milhaud wrote a score punctuated with jazz idioms. Unlike the ad hoc use of imagery in earlier paintings and performances, such as Paul Guillaume's *Fête Nègre*[9] and Jean Börlin's *Sculpture nègre,*[10] Léger studied Carl Einstein's *Negerplastik*[11] and Marius de Zayas's *African Negro Art*[12] to give his designs greater authenticity.

116 Léger wanted an element of surprise in his designs from the juxtaposition of traditional and contemporary forms. His most interesting innovation was their mobility. Referencing African forms, his costumes were designed as masks for the body that blended performers into the collective whole. Léger wanted them to fuse with the stage set, like moving scenery. His costumes and backdrops show kinship with his fragmented Simultanist paintings in this period. Like jazz, which seemed to capture the pulse beat of

modernity with polyrhythmic forms, all the elements in Léger's Simultanist designs were considered equal; he gave even the most mundane aspects of his compositions visibility. The result is a democratization of a painted surface in which negative and positive space, foreground and background, are equalized.

Léger's prewar paintings had depicted men climbing and descending stairs, exploring man's relationship to modernity and the notion of regression. Returning from the front, his imagery shifted to dull, mechanized, tubelike men in factories and modern industrial settings that emphasized the uncertainties of civilization, evolution, and the relationship of humans to the human environment. Léger's designs for the ballet communicated rebirth and regeneration crucial to the avant-garde's ideas about postwar humankind. They represented a positive statement about a vision for postwar France that put the symbolism of black culture at its center: *l'ordre primitif* based on African models of civilization.

There is a similar preoccupation with rebirth in the work of sculptor Constantin Brancusi. His *Beginning of the World,* with its egglike shape derived from *The Newborn* of 1915, called for a new world order. It suggested a fresh start after the First World War, based on simpler values and a more primitive existence. Brancusi's work also echoed the sentiments of the Ballets Suédois's *The Creation of the World,* and like the ballet it represented an aestheti-

cized blend of two distinct cultural forms. It achieved what Brancusi's close friends Eric Satie, Darius Milhaud, and Francis Poulenc had achieved musically, fusing classical European forms with African art.

Brancusi's *White Negress* and *Blonde Negresse,* fashioned on a black woman that he met in Marseille, gain their visual impact from similar, built-in tensions. Thick lips and a chignon are the two visible additions to his elemental designs that feminize and racialize these heads. But Brancusi's use of textured and highly polished forms also silently plays with codes of difference. Presenting them, he sets one sculpture off against another, underpinning his Negresses' svelte surfaces with contrasting crude and angular forms beneath, a combination of what Rosalind Krauss has termed "hard" and "soft" primitivism.[13]

Captured in photographs, Brancusi's images are like Man Ray's *Noire et Blanche,* in which otherness is heightened by the conceptual play of sameness and difference. In the latter, the head of model Kiki is placed next to an African mask in compositions that employ Man Ray's solarization techniques. Reversed, the mask appears white, and Kiki's face is blackened. The objectification and isolation of both images, devoid of context, allow them to be viewed as equal, to trade each other's differences while enhancing their similarities.

Fascinated with otherness, the surrealists employed this dialectic in their pairing of photographs. On the eve of photography's conversion to color, monochrome was still the popular form for geographers and ethnographers documenting the colonial world. The avant-garde, especially the surrealists already fascinated with other cultures, soon commandeered the medium, recognizing its value for artistic experimentation. The camera's facility for creating illusions made it a useful tool for producing what they called "the

marvelous," "the object," and "convulsive beauty." Experimental photography turned their attention inward, allowing them to consider more intimate areas of the self, the body, and the interior spaces of either, such as the id and the psyche (concepts popularized by Sigmund Freud).

Negrophilia, too, was subliminal and erotic enough to appeal to surrealist and dissident tastes. In magazines such as *ASDLR, Variété,* and *Jazz,* they manipulated the black image as an exploration of otherness and as a strategy of subversion. Black imagery was used as a foil to critique redundant aspects of Western culture: what dissident surrealist Georges Bataille considered the "shit" or detritus of civilization. Unlike other surrealists, Bataille saw black culture as entirely modern, and, like white culture, just as afflicted with the scourge of civilization.[14]

In Bataille's journal *Documents,* images of black people were placed side by side in ways that were rarely complimentary. The avant-garde selected photographs for what they signified and how they related to each other. This dynamic between these pictures became as important as the images themselves. Subjecting black people to what he called "formlessness," Bataille created a new way of referencing the black body, a way that inhered not so much in its form but in its signifiers.[15] We see this critique in pairings such as the montage of *Bessie Love's Dance Troupe in Broadway Melody* (1929) and the sad-looking group of *Schoolchildren from Bacouya, Bourail (New Caledonia).* The formal resemblance between these two culturally disparate images allows the ethnographic image to act as a critique of its Western counterpart. Their troubled meanings are continuously generated from their sameness and yet obvious difference.

Along with fellow dissident Michel Leiris, Bataille edited the journal *Documents,* showcasing ethnographic imagery alongside

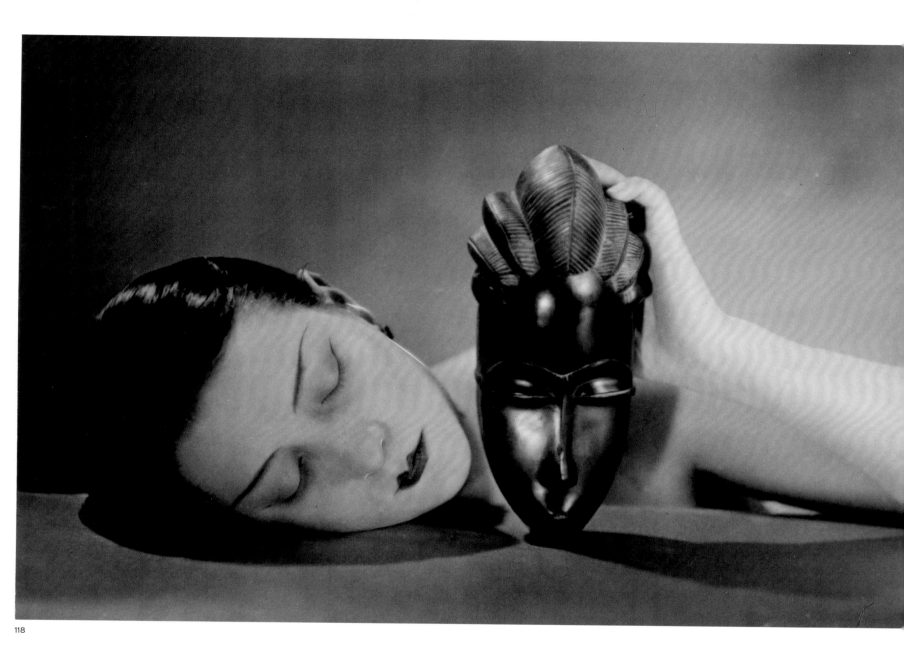

118

117 Constantin Brancusi. *White Negress*. 1923. Philadelphia, Philadelphia Museum of Art.

118 Man Ray. *Noire et blanche* (II). 1926. Jerusalem, The Israel Museum.

Bessie Love dans le film parlant " Broadway Melody "
qui passera incessamment au Madeleine-Cinéma.

119 Page with *Bessie Love's dance troupe in Broadway Melody* (1929) and *Schoolchildren from Bacouya, Bourail (New Caledonia)*. From *Documents* 1929, no. 4. London, British Library.

Enfants de l'École de Bacouya, Bourail.
(Albums de photographies de E. Robin, 1869-1871. — Musée d'ethnographie du Trocadéro.)

119

equally displaced European forms, steering the viewer from the familiar toward the alter "native." As Bataille described it: "In these various investigations, the sometimes absurd character of results or methods, rather than being dissimilated as usual in conformity with the rules of propriety, will be deliberately emphasized as much out of a hatred for platitudes as out of humor."[16]

But Paris's infatuation with blackness was not just about ideas,

inanimate objects, and imagery: bohemian Paris also fell in love with living black people as remedies to modern life. Like Baker, the black Americans who found themselves in Paris after the war were courted for their sense of style and vitality. Many were discharged soldiers loath to return to racial restrictions back home. Others were entertainers from stage shows such as Arthur Lyon's *Chocolate Kiddies* in Berlin, and James Reece Europe's marching band,

who found they could earn a living from the *beau monde*'s interest in jazz.[17] So they stayed. Ada "Bricktop" Smith, black singer and club owner whose popularity at times rivaled Baker's, made good money teaching "white bottoms" such as Scott and Zelda Fitzgerald and Ernest Hemingway to Charleston; she even tutored the Prince of Wales. No social evening was complete without black musicians and dancers, and by the end of the decade both Montparnasse and Montmartre boasted black communities of entertainers and nightclubs.

Renowned for its nightlife, Montmartre was where most blacks visited. This was the quarter for clubs, such as Zelli's, Le Grand Duc, Bricktop's, Chez Florence, and Chez Joséphine, often fronted by black celebrities but more regularly funded and supported by white patrons. These *boîtes* featured both jazz and Latin music. In spite of rigid opening laws, many still managed to party until dawn. Most jazz fans would begin reveling in one club and then "cruise" for the rest of the night in search of the hottest spots and musicians.

Not all blacks in Paris were hustlers or entertainers. Some were young, upwardly mobile professionals and intellectuals even before they came to Europe. The Diaspora elite who made a crossing of the Atlantic to Europe viewed themselves as pioneers. Their arrival in Paris was the continuation of their journey toward self-improvement and racial equality initiated by their earlier migrations to cities like Chicago, Washington, and New York.

After the war, Paris became the European hub for blacks from all over the Diaspora and Africa. There, they discovered a solidarity that had not been possible in America. Guided by W. E. B. Du Bois, Marcus Garvey, and other black thinkers, they used the city as a base to promote Pan-African unity and to establish political alliances such as the First Pan African Congress. Additionally, in the visual arts, the transatlantic crossings of artists Palmer Hayden,

Augusta Savage, Henry Ossawa Tanner, and Lois Mailou Jones, writers Countee Cullen and Joel Rogers, and intellectuals Alain Locke and later James Baldwin laid a network for cultural exchange between Europe's avant-garde and the vanguard of New York's Harlem Renaissance.

In Paris's poorer quarters such as Montmartre, African Americans mingled easily with their brothers from the West Indies and French Antilles, as well as Africans developing their own sense of being part of a wider black Diaspora that was cosmopolitan, in what became known as "French Harlem."[18] Palmer Hayden's sketch *Bal noir de Paris* (1929) illustrates this diversity with the same satirical style as his watercolor *Nous Quatre à Paris* (1927, New York, Metropolitan Museum of Art). He depicts African Americans dancing with French Creoles, distinguished by their plaid fabrics and handkerchief head wraps. The atmosphere is lively and convivial, suggesting the easy relationship that existed among these groups. Paulette Nardal, sister of Jane, and both crucial to the establishment of the *négritude* movement in Paris, described this "bal nègre" as "a place where blacks could be themselves."[19]

Jan Wieger's *Bal nègre* (1929) is even more telling. His oil painting shows how Paris was also a meeting ground for white women to mingle with black men, and vice versa. The *Bal nègre* or *Bal colonial,* as it was also called, first opened in 1928. It offered live Antillean music and the *biguine* folk dancing that attracted the French island Creoles. Discussing the dance form in 1930, Madiana Wardal contended that it had been much maligned for its obscenity. She described how its original form called for a subtle swaying of the hips and little body contact.[20] In Wieger's painting, by contrast, the mixed-race couple embrace as they dance. It is a portrait that suggests both the intimacy and intrigue that united blacks and whites with one another.

The white avant-garde was keen to support black expression. Spurred by their Negrophilia, antiracist ideals, commercial opportunism, or just philanthropic zeal, they patronized black culture by promoting exhibitions, publications, and stage productions. Foremost among these promoters were Paul Guillaume and Americans Albert Barnes and Thomas Munro, who through the work of the Barnes Foundation helped to develop an appreciation of African art among American audiences. They also deepened the African Diaspora's knowledge about *l'art nègre* and advanced it as a vital force that could reinvigorate anemic Western art.[21]

This message was especially communicated through Guillaume's publication *Les Arts à Paris,* an art journal that regularly contributed articles to New York magazines such as *Crisis* and *Opportunity.*[22] According to art historian Iris Schmeisser, Guillaume's constant references to *l'art nègre*'s ability to revitalize the Western canon "glossed over the material reality upon which the hype surrounding "art nègre" was based: cultural appropriation, expropriation, and exploitation . . . while ignoring the existence of the contemporary African art being produced at that time."[23] Ironically, Negrophilia ideas of Africa embraced by the black vanguard came via modernist appropriations of *l'art nègre* and primitivism that effectively undermined contemporary African art and the black vanguard's presence as part of a modern Diaspora.

This misrecognition was also the case with Josephine Baker, whose risqué performances form the basis of Paul Colin's *Le Tumulte noir,* a portfolio of forty-seven prints created a few months see 122 after her début at *Les Folies Bergère.*[24] The preface by the well-known satirist RIP assessed the craze of Negrophilia, or as he called it *négropathie:* a malady or mental illness that suggested feverish spread.[25] Albeit parody, use of pathological terms referencing malady or mental illness such as *virus noire, melanoma-*

nia, l'épidémie, négropathie, and *le rage* allowed those who suffered its sickness to disclaim responsibility and divorce themselves from their daytime identities. Colin's portfolio includes caricatures of Paris's *beau monde* and performers such as Cécile Sorel (b. 1873), Georges Goursat (1863–1934), Gabriel Signoret (1878–1937), Maurice Chevalier (1888–1972), and Mistinguett (née Jeanne Bourgeois, 1875–1956), who had been infected with the virus. They are depicted with palm trees, plaid pants, grass skirts, and even monkey tails, which were the props that signified blackness. Modeled on Southern plantation life but modified to suit urban Parisian taste, these themes blended easily with French codes of primitivism and an audience that objectified Africa and African Americans, conflating them into the same fantasy. For RIP, Baker's success represented the final triumph of *la vomito nègre* over white people; their enslavement to jazz was sweet revenge for slavery.[26]

The cross-cultural influences signified in Colin's portfolio suggest the extent to which the tropes and visual codes that characterized black people were transcultural, relaying easily between the cities of Paris, London, and New York. Before Colin's involvement with *La Revue nègre,* his contact with black people had been limited. Yet his poster for that review remastered the minstrel stereotypes already pervasive on Broadway and the U.S. black theatrical and entertainment circuit. He drew his depiction of Josephine Baker for the review's publicity poster from Cole Porter's *Jazz Baby* created by Miguel Covarrubias for the musical production *Within the Quota,* first performed in Paris in 1923.

Jazz Baby is a short-bobbed cutie dressed in a transparent chemise hiked above her thighs, in a style that would later inform Colin's depictions of Baker. *Jazz Baby,* the type, resurfaces again in 120 New York the following year, now as part of Covarrubias's "The New Negro, a Distinctive Type that had been recently created by

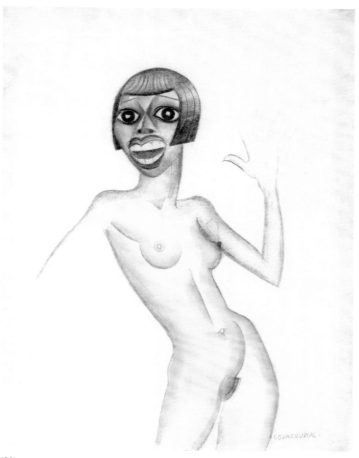

120 Miguel Covarrubias. *Jazz Baby*. Ca. 1925. New York, Michael Rosenfeld Gallery.

120

the Colored Cabaret Belt in New York," published in *Vanity Fair* in 1924 but revived two years later to illustrate Carl Van Vechten's *Prescriptions for the Negro Theatre,* the notes that seem to have directly influenced the visual and theatrical production of *La Revue nègre.*[27]

These primitive aesthetic codes involved hyper-racialized settings that called for blacks with blackened faces, bulging eyes, and wide, toothy grins drawn from the minstrel tradition. Van Vechten tapped into a vein of familiarity with French audiences already accustomed to their own performances of otherness during colonial exhibitions. But the review offered more, including picturesque depictions of the Deep South, images of blacks in jazzed-up urban settings, and a trio of picaninnies dancing the Charleston. Modeled from Southern plantation life, but modified to suit Parisian taste, they blended with French codes of primitivist Africanness. En route from New York during the ten-day Atlantic crossing, the producers of *La Revue nègre* applied Van Vechten's notes to modify the production and ensure its success.

Meanwhile in Paris, two events in 1925 helped to prime French taste for the review's African exotica and the primitivist codes rooted in Josephine Baker's dancing: Paris's *Exposition internatio-nale des arts décoratifs et industriels modernes*[28] and the much publicized return of *La Croisière noire,* the expedition across Africa led by Georges-Marie Haardt. *La Croisière noire* was the second in a series of expeditions across Africa from Dakar to Djibouti, sponsored by the French car manufacturer André Citroën. It was designed to expand colonial communications and to promote French manufacturing in Africa.[29] The expedition was afforded Hollywood-style treatment, launched with grand promotional advertising and regular press updates as the mission progressed. The potential of cinematography was not lost on its promoters, and the new medium was used to verify its scientific nature as well as glamorize the adventure.

The film *La Croisière noire* and the book of the same name (both translated into four languages) and expedition artist Alexandre Iacovleff's *Dessins et peintures d'Afrique,* prints of tempera paintings, posters, photography, African sculpture and furnishings would be exhibited a year later at the Musée des Arts décoratifs. Meanwhile, the *Exposition internationale des arts décoratifs et industriels modernes* in 1925 displayed many of its items in a room especially designed by Emile-Jacques Ruhlmann under the title *House of a Modern Art Collector.* Here the classical figuration of *art déco* de-

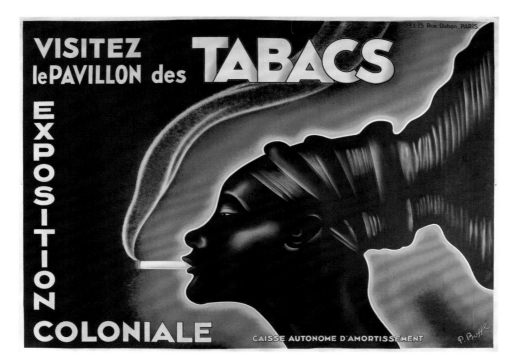

121 P. Bosse. *Visitez le Pavillon des Tabacs/ Exposition Coloniale.* 1931. Paris, A.M.I.

121

sign in furniture was clad with distinctly African patterning. Surfaces were covered in rich imported materials including ebony, ivory, straw, marquetry, and luxurious sharkskin. The intent was to bring the exotic to *art déco*'s bold designs to create something fresh and modern.

La Croisière noire's promotional material was branded with the image of Nobosudru, a woman from the Mangbetu tribe, later simply referred to as *La Femme Mangbetou.* Located in the Congo region of Central Africa, the Mangbetu were a curiosity for the expedition team. Their refined features, sense of physical grace, rich culture, and complex political structure challenged European preconceptions about "the primitive" state of African civilization. Mangbetu women were routinely depicted in profile to demonstrate and enhance their physical distinctiveness and "deformation" (as these colonials termed it) and promote visual parallels with Egyptian figure painting. Photographs from the expedition show these women posed to show off their physiognomy's parallels with Egyptian images, already popular as a result of the Tutankhamen discoveries in 1922. This publicized the Mangbetu as another lost tribe discovered by the expedition.[30]

During the next decade, *La Femme Mangbetou* would be restyled and packaged, promoting an assortment of events, goods, and services in Paris including the *Pavillon des Tabacs* at the colonial exhibition.[31] Nobosudru's image, like Josephine Baker's, became synonymous with Baudelaire's *Vénus Noire* or the Egyptian Queen Nefertiti and other iconic white male fantasies about Afri-

121

can women. Other images in the expedition's portfolio of Gan'za dancers suggest that their *danse l'amour,* particularly that of Batouala's dance with a wooden phallus, also influenced Baker's costume as Fatou in her début performance, *Danse Sauvage,* for *La Revue nègre.*[32]

In her opening act for the *Folies Bergère,* Baker assumed the role of Fatou, a desirable female African savage who spoke to colonial male fantasies. Staged in an African "jungle" with a sleeping white explorer, Baker appeared as if in a dream to arouse his "colonial desire." She was dressed in a girdle of flaccid bananas that quickly resembled phalluses with every bounce of her hips to the sound of the accompanying tam-tam rhythm. The significance of her banana skirt would not have been lost on French audiences. The fruit was becoming a big import, and it linked Baker to France's creole colonies such as Martinique *d'outre mer.*

Associated with the object of desire, her banana skirt upended and destabilized French colonialism's power relationship by teasing and mocking their implicitly aberrant taste. With this dance, and success at the *Folies Bergère,* Baker made her claim as Empress Josephine, trumping the status of the music hall's white "beauty queen" Mistinguett and claiming her historical links to creole culture and Napoleon's first wife, whose image experienced something of a fashionable revival in the 1920s. She also reaffirmed the French colonial belief in assimilation, that process through which its colonized peoples could be civilized and brought into the French family. Hence, Baker's transformation and evolution from

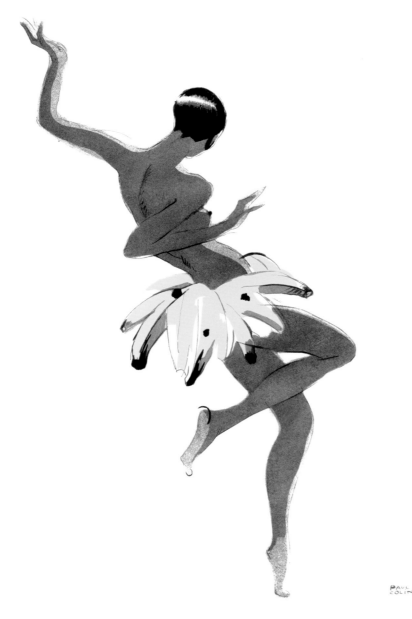

122

savage dancer to sophisticated empress was one that appealed to the French and their civilizing mission.

Ignoring the crudeness of Baker's famed dance, Colin chose to emphasize the aesthetics of the performance for his *Le Tumulte noir* portfolio. The ring of fruit that projected suggestively while Baker writhed becomes a tutu, and she is depicted as a nymph. Viewed from the side, with her body elongated and skin tone lightened, is a vision of Baker modified to suit Western notions of refinement. Contrast this with his images of Baker's animal-like persona. Her sexuality and ferocity are implied by the violence of her movement and the contortions of her body. In Baker behind bars, her splayed legs and vampish look, patterned stripes, and

startled expression suggest a caged animal with a voracious appetite.

In another work, the critic RIP is depicted half-naked observing a trio of cavorting showgirls. Like juvenile monkeys, they kick their legs in the air toward the smoke emitted from his suggestively phallic cigarette. Such imagery cannot be assessed in purely aesthetic terms. They speak to the darker side of Negrophilia's perception of black people as inferior and related to apes, a sentiment more accurately defined as Negrophobia and rooted in fear.

Animal imagery dominated Baker's personality and performances, caricatures that she herself fostered. Initially, her audiences associated her playful leaping, tumbling, and acrobatics with

monkeys, kangaroos, and feline creatures. Baker paraded her pet cheetah, Chiquita, as though it were an extension of her wardrobe. She kept a menagerie of animals in her nightclub, Chez Joséphine, and cultivated an animal-like presence in her sexuality. These signifiers were immediately apparent to audiences weaned on tales of contemporary African expeditions, such as *La Croisière noire* mission of 1925, and notions of exotic black tribeswomen living naked in the wild.

We can see from Baker's capitulation to appear nude and to adopt the primitivized styles created for her that black performers could also be complicit in the transmutation of African forms that reaffirmed a multitude of black stereotypes. Eager for success, they accentuated the more entertaining aspects of their culture by commodifying primitivist stereotypes. No one managed these adaptations better than did Baker, and Paul Colin's portfolio is a record of her ability to adapt and adopt these different personas. For the stereotype to be both fixed and fluid, it needs to appear unchanging but also must remain open to manipulation. Colin's portfolio and Baker's depictions work within these schemas, drawing on familiar African tropes while also parodying the *vogue nègre* epidemic. For the most part, Colin's characterizations were formulaic. Comparing his first pictures of Baker with later portraits, however, shows his understanding of her becoming more distinctive, intimate, and complex.

Present at Baker's début were Picabia, van Dongen, Cendrars, and Desnos. Later, other artists and writers, including Picasso, Matisse, Foujita, Aragon, Calder, and architects Le Corbusier and Loos would seek her out as model and muse. Jean Dunand depicted her in an exotic setting of palm trees holding an African charm, her body resembling his engraved furniture. Calder devoted his first wire-framed hanging mobile to Baker and her *dance de ventre*.

Le Corbusier's nude drawings of Baker suggest the intimate relationship he had with the singer after they shared a cruise on board the SS *Letitia* in 1929. Turned impresario, he envisaged a whole theatrical performance that showcased her journey from savage monkey to civilized showgirl. His sketches for the performance also suggest the extent to which the paradigm of the savage and civilized, even for the avant-garde, perpetuated the old tropes of fantasy, dreams, and desire.

Baker's ability to actualize these fantasies made them appear real to Europeans and served to perpetuate stereotypical imagery. As Baker grew more aware of the needs of her audience, her imagery became more sophisticated and symbolic. She became a black Cleopatra, her naked body coiffed, lacquered, furred, and bejeweled in a manner that spoke to imperial wealth and colonial power.

Colin was not naive. He consciously played with these ambivalences. Within the context of postwar Paris, Baker's identity vacillated between the savage and the civilized. She was courted by those who advocated social devolution and a return to *l'ordre primitif*, and by the mainstream who simply called for order. Colin's portfolio crudely expressed the *beau monde*'s inherent racism.[33]

As a talented black woman, "La Bakaire" enjoyed Paris because of the increased opportunities it gave her to realize herself and her goals. In Paris, she became the symbol of the New Negro, and within two years she was the highest paid, most photographed woman in the world. She was the first black actor to star in movies—the silent film *La Sirène des Tropiques* (1927), *Zouzou* (1934), and *Princesse Tam Tam* (1935)—paving the way for other black actors in Hollywood. Under the guidance of her mentor and partner, Pepito Abatino, she became a fashion icon and a model for French women. She had a weekly column in a newspaper and was featured in high-class magazines such as *Vogue*. She wore her hair with a

123
124

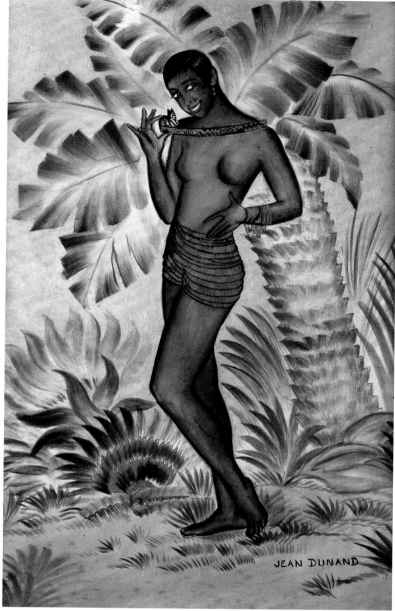

123

124

marcel wave or plastered flat to her head with shellac, creating a style that French white women mimicked. She also achieved great fame during the Second World War, and was even awarded the Légion d'Honneur for her resistance work. But despite her humanitarian concerns, she discovered that the admiration and success she gained from white society came at a cost. She was never truly accepted in the United States, either by the black vanguard, who believed she had compromised their race for European fame, or by white American audiences still unused to the idea of black equality or women's rights.

In 1947, a new Tériade art publication *Jazz* commissioned an aging Henri Matisse to create a series of prints.[34] Too sick to paint, he chose the collage and cut paper that would characterize his last works. This supremely modern portfolio of jazz prints—as a postscript to the bather scenes of his youth, and a nodding reference to Picasso's pink and blue periods—are minimalist in their use of color, space, and form. Like Picasso, he also mimics jazz in his use of improvisation in the portfolio. They are pared-down compositions focusing on the female form rendered in black against highly decorated and colored backgrounds. Whether the title was

125

125 Henri Matisse. *The Negress*. 1952. Washington, D.C., National Gallery of Art.

Matisse's is debatable, and whether Josephine Baker inspired this series is questionable. But the prints summarize much about black people, their presence in Paris, in the theater, circus, nightclubs, boxing ring, and street life that Matisse saw in his lifetime.

As a postscript to *Jazz,* Matisse created *Creole Dancer* (1950) and *La Négresse* (1952), depicting Josephine Baker in the same fragmented manner from pieces of colored paper. In *Creole Dancer* he captures her in a high-energy pose; her body is green and appears to leap from the page. *La Négresse* is more subdued, but significant for the banana skirt slung on her hips. In these prints, Matisse consciously and successfully places Josephine Baker at the heart of his

125

modern art narrative. For this aging artist to have made this statement suggests the effect that Josephine Baker and the image of her banana skirt had on the psyche of artists at that time.

Baker's image was powerful because she had liberated her female sexuality, and also because her blackness and fantasies of her availability contradicted social mores on sex and race. In an era in which artists were grappling with a polarized view of women and black people that embraced both the creative and the subversive, Baker was an icon of racial and sexual expression: the first black female celebrity.

9

AFROPHILIA AND AFROPHOBIA IN SWITZERLAND AND GERMANY (1916-1938)

CHRISTIAN WEIKOP

Of the Expressionist generation after the First World War, perhaps only Ernst Ludwig Kirchner, who was living a "primitive" life in self-imposed exile on the Swiss mountainside, really continued to find new ways of creatively engaging with the model of African and specifically Cameroonian art. In the German-Swiss Alps, he was enveloped by the woods, and he utilized the readily available pinewood to carve much of his own furniture, embellish his modest timber frame dwellings, and to continue to develop his woodcut and wood sculpture techniques. As he admired African tribal artists for what he understood as their authentic expression, observing "How much more advanced is the African in this kind of carving,"[1] so he connected with what he perceived as the noble simplicity of the lives of mountain dwellers and their "oneness" with the earth, a oneness that he saw as revealing itself in their craft as well as in their physiognomy. In considering these mountain peasants whom he never tired of depicting in woodcut and wood sculpture, he stated: "Their strong faces, partly covered with large black hats, seemed to form themselves out of the firs."[2] During this time, Kirchner conflated the material craft languages of indigenous Swiss peasant wood carving and African carving, and he assimilated the image of the Swiss peasant together with Cameroonian masks and figures to create a new kind of primitivizing *Urnatur* modernism. Between 1919 and 1921, Kirchner created at least four

elaborately carved chairs, stained with oxblood, for his "In den Lärchen" house in Frauenkirch near Davos. These four chairs each relate typologically to a chief's stool (created around 1900) from the western grasslands, Cameroon, which he and fellow Brücke artist Max Pechstein had seen in Berlin before the war. In 1913, Pechstein created a painting featuring a stool that took the multiple caryatid figures from the bottom register of the Cameroonian model, while later Kirchner's actual carved stools from his Swiss period, each responding to different aspects of the Cameroonian original, must have been based on a remembered encounter with the object in Berlin, possibly aided by sketches. In crafting these stools, Erna's bed (Erna Schilling was Kirchner's life partner), a bathtub frame, and various other utilitarian objects and sculptures inspired by African and Swiss carving, Kirchner turned his dwelling into a kind of arboreal *Gesamtkunstwerk,* an effect enhanced by the surrounding pine trees. With the help of his artist-sculptor friend Hermann Scherer, he also installed carved porch pillars for the veranda of his home in Frauenkirch-Wildboden where he moved in September 1923. These porch pillars (no longer extant) were based on palace columns of the royal palaces of the Cameroon grasslands that Kirchner most likely saw in Carl Einstein's *Afrikanische Plastik* (1921), which included two clear illustrations of such columns. This book had more than just a visual impact. Like

126 Ernst Ludwig Kirchner. *Stool I* (Stuhl I). 1921. Bern and Davos, collection of Eberhard W. Kornfeld.

127 Marcel Janco. *Invitation to a Dada Evening*. 1916. Zurich, Kunsthaus Zürich Grafische Sammlung.

his erstwhile Brücke companion Karl Schmidt-Rottluff, Kirchner was impressed with Einstein's writing in *Negerplastik* and *Afrikanische Plastik*. The analytical language that he used to articulate his thoughts on the formal qualities of his own wood sculpture in a pseudonymous article in 1925 was likely conditioned by his reading of Einstein's theories.[3]

Almost a year before Kirchner arrived in Switzerland, the "Cabaret Voltaire," an artists' pub and the birthplace of Dada, was opened (5 February 1916) by Hugo Ball at Spiegelgasse 1 in the Niederdorf quarter of Zurich. The Zurich Dadaists, like the Brücke Expressionists before them, were fascinated by African tribal art. Tristan Tzara, for instance, collected African and Oceanic sculpture from as early as 1916, and he wrote a piece titled "Note 6 Sur l'art nègre" for the modernist review *Sic* (September–October 1917). But while some of their ethnographic sources may have been the same, the Negrophilia of the Dadaists was of a different nature and manifested itself through performance and new media rather than through more traditional art forms, often with the in-

tention of shocking audiences out of their bourgeois complacency at a time of world conflict. Tzara and Ball used pseudo-African words in their plays and sound poems and experimented with the phonetics of "Negro" languages, while Richard Huelsenbeck declaimed "authentic" Negro poems during the raucous "African Nights" at Cabaret Voltaire. A powerful charcoal drawing by Marcel Janco, *Invitation to a Dada Evening* (1916) reveals another important element in Dada stage performances: the mask. The performing and menacing masked figures that Janco depicts in the strangely constructed space of the drawing appear part-human, part-ape, and part-sculptural, and they also seem to be mocking conventional academic poses. The animistic head of the foreground figure has bared teeth in the manner of a Bangwa mask, and the background figure proceeds with what could be, if not a ritual African dance, then some kind of African American cakewalk jazz move.

Janco had been inspired by the African and South Pacific masks that he had seen in the Zurich ethnographic museum, and he cre-

128

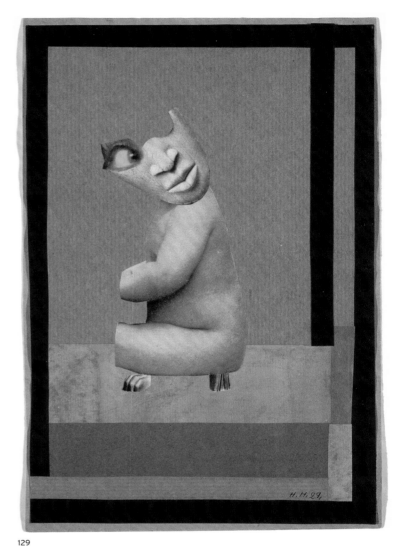

129

ated his own hybrid masks for Cabaret Voltaire and Galerie Dada performances that seem to syncretize tribal mask forms with the grotesque masks used in Swiss carnival parades, as well as those seen in Greek tragedy. These masks were constructed from horsehair, cloth, wire, cardboard, paper, and other materials, and were referred to by fellow Dadaists as "Negro masks." Janco's, Jean Arp's, and Sophie Tauber-Arp's use of recycled materials in their masks, constructions, and collages were meant to "evoke affinities with what they perceived as the art-making process in non-Western societies."[4] But beyond the material and formal aspect of African and Oceanic masks, there are other factors to consider in relation to

Dada, namely incantation and ritual dance. Just as Picasso had been struck by what he perceived as the "magical" and "intercessory" properties of African masks at the Trocadéro in 1906,[5] so the Zurich Dadaists understood that masks often formed a vital and dynamic part of ritual ceremonies and spiritual incantation in African cultures, and so they attempted to emulate the process of releasing totemic forces associated with the unconscious. In his Dada diary, *Flight Out of Time,* Ball observed in his entry of 24 May 1916 that he and his fellow Dadaists were transformed when they donned a Janco mask: "The masks simply demanded that their wearers start to move in a tragic-absurd dance.... The horror

128 Marcel Janco. Untitled *(Mask for Firdusi)*. 1917-1918. Antwerp, collection Sylvio Perlstein.

129 Hannah Höch. *Negro Sculpture (Negerplastik)*. 1929. Edinburgh, Scottish National Gallery of Modern Art.

of our time, the paralyzing background of events, is made visible."[6] As John Elderfield related, Ball felt himself to be possessed by demons of his era that needed to be exorcised to "clear away the chaos."[7] The Dadaist Hans Richter also described the embodiment of spiritual forces in Janco's masks, "which carried the audience from the primeval language of the new poems into the primeval forests of the artistic imagination."[8]

As in Zurich Dada, masks, marionettes, and puppets constituted an important aspect of Berlin Dada's carnivalesque aesthetic and performances. Huelsenbeck, who had returned to the German metropolis by January 1917 and was instrumental in forming Berlin Dada, would have brought with him ideas from the "African Nights" performances in Zurich. His friend and collaborator, the core Berlin Dadaist Raoul Hausmann, had acquired a copy of Einstein's *Negerplastik* on 13 November 1916. He heavily annotated it and ultimately passed it on to his lover, Dadaist Hannah Höch, on 2 August 1919.[9] Although their names do not appear in Einstein's writings, it seems likely that Hausmann and Höch would have at least made his acquaintance in this immediate postwar period as he became involved with the left-wing faction of Berlin Dada: George Grosz, John Heartfield (Helmut Herzfelde), and Wieland Herzfelde, founder of the Malik Verlag. Einstein devised the name of Malik Verlag's periodical, *Die Pleite* (Bankruptcy), to which he contributed three articles, and he was coeditor of *Der blutige Ernst* (Bloody serious), another defining publication of Berlin Dada, although there is no record of his participation in Dada evenings and performances.

While the male Dadaists' pseudo-African performances in many respects ideologically reinforced rather than reevaluated notions of "primitivism" and the place of Africans under a colonialist white European hegemony, Höch's photomontages of the 1920s

that dealt with issues of race and gender were rather more questioning of the status quo. Her work also seems to be a critique of the *vogue nègre* of the European avant-garde. The very title of her photomontage series, "Aus einem ethnographischen Museum" (From an ethnographic museum), reveals a reflexive understanding that "primitivism" as a guiding principle for avant-garde artists had become a cliché by the mid-1920s. The series consisted of approximately twenty works made between the mid-1920s and the early 1930s, about which Höch wrote the following: "The expansion of ethnographic research at that time only took in the 'primitives,' especially Negro art. The German Expressionists manifested this often in their oil paintings. I enjoyed experimenting in a less serious, but always precise way with this material."[10] Höch's work was both whimsical and sharply ironic, and yet as Maud Lavin has observed, "Even the whimsy Höch employed satirizes the notion of primitivism as somehow analogous to the primordial creativity embedded in the spirit of the artist."[11] Some ten years after she received her copy of *Negerplastik* from Hausmann, Höch created a photomontage that in title, dimensions, form, and material clearly relates to Einstein's work in such a way as to generate multiple meanings. She "used" Einstein's publication in a way very different from that of the Expressionist Schmidt-Rottluff, who, as discussed in chapter 7 of this book, was greatly influenced by *Negerplastik*'s photographs in creating his wood sculpture and woodcuts on the Eastern Front during the First World War. The geometric de Stijl–like "ground" of Höch's photomontage refers to the plain brown reverse of the jacket cover of either an early edition of *Negerplastik* or *Bebuquin*. The central figure is composed of a photographic fragment of an African wooden mask tilted at an angle and pasted onto another photographic fragment of a white baby's body that is seemingly mounted on a small stool and a sculptural claw. The

129

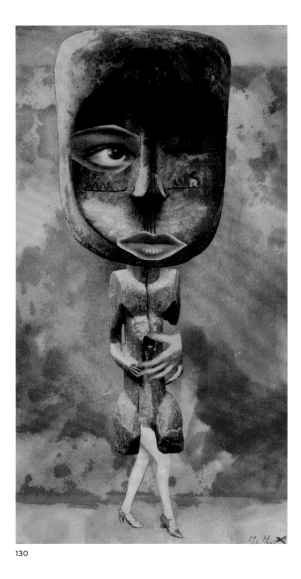

130

eyes have been cut out of the mask, and only one socket is replaced by an eye from another photographic source, possibly a photo of Josephine Baker or a fashion model from a magazine. In this work, Höch seems to be deconstructing many things at once.

First, the very fragmentary and hybrid nature of the photomontage with collage seems to subvert Einstein's own desire to stress the aesthetic formal purity of the singular objects of *l'art nègre,* photographed and reproduced in *Negerplastik,* objects frequently seen in "close-up views that invite reverie."[12] Second, she seems to be critiquing the universally high status of Einstein's *Negerplastik* in avant-garde circles (including her own)—a process of near fetishization not dissimilar to the avant-garde's fetishization of objects from ethnographic museums. Third, if the glamorous eye in the photomontage does indeed belong to Baker, then Höch may have also sought to critique the objectifying deification of the performer at this time as an ebony Venus, and the fragmented torso of the child could be a mocking allusion to the Venus de Milo in this

context. Finally, but most significantly, she seems to be calling into question the notion of primitivism as it was developed in the early twentieth century as a patronizing male construct, with the "primitiveness" of women, children, indigenous peoples, and the insane all being equated and imparted with positive value by the male artists of the Brücke, the Blaue Reiter, and the Zurich Dadaists.

Another photomontage in the "From an ethnographic museum" series, *The Sweet One* (1926) also deliberately confuses animate and inanimate material to create a mixed-race "cyborg," including, as Matthew Biro has pointed out, "parts of two different African sculptures—a mask and a male 'idol figure,' both from the Congo— and an eye, lips, left hand, and legs drawn from newspaper images of various Western female figures" against an abstract background.[13] The material hybridization of her photomontage is highly significant. This was a process of recycling and recontextualizing newspapers and art magazines, and she often culled her photographic fragments from the illustrated publication *Der Quer-*

130

130 Hannah Höch. *The Sweet One* (Die Süsse). 1926. Essen, Museum Folkwang.

131 Olaf Gulbransson. *The Black Occupation* (Die schwarze Besatzung). Illustration in *Simplicissimus* 25, no. 11 (9 June 1920): 168. Weimar, Herzogin Anna Amalia Bibliothek/Klassik Stiftung Weimar.

132 Hannah Höch. *Love in the Bush* (Liebe im Busch). 1925. Texas, Modern Art Museum of Fort Worth.

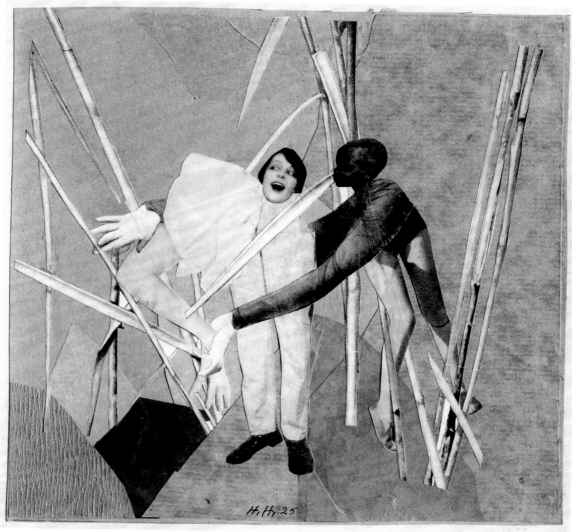

132

schnitt. That magazine featured reproductions of African, Asian, and Oceanic artifacts alongside modern European art and photographs of boxers, fashion icons, hippopotamus hunts in Africa, and other reportage. A Höch photomontage such as *The Sweet One* was designed to make the spectator reflect on prevailing conventions of beauty and race in terms of mass media constructions; and through a cut-up technique she also exposed the absurd incongruity of the photographic juxtapositions in *Der Querschnitt* and other publications of the German illustrated press. Furthermore, the hybridity of her work challenged the medium specificity and the posited *Stamm* authenticity of Expressionist woodcut and wood carving. She attempted to expose as myth and artificial construct the idea of there being some primal kinship (as Kirchner, Nolde, and other Expressionist artists and their critical interpreters believed) between their work and many of the artifacts on display in the ethnographic museum, estranged from their original concept and function.

Some of Höch's photomontage works of the mid-1920s refer to events beyond the avant-garde obsession with the ethnographic museum, works that effectively undercut an emerging German public paranoia concerning the "invasion" of the German *Heimat* by the "black savages" in the rank and file of French occupying troops in the Rhineland, who were generally from North African countries (see chap. 3).[14] The so-called black horror on the Rhine was an occupation that started in 1919 to force compliance with war reparation payments, and it reached a height of controversy in 1923 when the Ruhr was also occupied. The very presence of black occupying soldiers (a subversion of German colonialist ambitions) unleashed a wave of racist German press propaganda that stirred up fears of black men raping white females, the potential proliferation of "tropical" sexual diseases, and "contaminated" *Mischlingkinder.* Even satirical publications such as *Simplicissimus* consolidated as they mocked stereotypes of brutish black male sexuality, and they crudely adopted pseudo-Darwinian notions of black

133

131

132

"ape-men" seizing helpless white maidens. Höch's photomontages such as *Mischling* (Half-Caste) of 1924 and *Liebe im Busch* (Love in the Bush) of 1925 tapped into and deconstructed these fears. According to Wendy Grossman, the latter represents a "frenetic interracial tryst,"[15] but it is worth observing that the cut-and-pasted head of the black male that looks so ridiculously small in comparison to the torso and extended embracing arms with white "minstrel" gloves is not that of an adult but a young black boy. It is a joyous work that cleverly subverts the racist image of the brutish black rapist "ape-man" disseminated in much of the media coverage of the Rhineland occupation, while the inclusion of white gloves alludes to the performance of the *chanteur négre* (the blackface minstrel or "Negro singer") as represented by vaudeville figures such as Johnny Hudgins, Bert Williams, and Al Jolson.

It is interesting to consider the formal and ideological differences between Höch's photomontages and the work of a female artist who in many ways continued the Brücke approach in the idealization of the exotic Other. That artist was Irma Stern, born to German Jewish immigrants to South Africa in 1894. She was the product of two cultures: "Wilhelmine Germany, where her parents had family ties, and the insular highveld Karoo communities of central South Africa, where her father and his brother had established a mercantile business." As Marilyn Wyman has pointed out, "These African roots became the source of a mythologized Stern created by her early biographers to conform to the Expressionist

interest in the unspoiled innocence of the exoticized colonial subject."[16] But her relationship to the Brücke artists was more than one of mere mutual interest in exoticism. She met Max Pechstein in 1916, not long after he had returned from the Palau Islands, and he became an important mentor, supporting her efforts and encouraging critical coverage by writers such as Max Osborn, who wrote monographs on both him and Stern. She exhibited her paintings of South African native peoples and landscape with the Freie Sezession and the Novembergruppe, as well as in the Fritz Gurlitt Gallery in Berlin, well known for exhibiting Expressionist art and particularly work by the Brücke. Her paintings of the Weimar era created on her trips to Swaziland such as *The Hunt* (1926) reveal the influence of Gauguin, Marc, Pechstein, and Kirchner in the exaggerated sinuous shapes, jagged crystalline forms, compressed spaces, and dramatic color contrasts. Her painting *Umgababa* of 1926 also reveals her debt to Heckel's *Glass Day* (1913), which might well have functioned as a compositional model for Stern's work. It is a symbolic representation of "woman as nature," although Stern's idyllic scene is disturbed by the ominous dark clouds and the inclusion of rail tracks that seem to subdivide the landscape. In many respects it could be argued that in paintings such as *Lemon Pickers* (1928) Stern simply produced exotic subject matter that would appeal to an art market at a time of a pan-European *vogue nègre* and of commodification of Expressionism as an art style. Concerning this *vogue nègre,* James Clifford has writ-

133

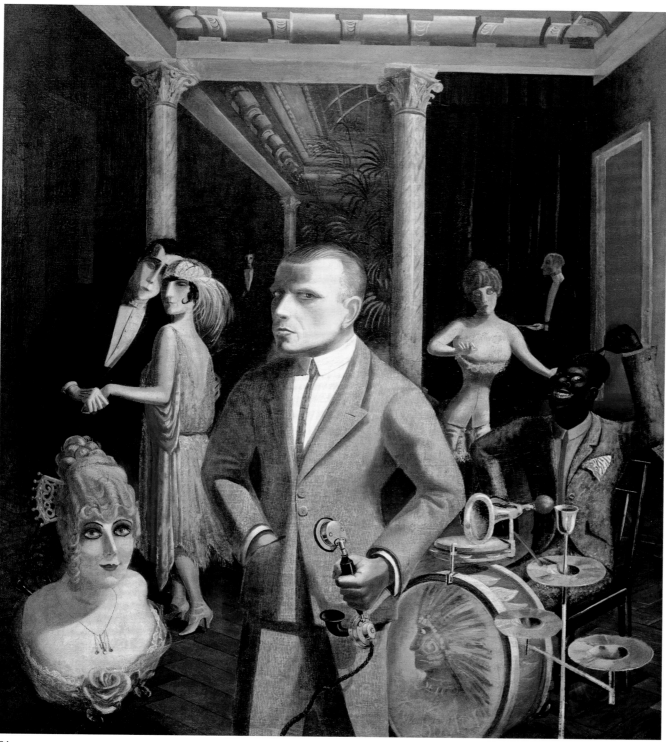

134

ten the following: "During the twenties the term nègre could em-
brace modern American jazz, African tribal masks, voodoo ritual,
Oceanian sculpture, and even pre-Columbian artifacts. It had at-
tained the proportions of what Edward Said has called an 'orien-
talism'—a knitted-together collective presentation figuring a geo-
graphically and historically vague but symbolically sharp exotic
world. If the notion of the African 'fetish' had any meaning in the
twenties, it described not a mode of African belief but rather the
way in which exotic artifacts were consumed by European aficio-
nados."[17]

Some of this *nègre* diversity is captured in Otto Dix's painting *An
die Schönheit* (To beauty) of 1922. Dix represents himself in a ball- 134

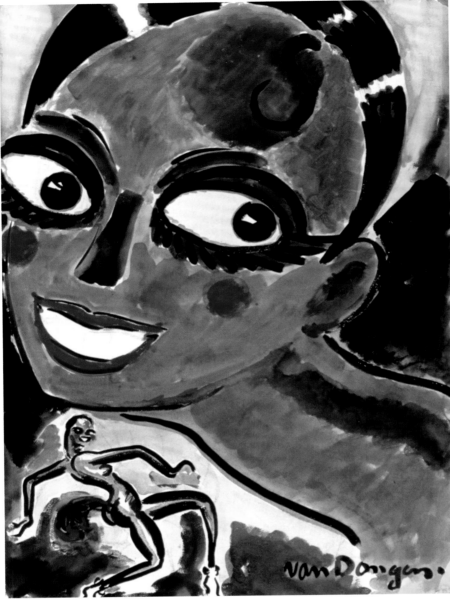

135

room setting, perhaps the famous Clärchens Ballhaus in Berlin, stiffly posing in an American suit with his slicked-back hair and defiant cool gaze. Around him are various other figures: an effeminate-looking man dancing like a marionette with a woman who in some respects represents the stylish Weimar "Neue Frau"; a female bust in the lower-left foreground that has the appearance of a brothel madam; and a mannequin-like figure in the right background, which could be one of the madam's "girls." To the side of Dix there is a "minstrel" jazz drummer, an African American, signified by his breast pocket handkerchief, portrayed manically banging a drum like a clockwork toy. This toylike aspect is heightened by the jazz bass drum skin, which depicts a Native American head and headdress. Here we encounter a conflation of stereotypes

of ethnicity, the *nègre* diversity referred to above, and part of a European avant-garde utopian vision of America as a place of dynamic futurist cities (with jazz symbolizing this urbanism) and "primitive" untamed landscapes (as symbolized by the *sauvage* Native American). Dix shared with Georg Grosz a boyish fascination with Native American culture as represented in the popular "Old Shatterhand" novels of Karl May, a German writer who was based in Dresden at the time both artists were receiving an art education around 1910. The Brücke artists, who were in Dresden from 1905 to 1911, had the same interest, and May-inspired bow-and-arrow motifs appeared frequently in their work at this time, although Dix later went further than the Brücke and actually represented himself in Native American costume in *Ich als Indianer*

(Myself as an Indian, 1923). Susan Funkenstein has argued that Dix "cultivated an image of himself as Native American in ways similar to his self-construction of blackness" and that his alliance with the drummer in *To Beauty* can be interpreted as a "move up a social ladder of trendiness"; given the "Weimar vogue for jazz and African art in Germany's urban centers, blackness carried social cachet."[18] Funkenstein also points out that Dix, who was a gifted jazz dancer, was given the nickname of an African American "Jim," the "commonly used moniker of the African-American shimmy figure found often in jazz operas," and that the shimmy figure was the "quintessence of ethnic drag."[19] Intriguingly, she concludes that two social ladders are represented in *An die Schönheit,* "one the aspiration for a white bourgeois identity, the other for an African-American one," although there is a sense by which both these identities were in a Brechtian sense "performed" by the artist.

Dix attended performances by jazz musicians in Berlin and also by the African American dancer Josephine Baker. Baker and her touring troupe were at the heart of *vogue nègre,* a vogue constructed by writers of the avant-garde and the popular press, as well as artists such as Kees van Dongen, who sought to confer an exotic, erotic African primitiveness to her athletic dance performances. The Expressionist writer Ivan Goll was one of those who related Baker to the roots of her ancestral "jungle," but his article "The Negroes Are Conquering Europe" (1926) was written in a tongue-in-cheek manner, and he observed a high degree of self-parody in Baker's "African" numbers. He thought the *Revue Nègre* was a revitalizing force for a jaded war-weary Europe: "The Negroes are conquering Paris. They are conquering Berlin. They have already filled the whole continent with their howls, with their laughter. . . . Negroes dance with their senses. (While Europeans can only dance with their minds.)"[20] But Oscar Bie, the dance critic

of the *Berliner Börsen-Courier,* was not being tongue-in-cheek when he wrote that he saw in Baker's performance "the remains of a genuine paganism, of idol worship, of grotesque orgies."[21] As Peter Paret has pointed out, Bie wanted to impute a "similar chthonic feeling to the Chocolate Kiddies," a dance troupe that appeared at the Admiralspalast, Berlin, in May 1925. That group's performance, according to Bie, constituted "a true joy of the earth in drumming, shouting, dancing, singing, and jumping . . . barbarically beautiful, full of primitive improvisations."[22] Yet, despite Bie's comments, the "primevalism" of both troupes was met in other quarters as heralding a new urban phenomenon. The great patron of the German avant-garde, Count Harry Kessler, after witnessing Baker's gyrating banana dance and the moves of her dance troupe at the Nelson's Theatre on February 17, 1926, felt compelled to write in his diary: "They are a cross between primeval forests and skyscrapers; likewise their music, jazz, in its color and rhythms. Ultramodern and ultraprimitive."[23]

Baker was conscious of the *sauvage* "Ebony Venus" image that had been constructed for her, and she deliberately played off these racist stereotypes, acting the "primitive" femme fatale for her own celebrity and commercial success, and to the degree that a post-feminist theorist writing today might well consider her control of her artistic "persona" as highly empowering. Baker is quoted in her first biography as saying: "In the magazines and newspapers of Berlin, they wrote that I was a figure of the contemporary German *expressionismus,* of German *primitivismus,* etc. . . . Why not? . . . Alles für Josephine."[24] At Berlin's Theater des Westens in 1928, she was even photographed shaking her banana skirt in front of a stage curtain that had a huge stylized representation of herself naked but for that skirt, exotic jewelry and headpiece, an image drawn by Benno von Arent that symbolically stressed the size of her fame

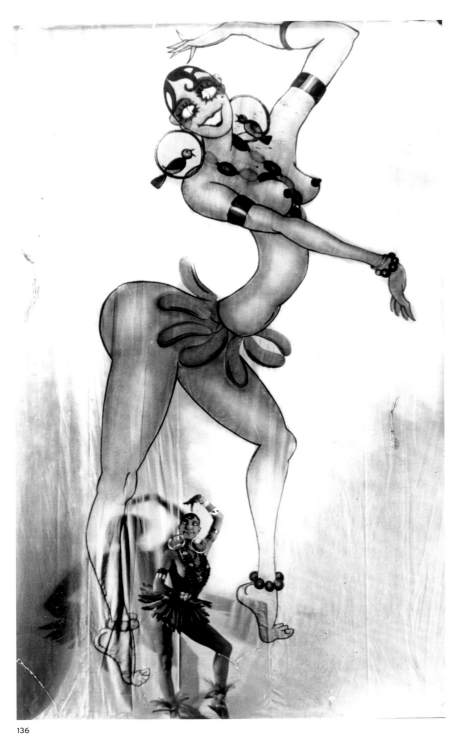

136

136

136 Photograph of Josephine Baker in her banana skirt at the Theater des Westens in Berlin. 1928. The curtain was drawn by Benno von Arent. Image from *Das Theater* (December 1928).

137 Rolf Nesch. *Negerrevue*. 1930. London, British Museum.

but falsely represented the size of her buttocks, as he exaggerated her body type in terms of "Hottentot" steatopygia. It is an image that reveals that the artist had conformed to a colonialist idea of "primitive" hypersexuality, an idea that, as I discussed in chapter 7, also pervaded much Expressionist art. It is highly ironic, given this contribution to what the National Socialists would have identified as a "degenerate Negro art," that Benno von Arent would in 1936 be appointed by the Nazis as the official Reich set designer. After Baker's success in Berlin, the *Revue Nègre* became a fixture in many German cities, but acts did not always involve the heterosexualized image of the black, although no doubt Baker or Baker-like performances from other sultry female black dancers would often be the main attraction. Sometimes the revue shifted from the exotic to the grotesque, as captured in a well-known late Expressionist print by

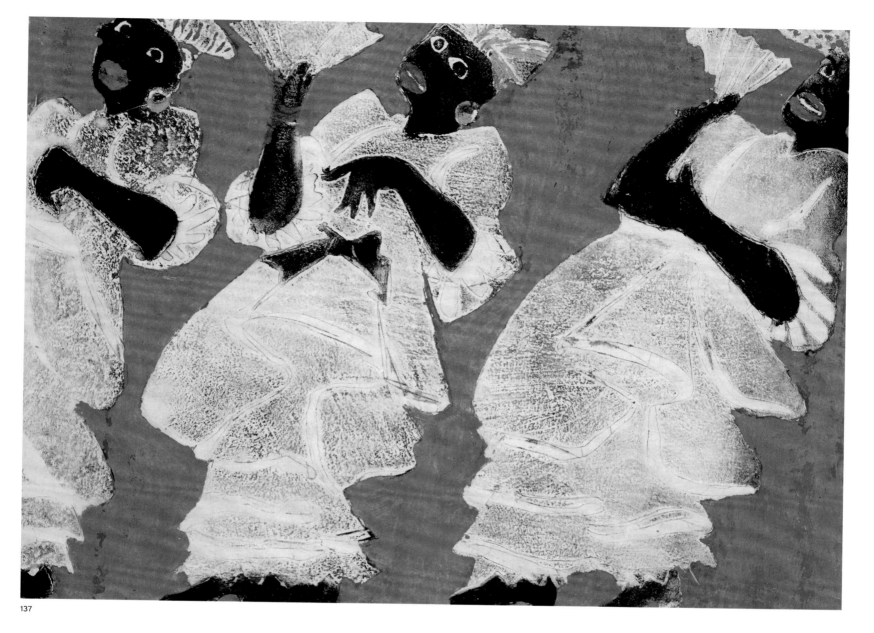

Rolf Nesch of 1930 that depicts a dance troupe from Louisiana that performed in St. Pauli, the notorious red light district of Hamburg. The well-built black male dancers are in drag and possibly in "blackface," judging by their "minstrel" features, and they are incongruously dressed as African women in wrapper skirts with head ties and clasping fans.

Beyond the *Revue Nègre,* more complex and challenging images of the black were generated by German artists in this Weimar era, which also saw a turn toward a Neue Sachlichkeit (new objectivity). This subtle complexity is evident in the photographic work of August Sander, and especially his "Circus Workers," which depicts a black male relaxing with a white female coworker over bottles of beer and a flask of tea or coffee, simply sitting on deck chairs next to a fold-up table in front of the circus tent canvas and gazing di-

rectly at the photographer. In representing a quotidian scene such as this one, the image would have confounded viewer expectations of the aggressive or degenerate black male that had been generated by artists and the popular press in this period, particularly during the Rhineland occupation, and by the numerous codifying racist images of morally lax, buffoon-like minstrels and jazz dancers. According to much racist typologizing of this period, the black male here *might* be classified as a mulatto or *Mischling,* although he could also be North African or from an Indian community of African descent. His demeanor projects casual self-assurance, and his female companion is equally relaxed and smiling; it is a curiously democratic scene of itinerant people on society's margins. Katherine Tubb has remarked that Sander may well have been taken by the "non-performative" engagement of this pair, and has suggested

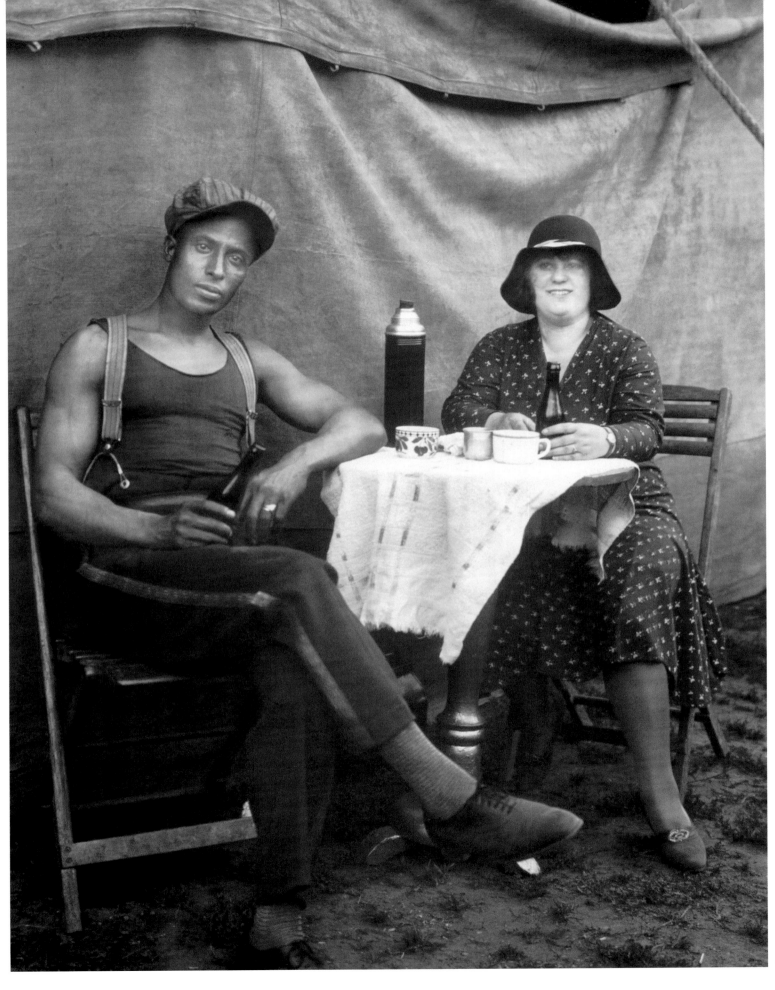

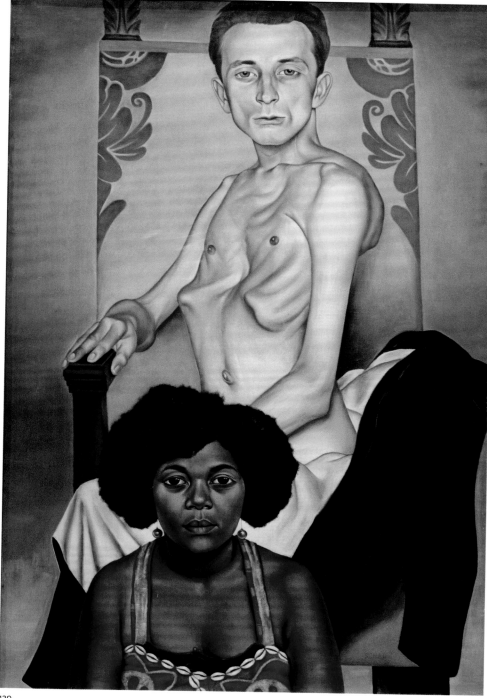

139

138 August Sander. *Circus Workers* (Zirkusarbeiter). 1926–1932. Artist Rooms, Tate and National Galleries of Scotland.

139 Christian Schad. *Agosta, the Winged Man, and Rasha, the Black Dove* (Agosta, der Flügelmensch, und Rasha, die schwarze Taube). 1929. London, Tate Modern.

that it is an image that "opposes Weimar's popular discourses, visual and textual, on 'inter-racial' relations between the sexes" in its documentary lack of sensationalism.[25]

Another "Neue Sachlichkeit" image of a "couple" that frontally engages the viewer is *Agosta, the Winged Man, and Rasha, the Black Dove* (1929) by Christian Schad, who had been involved with Zurich Dada before becoming a leading exponent of the new objectivity movement. In this work, he depicts "freak show" performers on the margins of society, the type of itinerants who would later under National Socialism be removed from the margins altogether. As with Sander's *Circus Workers*, it is an image that departs from the visual discourse of dynamic Expressionist representations of circus performance. Here the performers are not performing, but resting between acts—still, contemplative, and questioning the voyeuristic gaze. The enthroned Agosta, "the winged man" with a seriously deformed chest, is seated above Rasha the "black dove," a

snake charmer, though her name also suggests some physical deformity, and both worked at the Uncle Pelle circus in the working-class district of Wedding in Berlin.[26] Given that Rasha is represented with none of the props that might visually indicate the nature of her act, her blackness in part registers an exoticism that seems to be equated with Agosta's disability. Curiously, this alignment brings to mind Paul Schultze-Naumberg's insidious book *Kunst und Rasse* (1928), which juxtaposed primitivist paintings by avant-garde artists such as Schmidt-Rottluff, Nolde, Modigliani, and Picasso with photographs of people with deformities, thereby reinforcing the idea of modernism as sickness or degeneracy. Schad's artworks were not confiscated from art museums in the same manner that befell the Expressionists, which prompts some further reflection on how his work was received by the Fascist regime. However, unlike Nolde, Schad was no Nazi sympathizer, and he lived in a state of "inner exile" in National Socialist Germany.

To understand black representation in this Weimar era, it is worth considering one more Neue Sachlichkeit artwork. Ernst Neuschul, born in Aussig to Sephardic Jews, moved to Berlin in 1925. He joined the Novembergruppe a year later, and under that influence his work became harder-edged (more *Sachlich*) and socially committed. Like Sander, he produced some memorable images of a Weimar underclass of Gypsies and the unemployed, but in oil-on-canvas rather than photographs. The painting *Negro*
140 *Mother* (ca. 1931) is one of his most powerful works. The painting is striking in terms of its "frontality" and "monumentality" in depicting a black woman caught in a private maternal moment of breast-feeding her baby. In terms of subject it is reminiscent of
see 95 Modersohn-Becker's *Kneeling Mother and Child,* but the near-photographic realism of Neuschul's painting, a realism that arguably surpasses the precision of the lens, is more compelling in cap-

turing the dignified but slightly defiant expression of the mother, a look mirrored by her suckling infant. The painting was taken by Neuschul to the USSR in 1935 and exhibited in a one-man show in Moscow, where, according to a Leicester City Museum exhibition catalogue, "it was seen as a vivid representation of the kind of 'revolutionary' theme guaranteed to frighten the reactionary forces of German authoritarianism."[27] Neuschul had already upset Goebbels in 1933 when he had a shouting match with him at the Reichskunstkammer, and soon afterward Nazi thugs slashed his paintings at an exhibition. Because of his Jewish birth and radical political opinions, his position as a professor at Berlin's Academy of Fine Art was taken away from him when the Nazis assumed power.

In April 1930, some three years before Hitler's appointment as chancellor, one of his deputies, Wilhelm Frick, who was minister of the interior and culture in a right-wing coalition in Thuringia, introduced a regulation called the "Ordinance against Negro Culture." The ordinance was designed to rid Thuringia of all "immoral and foreign racial elements in the arts," demonstrating one aspect of what the Nazis increasingly claimed to be "degeneracy": avant-garde enthusiasm for "un-German" cultures.[28] This resulted in the purging of modernist art, including works by German Expressionists, from the Weimar Ducal Museum and, as Erik Levi has observed, the banning of performances of jazz band and percussion music, "Negro dances" and "Negro songs" in the interests of preserving the "German spirit."[29] The National Socialist clampdown on the Swing Kids, youthful German groups of jazz and swing lovers who were in sympathy with the expressivity of African American culture and antipathetic to the values of the Hitler Youth movement, also continued throughout the 1930s. The racist ideology of Frick, Schultze-Naumberg, and many other National Socialists, developed through publications and regulations in the last five

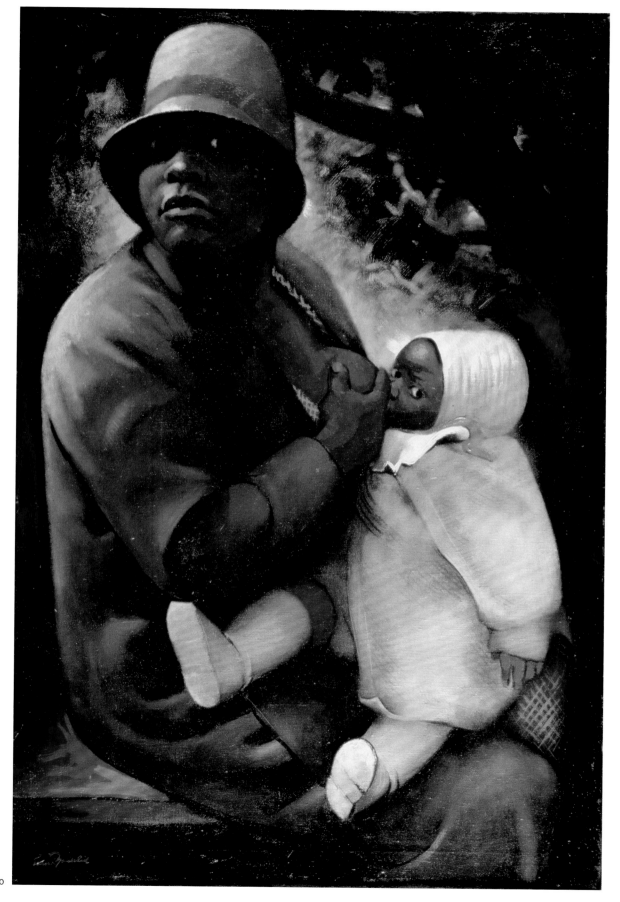

140

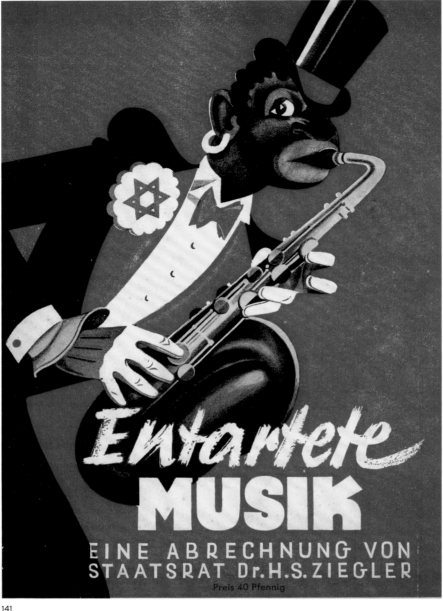

141

years of the Weimar Republic, would spiral into full-blown exhibition campaigns against so-called degenerate art and degenerate music in the Third Reich. The first defamatory exhibitions took place in 1933 in Karlsruhe, Stuttgart, Mannheim, Nuremberg, Chemnitz, and Dresden, but the major touring show of *Entartete Kunst* that started at the Archeologisches Institut in Munich in July 1937 was organized by Adolf Ziegler.[30]

Like "degenerate art," "degenerate music" examples were displayed in public exhibits in Germany beginning in 1938. One of the first of these was organized in Düsseldorf by Hans Severus Ziegler (no relation to Adolf), who at the time was general manager of the Weimar National Theatre. A National Socialist propaganda poster created for this *Entartete Musik* exhibition was in ef-

fect a grotesque caricature of the original poster and early editions of the music score for the jazz opera *Jonny spielt auf* (Jonny strikes up the band) by Ernst Krenek. This production premiered in Leipzig on February 10, 1927, and was soon thereafter targeted by the National Socialists as an "outrageous introduction of Jewish-Nigger filth" by the "half-Jewish Czech," although Krenek was actually neither. This racialist viewpoint was given further ideological underpinning by Richard Eichenauer's *Musik und Rasse* (Music and race) of 1932, which evidently followed on from Schultze-Naumberg's *Kunst und Rasse* and was visually articulated in the Nazi poster for the 1938 exhibition, in which a stereotyped fat-lipped black saxophonist wears a Star of David instead of a carnation in his tuxedo lapel. The saxophonist's red lapels, bow tie, hat-

141

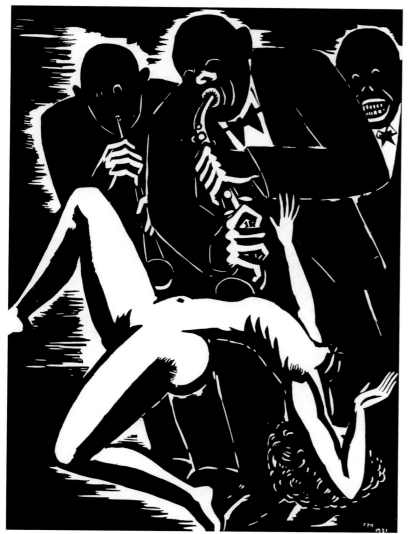

142

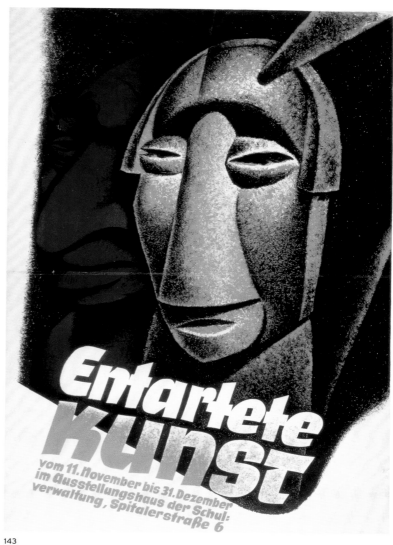

143

band, which all match the background, would have also signaled to the German public that this absorption of black culture was a Jewish-Bolshevik conspiracy. The racism underpinning this image is evident, but the image is not as extreme as an Expressionist woodcut by the Belgian artist Frans Masereel, whose woodcut novels were highly regarded by both the avant-garde and a wider public in Germany, although his work would later be dubbed "degenerate" and burned by the National Socialists. In Masereel's lewd print *Jazz* of 1931, three black musicians loom threateningly over the ecstatic nude body of a white female dancer who is being driven to a wild orgasmic state by the sound of their phallus-like instruments. Again, the image seems to reiterate stereotypes of primitive black sexuality, but the message is made particularly disturbing by the manic leer of the simian-faced black figure to the right of the central saxophonist; it is a racist depiction of the black as a predatory ape, reminiscent of the *Simplicissimus* Rhineland

142

see 131

terror image, although in this case the girl has been beguiled by the music rather than being dragged along by a captor. The image complicates our understanding of the intentions of more progressive artists in this regard and proves that they were also capable of perpetuating rather than challenging racist stereotypes, although an image such as this one would not have appealed to National Socialist thinking, as the white nude figure seems to be wantonly submitting to rather than resisting the power of jazz.

In the visual arts, Nazis objected not so much to African culture per se, but to the assimilation of what they saw as inferior non-Western cultures by German artists, in a way that they considered to be a contamination of German tradition, a point that is expressed on the pages of the program to the Degenerate Art exhibition of 1937–1938, which carry the slogan "A highly revealing racial cross-section" (Ein sehr aufschlußreicher rassische Querschnitt"). According to National Socialist ideology, German artists

had been encouraged down this path by a shadowy network of Jewish art dealers, something exemplified in Rudolf Hermann's poster for the Hamburg iteration of the touring Degenerate Art exhibition, which depicts a Shylock-like character lurking with intent behind the creation of a primitivizing *Head* sculpture. The visual message was that the Jewish dealer was a contemptible demonic figure who had seduced German artists into seeing the world unnaturally; some Faustian pact is thereby implied. The image is in keeping with Nazi propaganda that stereotyped Jews as rootless wanderers who, having no sense of *Heimat,* promoted assimilatory tactics in everything they did. The poster looks like a conflation of work by Otto Freundlich, Schmidt-Rottluff, and Otto Dix. The anti-Semitic aspect is drawn out by the fact that Hermann's lurking Shylock is curiously reminiscent of Dix's unflattering portrait of the Jewish art dealer Alfred Flechtheim. The narrow eyes and elongated nose of this imagined head sculpture negatively refers to "un-German" influences, such as the tribal masks of Oceania and Africa, particularly pertinent to the wood carving of Schmidt-Rottluff, whose work featured heavily in the Degenerate Exhibition as it toured German cities. A photograph taken in 1938 of Room 4 of the exhibition at the Berlin iteration clearly shows Schmidt-Rottluff's wood carvings and paintings displayed in close proximity to Nolde's *Mulatto* of 1913.

In publications such as Hans Weber's "Volkstum im Handwerk" written for *Die Kunst im Deutschen Reich* (1940), the author propagates the view that the use of "wood" as a craft material was most characteristic of the German race, arguing: "Only the Nordic race has achieved such perfection in the treatment of wood and only it possesses such a decided feeling for the beauties that lie in the material."[31] These assumptions were not so very different from the rhetoric of Weimar-era supporters of Brücke Expressionism, but

Weber's blinkered nationalism meant that he deliberately omitted from his discussion any other nation whose people had worked with wood, and especially the *Negerplastik* eulogized by modernists such as Carl Einstein. Furthermore, his celebration of German arts and crafts carefully avoided any mention of Expressionist woodcut and wood sculpture, which were viewed by many Nazis as "un-German" and highly degenerate precisely because of their indebtedness to African and South Sea island tribal art and artifacts.

The National Socialist response to the image of the black was often contradictory. While so-called unhealthy Expressionist artworks that were indebted to African and Oceanic art were ridiculed by the Nazis in the Munich Degenerate Art exhibition for, among other things, their racial impurity and for celebrating what was seen as an inferior non-Aryan culture, the "healthy" works of artists such as Werner Peiner were shown down the road at the official "Grosse Deutsche Kunstausstellung" in the Haus der Deutschen Kunst (now the Haus der Kunst). Peiner's triptych, titled *The Black Paradise,* depicting the East African Masai in an unspoiled landscape, was sold to Hitler after it was exhibited at the Haus der Kunst, and it was prominently displayed among other African images in the New Reich Chancellery in Berlin. On the one hand, it could be argued that the acquisition of such images was simply a process of publicly registering the regime's colonialist ambition; on the other, it seems that the National Socialists did indulge in escapist primitivist fantasies about exotic places that culminated in the heroic figure of the "blood and soil" native. Peiner's paintings of the Masai, created on trips to Africa from 1935 onward, particularly appealed to the strange aesthetic taste of Hitler and other National Socialists who viewed them as evidence of an East African master race, a formulation based on the Masai war-

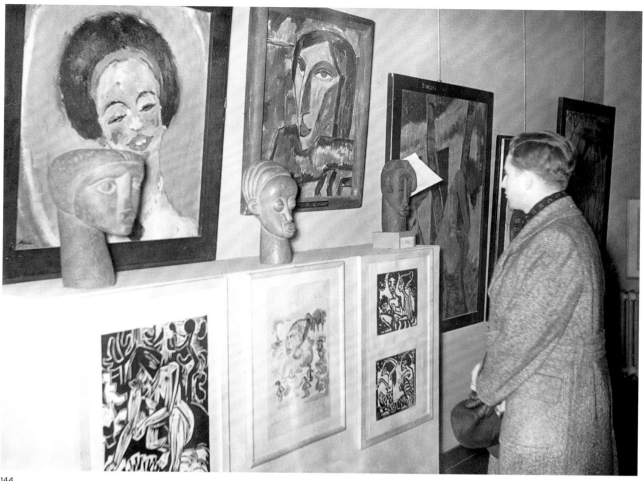

144

riors' alleged superior physical attributes in relation to other Africans. This was a deviation from the more usual negative National Socialist line on so-called alien races *(Fremdrassen),* but even then "primitive" art, whether African or Oceanic, was not always devalued and in fact often praised in publications such as *Kolonie und Heimat,* as an expression of purity and healthy tribalism, as long as indigenous artists remained faithful to their tribal heritage *(Stammesverbundenheit).* Such ideas had already been played out in the late nineteenth century and were adhered to by the likes of Emil Nolde, irrespective of the hybridity of his own art. This all becomes less paradoxical if we consider the Nazis' obsession with typology and ethnography and their celebration of regional peasant life. In this respect it is interesting to compare *Kolonie und Heimat* with the work of the photographer Erna Lendvai-Dirksen, commissioned by the Nazis to produce photobooks of Aryan types, such as *Nordsee Menschen* and *Das deutsche Volksgesicht,* in which portraits of regional farmer types were also depicted as representative of their *Stamm* (their tribe).

The German film director and photographer Leni Riefenstahl, a close associate of Hitler who produced documentary films for the National Socialist Party such as *Triumph of the Will* (1935) and *Olympia* (1938), the latter known for its highly aestheticizing approach to the human body (specifically the "Aryan" body), continued her focus on the beauty of physique in her still photographs of Masai and Nuba tribes, especially in her publications *The Last of the Nuba* (1973) and *The People of Kau* (1976). Susan Sontag argued that these images, produced some time after the Second World War on various long trips to Africa, reveal that Riefenstahl continued with rather than broke from Fascist master race aesthetics in that she was primarily concerned with a primitivist "Noble Savage" ideal. That this ideal was based on the athletic build, beauty, artistic temperament, and strong sense of spiritual relations of a black African tribal community, rather than an Aryan people, did not, according to Sontag, detract from the fact that they evoked "some of the larger themes of Nazi ideology."[32] Sontag suggested that Riefenstahl's photographs celebrate the ways "the Nuba are exalted and unified by the physical ordeals of their wrestling matches, in which the "heaving and straining" Nuba men, "huge muscles

145

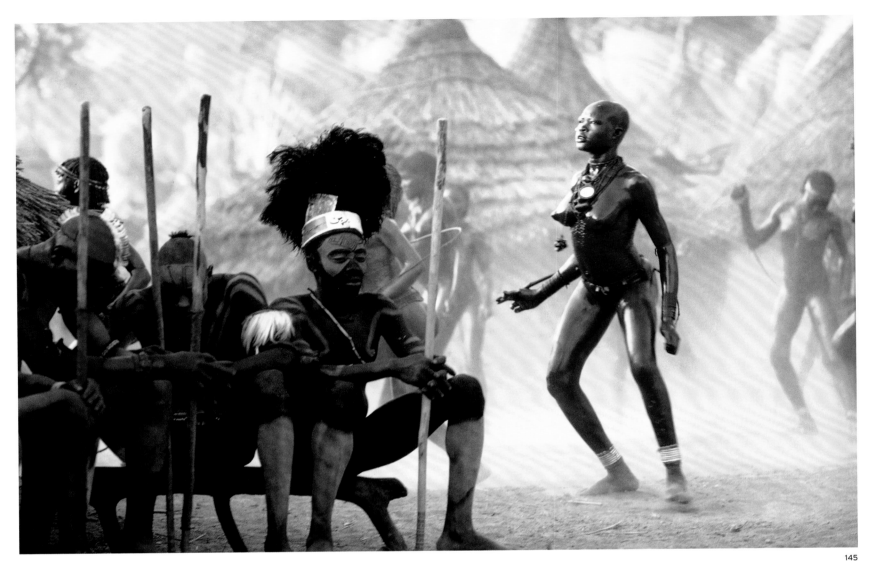

145 Leni Riefenstahl. *Libestans*. 1975. Reproduced in Leni Riefenstahl, *The People of Kau* (New York, 1976).

bulging," throw one another to the ground—fighting not for material prizes but "for the renewal of the sacred vitality of the tribe."[33] One can only speculate that this underlying Fascism was what Gerhard Richter was trying to expose when he used a "found" image of wrestling Nuba for one of his blurry photo paintings *Negroes (Nuba)* in 1964. It is not certain whether this image was based on a Riefenstahl photograph, but it clearly brings to mind her work, and it might be that Richter, like other post-1945 German artists who attempted to deconstruct National Socialism, was alluding to a repressed Nazi history. Given the complexities of the National Socialist response to the image of the black, it is a history well worth deconstructing.

10

PAINTED BLACKS AND RADICAL IMAGERY IN THE NETHERLANDS (1900-1940)

ESTHER SCHREUDER

Though the Netherlands may be a small country, it is important from the point of view of the African Diaspora and the representation of blacks in art. This is particularly true of the Negrophilia phase in the years following the First World War period. There are also significant differences between the Netherlands and other European countries as a result of its particular colonial history, culture, ethnicity, language, and politics.

At the beginning of the twentieth century, the Dutch ruled over the Netherlands Antilles and Surinam in the Caribbean, and over the Dutch East Indies, now called Indonesia. Unlike Germany, France, and other European countries, the Netherlands had no colonial ties with black Africa, but there were close ties with white Africans. The Boers or Afrikaners in South Africa were seen as *stamverwanten* (people from the same tribe). Hendrik Verwoerd, born in Amsterdam in 1901, moved with his family to South Africa, where, inspired by Hitler during a stay in Germany, he became the principal architect of the apartheid system. A further distinctive feature of the Netherlandish situation was that in the nineteenth century, the Dutch tended to focus inward, in the arts as in other fields. With a few exceptions, remarkably little attention was paid to people of African descent in the visual arts.[1] In the twentieth century this would change under the influence of pioneering artists, black intellectuals, and

international contacts; political and artistic revolutions were in the air.

Negrophilia in the Netherlands

Though the height of the Negrophilia period in Holland was in the mid-1920s and 1930s, it took off earlier, judging from the coverage in Dutch newspapers and magazines. In the newspapers from 1900 until 1940 the word *neger* increases in frequency from about 1910, declining a little during the war, and then rapidly increasing to its high point in the 1920s.[2] By far the most prominent subjects in the news were lynchings, followed by black boxers, black entertainment, and race issues in the United States. The Dutch colonies in the Caribbean, Africa, and European blacks generated far less news.

Several articles were written on Harlem, and the craze for all things black in Europe. Jeanne Kloos in 1929 wrote in *De Nieuwe Gids* an article titled "Black Magic," which looks with a humorous and critical eye at Negrophilia in the Western world:

Oh, that black magic . . . which about the year 1902 began to bewitch us with the cakewalk, and all its power stretched farther and farther, until we now, surrendering defenseless, find

almost our whole life to be decorated in the fashion of the "Negro." "Notre âge est un âge nègre," Paul Morand has one of his people say. Unfortunately he is right! . . . In 1914 the Senegalese troops marched along the Parisian boulevards; Darius Milhaud came in 1919 from Brazil and introduced the Negro sambas in his *Boeuf sur le toit.* In 1920, jazz music conquered all bars. . . . What will be the end of this "social mystère," as Carl van Vechten calls it.[3]

The article talks of the admiration for everything black, listing twenty-eight "black countries" of which only the island of Curaçao is Dutch; there is nothing about Surinam or the other Dutch Caribbean islands.

Shortly afterward the magazine *De Groene Amsterdammer* devoted an entire issue to the phenomenon, titled "Het groote Negernummer" (The great Negro issue). A little attention, primarily ethnographic, is paid to the Dutch colonies; the bulk of the content is, however, devoted to black American culture and "old" African art objects. There is a critical essay on old and new "Negro art" mentioning Archibald Motley and Aaron Douglas, a piece on a performance of Eugene O'Neill's play *The Emperor Jones* starring Paul Robeson, a story on jazz, pieces on W. E. B. Du Bois and other black writers, a story about spirituals, and an article titled "White American versus Black American." A piece about heavyweight champion Jack Johnson addresses the subject of blacks in sports, and there is a story about the actor Daniel Haynes in the film *Hal-*

lelujah. In this last article, the film critic L. J. Jordaan concludes on Negrophilia in the movies: "It will be apparent to all that in this film *negrerie* has nothing to do with the Negro-movie. In accordance with the fashion of the times the Negro is now romanticized and sentimentalized . . . in other words humiliated—as always. . . . When will the true Negro movie appear? When will we see the expression of the black artist's own life in film? . . . The talkies have discovered that the Negro possesses a voice. Will they ever acknowledge that he has something to say?"[4] The magazine also contains translated poems by Claude McKay, Frank Horne, and Langston Hughes, and the renowned art critic Albert Plasschaert devoted a double page to Dutch artists who were painting "Negroes," subtitled "An Art That Can Be Full of Meaning."[5]

Dance and Music

The first signs of emergent Negrophilia can be seen around 1900 when artists in the Netherlands were fascinated by the exoticism of groups of female dancers that were touring the country. They included an "Ashanti Caravan," and the artist Isaac Israëls followed this group from city to city, filling several books with drawings of dancing women and the drummers who accompanied them. As an Impressionist he sought to capture African gestures. Repeatedly, in an almost obsessive manner, he made studies of their uninhibited and trancelike movements, sometimes concentrating on a particular dance position.[6] The drawings foreshadow the strong effect that

146 L. J. Jordaan. *Black Shadows.* Netherlands, 1930. "Het Negernummer," *De Groene Amsterdammer weekblad voor Nederland* (19 April 1930), p. 7. Amsterdam, De Groene Amsterdammer.

147 Isaac Israëls. Ca. 1900. The Hague, Gemeentemuseum Den Haag.

147

black dance and music would have on the next generation of modern Western artists and fashions.[7]

Israëls's younger colleagues Kees van Dongen, Jan Sluyters, and even Piet Mondrian also felt this fascination for black dance, dancers, and music, and developed it further during their transformation from academic and Impressionist to modernist painters. Mondrian was himself a passionate dancer who saw modern life and feeling expressed in the *mating dance,* as he frequently discussed in his theoretical writings. Later in his career he would also write about jazz and Neoplastic painting, which were, in his words, "extremely revolutionary phenomena: they are destructive and constructive. They don't destroy their personal content of form: they only deepen form, to lift it to a new order. They break the unity of 'form as separate nature' to make universal unity possible."[8]

Jan Sluyters

After his classical art training in the Netherlands, Sluyters won the *Prix de Rome,* which gave him a chance to go to the Italian capital in 1906. He ignored the wishes and advice of his Dutch teachers and went to Paris instead, where he discovered Paul Gauguin, Pablo Picasso, and the Fauves Henri Matisse and Kees van Dongen. Inspired by what he had seen in Paris, especially the dancers

148

of his compatriot Van Dongen, he started to paint around 1910 his *Groene danseres/Dansende negerin (Green Dancer/Dancing Negress).*[9] The challenge in this painting was not to catch the movement or the moment, as Israëls had sought, but the colors and the emotion behind them. The body of the dancer is completely green, and her legs seem to move as if detached from her body in an almost abstract landscape. He probably altered the background of the dancer in the following years, as his color combinations and compositions became more daring.[10]

For Sluyters, color was a way of transmitting his experience, whereas for Mondrian it was a means toward a higher universal

spiritual level.[11] Mondrian followed the path of cubist deconstruction toward abstraction, Sluyters the possibilities in Cubism's deformations, Futurism's speed and movement, and Expressionism's use of colors and material. Only a few of Sluyters's works moved near to abstraction in 1914.[12]

Boxers

In the same year Sluyters exhibited *Negro Boxer,* which was a return to realism.[13] He experimented with the complexion of a fierce-looking man, his character, and the surroundings. His skin is

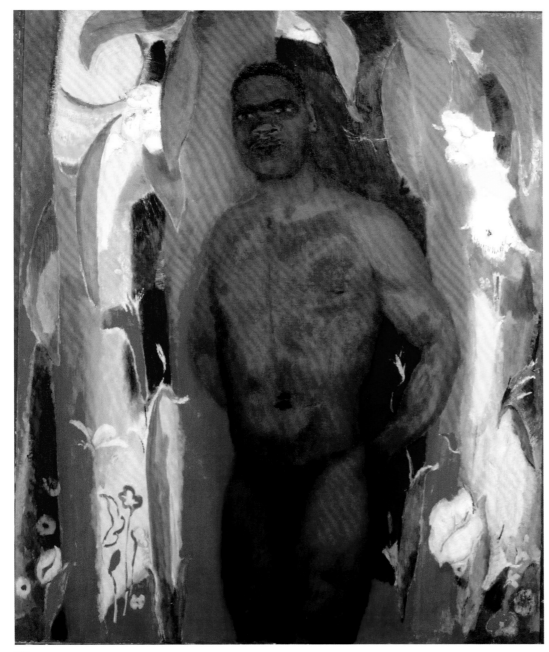

149

148 Jan Sluyters. *Green Dancer/ Dancing Negress.* ca. 1910. Private collection, Family Sluijters.

149 Jan Sluyters. *Negro in Jungle.* 1915. Utrecht, Collectie Centraal Museum.

brownish green, he is dressed in a shiny yellow loincloth, and he is standing with his fists between crooked red curtains, against a blue background. The work immediately attracted the attention of critics. Cornelis Veth wrote, "This painting boils and bubbles, there is passion, love or hate, it does not matter which. There is not a well-painted piece here, it's not sketchy, nor good, it's brutal but it has a witty brutality."[14] Just Havelaar wrote in 1919, probably about this work: "It is not a psychological portrait of an individual, but the idea of brute animal manpower is expressed synthetically."[15]

Even more exciting than *Negro Boxer* is a work he painted a year later, *Negro in Jungle,* in which he seems to embrace the revolution-

ary new works of Kandinsky, Die Brücke, Gauguin, and Matisse.[16] Only he paints not a graceful nude in a decorative space, but a large, black, very muscular, completely naked man, with blue lips.[17] The colorful background and the powerful brown figure clash to such an extent that, Havelaar concluded in his book on Sluyters, this work was even closer to the idea of brute animal power because Sluyters abandoned some pictorial beauty and textural illusion.[18]

Van Dongen and Sluyters shared a love for popular culture, theater, and especially boxing. Either Sluyters was inspired by Kees van Dongen's *Jack Johnson* of ca. 1914 or vice versa. This painting is

149 150

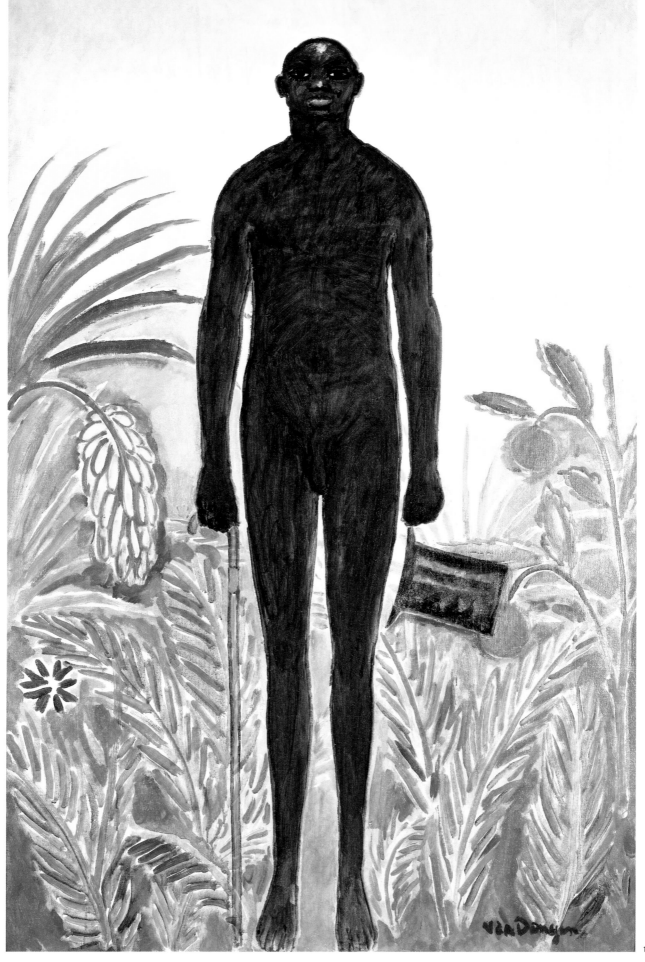

150 Kees van Dongen. *Jack Johnson*. Ca. 1914. Monaco, collection Palais Princier.

151 Jan Sluyters. *Little War's First Birthday (Oorlogken is jarig)*. 31 July 1915. Amsterdam, De Nieuwe Amsterdammer.

also known as *The Morning Walk,* and is inscribed on the back: "There is no justice for me in America after beating Jeffries."[19] The work shows a naked Jack Johnson with a top hat and walking stick: a man of humble origins with considerable personal dignity. His body is a flat black surface with a red outline, in a subtropical landscape. It is a work of provocation, in the spirit of Johnson himself.[20]

In this period Johnson dominated international and Dutch newspapers. Because of his refusal to play by the white establishment's rules in the United States, he was forced to flee to France. However, unlike Van Dongen's painting, Sluyters's boxer seems not to be Johnson, but a composite of all the famous black boxers of the time: Johnson, Joe Jeanette, Sam Lanford, and Sam McVey.

It is possible that *Negro in Jungle* also expressed shock at what humanity was capable of in the era of modernization. The horrors of world war seemed to affect Sluyters deeply, and he was greatly and determinedly opposed to militarism. The year that Sluyters painted *Negro in Jungle,* he also designed cartoons for the left-wing weekly magazine *De Nieuwe Amsterdammer,* including an allegorical lithograph, *Little War's First Birthday,* commemorating the first

year of war. It contains three figures: Mars, the god of war; a one-year-old child; and the child's mother, also symbolizing Death. The heavily armed Mars has the features of a black man, exaggerated, however, for effect; face and body are displayed in extreme proportions. Sluyters's cartoons are clearly meant to evoke unease and even horror.[21] In both works, the painting and the lithograph, the black man seems to stand for Manhood or "brute animal power," in Just Havelaar's words.

Sluyters was never attached to a political organization or art movement, yet he designed at least two lithographs in the *Nieuwe Amsterdammer* that are unmistakably anticolonial, and many of his works are antiwar and hostile to the president of the United States at the time, Woodrow Wilson.[22] *De Nieuwe Amsterdammer* took a radical and anticolonial stance in its critical comments on the situation in the Dutch Indies (Indonesia) and on the position of blacks in the United States.[23] In one lithograph, which parodies the story of Samson and Delilah, the elegant, naked white seductress is the League of Nations, who, prompted by President Wilson (hidden behind the curtain), prepares to betray the unsuspecting

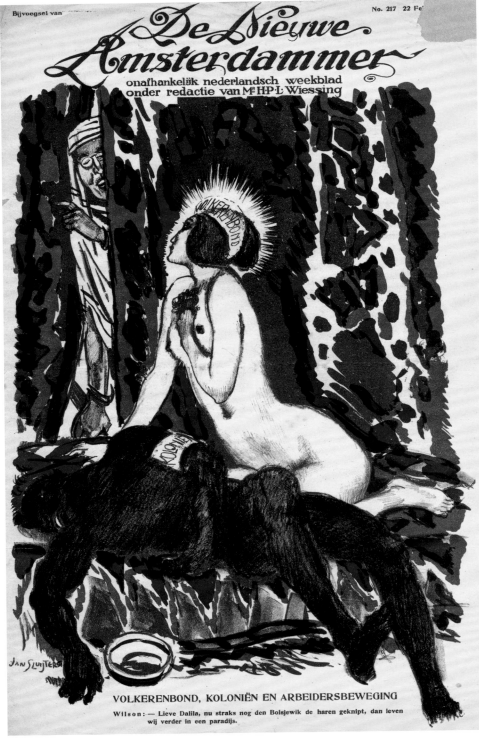

152

and defenseless black figure, who personifies the colonies. And an inscription beneath says: "Dear Delilah, soon cut the hair of the Bolshevik, then we go live in paradise."[24]

152 Sluyters made more than fifty works in which black people play a leading role. Most are individual portraits of fashionably dressed men and women, differing from each other in character, style, and emotion.[25] His real muse was Tonia Stieltjes, born in Amsterdam in 1881 of a mixed marriage, who led him to extend his range by making strong contrasts between colors and her own somber appearance.[26] Sluyters regarded his *Portrait of Tonia Stieltjes* to be one of his best. She is very elegantly dressed in black, and her face is covered in white powder. He borrowed the work back regularly for 153

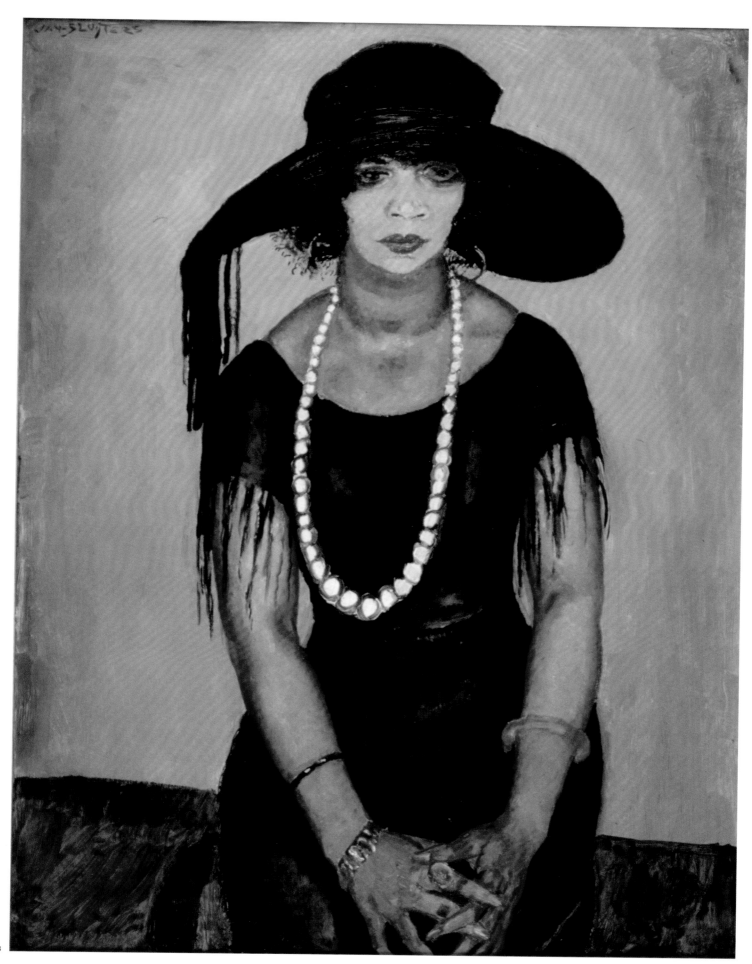

exhibitions and recommended strongly that it not be varnished, making it notably subdued among his works.[27]

Carel van Lier and Non-Western Art

Sluyters was, like many other modern artists, a collector of "primitive" art. He bought most objects from the art dealer Carel van Lier, who ignited his love for sculptures from the Ivory Coast and Congo.[28] Van Lier showed in Kunstzalen Van Lier (opened in 1927) Dutch and international modernist artists alongside Asian and African classical art, arousing the interest of Dutch artists, the press, and museums in the latter.[29] He also showed unknown contemporary artists and art from non-Western countries such as Ronald Moody, the Jamaican sculptor (see chap. 11). Van Lier had seen Moody's *Wohin* (1935) in England at the home of a friend, the writer and actress Marie Seton. He contacted the sculptor and showed Moody's work in Amsterdam after the Paris show at gallery Billiet in 1938.[30] The exhibition was a success, and Moody and his wife, who lived in England, were invited to stay at Thedinghsweert at the invitation of Annie van Beunigen-Eschauzier, and Ronald Moody was asked to make new work on commission.[31]

Irma Stern, an Artist from South Africa

Another contemporary artist of non-Western background, the South African–born artist Irma Stern was featured by Van Lier in 1930. She chose to exaggerate her African roots, commenting, in the catalogue of an exhibition in 1919 at the Gurlitt Gallery in Berlin, "These works partly come into being in the Transvaal, the artist's home, during the years in 1913 to 1918" though in reality she was brought up, between 1901 and 1920, in Germany. She only re-

turned to South Africa for good after the First World War, in 1920. She was then twenty-five years old and had spent only seven years in her country of birth. She was always torn between the worlds of Europe and Africa.[32]

She showed one of her finest early works, *Drei Swasi Madchen/ Three Swazi Girls* in 1925 at the Van Lier Gallery.[33] Stern recalled meeting the girls while traveling in South Africa: "Today I accepted an invitation to Swaziland. The car drove through lonely regions to an isolated village consisting of only a few huts. And here in front of a hut I found three girls of a magical, colourful loveliness, which I immediately tried to capture. They reminded me—I don't know why—of three rococo girls—they stood pressed close together—all three of them had their hair cut in the same way and colored with white chalk—colorful cloths wrapped round their bodies, their slender wrists and ankles encircled with a touching thread of colored wool, the same color which I found at the throat—they were dainty and graceful—and I thought that I had never seen so much beauty together."[34]

The three gracefully intertwined girls with their seemingly fashionable hair look slightly suspiciously at the viewer. The style of the painting resembles the work of Stern's friend and mentor, Max Pechstein, and of other Brücke artists, with bright colors, broken lines, and distorted figures, as Dutch critics of the time noted.[35] But the feeling and atmosphere that this work and other works by Stern express is unusual.[36] Unlike the works of the German Expressionists, almost all her black and other models look aloof, distant, sometimes even hostile, and arrogant. Whether this reflects Stern's moods or those she observed in her models is not entirely clear.[37] Perhaps related and also not clear is her position in relation to apartheid; it has long been disputed in South Africa and Germany. Irene Below concludes that Stern never openly protested against

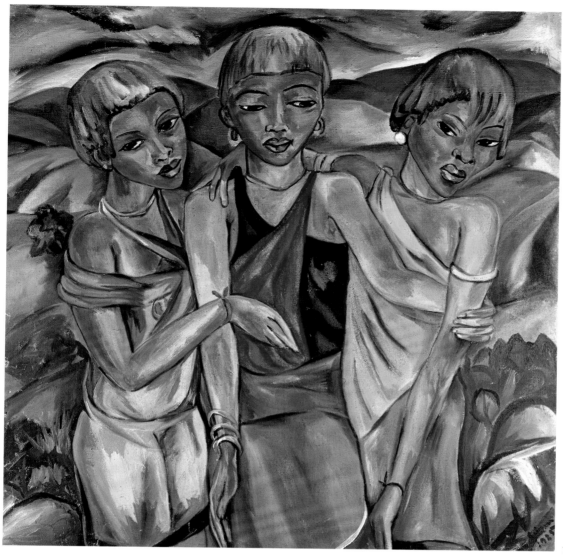

154

apartheid and that she never challenged the colonialism and paternalism of the white Afrikaner government, though whether out of indifference or fear—she was, after all, Jewish—has never been established.[38]

In 1930, Dutch critics were not charmed by her work and focused on the feminine features they thought they saw.[39] The well-known and highly regarded art critic and future museum director Jos de Gruyter had more interest in the African art that was shown in the galleries below her exhibit.[40] He wrote, "Maybe it was to Irma Stern a misfortune that an exhibition—in her honor—also contained some Negro statues in the lower room of the gallery. Instinctively one then compared and committed injustices. . . . Because it may not be necessary to point out that part of the current interest in Negro art is not entirely healthy. . . . This art, dark, fatalistic and without the grace of intelligence, without the tenderness of eroticism, without the bloom of a vast, complicated awareness,

this art . . . [has] an intensity and immediacy that often amaze. . . . What tension in these forms, what tension in these contours, what a fierce expression, especially in the head and arms! And we have long forgotten Irma Stern and Gauguin himself."[41]

In 1938 Stern was admitted as an artist in an exhibition aiming to be an overview of Dutch art and their kinsmen in Belgium, Dutch East Indies, and South Africa. By that time, Stern had broken all contacts with Germany because of the takeover of the Nazis and the persecution of the Jews. Her art, like that of her Expressionist colleagues, was regarded as degenerate.[42]

Anton de Kom

Visual artists from Surinam and the Dutch Antilles or black artists from South Africa were hardly visible in the Netherlands between 1900 and 1940,[43] but black writers from the West Indian colonies

155

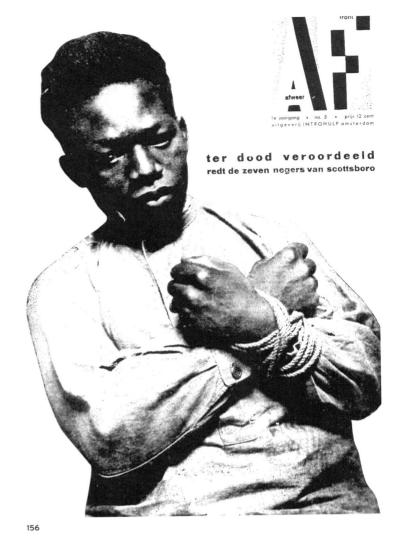

ter dood veroordeeld
redt de zeven negers van scottsboro

156

155 Cas Oorthuys. *Adekom, Scotsborough, Negro Number Links Richten.* 1932. Amsterdam, collection of Carl Haarnack.

156 Cas Oorthuys. *AF/Afweerfront. Afweerfront.*

157 Piet Zwart. *We Slaves of Suriname.* 1934. The Hague, Gemeentemuseum Den Haag.

and the United States were very influential in those years.[44] Anton de Kom, a writer who was born in 1898 in Surinam and moved to the Netherlands, promoted knowledge of the history of Surinam and its black heroes. He raised awareness of Surinam's problems, especially the situation of the Javanese contract workers, who worked on the plantations in very poor conditions. In the 1930s, he became a communist fellow traveler, sharing the goal of reaching out to oppressed workers throughout the world, and allying with victims of colonialism.[45]

In 1932, De Kom moved back with his Dutch wife and children to Surinam, where he was shortly after arrested. The magazine *Links Richten* drew attention to his imprisonment in Paramaribo in

its ninth issue, *Adekom, Scotsborough, Negernummer* (Negro number). It included a passage from De Kom's forthcoming book, *We Slaves of Suriname;* an excerpt from the book *Because I'm Black* by the French journalist Magdeleine Paz; and a poem by Langston Hughes.[46] Three of the twenty contributions deal with De Kom and Surinam; for the most part, however, the magazine deals with the Scottsboro trial and lynchings in the United States. On the cover is the portrait of a man with a distinct resemblance to De Kom, though in fact another individual—probably the man illustrated on the cover of the "Scottsboro" special edition of *AF/Afweerfront* (Defense front) in 1932. The Scottsboro trial case, in which nine black youths were accused of raping two white women in Alabama

155

157

158 Piet Zwart. *Portrait of Anton de Kom*. 1933. Rotterdam, Fotomuseum.

159 Nola Hatterman. *On the Terrace, Jimmy van der Lak*. 1930. Amsterdam, Museum Amsterdam.

in 1931, was front-page news in the Netherlands.[47] The evidence for charges was extremely doubtful, and witnesses were found to have lied, and all but a twelve-year-old were convicted of rape and sentenced to death. The case was given huge publicity by a campaign organized by the international, American, and European Communist Parties and organizations, sponsored by the Comitern in the USSR.[48]

Both Dutch Scottsboro covers are the work of the Communist photographer, illustrator, and graphic designer Cas Oorthuys, who belonged to the *Arbeidersfotografen* (the Worker-Photographers) and whose work was inspired by AIZ *(Arbeiter Illustrierter Zeitung/Workers Pictorial Newspaper)*. This group regarded the camera as a weapon in the class struggle, and Oorthuys was much influenced by the Russian photographers Alexander Rodchenko and El Lissitsky and the radical German photomontage artist John Heartfield. Oorthuys's design for the *Links Richten* cover is the avant-garde style of the Russian Revolution, with dynamic and simplified picture doubling. The man's head, floating in space, is cut obliquely, and in the photograph of the same man on the *AF/Afweerfront* cover his body is visible, and his hands, tied with a rope, show him acting as a prisoner.[49]

We Slaves of Suriname

Anton de Kom's return to the Netherlands from Surinam in 1933 made the front page of the Communist newspaper *De Tribune*, and more than two thousand people welcomed him when his ship docked in Amsterdam.[50] In the meantime, Europe had changed. The persecution of Jews in Germany had begun, and many German Jews, communists, and artists fled to the Netherlands.

De Kom published in 1934 his book *We Slaves of Suriname,* a historical study, personal statement, and political manifesto, which promoted black self-awareness, organization, and proletarian unity.[51] The typographic pioneer Piet Zwart designed the cover on de Stijl and constructivist principles. In general, such innovations in photography were led by designers and typographers, who introduced photographs as visual elements in advertising. They were also influenced by Russian cinema with its use of "bird and frog perspectives" and extreme close-ups. In his writings, Zwart insisted on the artistic and social significance of the "new photography" and proclaimed "picture vision" as a new view of the world.[52] In the middle of the cover design, following photomontage principles, is the portrait of a stern-looking De Kom, surrounded by a montage of several vignettes of other Surinamese.

The publisher in the end chose a simplified version, with only the central photograph by Zwart of De Kom, in an extremely sharp close-up. De Kom himself was not satisfied with this cover and complained about it to a friend.[53] The publisher probably rejected the original cover because he either wanted to focus on De Kom or to distance the cover from a style associated with Communist propaganda. Throughout the process of publication, both the Communist organizations and the Dutch secret service tried to influ-

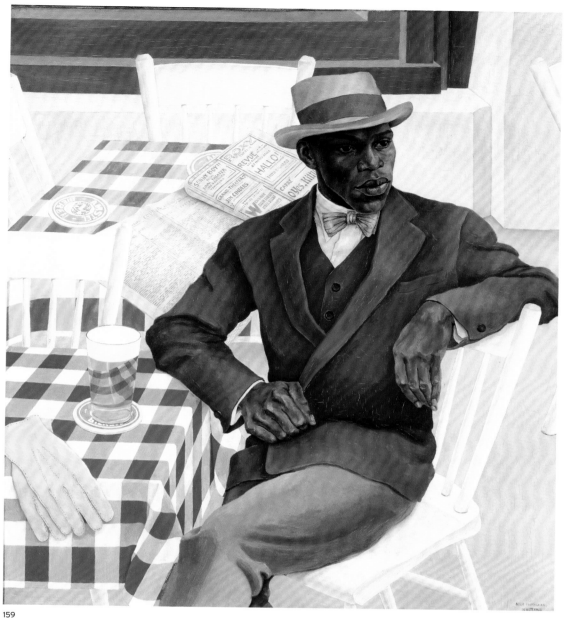

159

ence the outcome—the former to create a manifesto, the other to prevent it from being too anticapitalistic and anticolonial, but this struggle only gained free publicity for the book, which sold well. Despite the book's success, De Kom himself could not find work, and he became disillusioned with Communism. He wrote for the resistance in the Second World War and died in a concentration camp shortly before the end of the war.

Nola Hatterman

The painter Nola Hatterman admired Anton de Kom immensely and worked for a while with him. They met through the Surinamese Otto Huiswoud, who had been the only black cofounder of the

American Communist Party.[54] Huiswoud spent some time in the Netherlands, where he published the *Negro Worker,* to which both De Kom and Hatterman contributed. In interviews, Hatterman claimed to have painted black people all her life, but in fact she began doing so in 1927 when she showed a work with the title *Kleurling* (Man of color) that was well reviewed. It was illustrated with the review. Unfortunately, it is now one of many works from that period that are lost.

Not lost, however, is *On the Terrace, Jimmy van der Lak (Op het terras),* and this work can now be called one of the finest examples of the Dutch new objectivity school, in its smooth brushwork, distorted perspective, and psychological distance. There is much attention to objects such as a glass of beer.[55] The artist claimed that

159

the Amstel brewery had ordered a painting of a well-dressed man with a beer on a terrace. The brewery did not specify that he had to be white, and the contract was canceled when they saw the work. The man in the picture is Jimmy Lucky or Jimmy van der Lak, his Dutch name. In the background are newspapers advertising American theater and musical productions, for black Surinamese were often expected in Holland to act as if they were super-cool New Yorkers from Harlem.[56]

For Hatterman, black people were at first principally an engaging subject that fitted the style she was working in. Later, they also took on a political symbolism, especially in the 1930s. She attributed her love for the Surinamese to the colonial past of her family in the East Indies and to her rebellion against the position of women. And Hatterman found the Surinamese not only physically but also socially attractive, feeling more comfortable in their company than with white Dutch people. She even expressed a desire to be black herself. A poem from 1953 talks too of her last wish—which was in fact fulfilled.[57]

> One day I will die
> No one knows when
> And I do not know where
> But I wish that
> When the day is there
> Surinamese ground will absorb me
> And black hands will bury me.[58]

She went to Surinam in 1953 and founded an academy of arts education similar to Edna Manley's in Jamaica. For her, the bond of affection with black people was not a passing fancy but a lifelong commitment, which she honored to the end.

Conclusion

Many factors influenced the development of Negrophilia in Holland. Though it was influenced by artists in Paris and Berlin, New York was equally important, whereas the Dutch colonies attracted relatively little attention. The people of the colonies who came to the Netherlands were eagerly used by artists as models, but they were overshadowed by the legendary blacks associated largely with New York's Harlem: the boxers, writers, musicians, and entertainers. These included Paul Robeson, who was mentioned at least 720 times in the Dutch papers in the 1930s, and Josephine Baker, who was mentioned at least 829 times in the 1920s. Artists including Jan Sluyters, Kees van Dongen, and Nola Hatterman were guided in their choice of black subjects by revolutionary tendencies in politics and art, and they created compelling and unique works. The success that Van Dongen and Sluyters had with their work inspired other artists to paint African themes, among them Hatterman, for whom they became, after 1930, her main subject.

III

Beyond Europe:
The Caribbean and Latin America

11

THE IMAGE OF THE BLACK IN TWENTIETH-CENTURY ANGLO-AFRO-CARIBBEAN ART

PETRINE ARCHER

This chapter considers the art and histories of the English-speaking islands of the Caribbean—Jamaica, Trinidad, Barbados, the Bahamas, and mainland Guyana—in addition to the French-speaking Haiti, Martinique, and Guadeloupe.[1] Presenting them thematically and mostly chronologically, it ties the work of these islands and their artists into a larger theoretical framework related to colonization, creolization, modernity, memory, identity, and, ultimately, "home."

Any discussion of how the black image became prominent in the art of these islands is a complex exercise that calls for an understanding of the region's shifting power relations, its tangled historical beginnings, polyglot communities, distinct colonial legacies, and artistic traditions. Although all the islands have similar aboriginal beginnings with a shared native Indian heritage, the more recent history of art in the Caribbean has numerous stylistic threads and cultural quirks related to the tangible realities of colonialism, slavery, and indentured labor. The region's fragmentation makes any art survey challenging and a single narrative questionable.[2] Indeed, it is essential to explore the Caribbean visual arts comparatively to better understand the region's sense of place and collective identity. This then is a postmodern narrative that highlights the work of artists who for just a century have been applying themselves to a process of excavation and recovery.

Caribbean art today is the outcome of this search for identity. It is the result of the creativity and invention of artists who have no recourse but to validate their past from a vantage point in the present. In the face of colonial exclusion and invisibility, their art represents an attempt to reenvisage the past and the black self in a likeness that can best represent their experiences of "arrested development" and survival.

This chapter mirrors the Caribbean artists' methodology, which skips between past and present and fills the gaps of memory with the products of their imagination. Marrying history and twentieth-century imagery seems appropriate now because so much of the region's contemporary art foregrounding the black image is preoccupied with the retelling of history and reconstructing the past.[3] As cultural theorist Stuart Hall points out, Caribbean identity is "always a question of producing in the future an account of the past."[4]

The Caribbean formed part of what has been called "Plantation America," the vast swathes of land repopulated with Africans shipped in the millions mainly from West and Central Africa to work as slaves.[5] This forced migration was both traumatic and transformative. Depicting this Middle Passage journey is almost a rite of passage itself for artists in the Caribbean Diaspora who use memory to reimagine its horrors. This is the route navigated by Maria Magdalena Campos Pons, Keith Piper, Charles Campbell,

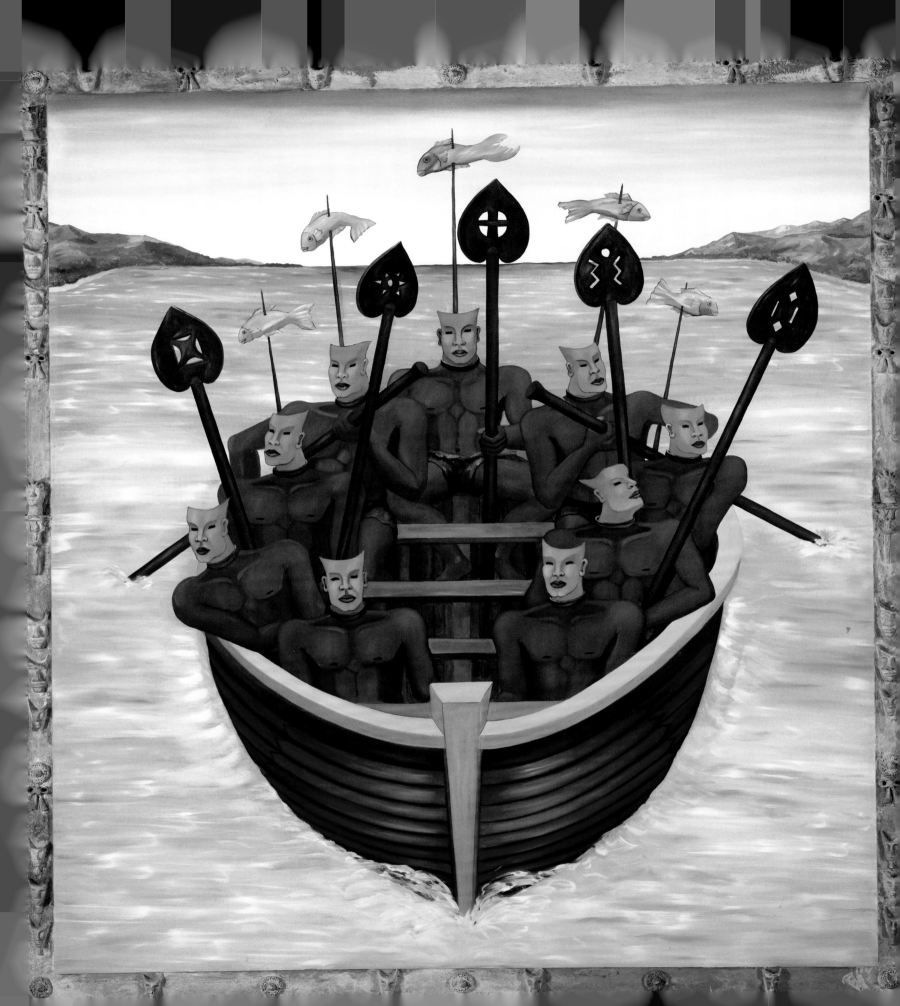

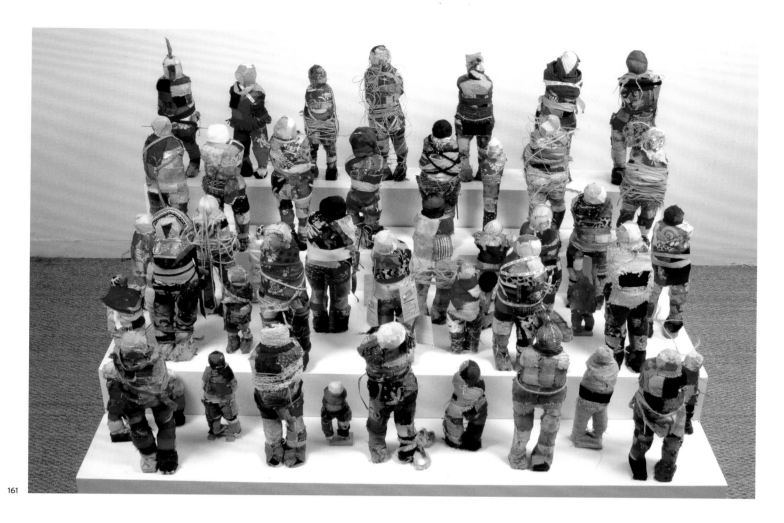

161

160 Edouard Duval-Carrie. *Retable des 9 Eslaves* (central panel). 2008. Little Haiti, Miami, collection of the artist.

161 Alex Burke. *The Spirit of the Caribbean*. 1999. Paris, collection of the artist.

David Boxer, Kcho (Alexis Leiva Machado) and Edouard Duval-Carrie, and Thiery Alet. Rafts, boats, ships, or just the vicissitudes of the ocean all prefigure in their "rememberings," which recount this narrative of displacement so central to any understanding of the Caribbean's black identity. Only rarely is that journey envisaged in terms of drowning; rather, vessels are wombs for rebirth and spiritual awakening. Edouard Duval-Carrie's *Retable des 9 esclaves* (2008) *(Altar for 9 Slaves)* depicts slaves as boat people in a modest canoe rather than a slave ship. As blue-faced voodoo gods, they are steering their own vessel and in charge of their own destiny. The centerpiece of this nine-paneled altar is surrounded by portraits in which the slaves are represented as winged angels grappling with the vagaries of a new land.

Alex Burke's *The Spirit of the Caribbean* (1999) is more macabre. Removing any sense of physical agency, he presents human forms that are tightly bound with scraps of colorful cloth. The mummified forms are faceless, armless beings. Unable to cry, fight, or

swim, they are propped up or laid out in ways that suggest their densely packed passage west. Despite being mute, these oversize voodoo-like dolls radiate an immutable presence because of their refusal to be silenced or just die. In this defiant zombie-like state, they share a haunting sense of spiritual survival and continuity.

The Middle Passage represented a rupture and slave-ship re-birthing into a life of compromise and despair, accommodation and survival. The contingency of slaves' New World lives shaped their formation of imagined communities and identities based on transposed cultural forms and a forced consciousness of their race and its restrictions. As a result of this wrenching, a return to an African homeland would be impossible. The rigors of plantation life undermined the slaves' creativity in textile making, carving, and pottery, a creativity that might have sustained their links to Africa. Within generations, they could no longer trace a direct line to an African past, save through the intimacy of their spiritual lives. In Haiti, this became increasingly important, as Christian

rituals were displaced by African ones that allowed for Vodou and alternative belief systems. Other islands shared similar rituals but with different names, such as Obeah in Jamaica and Trinidad or Santeria in Cuba.

Slaves, as a silent black majority ruled by a white and later a colored minority, were outwardly forced to embrace their new Caribbean environment and creole citizenship that was syncretic and heavily influenced by their European colonizers. Photographer Leah Gordon has reenvisioned the deeply racialized, hierarchical system that governed the daily fortunes of black people in Haiti before the revolution. She calls the series of photographs *Caste* (2010), referencing the classification system introduced by French colonialist Moreau de Saint-Méry, with categories ranging from *Noir* through *Sacatra, Griffe, Marabou, Mulâtre, Mamelouque, Quarteronnée, and Sang-Melée* to *Blanche:* varying shades of blackness that carried with them physical, moral, and intellectual attributes. Her images are beautiful, almost stately forms that confound their historical origins. Gordon uses contemporary models dressed in historical garb against stark backgrounds that parody famous Renaissance portraits but also belie the rudimentary conditions in which they were created in post-earthquake Haiti. "We did the shoot in a slum," she said. "It looks so neat in the photos, but the set was made from an old trestle table, some models had to stand on blocks, and the backdrop kept blowing away. Amazingly, the camera created these beautiful moments of peace amid all that."

Haiti's caste system with its "nine degrees of the skin" was mirrored throughout the region, only with different nomenclature that ensured that black skin remained a mark of inferiority and even bestiality. The grinding poverty, sense of displacement, existence on the lowest rungs of society, and desire to return to Africa deterred the ex-slaves' identification with the Caribbean as home.

Sugar Cane Alley (1983), the Martinican film directed by Euzhan Palcy set in the 1930s, graphically depicts how an older generation of Africans still pined for their motherland even as they slaved to secure a place for their children in French society. The traditional *cric-crac* story exchanged between young Jose and his mentor Medouze keeps alive the memory of revolt and the frustration of assimilation:

> We were sold to cut cane for the whites, crick crac
> I was a young boy like you Medouze
> All the blacks came from the hills with sticks
> Machetes, guns and torches
> They invaded the town of St. Pierre
> They burned all the homes
> For the first time, blacks saw whites shake with fear, lock
> themselves in their mansions and die
> That was how slavery ended, crick crac
> and the old man said
> I think I ran around all Martinique
> When my feet refused to go on
> I looked ahead and behind
> I saw I was back in the Black Shack Alley again
> It was back to the cane fields
> We were free but our bellies were empty
> The Master had become the Boss
> So I stayed on like all the other blacks
> in this cursed country.

These tensions between victory and loss, yearnings for home versus a sense of no return, and a recognition that so little really changes, resulted in art forms with hidden modalities, methods of

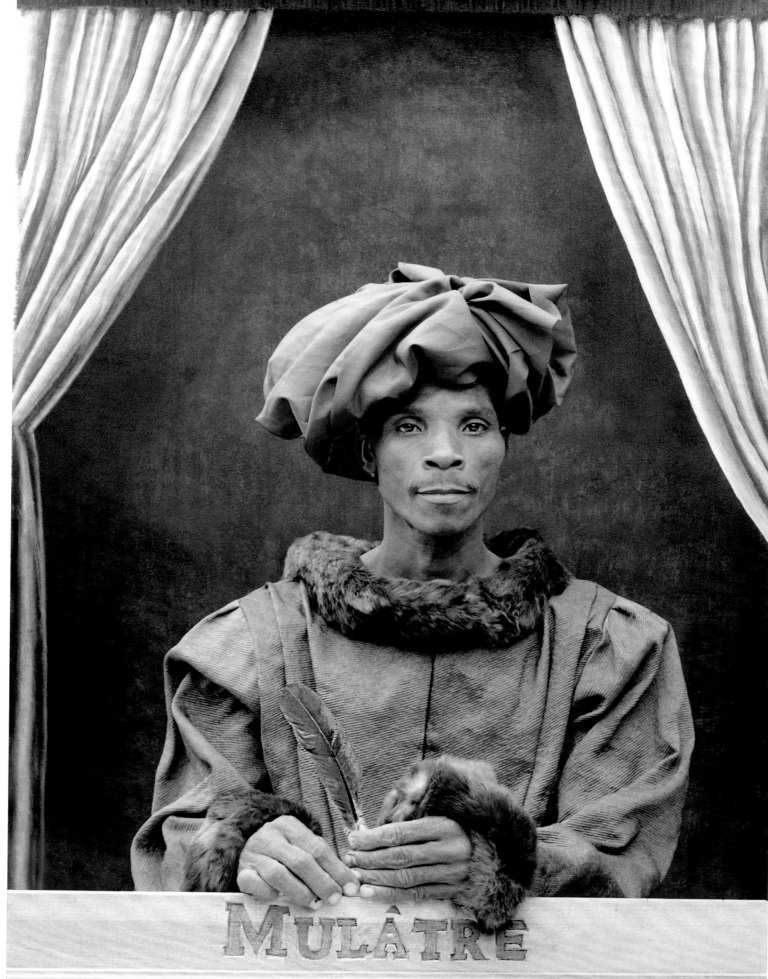

MULÂTRE

signing and signifying that operated on multiple levels, what Erica James has called "metapictures" that communicate nuanced, multi-layered, and sometimes contradictory readings.[6]

Haitian flags are a good example of these coded forms; portraits created from bric-a-brac and sequins depict saints such as St. Peter, St. Anthony, or Our Lady of Sorrows while displaying markings that signify Legba, Dambala, Erzulie, or other Yoruba gods and goddesses. These *veve* would be known only to the initiated or secret society members who could carry on their worship of traditional Catholic forms without compromising their African beliefs.

By 1900, the Caribbean population would be characterized by disaffection and migratory restlessness at all levels of its racially stratified society. For its upper classes, absentee landlordism intensified following the revolution in Haiti: the wealthy preferred, as before, to manage their properties from a safe distance for fear of further uprisings or reprisals. After emancipation, their lands were administered by mixed-race Creoles or mulattoes distinguished by their birth in the islands and education elsewhere. Jewish refugees and traders from the Middle East added to this middle tier of caretakers and merchants, while the steady influx of indentured laborers from India and China in places such as Trinidad and Guyana, Surinam and Jamaica made the lower classes less homogeneous. The beginning of the twentieth century was marked by constant shifts in the population, with large numbers of men especially, moving in and out of the region in search of work on plantations in South and Central America, or on construction sites in such places as Panama and the Canal Zone.[7] Caribbean culture was therefore more outward looking than inward, more fragmented than centered.

Initially, the production of fine art in the islands was a luxury pastime that fell to women of privilege. They chose craft as a complement to their feminine character. As Felix Angel tells us, skills in the applied and decorative arts "were particularly welcomed in places such as the colonies, where a delicate touch could do much to alleviate the drudgery and uncertainties of daily life. However, becoming a professional artist and producing fine art lay outside the nature of things for women in colonial society."[8]

The training, vision, and preoccupations of these artists of the creole class were essentially European, reflecting their places of learning and metropolitan styles in Paris, London, or Spain that they initially emulated. Kathleen Hawkins was the first Barbadian to be awarded an associateship of the Royal College of Art in London. Typically, on her return to the island she took up teaching, devoting herself to that profession for thirty years and creating images in a range of media for their educational value. Her work was renowned for its nostalgia. She preferred to capture aspects of the island's peasant life that she believed to be vanishing. She intentionally avoided dating her works so that they might be perceived as fragments of the past and documents that could elucidate the island's history.[9] Her *Plantation Workers on Their Way Home*, date unknown, speaks to this art form that sentimentalized the depiction of black people while containing them within a plantation landscape and tropes of docility. The work reflects a time when the plantocracy were redefining their emancipated black populace and their territories as peaceful, productive, and free from revolt, especially since the banana industry and tourism were poised for growth.[10] In this sense, these twentieth-century images continue the itinerant tradition of an earlier century. For all the artist's earnest intentions, this weary couple is locked in time and place. Captured with the backdrop of a sugar factory, they are objectified, showing little advance in their personhood or social status.

163

The *mouvement indigéniste,* a term coined in Haiti about 1925 by writer Jacques Roumaine, contrasted sharply with this idea of temporal fixity and social stasis. This group valued Haitian culture and its African origins and the use of Haitian dialect and local subjects. Unlike the *école indigéniste,* Roumaine favored a term that allowed for progression and change. The *mouvement indigéniste*'s ideas initially applied to literature, but eventually had parallels in the visual arts as the region's artists and intellectuals turned their attention inward, looking for inspiration from local subject matter.[11]

This movement was not entirely insular or removed from Western influence. Rather, this appreciation for folk culture was in step with postwar interests in the primitive shared by Europe's avant-garde who despised bourgeois complacency. Especially after the First World War and the mechanized carnage many of these young artists witnessed, they promoted other cultures and a return to new beginnings based on simpler values and an idyllic existence originally envisaged in Paul Gauguin's paintings of Martinique and, later, Tahiti. Looking at this trend, we can recog-

nize how the Caribbean and its art were perceived as being "already modern." It was framed within a modernist discourse when avant-garde artists, disenchanted by the spoils of imperialism and inspired by the art of other cultures, posited new ways of seeing.

Following in the footsteps of Paul Gauguin, a handful of European writers and artists went to the Caribbean in search of a primitive lifestyle. In 1929, William B. Seabrook published *Magic Island,* describing his travels and "baptism of blood" in Haiti. Documenting Vodou beliefs and rituals, this book was enormously influential in surrealist circles, especially with dissident Michel Leiris who seems to have patterned his own journal about travels in Africa, *L'Afrique fantome,* on Seabrook's occult research. *Magic Island* depicted Haiti as savage, exotic, and mysterious, applauding its history of defiance that had ousted the French colonial rule to become the first black republic. Its author's research involved adventurous fieldwork, the taking of secret oaths, and living intimately with Haitians to learn their customs.[12]

Portrait painter Augustus John visited Jamaica in 1937.[13] In-

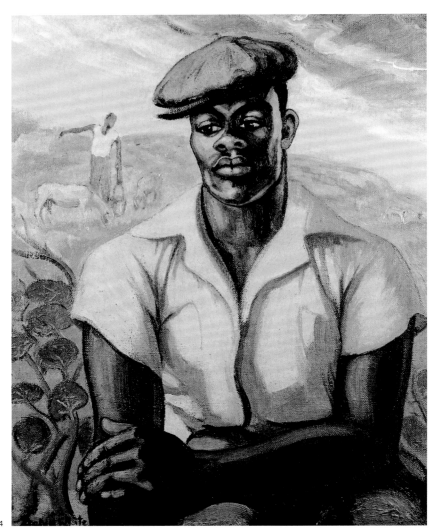

164 Golde White. *Black Man in a Cap.* Date unknown. Washington, D.C., private collection.

164

spired by a psychic's reading and the lure of "rum, treacle, white devilry and black magic," the British artist spent two months painting, using local models and exploring the island, even offering encouragement to local artists. John lamented that Jamaica had been blighted by colonialism that had "subdued its natural exuberance into a sober monotony." Like Seabrook, he relished the *Pokomanya* revivalist meetings he attended, conducted by shepherd and sculptor Mallica Reynolds Kapo, and was "deeply stirred."[14] While there, he painted *Two Jamaican Girls,* 1937 (Liverpool, Walker Art Gallery), an Impressionist-styled portrait that set the trend for a number of itinerant expatriates including John Wood and Vera Cumming who spent extended periods in the island painting local subjects. Meanwhile, Edna Manley drew on a small collection of works by modern British painters such as Vanessa Bell and Duncan Grant in the Bloomsbury group as teaching tools for her classes.[15]

A similar concern with local beliefs is true for surrealist André Breton, who escaped to Martinique from imprisonment as an an-

archist in war-torn France in 1941. Breton used the island as a brief refuge and a source of inspiration for his book *Charmeuse de Serpent (Snake Charmer)* titled after the fantasy primitive painting by self-taught artist Henri Rousseau.[16] For the month he was there, Breton believed he was in paradise and confided this to his surrealist friend André Masson, who shared his onward journey to New York.[17] His short stay inspired the poem "Un Grand Poète Noir" that also provided a platform for the young writer Aimé Césaire and his new work "Cahier d'un retour au pays natal" (1939), a seminal work for the *Négritude* movement a decade later (see chap. 13).[18]

The Caribbean also attracted Diaspora artists such as Edna Manley in Jamaica, Richmond Barthé there and in Haiti, and Wifredo Lam in Cuba. They were not immune to ideas of the primitive. But more important, they came in search of black identity to islands where they felt some cultural connection.

With the creation of works such as Edna Manley's *Beadseller* (1922) and Golde White's *Black Man in a Cap* (n.d.) we can speak 164

of an art form rooted in local subject matter by artists who identified the Caribbean as home. Ironically, like Lam in Paris, this appreciation for local culture had come from their study experiences abroad and their exposure to avant-garde thinking. Kobena Mercer notes that in Paris: "French West Indian students sent to the metropolis to be trained as middle class professionals not only laid claim to their blackness as an empowering act of cultural affirmation but also went back to the Caribbean with altered perceptions of the region's 'indigenous' folk cultures as a potential route towards the higher reality or sur-reality that would transform the experience of everyday life."[19]

Trends in Britain affected students there, too. Both Golde White and Edna Manley had studied in London when academicism was under attack from members of the Arts and Crafts movement as well as from modern movements such as Post-Impressionism and Cubism that filtered through from Europe. "A typical student . . . would therefore have to correspond to incompatible regimes. There would be the diet of national 'academic' exercises . . . featuring anatomical drawing, flower painting, drawing or modeling from nature, while at the same time responding to the vague iconoclasm of Vorticism and the refinements of pure abstraction."[20] This ambivalence is evidenced in Edna Manley's earliest Jamaican works created in the 1920s. Fresh from St. Martin's School of Art in London, her styles ranged from the conventional to the Cubist as she experimented with forms that could best suit her new environment and Caribbean subject matter. In the next decade, with the creation of works such as *Eve* (1929) and *Pocomania* (1936, Jamaica, Wallace Campbell Collection), she settled on robust organic figures inspired by Picasso, Henry Moore, and Barbara Hepworth but wholly focused on the black physiognomy.

Eve (1929) is an Edenic Amazon mother carved out of solid ma-

165

165

see 58

see 65

166 Ronald Moody. *Midonz* (goddess of transmutation). 1937. UK, private collection, Cynthia Moody.

167 Philip Moore. *1763 Monument*. 1976. Georgetown, Guyana.

166

hogany. In keeping with the modernist sentiments of that era, she shares much in common with Pablo Picasso's nudes that twenty years before had laid the foundation for Cubism and his watershed abstract work *Les Demoiselles d'Avignon* (1907). Manley's *Eve* bears a close resemblance to his 1906 pair of nudes who stand in profile facing each other but gaze backward coyly. *Eve* offers the same gesture with a lift of her hand toward her mouth, suggesting self-doubt or shame as she looks behind her. She is massive. Her whole body is bulbous, and with deep brown tones that suggest her African origins. Yet, her facial features and hair bear no distinctive phenotype. Like the work of fellow Jamaican Ronald Moody, this *Eve* stands for a universal woman, a prototype predating constructs of race.

These pioneering images, along with the iconic *Negro Aroused* (1935, National Gallery of Jamaica), provoked racial awareness and promoted black imagery. They expressed antipathy toward colonialism and concern for the nonwhite world's independence. These interests coincided with shifts in political power from colonial administrations to a growing middle class attracted by cultural nationalist sentiments and the New Negro philosophies that swept through America's cities in the 1930s. Ronald Moody exhibited 166 *Midonz* (1937) alongside the work of other Harlem Renaissance

artists in the Harmon Foundation's *Contemporary Negro African Art* exhibition (1939). This large female Buddha head with pronounced features put the interior life of black people at the center of discussions about spiritual awareness and human development already cultivated in Paris after the First World War, especially among the Surrealists. Although Moody had left Jamaica in 1923, he carried with him an acute sense of cultural memory and place that would echo through the silence of his gargantuan forms. Moody's intuitive harnessing of Egyptian and pre-Columbian forms predicted the marriage of forms that would become a feature of the Caribbean aesthetic, later witnessed in imagery such as Philip Moore's *1763 Monument* (Guyana) or LeRoy Clarke's *In the* 167 *Maze, There Is a Thin Line to My Soul* (1986, Trinidad, artist's collection).

The twentieth century witnessed the first grassroots challenge to colonial authority through the efforts of Marcus Garvey and his Pan-African Universal Negro Improvement Association. This black separatist organization, based in Harlem but with strong roots in Jamaica (Garvey's homeland), and a network of migrants who had worked in Honduras, Venezuela, Costa Rica, Nicaragua, Panama, and on ships throughout the Caribbean, promoted a Back to Africa program that found traction with his largely underprivi-

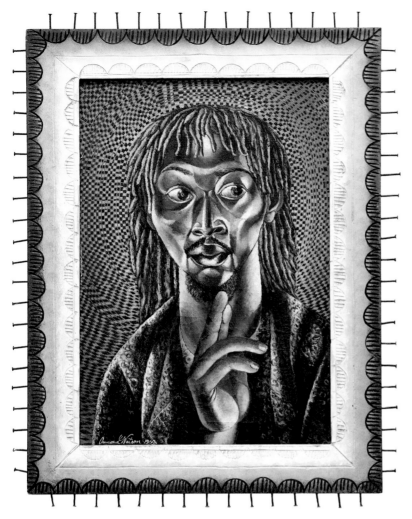

168

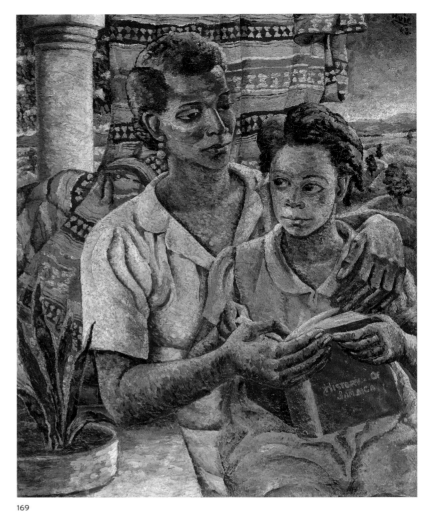

169

leged black audiences in cities throughout the African Diaspora. Garvey's movement appealed largely to working-class men and women. With rudimentary education and limited instruction in art making, many of the Caribbean's earliest self-taught artists developed their craft from practical skills that relied on their hands. They were woodworkers, cabinetmakers, welders, sign painters, and even barbers. Stanley Greaves recalls that he first became aware of art from his father:

> I think it was [from] growing up in a house where my father did signboards, like J. Smith: Carpenter, or Tinsmith or Tailor, for friends of his. I used to help him: he drew the outlines and I would fill them in. He also did headstones for graves. That's where I learned the distinction between roman and italic lettering, and Germanic capitals. I think I got riveted through seeing images. My father used to retouch and repair the certificates of societies like the Freemasons and the Scot-

tish Lodge. He also repaired the aprons that Freemasons wore, with images of the square and compass and the eye looking out of a pyramid. I found the symbols extremely mysterious, and my mind was compelled to find out what all these things meant.[21]

Garvey aimed to raise black consciousness through an understanding of black history and by promoting African culture. He was particularly drawn to the art of Egypt, teaching that it represented black people's earliest contribution to world culture. Garvey recognized the importance of positive images, particularly for black men who since slavery had been treated as boys. He gave these working-class masons, soldiers, and factory workers an image of themselves that was purposeful and ambitious. His use of military garb and other regal paraphernalia was a way to reinstate their manliness and sense of self-worth.[22] It also helped reestablish their connection to Africa as stakeholders and defenders of a

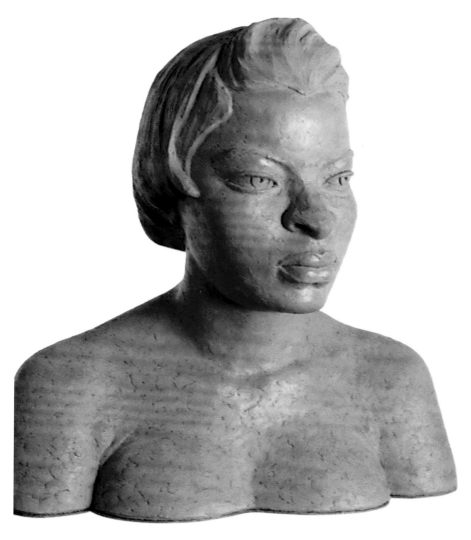

170

168 Osmond Watson. *Peace and Love*. 1969.
Kingston, National Gallery of Jamaica.

169 Albert Huie. *The History Lesson*. 1943.
Kingston, private collection, Judy Ann MacMillan.

170 Karl Broodhagen. *Patricia*. Date unknown.
Collection of the artist.

new homeland, envisioned initially in Liberia but later replaced by Ethiopia. Although many of the artists who responded to his challenge were largely self-taught, their images of themselves and their communities would underpin the movement for racial pride and self-awareness that marked black activism in the twentieth century.

Black people painting images of themselves in the Caribbean then is an entirely modern phenomenon. When Jamaican artist Osmond Watson painted his iconic *Peace and Love* in 1969 he was responding directly to Marcus Garvey's earlier clarion call that his Universal Negro Improvement Association members should see God through "the eyes of Blackness" and that artists should create black Christs and Madonnas to educate black children.[23] In the 1940s, Watson had witnessed Garvey's influence on Kingston's street-side preachers who spread a message of black "upliftment." Watson was also aware of other itinerants like Leonard P. Howell and Joseph Hibbert, forerunners of a bourgeoning Rastafari move-

ment, who as early as 1935 sold coronation photographs of His Imperial Majesty Haile Selassie, the recently enthroned emperor of Ethiopia, considering him to be Christ incarnate.

Watson's painting *Peace and Love* fulfilled the promise of a lineage of Caribbean-based artists, including Petion Savain (Haiti), Albert Huie (*The History Lesson,* 1943, Jamaica), and Karl Broodhagen (Barbados), who had already captured this message of race pride in their work. But few of them could match Watson's technical skills, spiritual conviction, and unique artistic vision that aptly depict Garvey's canonization of Jesus Christ as the "Black Man of Sorrow." Watson's modest background—his street-smart "grounations,"[24] local art school training, a British Council scholarship to St. Martin's in London, and his eventual rejection of European methods in favor of Africanized forms—meant he was perfectly suited to articulate visually the image of race consciousness and divine blackness that orator and reformer Marcus Garvey had hoped for almost half a century earlier.[25]

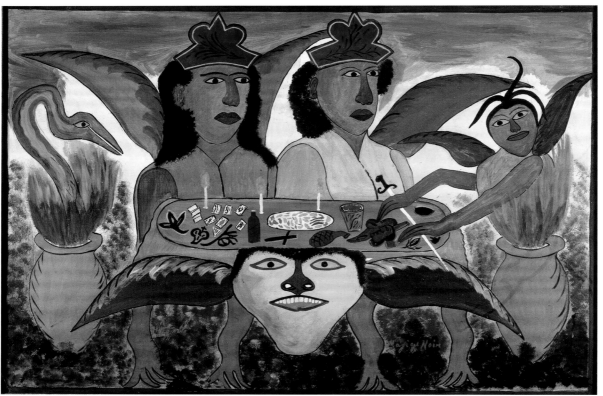

171 Hector Hyppolite. *Black Magic* (Magique Noir). Ca. 1946–1947.
Milwaukee, Museum of Milwaukee.

Created in the artist's characteristic style, which synthesized his modern art school training with his growing interest in black portraiture, Watson demonstrates an understanding of his inner divinity and the Rastafarian *I and I* principle that recognizes their spiritual union with God. Mimicking but also mocking Christian icons, Watson employs his own image where we might expect to see Christ's. Depicted in multiple brown skin tones, this black Christ's face is dramatically defined by a Cubist-styled angularity that also challenges the long-held stigma that the hues of black skin do not reflect light and are therefore difficult to paint.

Christ's eyes, almost perfectly oval and smoked with tinges of red, bulge as they turn away from the viewer and focus outside the frame, while his pursed lips reinforce the blessing of his hand raised in a benediction of peace and love. It is Christ's hair, however, that confounds the modern viewer. Christ's perfectly groomed but woolly looking locks, like a halo surrounding his head, sanctify this image and reinforce the artist's message about race and inner divinity. Blue patterning heightens the aura and brings to mind the jeweled quality of Byzantine icons. Meanwhile, the carved frame

bordered with nails speaks to Christ's persecution but also hints at Watson's awareness of the Congo Nkisi's traditional use of nails when creating objects of power. These elements represent a shift from the Christian missionary promotion of a blond-haired, blue-eyed Christ (an image on many living room walls that was the spiritual staple of the colonized Caribbean) toward a new aesthetic rooted in an Old Testament past and Africa.

The Caribbean's black Diaspora imagery traces its lineage back to Haiti's revolution in 1789, slave rebellions of the nineteenth century, and the spread of Garveyism and its later manifestation in Rastafari after 1930. Unlike the educated creole middle class, self-taught artists across the Caribbean developed their imagery within this social ethos. These include Hector Hyppolite (*Black Magic* [Magique Noir], ca. 1946–1947), Mallica "Kapo" Reynolds of Jamaica (*Revival Goddess Dinah,* ca. 1968), Amos Ferguson of the Bahamas (*Woman Lying on a Couch,* 1960, private collection, the Bahamas), Ivan Payne of Barbados (*Maube Seller,* n.d.), and Honore Chosrova of Martinique (*Séance,* 1988). Most developed their styles from trial and error, or, like Chosrova, from correspon-

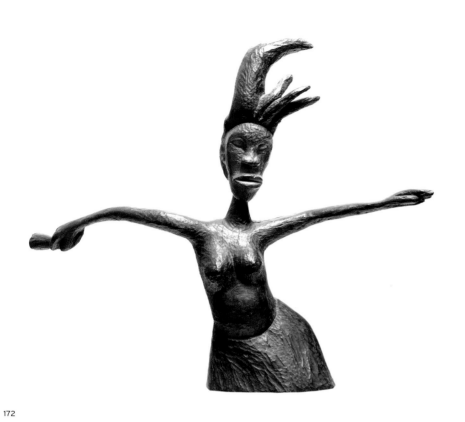

172

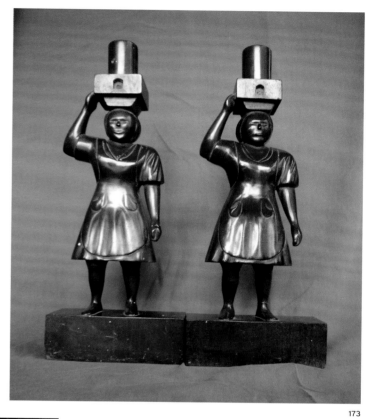

173

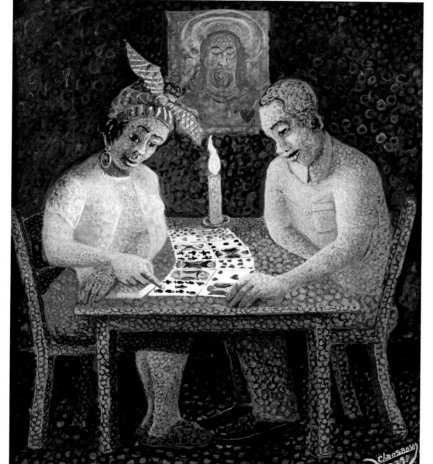

174

172 Kapo (Mallica Reynolds). *Revival Goddess Dinah*. Ca. 1968. Kingston, National Gallery of Jamaica.

173 Ivan Payne. *Maube Seller*. N.d. Kingston, private collection, Elombe Motley.

174 Honore Chosrova. *Séance*. 1988.

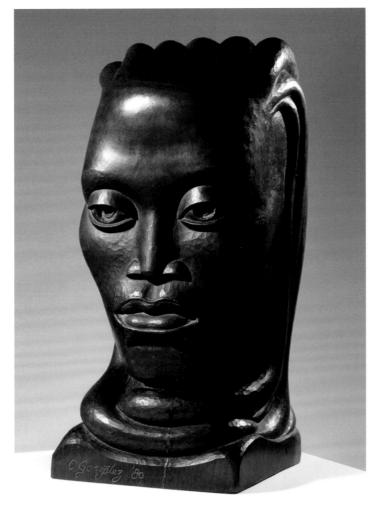

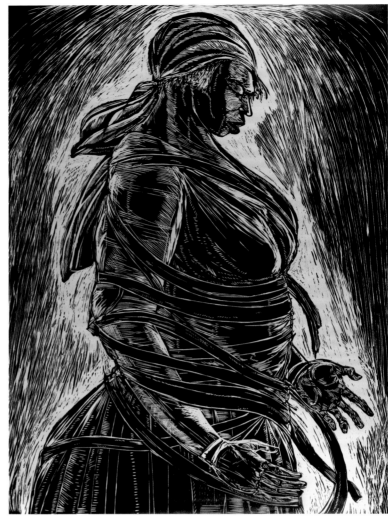

175

176

175 Christopher Gonzales. *Mountain Head* (Woman of Zion). 1980. Kingston, private collection, Mrs. Sheila Graham.

176 Max Taylor. *Love and Responsibility*. 1997. Private collection.

dence courses and evening classes in Paris. Other art school–trained artists such as Christopher Gonzales of Jamaica (*Mountain Head*/Woman of Zion, 1980), Max Taylor of the Bahamas (*Love and Responsibility,* 1997), and Joseph René-Corail ("Khokho") of Martinique (*Untitled,* 1963) also consciously drew on this black worldview, harnessing their art school techniques selectively and combining them with a more conscious African aesthetic.

175

176

177

These works share strong matriarchal imagery that militates against the sexualized and fecund stereotypes regularly placed on Caribbean women since the days of Paul Gauguin.[26] These women are wizened, with heads tied and aging bodies. The black Madonnas suggest stability, industry, and spiritual strength. In Stanley Greaves's *The Annunciation* (from the *There's a Meeting Here To-night* series, 1993, Guyana), the grandmother stands next to a youth, prepared to carry the burden of his folly. The artist also draws on iconography peculiar to Caribbean pop culture, a microphone, an oil drum, and the deejay youth's cap bearing the American flag turned backward on his head. These spiritual and secular symbols have inherited meaning from the Caribbean Diaspora's long march to freedom. For generations starved of visual stimuli or tokens from home, these are surreal imaginative constructs that share a local collective intelligence.

178

In time, social acceptance of Rastafari and the popularity of works by Ras Dizzy of Jamaica (*The Rasta Says,* 1987), Everald Brown (*Victory Over Satan,* 1968), or Ras Daniel Heartman has meant that these homegrown art forms, combined with their ubiq-

179

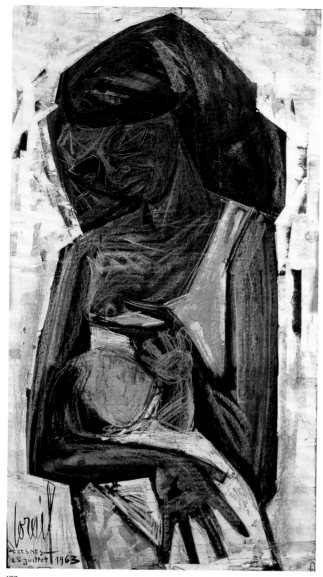

177

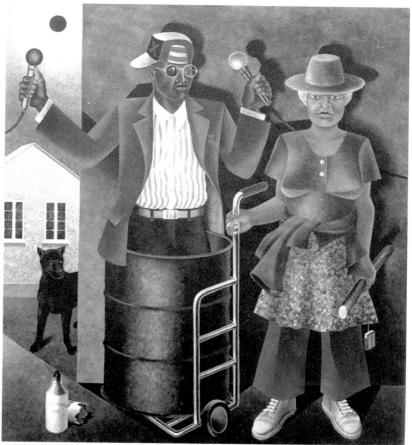

178

179

177 Khokho (Joseph René-Corail). Untitled. 1963.

178 Stanley Greaves. *The Annunciation.* From the *There's a Meeting Here Tonight* series. 1993. Barbados, private collection.

179 Everald Brown. *Victory Over Satan.* 1968. Jamaica, private collection.

180

181

uitous images of reggae musician Bob Marley, Haile Selassie, and biblical symbols such as the Star of David, the lilies of the field, the Lion of the Tribe of Judah, and the Stem of Jesse, have become part of the Caribbean Diaspora's visual lexicon. They appear on LP albhum covers, garments, and Rasta memorabilia.

180 Karl Parboosingh was one of Jamaica's earliest trained artists to portray Rastas and their symbolism (*Ras Smoke I,* 1972). But the contemporary conjurer of these visual iconographies is Ras Ishi 181 Butcher, who is devoted to the exploration of the black man's four-hundred-year history in the Caribbean (*Blazin 1,* 2003–2004). His paintings, which employ Egyptian hieroglyphs, colonial emblems, stripped-down cartoon forms, grotesquerie, portraiture, and codified racial ideograms, repeat themselves throughout his oeuvre, morphing with each new series to extend their meaning and the viewer's understanding of his visual repertoire. Ras Ishi's work collates, collages, and summarizes the multiplied meanings that have riddled the black man's sojourn in the Caribbean Diaspora since he disembarked. Ras Ishi's works are an ongoing visual diary that includes gang workers, chattel houses, colonials in panama hats,

and local vegetation that tell a story about how that history has defined the black man's relocation. His paintings are punctuated statements that in their graphic, flattened, and overlaid posterlike presentation constantly repeat his slogans for change.

Even as black people were mobilizing for repatriation to Africa, the region's middle-class Creoles sought to go beyond their European influences to accommodate African, Asian, and Native American histories. They took inspiration from local subjects as well as Pan-African movements such as the Harlem Renaissance and its ideas of a New Negro.[27] The nationalist movements of the twentieth century were cultural as well as political. They coalesced around clusters of middle-class artists, writers, and intellectuals keen to reconnect the region with its Taino origins, Asian and African heritage, while supporting independence from their mother countries.

Norman and Edna Manley were at the center of nationalist decolonization debates in Jamaica during the 1940s. Educated and married in England, after returning to Jamaica they immersed themselves in politics and local culture. In the period preceding

180 Karl Parboosingh. *Ras Smoke I.* 1972. Kingston, National Gallery of Jamaica.

181 Ras Ishi Butcher. *Blazin 1.* 2003–2004. Barbados, private collection.

political independence in Jamaica, their home was a hub for artists, poets, and intellectuals keen to promote Jamaican self-government and a homespun artistic and literary aesthetic.[28] With artists and writers such as Roger Mais, George Campbell, and Koren der Harootian, they articulated a new social contract for the country that emphasized political independence and cultural nationalism. Through the Institute of Jamaica, they promoted a homegrown culture and the establishment of a national art collection started in 1937 with the purchase of Edna Manley's *Negro Aroused* (1935).

Similar scenarios supporting local culture occurred throughout the region. Museums and collections such as the British Guyana Arts and Crafts Society in 1929 and the Barbados Museum and Historical Society founded in 1934 laid a foundation for national exhibitions and competitions. Instruction in local art forms would follow with the founding of national art schools such as the School of Applied Arts in Martinique in 1941 or the Junior Centre in Jamaica after 1940. In Haiti, the establishment of the Centre d'Art by Dewitt Peters in 1944 provided a more formal structure for a handful of self-taught artists to create, showcase, and sell work that they had been producing for almost a decade. Meanwhile in Trinidad, the Society of Trinidad Independents was formed in 1929 around Amy Leong Pang, and later the Trinidad Art Society was guided by Sybil Atteck after her return to Trinidad in 1948. Both groups promoted freedom of expression and the promotion of a national identity. They began under the patronage of the colonial administration with exclusive salons, but later the Trinidad Art Society broadened its base, even accommodating self-taught artists.[29]

By the 1940s, the Caribbean had become an accommodating cultural hub where black ideas about Africa and European idealistic notions related to folk culture and primitivism could safely interact. The region was what Kobena Mercer has called a "contact zone" where artists of different ethnicities were entangled in cross-cultural dialogue that provided the impetus for black modernism. Mercer even suggests that key words from that era such as "amalgam" can be viewed as "a synonym for cultural mixing; we begin to observe that many of the metaphor-concepts put into play by the post colonial turn of the 1980s—hybridity, syncretism, creolization—were first registered in debates of the 1940s that saw cross-cultural exchange as a source of fresh aesthetic possibilities brought about by the global conditions of modernity."[30] In short, ideas about race and multiculturalism first raised in the Caribbean set the stage for postmodern thinking half a century later.

Antonio Benitez Rojo postulates the idea of being and even becoming as an essential option for the survival of a community with no common past. This notion of survival was built into a type of creole poetic discourse that informed representational politics during the 1940s. The ferment produced Caribbean intellectuals like C. L. R. James, Norman Manley, and later Eric Williams, who promoted political development rooted in cultural nationalism. They were strongly supported by a "brown skin" middle class who recognized that as a colored minority with a history that could not slot back easily into Europe or Africa, they had nowhere else to go.

Their bid for political ascendancy in the pre-independence years came out of a recognition that the Caribbean would be home, and they began to define their identities in creole terms that reflected their checkered cultural backgrounds. They encouraged Caribbean people to recognize how their European, African, Asian, and Native American heritages made them distinctly Caribbean: the result of a gene pool of races that could be unified through mottoes such as Jamaica's "Out of many, one people" or Trinidad's "Together we aspire, together we achieve." Sybil Atteck's *Pan Men* (ca. 1960, Trinidad Citizens for Conservation) illustrates

182 Georges Liautaud. *Danbala.* Ca. 1959. Milwaukee, Milwaukee Museum of Art.

183 Brent Malone. *Junkanoo Ribbons.* 1984. Kingston, National Gallery of Jamaica.

this ethos, depicting a group of men playing the steel pan, some with the pans strung around their neck, others standing beating oil drums. The artist uses this unique, locally created instrument as a unifying symbol of nation and modernity.

The Creoles' defining of the larger black population that they represented was benevolent. The black man was framed in romantic and enlightened ideas about the noble savage, which reflected their own Negrophilia sentiments. This was characterized by the poetic idealization of the tropic island existence, the Spanish *paradiso,* and a growing interest in the craft and culture of black urban and rural peasant folk. Institutional patronage of Haitian artist Georges Liautaud or, later, Tyrone Ferguson of the Bahamas, both initially blacksmiths and welders who were drawn to sculpture, speaks to their retention of ironworking from ancient West African traditions. Liautaud's imagery developed out of the crosses he designed to decorate graves in Haiti. His ornate work captured the attention of DeWitt Peters, who encouraged him to work at the Centre d'Art and expand his use of materials. Liautaud would go on to create enigmatic *Loas,* figures cut from the flattened metal of oil drums, inscribed with *veve* markings. He established a style mimicked by others, although not with the same sense of spiritual profundity, a circumstance that has led many to question the role of patronage and its manipulation of folk forms.

Middle-class support for volunteer art classes at the Institute of Jamaica fostered young talents such as Albert Huie, Ralph Campbell, Henry Daley, and Osmond Watson in classes that would become formalized into an art program offered at the Jamaica School of Art. Guyana was the same. E. R. Burrowes established the Working People's Free Art Classes there, encouraging young men such as Stanley Greaves and Donald Locke to develop their skills and create imagery rooted in their own culture. These informal classes would be incubators for talented artists who used the British Council's scholarships to study abroad, as an alternative to a more mundane career path in the civil service.

In the 1950s and 1960s, many of the region's artists received formal training in Britain as a result of various study grants: Carlisle

183

Chang (Trinidad); Albert Huie, Ralph Campbell, and Barrington Watson (Jamaica); Donald Locke and Stanley Greaves (Guyana). Most trained at reputable British art institutions such as Goldsmith's College, Royal College of Art, and St. Martin's School of Art, each developing his own representational style influenced by Post-Impressionism, realism, and Cubism, respectively. Then, like Brent Malone of the Bahamas, they returned to teach at their local colleges and institutions in the Caribbean. Their art referenced an aesthetic that was historically African and more latently Caribbean in an environment of post-independence optimism.[31]

Barrington Watson's *Mother and Child* (1958) aptly illustrates how his academic training at the Royal Academy in London could be harnessed to serve local Caribbean ends and to develop an iconography better suited to the region's collective psyche. Here, this classical theme is translated into the intimate setting of the bedroom of the artist's own mother. This more humanized and domesticated Madonna glances fondly toward the son she is potty-training. The theme is elevated beyond the mundane by its salon-size scale and Watson's masterly attention; the artist treats the theme as if it were a subject of national significance and suggests that the particularities of Caribbean people's daily lives can

184

184

184 Barrington Watson. *Mother and Child*. 1958. Kingston, National Gallery of Jamaica.

185 Alexandre Bertrand. Untitled. N.d. Private collection.

185

take priority over the glorified images and ideas imported from elsewhere.[32] A similar sentiment is communicated through Alexandre Bertrand's *Untitled* (n.d), in which a young mother and a child walk hand in hand along a rural path. The two baguettes in the young mother's other hand and the simple diaper worn by the toddler underscore the value of companionship even in the face of ingrained poverty.

This type of imagery related to cultural nationalism, which remained the main ideological sentiment behind the Caribbean's ar-

tistic movements and their products up to and beyond independence. As a result, viewers still warm to such images of themselves, their portraits, genre scenes, and landscapes; they relate the images to their daily lives, and that serves to locate them within the Caribbean experience. Mainstream artists such as Barrington Watson, Boscoe Holder of Trinidad, or the Bahamas's Brent Malone have been popular because they held a flattering mirror of a contented society to the growing middle class. Yet, this type of genre painting mixed too easily with more kitsch tourist art that played out the

186

186 Boscoe Holder. *Untitled Male Nude*. N.d. Private collection.

stereotypes of an island existence. Palm-strewn beaches, bustling markets, and rural areas populated with sturdy black men and sinewy woman were part of the region's iconography shared by both high- and low-art forms. In this sense, Boscoe Holder's portraits of dancers go against the grain of commodification. These more intimate paintings referencing his life as a dancer, as in his *Untitled Male Nude* (n.d.), allude to another aspect of our Caribbean reality related to gender and difference that is often elided. His frank painting of the male form in ways that are beautiful, eroticized, and even feminized broaches a subject rare for that era.

186

Abstraction, allegory, and satire were pictorial options for artists to maintain their precarious balance as social commentators. In Haiti and Jamaica, where political affiliation might lead to victimization, satire proved a useful tool for communicating truths without compromise. Among the masters of this kind of disguise are Milton George in *The Art of Being Polite on a Red Background* or the *General Speaks at 8*, Edouard Duval-Carrie in *J. C. Duvalier as Mad Bride* (1979), Stanley Greaves in *The Annunciation,* and Eugene Hyde in *Casualties Series* (1978).

Women artists also used these strategies of allegory effectively as ways of making statements about their role in society and feminism. During the 1980s, windows and doors were their preferred symbols of unrest and longing. But the landmark exhibition "Lips, Sticks and Marks," mounted by seven women in 1998, introduced the female body as a site of contest.[33] Although this show made significant statements about women's worlds, a more lasting perception was that in exploring their Caribbeanness, these seven women, none of whom was black, opened up another space for young white Caribbean artists prepared to use art to reevaluate their historical identities and their legacies of slavery. In the new millennium, with the waning of regional exhibitions and dwindling opportunities to exhibit abroad, their contribution to the arts also triggered discussion about what constitutes the national art forms, and whether the black aesthetic, so visible in the work of self-taught artists, represents a truer reflection of regional identity than does the Westernized or "whitewashed" forms of art school–trained artists.[34]

Debates have been most strident around public monuments, especially those related to slavery and emancipation, where the majority viewers of African descent have claimed a greater stake in how their lives and freedoms are envisioned. Regularly, art school–trained artists have designed these monuments with a vision that differs conceptually and sometimes even materially from the black majority's self-perception. Among those that have proved controversial are the statue of abolitionist Victor Schoelcher in Martinique (1904; see *The Image of the Black in Western Art,* Vol. IV, pt. 1, fig. 173), the monument associated with slave revolt leader Bussa

in Barbados (1985), and the memorial of the Coramantee slave Prince Klaus in St. John, Antigua (1983). The most recent case has been Laura Facey's *Redemption Song* (2003), a monument erected in Kingston's Emancipation Park to mark the bicentenary of that event in Jamaica.

Redemption Song is a larger-than-life depiction of a naked man and woman facing each other with heads turned heavenward. Cast in bronze with a darkened skin tone, their bodies have been honed to ensure that they communicate their racialized features. But many argue that the artist's depiction of both male and female, her endowing the woman with pendulous breasts and the man with a pendulous penis, is offensive. Some contend that their posed inertness, with hanging listless arms, is too passive for a work of this nature. Others argue that these figures should have been clothed and given active gestures that represent the victory of emancipation and recognized that slaves viewed the representation of their nakedness as a memory of their disinheritance and impoverishment. Most question whether a white artist could have the moral or racial sensitivity to depict such an important moment in black history with conviction. They argue publicly that the decision to award the commission to a white Jamaican artist is indicative of a small white and brown social elite's control and legislation of culture and raises the question, "Who has the authority to memorialize this event?"[35]

Similar issues arise in carnival, a public sphere that historically is a marketplace for the fluid and complex exchange of identities. After more than two hundred years, carnival remains a popular annual festival, especially in Cuba, Trinidad, and Haiti, where its celebrations remain highly charged performances that use parody, satire, and caricature to critique contemporary society. Cultural historian Gerard Aching in *Masking and Power* explains their in-herent ambiguity since "amidst the annual revelry in which different classes and sectors of Caribbean societies simultaneously took to the streets, the festivities also became events through which colonial authorities exercised, measured, and reaffirmed their power by employing exhibited techniques of crowd control."[36]

This controlled "uncontrolled" space seems all the more relevant today where islands have adopted carnival for the purposes of tourism and where sponsorship promotes visibility. But in an era in which glitz and skimpy costume parades dictate media visibility, the ultimate subversion is *J'ouvert,* in which people dressed as devil bands or *Jab-Jab* rope throwers coated in black soot and molasses, often padlocked to one another, run amok through the streets beating tin pans and other crude percussion. The increasing popularity of *J'ouvert,* especially with the young, suggests the appeal of these outsider characters who maraud on the edge of society's moral boundaries.

The choice to blacken one's skin still further, as Aching notes, "facilitates a strategic 're-appropriation' of blackness beyond which no further mimicry is feasible."[37] But even more, the act of affirming one's blackness calls out whiteness, bringing it into plain sight. Leah Gordon, a British-born photographer living in Haiti, has experienced this kind of self-recognition. It is the route she has had to take to understand her cultural inheritance and her privileges as the daughter of white working-class Mancunians, also implicated in the Atlantic slave trade. Her powerful images of *Jab-Jab* youths in Haiti pulsate with juvenile malevolence even as they speak to the reclamation of old identities and the country's own demonization.

The region's artists as cultural agents, middle class or otherwise, have played an important role in nation building. The most effective are those able to underpin their day-to-day realities with a

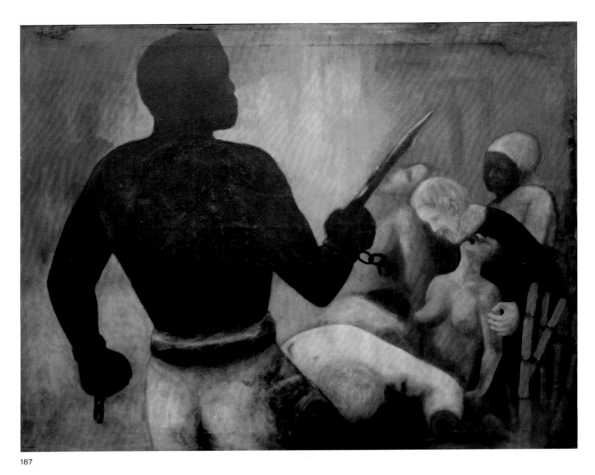

187

187 Aubrey Williams. *Revolt*. 1960. Georgetown, Castellani House.

188 LeRoy Clarke. *In the Maze, There Is a Thin Line to My Soul*. 1986. Port of Spain, Trinidad, collection of the artist.

sense of cultural memory. As social inheritors of slavery, and with only fragile links to the past, they use their imagination as a creative resource. Their formations of a new Caribbean identity are those that exist in an abstract mental realm harnessed through memory and intuition, such as Karl Broodhagen's *Slave in Revolt/ Emancipation Monument "Bussa"* (1973, Barbados, St. Barnabas Roundabout) and Aubrey Williams's *Revolt* (1960, Guyana), the latter eventually employing the language of abstraction and expressionism to explore these dark recesses. With a past shrouded by dislocation, absence, and forgetting, Caribbean identity would need to be constructed outside of history.

Leon Wainwright describes Aubrey Williams's *Revolt* as an anachronism.[38] This representation of a slave revolt in the Dutch colony of Berbice, now a county of Guyana, harkens back to 1763 and is styled in a manner that defies Williams's contemporary explorations with abstraction. The image shows a robust figure (not unlike the artist himself) standing menacingly over a maimed white body, a naked white woman, and a cowering white man. Williams's figure brandishes a cutlass and wears broken chains, popular symbolism of the day that Wainwright sees as standing "not so much for the deliverance of emancipation, but the winning of freedom."[39] The painting's graphic narrative even in pigment

tells a story so powerful that it was rejected by the organization to which it was initially given, Guyana's Royal Agriculture and Commercial Society. Today the painting is part of the collection of the National Gallery of Guyana, an acceptance that demonstrates how the timeless principles behind its painting have outlived our more temporal understanding of history's inherent distortions and ideologies.

The temporal elision is even more profound when we recognize that Williams painted this event in Britain in 1960, a time when he and many other black immigrants were facing renewed prejudice for their presence there. By inserting himself into this rebellious scene he makes a bold statement about his own feelings of resentment in the face of oppression. As Wainwright explains elsewhere: "Painting had a dynamic potential for Williams as a vehicle for his wide exploration of interior and exterior life. He used his art practice to engage and change modern art's concerns with philosophy and aesthetics. He was attracted to the idea that modernism could be a way of criticizing centers of power, and could itself undermine the idea that there should be a single best way of seeing and showing the world."[40]

The 1960s was a volatile period that deeply affected Caribbean artists at home and abroad. The turbulent events of the decade in-

188

cluded the Bay of Pigs attempted invasion of Cuba; civil rights marches and deaths; student riots in the United States, France, and Vietnam; decolonization; and the spread of the Black Power movement. The Caribbean was not immune to any of these events.

In Martinique, painter Joseph René-Corail, nicknamed Khokho, was at the center of the movement for French decolonization. He was considered radical for his communist views, his conscientious objection to completing the French national military service, and his activism in supporting independence from France. After becoming involved in the Youth Organization of Anti-colonial Martinique (OJAM) he was considered a political prisoner. Arrested in Martinique, he was imprisoned in Paris until acquitted in December 1963. Upon return to Martinique, he took up a professorship at the School of Applied Arts and devoted the rest of his life to the promotion of Martinique's culture, creating many of its public monuments from clays, metals, cloths, and woods such as bamboo.

He continued his activism in the Martinique Independence Movement, setting himself at odds with the status quo and Martinique's historical relationship as a department of France. Khokho see 177 created his mother-and-child painting (*Untitled,* 1963) while imprisoned in Fresnes. He is viewed as a cultural icon in Martinique

and Guadeloupe, where some still have ambivalent feelings about political autonomy and self-determination.

LeRoy Clarke's status in Trinidad is similar. He returned to Trinidad after studying and working in New York in the 1970s. His experiences in the United States when the civil rights and black power movement were on the rise strengthened the message of race consciousness in his work even as he acknowledged his sense of Caribbeanness. His complex portrait *In the Maze, There Is a Thin Line to My Soul* harnesses both African and American Indian imagery while still being informed by an Afro-Cobra aesthetic.[41] It also references Sun Ra's musical abstraction of the late 1960s when the inner mind, like outer space, was envisaged as a place of refuge from white iniquities and planet Earth, and the black person was viewed in futuristic terms.

This head's multifaceted, compartmentalized forms are at once ancient and modern. Clarke allows the viewer access to the inner workings of the black mind, its thinking and feeling centers, and depicts them as an interaction of the fixed and the fluid. Its robotic, almost digitized compartments are intersected with juicy molten globs of liquid, lava, and membrane that pulsate and mutate. Yet, in the midst of these myriad thoughts is a single line that dissects the

189

form right through its line of vision. The title's reference to the soul, so much a part of that era's pop vernacular, distinguishes this mind-blown, spaced-out self-portrait as nevertheless whole and spiritually rooted. Clarke is a self-professed Obeah man, and he holds that his nation's embrace of its culture and its blackness is the way to reclaim the past and liberate its people.

This act of re-creation places Caribbean artists in a valued position as seers and healers who are allowed to dream in the past, present, and future. In the troubled 1970s and 1980s after independence, against a background of political turbulence and economic hardship, another generation of artists such as Omari Ra of Jamaica and Ras Akyem and Ras Ishi Butcher (*Ital Princess*, 1986) of Barbados gave visual form to their pan-African identities as they hopscotched through history to recover a lost heritage. Harnessing imagery inspired by rituals, mutinies, and slave heroes, they affirmed a black spiritual tradition that harshly critiqued the white West, even as they posited new models for survival.

Omari Ra places his own larger-than-life portraits at the center of historical dramas. In self-portraits with characteristically convoluted titles such as *Bois Caiman's Foreign Policy Retro Reconstruction Globe Shrugged* (2004), he paints himself into history, replacing the faces of slave leaders such as Tacky or Jack Mansong with his own distinctly African facial features. These gargantuan heads completely fill his oversize surfaces. With little else to distract the eye, the viewer is forced to confront his blackness painted in monochrome tones of red or green with dramatic chiaroscuro lighting. In his imagery devoted to the Bois Caiman rebellion, two massive portraits are placed side by side. Despite their physical resemblance, they do not relate to each other. They appear like smudged photographs of black military heroes. Apart from their enhanced racialized features, their only distinction is their tightly fastened military garb that bears *veve* markings rather than the gold-braided emblems favored by Garvey. Omari Ra's portraits are created knowingly. Like visual dub-plates, they riff on the imagery

189

and iconography of black activists and artists gone before. They bring history up to date, affirming a black spiritual heritage that harshly critiques the white West.

Not all these artists employ such strident strategies. Some approach the problem of the black man's existence in the region from the perspective of *not* calling attention to the pain of his extended exile from Africa. Barbadian artists Ras Akyem I Ramsay (*Untitled No. 2,* n.d.) and Ras Ishi Butcher (*Blazin 1,* 2003–2004), both of whom were mentored by LeRoy Clarke, posit new models for survival that take a more persuasive but also more problematic approach to the black body. In their understanding of Caribbeanness they have avoided the black separatist message of Ra to portray instead the Caribbean man in his present-day existence. Their images are stripped-down, winnowed forms that hint at Jean-Michel Basquiat in their scarred vulnerability, but show an even greater influence of the digital age that postdates him. Ras Akyem's images are the most disturbing. His bloated, disfigured, amputated, nerve-wracked forms trouble any idyllic reading of place and identity.

see 181

It is against this backdrop of independent vision and anticolonialism that we can begin to view the Caribbean art of the postmodern era. The Caribbean Diaspora's restless migratory patterns since slavery have left island communities in constant motion, a people of the sea, forever looping back to points of entanglement rather than origins.

That all Caribbeans derive from people who came from somewhere else has set in motion a repeating pattern as they have scattered themselves around the globe to urban communities in London, New York, Toronto, and Miami as migrant workers in search of opportunities and a better life, making the island nations what Stuart Hall calls "twice diasporized." Those who return (and most do) are what cultural theorist Annie Paul has in their defense la-

beled "alterNATIVES," or natives who, like Trinidad artists Chris Cozier or Steve Ouditt, have been altered by their contact with the wider world or by their education abroad, but who still continue to contribute a great deal to their home countries by virtue of their double vision.[42] Any contemporary cultural history of the region must take account of these trends and tensions, which are at once both global and local and which generate imagery, such as Cozier's *The Castaway* (2006), that speaks to these wider issues.

190

In the 1990s, a greater awareness of postmodern trends and a connection with Jamaica's wider Diaspora communities in Britain, Canada, and the United States saw many artists reappraising their personal cultural histories and revisiting the sites of their ancestral origins, be they indigenous Indian cultures, Asian, African, or European, or, in the case of Chris Cozier, their sense of nomadic "unbelonging," which led to his depiction of the black as an amphibian survivor with a mast on his back that keeps him afloat.[43] These artists are trying to understand and communicate the experience of being Caribbean and to explore their own sense of place within the African Diaspora.

Albert Chong's *Seated Presence* is perhaps the most personal work from his *Throne Series* (1992). Here the artist captures his own blurred naked image, seated but open to the camera's scrutiny. Superimposed over his body are artifacts, coals, skulls, and antelope horns that speak to preoccupations with Santeria and the artist's sense of inner power and divinity. The work references his Asian-African-Caribbean roots as well as his peculiarly Catholic accommodation of symbolic spiritual forms. Through his photographs and assemblages, Chong seamlessly blends the artistic and the spiritual while quietly critiquing traditional religious iconography. From a close examination of his ideas and processes we learn not just about this artist as a keeper of memories but also about

191

191

190 Chris Cozier. *The Castaway* (from the *Tropical Night* series) (detail). 2006-Present.

191 Albert Chong. *Seated Presence*. 1992. Colorado, collection of the artist.

192 Joscelyn E. Gardner. *Veronica Frutescens* (Mazerine) (from the series *Creole Protraits*). 2009. Artist's collection.

193 Roberta Stoddart. *Earl* (from the series *In the Flesh*). 2006. Port of Spain, Trinidad, W.I., private collection.

multiple Caribbean identities. The cultural work that Chong carries out through the production of these images is important to the African Diaspora and ancestors of slavery, since these identities exist in an abstract mental realm that is necessarily constructed in the present and subject to its vagaries.

Globalization and its attendant postmodern sentiments have encouraged the search for a new language that better suits the region's diversity and cultural complexity. This "new worldism" is evidenced in an interest in the region's indigenous cultures and a more clearly defined sentiment for Africa. This process of creolization, in which blacks and whites recognize their commonality and cultural indebtedness, has also triggered an exploration of the past from both sides of the racial and class divide. There have been

many attempts to confront and redress the more shameful aspects of the Caribbean's history. As a descendant of the planter class, Joscelyn Gardner has embarked on a project that puts a face to this process. Her series of prints titled *Creole Portraits* references the region's "disordered past" with depictions of the braided heads of slave women from Barbados's Egypt Estate intertwined with tools of torture such as iron collars, bridles, and shackles. In her later series *Bleeding and Breeding,* the same heads are woven with the imagery of botanical plants that these women used to self-abort after being impregnated by their masters.

Prepared to own her guilt, Gardner chooses subjects that allow her to explore plantation life and its atrocities. She says in a statement about her work that she uses "a postcolonial methodology to

192

193

probe colonial material culture . . . to explore my (white) Creole identity. Specifically, I aim to articulate the historically intertwined relationship shared by black and white women in the Caribbean by recognizing that under patriarchy and colonialism the lives of all Caribbean women have been shaped by 'mastership.' My project also aims to address the repression and dissociation that operate in relation to the subject of slavery and white culpability."[44]

Roberta Stoddart's imagery is less ambivalent but equally challenging. In her hyperrealist style, she employs psychological tension in her work that echoes issues of race, gender, and sexuality. In her *In the Flesh* series, she explores the human psyche and its desire for place by depicting the homeless and vagrants in painstaking detail. In *Earl,* her painting of a young albino man suffering from a skin disease that destroys black pigment, she questions notions of blackness and the prejudices of a black society that has itself experienced discrimination. Earl is culturally black but physically white, or even colorless, and Stoddart exploits his lack of facial racial identity by painting his skin, "warts and all," with a cruel and calculating eye.

Younger artists such Ebony G. Patterson and Peter Rickards are engaging with similar issues related to the social dislocation that came with Jamaican independence. These artists recognize that old models of social organization within the church, state, and society are shifting and being replaced by post-nationalist forms with different spatial and spiritual codes of belonging.[45]

Patterson approaches these trends in her work by exploring gen-

194

194 Ebony G. Patterson. *Di Real Big Man.* 2010. Kingston, National Gallery of Jamaica.

der ambivalence in Jamaica. This subject, which has absorbed her energies for the past decade, requires an understanding of slavery, colonial history, local attitudes to authority and violence and to spirituality and worship. But Patterson's images are far from analytical or dreary. Rather, they are adrenaline-pumped, color-saturated, richly textured, and highly patterned works that shout for her viewers' attention. Over the years her work has shed any cultural insecurity arising from her formal art school training, and in her dance hall subject matter she has liberated her palette to make her work gaudier, more lavish, and more "ghetto fabulous." Through these paintings, Patterson questions why young black men, especially those related to Jamaica's dance hall culture, are regularly viewed in terms of aggression. To counter these perceptions, she balances their male macho personas with feminine touches and homoerotica.

Her portraits of Jamaican ghetto leaders known as "dons" and their "disciples," who practice skin bleaching, are sanctified in her portraits, which show their stark faces with rouged lips, halos, and other marks of beatification. Bleached of color, their complexions speak to a complete shift in the racial register and a debunking of nationalist narratives that prioritize art and spirituality over commerce and the marketplace. Although surrounded by glitz and glamour, these portraits no longer reflect the angst of race or the moralizing consciousness of Revivalism or Rastafari. They are a new breed of rude boys worshipping consumerism whose faces stare back at their African heritage—blankly.

These ideas and events are still unfolding, but they suggest that a younger generation of artists must consider and compete with the more glaring aspects of the Caribbean's popular culture, especially dance halls, ghetto fabulous fashions, street art, and the aesthetics of bling funerals for a stake in the nation's visual memory. In this new hyped environment, art has morphed into other forms of media such as Facebook and Twitter, which venerate celebrity status and a more materialist consumer culture. They also provide anonymity and the possibility of choosing an identity outside the construct of race.

After more than a century, Caribbean artists are responding to definitions of blackness in multifarious ways. Their imagery provides more options for identity beyond the phenotypical, and they illustrate a narrative unrestrained by the problematic history that once shaped the destiny of their islands. These artists are confident in their choices, recognizing that the rich recipe of their callaloo culture can produce valuable ways of thinking and seeing that can be models for a "post-black," post-racialized world.

12

THE IMAGE OF THE BLACK IN LATIN AMERICA

DAWN ADES

The concept of Latin America as a geographical and political entity took shape in the 1850s in response to struggles over international trade routes, the territorial and capitalist expansion of the United States, and the need to defend multiracial democracies.[1] Leading Spanish-speaking intellectuals began to use the term "Latin America" as opposed to Anglo-Saxon both globally and more specifically within the Americas. Issues of race and color were as central to the adoption of "América Latina" as that of sovereignty, and the way they are entwined throws light on the ambiguous and often paradoxical relationship between race, nation, and culture in the new Spanish- and Portuguese-speaking republics of America.[2]

A flash point in American relations in the 1850s was Panama, then a semiautonomous federal state of New Granada (now Colombia) which had been, since the gold rush started in 1848, a busy and prosperous transit hub from the East to California.[3] Slavery was abolished in Panama in 1852 to widespread celebrations, and in 1853 suffrage was extended to all adult males. Racial tensions and violence between the white migrant gold seekers and local tradesmen and officials, who were often black or of mixed race, led to demands by the United States for a separate judicial system for its citizens, who couldn't accept judgment and imprisonment from those they regarded as their racial inferiors. The political hierarchy in Bogotá was incensed by these attempts to deny the sovereignty of the country, which was moreover threatened by the filibusters, adventurers who marauded Central America with the aim of annexing countries for the United States, such as William Walker, who took over much of Nicaragua in 1855.

This was one of the situations in which the assertion of "Latin America" as resistance to U.S. expansionism and its threat to democracy was formulated. Justo Arosemena, a member of one of the elite families of Panama City, argued that "Latin American interests" lay in a Hispanic American Confederation that would include not only Gran Colombia (Panama, Venezuela, Colombia, and Ecuador) but the whole of the rest of South America. Arosemena criticized the United States for discriminating against people of color but did not explicitly open his Latin America to African Americans or to indigenous people, who, in the case of Panama, he incorrectly assumed had ceased to exist. Independence had largely been orchestrated by and for the Spanish- or Portuguese-speaking Creole elites with the assistance of Afrolatinos, and although often accompanied by the promise or fact of emancipation and by antiracial legislation, there is often a discrepancy between the ideal of a racial democracy (which insofar as it did exist was shocking to the United States) and economic and social conditions for the African Americans and indigenous Indians of the new republics. While there was greater fluidity in Latin America than in the United

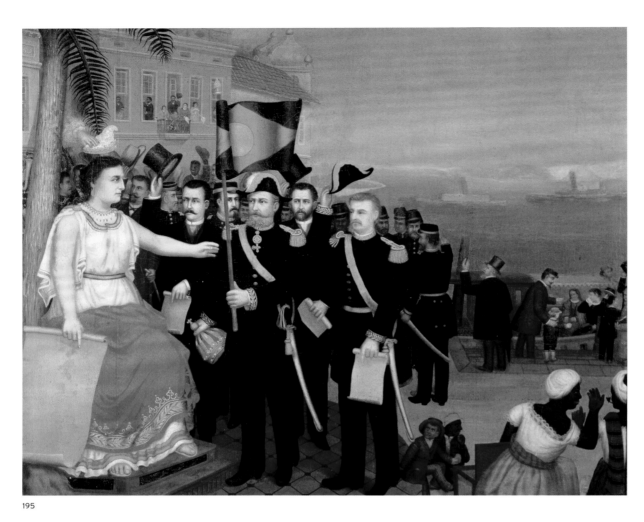

195 Anonymous. *Allegory of the Departure of Dom Pedro II After Independence*. 1890. São Paulo, Fundação María Luisa e Oscar Americano.

196 R. Brandão Cela. *The Abolition of Slavery*. 1938. Fortaleza, Academia Cearense de Letras.

States because of intermarriage and the absence of segregation, it has been argued that this has sustained a myth that masks continuing inequality.[4]

The following account of the image of the black in twentieth-century art from Latin America is necessarily selective; it is organized predominantly by country rather than by theme. Or rather, the country or nation is, to an extent, the theme; in the new republics that formed out of the old Spanish and Portuguese empires, the forging of a national identity was a political and social priority that often sought to override questions of race and individual cultural traditions in its own interests. The nineteenth-century independence heroes who continue to be celebrated were not infrequently of mixed race, but this is not often foregrounded. An exception is the portrait of *General Gregorio Luperon* (1955) by Jaime Colson (1901–1975), which emphasizes the black ancestry of the military leader and statesman, of humble origins, who led the resistance to Spain's annexation of the Dominican Republic in the 1860s.

From the early decades of the twentieth century, artists embracing their black roots found much common ground in the surviving African rituals, dances, music, and imagery—*Candomblé* in Brazil, *Candombe* in Uruguay, Santeria in Cuba, voodoo in Haiti. How to respond to this without losing sight of modernity or slipping into superficial folklorism is one of the issues in the complex stories of art in Latin America. The idea of a Black Atlantic producing "an explicitly transnational and intercultural perspective" on the heterogeneous communities of the Americas, the Caribbean, Europe, and Africa, with shared but still diverse cultures, has offered a positive and less nationalistic approach to racial identity.[5]

The first decades after independence in most new nations in Latin America did not see the anticipated flowering of the arts, with original expressions matching the aspirations of the new republics.[6] With the exception of vigorous local artworks, dismissed usually by the cultural elites as folkloric or naive, paintings and sculpture in the second half of the nineteenth century were remarkably similar to those in the academic salons of Europe. Admittedly there was a new interest in historical scenes and landscapes specific to America: episodes from the arrival of the Europeans and the Conquest, or from prior periods in Native American history, such as José Obregón's *Invention of Pulque*. Genre and *costumbrista* scenes often respond inventively to the

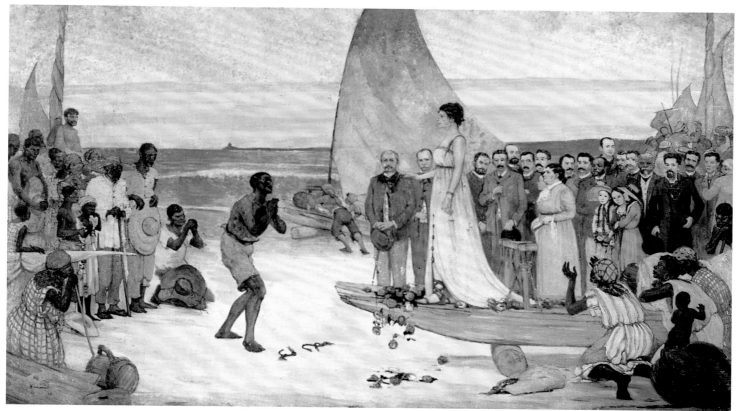

196

new social and economic conditions and occasionally included black figures. Almeida Junior (1850–1899), who spent much of his career in Paris, for example, includes a black laborer prominently in the foreground of the busy scene of boats leaving port to go upriver to the mines of the Matto Grosso *(A Partida da Monçâo)*. The Mexican painter José Agustín Arrieta's impressive portrait of a young fruit seller *(El costeño)* is one of the few nineteenth-century *costumbrista* images to single out the black.

Increasingly in the twentieth century, the division between elite and popular began to break down as artists in Latin America attended to the complex mixture of the region's cultural traditions and examined their own place in them. African traditions in music, religion, and art that had survived centuries of slavery, emerged as a regenerative current.

Brazil finally abolished slavery in 1888, and in 1889 declared independence, with the departure of the emperor for Europe: an event celebrated in an anonymous picture titled *Allegory of the Departure of Dom Pedro II After Independence* (1890), also known as *The Proclamation of the Republic of Brazil*. It is a curious mixture of allegory, narrative, and document, in a vivid and untutored style.

The allegorical female figure representing the republic holds a blank scroll in one hand and with the other receives the flag from a deputation of military and civic leaders, distinctive and realistic enough to be portraits. The peaceful transition of power is encapsulated in the modest, distant figure of the top-hatted departing emperor. In the crowd, one black man raises his hat in an echo of the foreground figures, while at the bottom right of the painting a black couple appear to be in vigorous debate. The woman is daintily dressed, and the man is smoking a pipe; perhaps they are market traders, but in any case they are certainly free, and they form a deliberate counterpoint to the white bourgeoisie on the balcony of a house to the far left; both are elements in the new republic. An interesting comparison can be made between this festive and naive picture by an unknown artist and the huge painting by R. Brandão Cela (1890–1954) in the Government Palace at Fortaleza, *The Abolition of Slavery* (1938). Brandão Cela was celebrated for his realism; here, he adapts the academic style of grand history painting to the relatively recent event, but with the curious addition of an allegorical figure, not unlike that in the earlier painting. This female figure, wearing Grecian clothes and sandals, is elevated above three

195

196

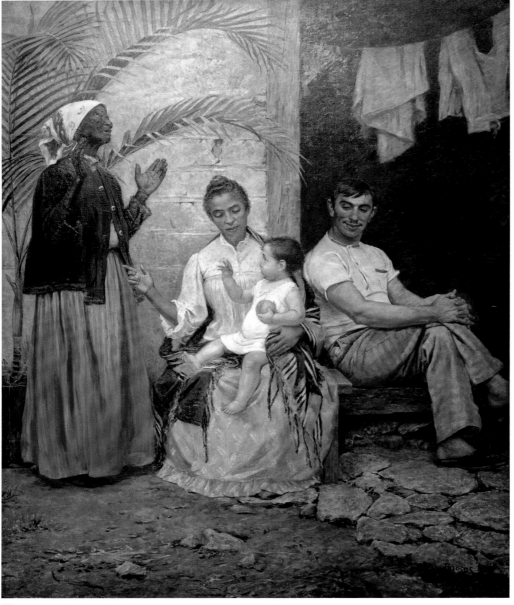

197

groups—former slaves on the left, a huddle of women and children on the right, and a bourgeois crowd, which includes some black figures, massed behind her. Representing both the republic and abolition, she faces the freed slave, his broken shackles lying on the sand.

The watchword of Brazil's republican revolution was "Order and Progress." But although it embraced the rhetoric of progress and racial democracy, "the political structures of the Republic enshrined the power of the great landlords, bankers and merchants."[7] These were almost all Creoles, that is, Brazilians of European descent born in the New World. Following emancipation in 1888—which, having been legislated by the imperial government, was not something the new republican authorities could boast about—

most of the black and mixed-race population was economically marginalized, but at the same time, "The mainstream of Brazilian culture had a dynamic African undercurrent," which was increasingly recognized in literature, art, and anthropology, even if from the outside.

In 1895 Modesto Brocos (1852–1936) won the gold medal at the annual Salon in Rio de Janeiro with his painting *The Redemption of Cain*. This notorious image shows three generations of a family: black grandmother, mulatto daughter with partner of European origin, and their white baby. It is in some ways a variation on the Mexican *casta* paintings (see Thomas Cummins in *Image of the Black in Western Art*, Vol. III, pt. 3, pp. 246–59), the obsession with racial intermarriage and its offspring translated into a multi-

197

197 Modesto Brocos. *The Redemption of Cain.* 1895. Rio de Janeiro, Museu Nacional de Belas Artes.

generational genre scene. But there is a very specific context in post-slavery Brazil. The grandmother is a former slave and the white grandfather is, obviously, absent, although his absence speaks to an amnesia about slavery, which was common in this period and, through to the writings of Gilberto Freyre in the 1930s and beyond, presented as less violent, with sexual relations less coercive than elsewhere. The grandmother appears to be thanking God for the arrival of a white grandson, a reading in line with the title, but it has also been suggested that there is a more scientific aspect to the image related to contemporary ideas about miscegenation, in which case her expression may be one of surprise at the mysteries of genetics.

The whole scene exemplifies the complexity of race and sexual and social relations in Brazil, offering a striking contrast to those in the United States, where segregation was in force. The painting was reproduced with the caption "the black passing to the white in the third generation, by the effect of the crossing of races" in an essay presented by Dr. João Batista Lacerda at the First Universal Races Congress, held at the University of London in July 1911, on "The Métis or Half-Breeds of Brazil." Lacerda was a scientist at the Museo Nacional in Rio de Janeiro, and his essay was the only contribution from South America to this congress (there was a paper from Haiti). The congress aimed to find ways to break down racial and other prejudices; there were fifty-seven papers by delegates from Africa, America, Europe, Turkey, Japan, and other countries, including economists, historians, scientists, sociologists, and anthropologists. Two delegates whose research has been of fundamental importance in challenging racism were W. E. B. Du Bois, who presented a paper titled "The Negro Race in the United States of America," and Franz Boas, whose paper was titled "The Instability of Human Types." Boas's paper, controversial at the time, has

had a long-term influence; it argued against innate racial inferiority or superiority, proving through a comparative study of cranial size that human types are not fixed and that it is culture, not nature, that determines difference among the peoples of the world. Lacerda presented Brazil as an example of the mixing of races. He favored the progressive "whitening" of the *Métis* through intermarriage, and his ideas can be linked to the immigration policy of Brazil, which between 1872 and 1975 encouraged more than five million immigrants to come to the country from Europe and the Middle and Far East.[8] On the one hand, therefore, Brazil actively fostered intermarriage, and segregation was banned. On the other, this was less a recognition of racial equality than, at least in Lacerda's case, an order favoring whiteness.

Lacerda's ideas, as the Brazilian social historian Gilberto Freyre said, were influential, but Freyre himself took a very different position. Far from subscribing to *branqueamento,* Freyre argued that Brazil could be proud of its mixed-race heritage and its distinction of being the world's first racial democracy. Freyre took the view in his important book *Casa Grande e Senzala* (*The Masters and the Slaves;* 1933) that African and indigenous cultures were fundamental to Brazilian identity and that social relations between African peoples and European colonizers had been much less harsh than in Anglo-Saxon–colonized countries because slavery in Latin America was less violent. That view was repeated by Frank Tannenbaum in his study *Slave and Citizen: The Negro in the Americas* (1946), but was subsequently widely challenged. Henry Louis Gates, Jr., writes in *Black in Latin America* that Freyre's writings "changed attitudes about race across the entire nation. Many of Brazil's leaders, no matter what their politics were, sooner or later embraced his ideas. They overturned institutionalized policies that overtly discriminated against blacks. Brazil's official whitening

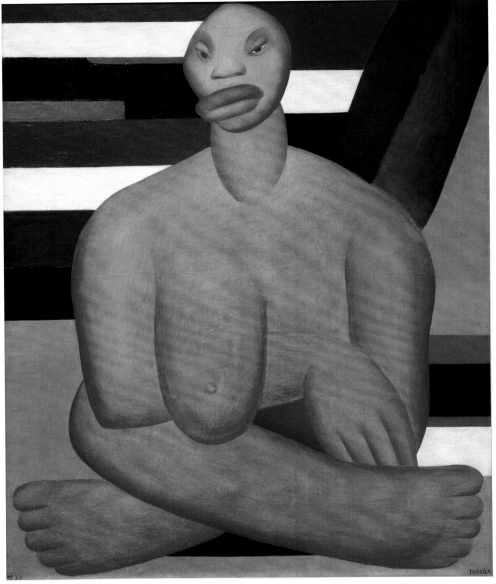

198 Tarsila do Amaral. *A Negra* (Black Woman). 1923. São Paulo, Museu de Arte Contemporanea de Universidade de São Paulo.

198

process came to an end. And Freyre fixed, in its place, the concept of 'racial democracy'—the idea that Brazil was so racially mixed that it was beyond racism."[9] But Gates goes on to argue that this was to become a convenient concept that bore little relation to social realities in Brazil.

By the time Freyre published *Casa Grande e Senzala* in 1933, there had already been a change in cultural attitudes in Brazil, although it could be argued that this was only among the intellectual and artistic elite, itself largely white. The "dynamic African undercurrent" that continued despite the suppression of African religious and cultural manifestations following the abolition of slavery became a significant force within Brazilian modernism. The Brazilian avant-garde, eager to root their art and poetry in Brazilian as opposed to European forms and themes, did their best to harness

this undercurrent. Prominent among them was the small group of artists and writers including Tarsila do Amaral and her companion Oswald de Andrade (whom she married in 1926). Tarsila's painting *A Negra* (The black woman), of 1923, is a striking invention that places the image of a black woman center stage but in a non-naturalistic and partially abstract manner. The radical nature of the image lies not just in its modernist style but in the absence of an obvious setting—there is no manifest clue to her personal or social identity, unlike most paintings of black women in the first decades of the twentieth century. A brief comparison with examples of such images will clarify the significance of this.

The relatively naturalist style of such paintings as Armando Vianna's *Nettoyant les métaux de cuisine* (1923), Lucilio de Albuquerque's *Mère noire* (1912), or Antonio Ferrigno's *Mulata quintandeira*

198

199

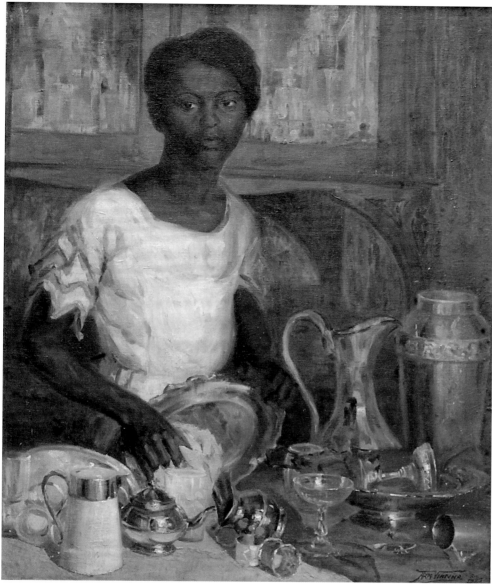

199

199 Armando Vianna. *Nettoyant les métaux de cuisine.* 1923.

(ca. 1893–1903) identifies the figure and binds her to her circumstances: the maid, the wet nurse, the street trader. Each is in a marginal, dependent, and even miserable position economically and socially. *Mère noire* is a poignant image of a young mother—far from the stereotype of a comforting black mother figure—breastfeeding a white baby who has been farmed out to her, with her gaze on her own baby lying beside her, in a bare, poor room.[10] These three paintings settle in different figurative modes: *Mère noire* has something of a social realist character; *Mulata quintandeira* harks back to the picturesque manner of *costumbrista* imagery, though the painter's consciousness of the economic reality of the features that made an object "suitable to be the subject of a picture" allows an element of awkward realism to enter.

Nettoyant les métaux de cuisine, painted in the same year as *A*

Negra, is the most ambiguous from this point of view in that it seems the subject, a maid cleaning silver, is no more than a "motif." This subject was quite familiar among Impressionists and Post-Impressionists who chose to paint domestic scenes, their everyday surroundings. Matisse, for example, in *The Dinner Table* (1896–1897) and *La Desserte* (1908) includes the maid setting the table but gives her no individual identity. The black girl in Vianna's *Nettoyant les métaux de cuisine,* by contrast, is clearly taken from life. Armando Vianna was of modest origins in Rio de Janeiro and the grandson of slaves, but this seems to be the only image he painted of a black subject. Showing her gazing into the distance and evidently detached from her task, he appears to sympathize with and criticize her menial status.

To return to Tarsila's *A Negra:* unlike the three paintings of black

women discussed above, there are no clues to her social situation or circumstances. There is no setting—in fact the abstract geometrical backdrop deliberately evades this. It has been suggested that the figure could be based on a photo of a family servant in her photograph album, but a much more convincing source is the African goddess Yemanja. A nineteenth-century painted wooden statue from Bahia, for instance, bears a close similarity to *A Negra,* in particular the pendulous breast and compressed body.[11] Yemanja is goddess of sea and freshwater, and mother of all the *orishas.*[12] She is the symbol of maternity and fecundity, as nothing can exist without water. This is not a painting of the Bahia statue, and the black woman is not explicitly identified with Yemanja, but the absence of a social context suggests that the figure has a symbolic quality. It points to aspects of African-Brazilian identity that were still overlooked and had in recent years been discouraged and sometimes actively repressed: the *Candomblé* rituals, music, and dances and the "gods" such as Yemanja, who had taken root in the New World. *A Negra* not only anticipates the revaluation in the avant-garde circles in which Tarsila moved of the African heritage in Brazil but shows how important this heritage was to the artists and writers seeking modern forms of expression. As the artist Frank Bowling, who was born in British Guyana, put it: "The black soul, if there can be such a thing, belongs in Modernism."[13]

A Negra was painted in Paris, where the passion for African art and music stimulated Tarsila's interest in the African-Brazilian world. Contacts went both ways: a close friendship developed between Tarsila, her husband Oswald de Andrade, and the poet Blaise Cendrars, who visited Brazil several times. The drawing for *A Negra* was used for the cover of Cendrars's book of poems *Feuilles de route* (1924). *A Negra* and paintings that followed in the 1920s, such as *Carnaval em Madureira* (1924), have close connections

both with the ideas presented by Oswald de Andrade in his manifestoes *Pau-Brasil Poetry* (1924) and *Anthropophagite Manifesto* (1928) and with the work of Fernand Léger. *Pau-Brasil Poetry* famously announced: "We have a dual heritage—the jungle and the school. Our credulous mestizo race . . ."[14] In jagged, elliptical prose, de Andrade celebrates a new world ("Ports and airports. Pylons. Petrol Stations . . ."), attacks naturalism, romanticism, bureaucracy, and erudition, welcomes an aesthetics of invention and surprise, and quotes from Cendrars, who was a friend: "A suggestion from Blaise Cendrars: stoke your engines, you're ready to go. A black turns the handle of the rotating platform you're standing on."[15] The implication here is that there will be a revolution in culture if not more widely, and the impetus will come from the black.

Cendrars had written the scenario, based on African myths, for the ballet *The Creation of the World* (Paris, 1923), with sets and costumes by Fernand Léger and music by Darius Milhaud, inspired by the jazz he had heard in New York. It was through Cendrars that Tarsila met Léger, whose work influenced her painting. The combination of the figure with abstract motifs in the background recalls the stage set for *The Creation of the World.* Léger's designs for *The Creation of the World* continue to resonate in Tarsila's paintings through the '20s, but specific references to Brazil become more emphatic. A series of paintings of 1924 focus on two contrasted aspects of Brazil: the modern city with its gas stations and pylons, and favelas and villages in the country with their black inhabitants *(Carnaval em Madureira).* The heavily outlined, simplified shapes of hill, tree, and house, with subtly modulated shading, that creates a tension between the flat surface and an illusion of depth, develops from Léger's designs for *The Creation of the World* and his paintings of the early 1920s.

Oswald de Andrade's *Anthropophagite Manifesto,* closely related

see 116

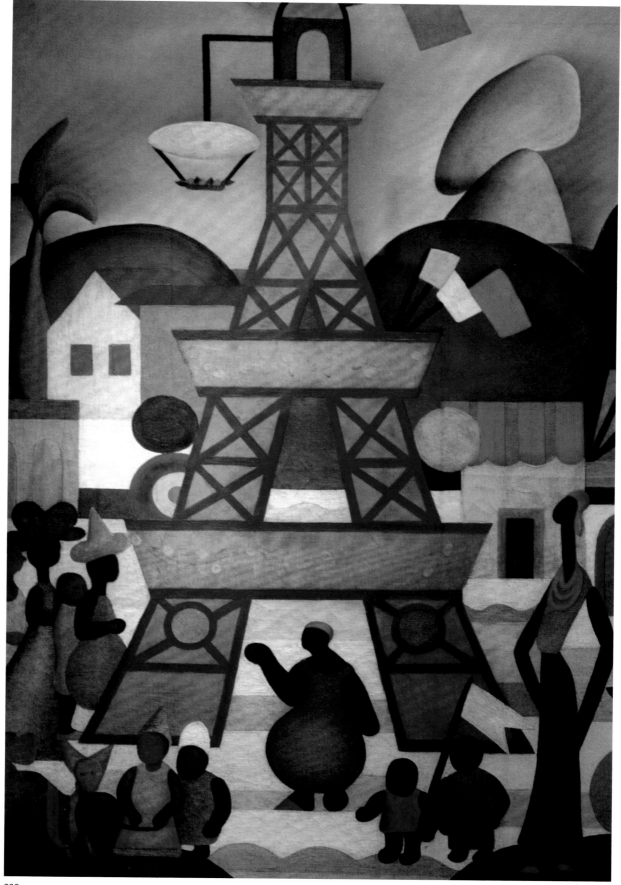

200

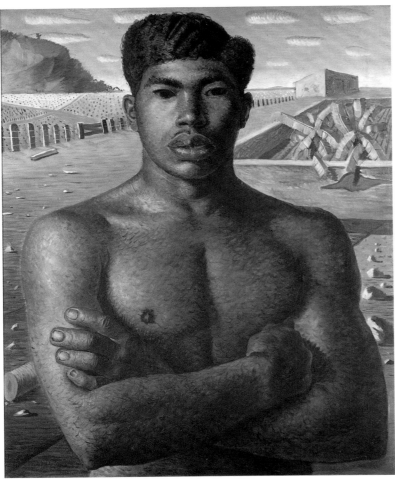

201

201 Cândido Portinari. *O Mestiço*. 1934. São Paulo, Pinacoteca do Estado.

202 Cândido Portinari. *O Lavrador de café*. 1939. São Paulo, Museu de Arte de São Paulo.

to Tarsila's paintings *Abaporu* ("He who eats" in the indigenous language Tupi-Guarani; 1928) and *Antropofagia* (1929), has had a long fuse as a statement of cultural independence. The cannibal metaphor has had a continuing anticolonial resonance—not just resisting or rejecting the colonizer and European traditions, but ingesting and thus transforming them. Tarsila's paintings are imprecise in terms of race, though they clearly situate the naked, primitivized bodies in a tropical "American" landscape with both cacti and banana trees. The *Manifesto* is a tumultuous invocation of hybrid Brazil; it mentions Bahia, where the largest Afro-Brazilian population lives, but foregrounds indigenous peoples rather than those of African origin. It runs together a "Carib" revolution with the French Revolution and Surrealism in an extraordinary eclectic dream in which foreign and native are absorbed and devoured cannibalistically in order to cease looking to other cultures and to create one that is truly independent.

How artists represented their country and their compatriots, following their embrace of a modernity that was to be specifically national, varied. In Brazil, as in other countries in Latin America, some avant-garde artists looked to African cultural traditions for

inspiration, while others observed current conditions in their country critically. Whereas some celebrated the mixed racial and cultural situation with depictions of carnival, dancing, and rituals, others addressed the continuing divide between rich and poor. Artists on the left, such as Cândido Portinari (1903–1962), tended to see inequality as a question of class rather than race. In the 1930s, Portinari, a member of the Communist Party, developed a distinctive form of socialist realism that gave it a nationalist twist. *O Mestiço* (1934) is a symbol of Brazil as racial democracy but with a particularly prominent affirmation of the African roots in this mixed-race heritage. The painting gives great dignity to the bare-chested worker who almost fills the frame of the canvas, against the bleak background of the plantation.

In the mid-1930s, Portinari painted a number of pictures on the theme of labor in the coffee plantations, where he had been brought up in a poor immigrant household. In *O Lavrador de café* (1939), again a mestizo laborer dominates the bare landscape, stripped of its vegetation for the planting of the endless coffee bushes. His enormous bare feet and the gigantic hoe he grips in his hand speak to the grueling nature of his work but also to his root-

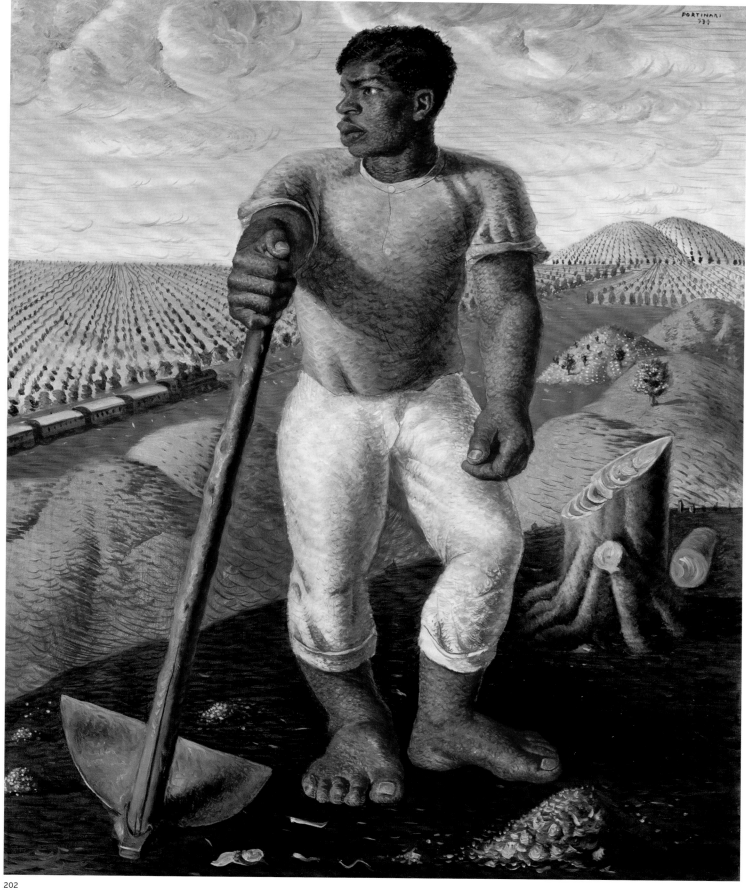

202

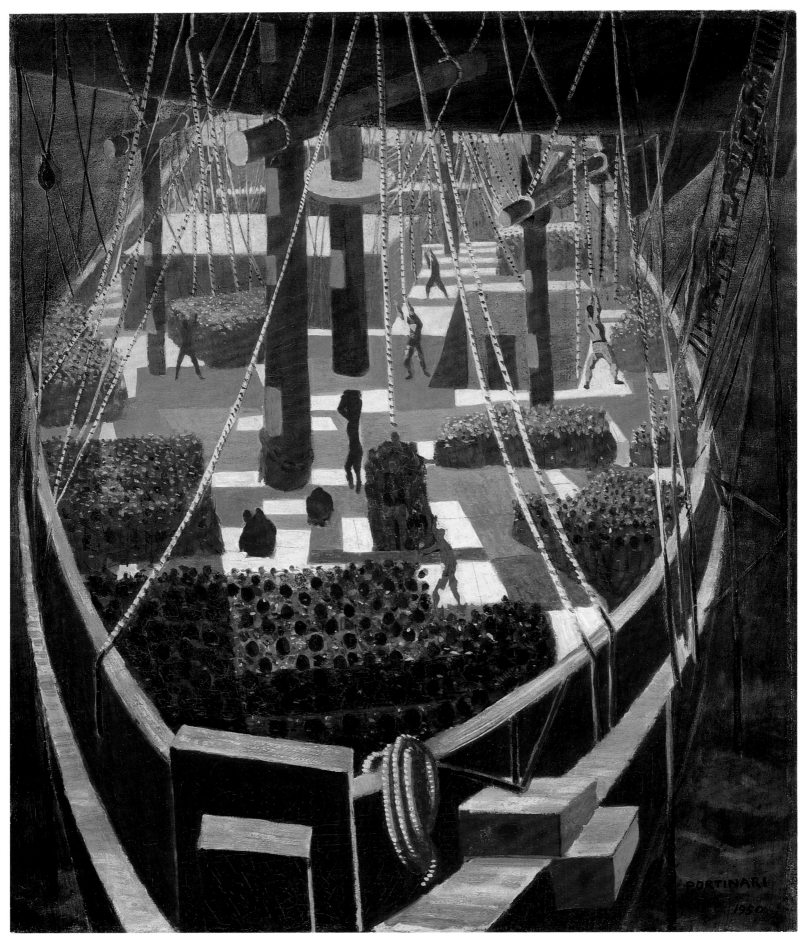

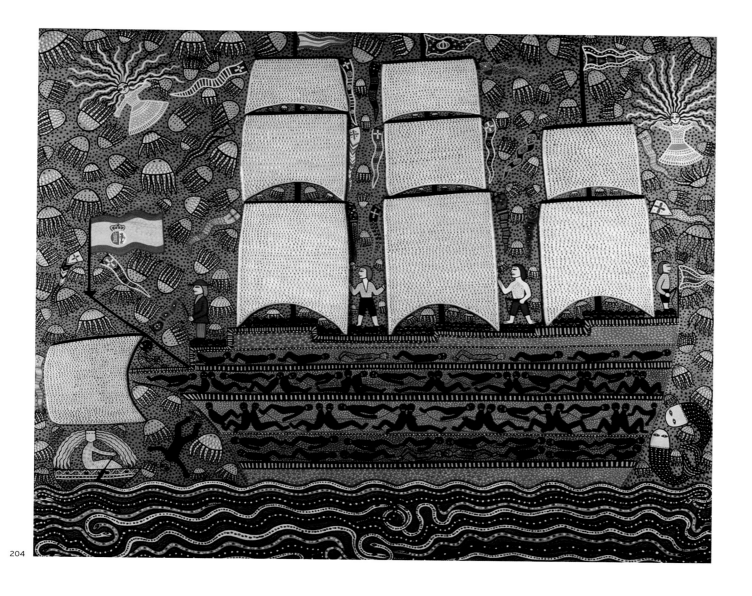

203 Cândido Portinari. *Navio negreiro*. Sold at Christie's May 2012.

204 Manuel Mendive. *Barco Negreiro*. 1976. Havana, National Museum of Cuba.

edness in the earth. The image recalls one of the verses from the "Song of the Revolution" in the Mexican muralist Diego Rivera's frescoes in the Ministry of Education in México City: "He who wants to eat must work." Later in his career, Portinari's work shows the influence of Picasso and other modernist artists, but he never lost his social conscience. From the 1940s he painted scenes from Negro life, searing images of the dispossessed and episodes from Brazil's history. *Navio negreiro* treats the terrible experiences of the Africans being shipped on the Middle Passage to become slaves in Brazil; the space is compressed, and the figures dwarfed by the ship, the ropes, and the sails. The Cuban artist Manuel Mendive's

Barco Negreiro (Slave ship) of 1976 presents the same subject in a very different way; apparently decorative in its detailed patterning, Mendive's image uses a visual vocabulary and African motifs to re-claim this symbol of historical oppression from a distinctly Afro-Cuban perspective.

The depiction of skin color and racial characteristics by artists in Brazil took diverse forms in relation to the rhetoric and reality of its mixed populations. Emiliano Di Cavalcanti (1897–1976), one of the artists associated with Oswald de Andrade and the stirrings of modern art in Brazil in the early 1920s, celebrated difference, for example in his *Cinco moças de Guaratinguetá* (1930), where five

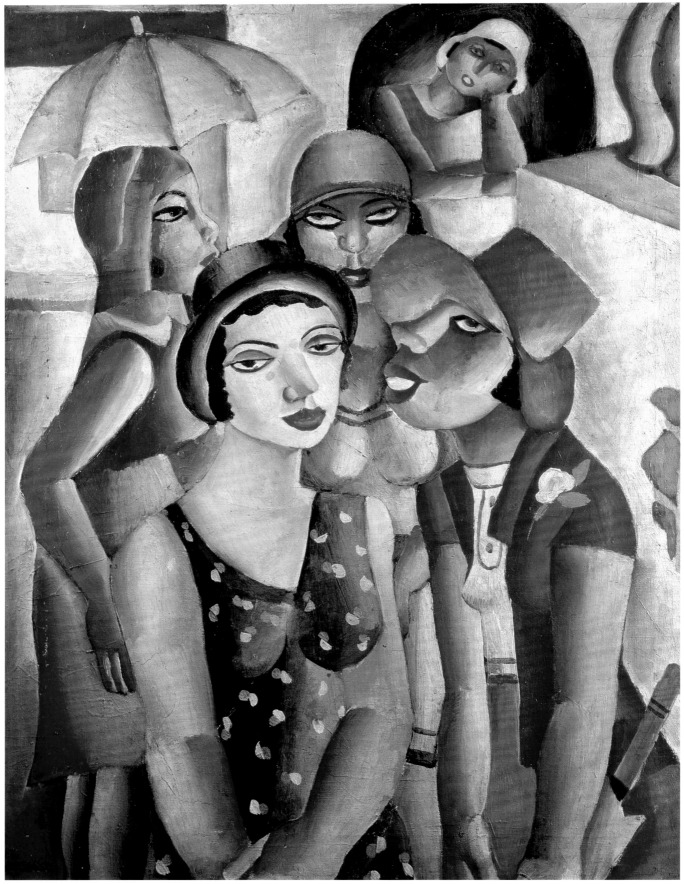

205

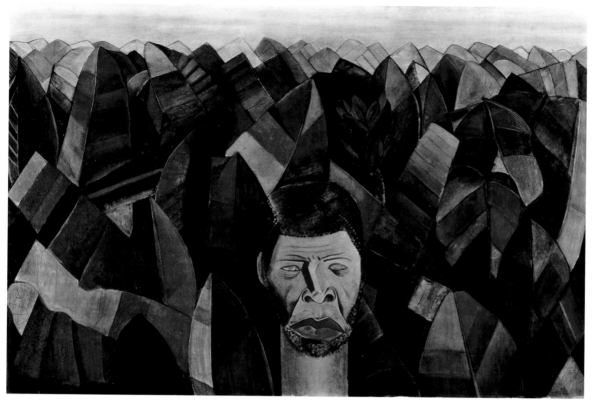

206

205 Emiliano Di Cavalcanti. *Cinco moças de Guaratinguetá*. 1930. São Paulo, Museu de Arte de São Paulo.

206 Lasar Segall. *Bananal* (Banana plantation). 1927. São Paulo, Pinacoteca do Estado.

glamorous girls range in color from light to dark without any being specifically black or white. (Brazil has, apparently, more than one hundred terms for variations in skin color.) The immigrant Russian Jewish artist Lasar Segall, in his series of etchings, woodcuts, and prints of prostitutes in a notorious district of Rio de Janeiro, emphasizes, in his expressionist style, their racial diversity; some are given clearly African features, like the head of the worker in his famous painting *Bananal* (Banana plantation; 1927).

México, despite its huge cultural achievements in the twentieth century and the influence of José Vasconcelos's espousal of a mixed-race nation, figures little in this short account of the image of the black. The Mexican Revolution (1910–1917) had transformed the way the country saw itself; the ethnographer and archeologist Manuel Gamio published *Forjando Patria* in 1916, drawing attention to the fact that the great majority of the population were indigenous Indian or mestizo, and, like Franz Boas, rejecting the theory of superior and inferior races. His survey of the Valley of México revealed that 60 percent of the population was

Indian, the rest mostly mestizo, but 90 percent of the land was owned by a handful of absentee landlords. The disparity in conditions between rich and poor, between the largely Creole elite and the rest of the population, had deepened since independence. The revolution brought to the fore the "Indian face" of México, which was celebrated by artists even as the official policy of assimilation, mounted as part of an effort to create a fully modern México, was under way. Mexicans of African descent rarely if ever featured in the discourse, but occasionally appeared in murals and prints, as for example Fernando Leal's *Timoteo*. The dark-skinned groups in Diego Rivera's murals are usually demonstrably, almost caricaturally, indigenous in feature and dress, though occasionally he represents mestizos or mulattoes. These are more noticeable in the cycle he painted in the Ministry of Education, the "Corrido de la Revolución," following his trip to the Soviet Union in 1927. The revolutionary groups become more evidently universal, made up of workers and peasants from all lands. The female revolutionary in "He who wants to eat must work" and the male worker in *The*

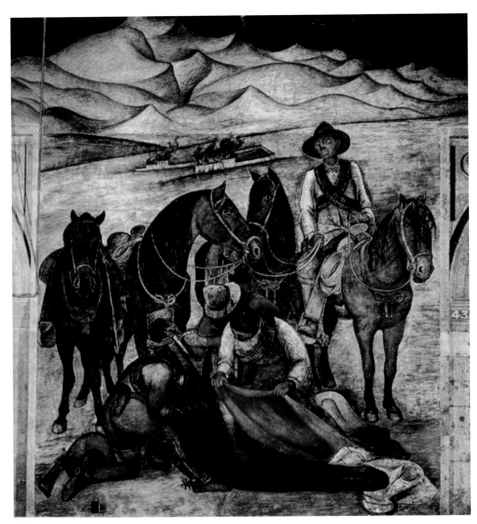

207 Diego Rivera. *The Liberation of the Peon.* (1923–1924). México City, Ministry of Education.

207

co-operative have notably dark features and African hair. An earlier scene in the Ministry of Education murals, however, centers on a black figure in a specifically Mexican context. In *The Liberation of the Peon* a prostrate black figure tied to a post is freed by a band of revolutionary soldiers who have set fire to the hacienda where he worked. Although slavery was long abolished in Mexico, the conditions in which the peons worked on the huge sugar, henequen, and cotton estates were still inhuman, and Rivera is hinting at this long history of exploitation. The suffering figure, subjected to the worst indignities, is depicted as a kind of *Pietà*, or *Descent from the Cross*.

Artists addressing the social and cultural conditions in their countries depicted black communities as part of the wider question of modernity. For some, this was couched in terms of a national narrative; for others it was not so circumscribed but was part of wider, transnational issues. Two painters in particular, neither from countries with extensive black communities, produced series of works with the black as the subject but from contrasting positions: Pedro Figari (1861–1938) from Uruguay and Oswaldo Guayasamín (1919–1999) from Ecuador. Whereas the context for Figari was his country and its history, Guayasamín was not concerned with national narratives, but rather with political and social conditions in Latin America as a whole. A close friend of Fidel Castro, Guayasamín was one of a generation of Latin American artists who, as his obituarist Richard Gott said, "found a comfortable political home in the continent's communist parties."[16] Guayasamín was proud of his Quechua Indian origins, but the issue of social inequity for him was class more than race. This is a complex question in a world where the working classes, the oppressed, and the poor were mostly the indigenous peoples, blacks and mestizos.[17] He spent time in 1943 working with the mural painter José Clemente Orozco in México, and traveled through Peru, Chile, Argentina, and Bolivia sketching the people and amassing material for his Huacayñán series. In 1952 he exhibited 103 pictures in Quito from the series whose title, "Huacayñán," is Quechua for "The Way of Lamentation"; many of the images are of

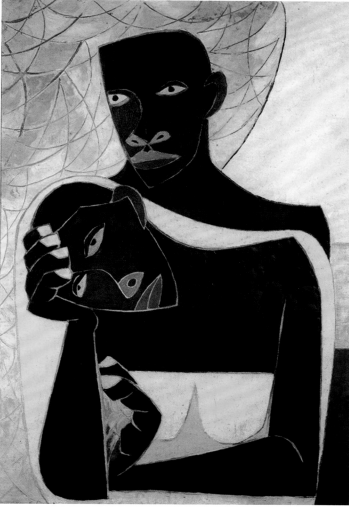

208

208 Oswaldo Guayasamín. *The Lovers.* Negro theme from Huacayñán series. 1950. Barcelona, Fernando Rivière collection.

sorrowing or suffering. The two main groups within the series are dedicated respectively to "Amerindian" and "Negro" themes. Most are close-up images of single or small groups of figures, and there is a strong sense that Guayasamín wants to stress the universality of human experience rather than any picturesque character of his subjects. The series shows a progressive adoption of a simplified cubist mode indebted to Picasso, and it is likely that he saw this as enhancing its transnational appeal. A lyrical study in black and golden yellow of *The Lovers,* one of the Negro themes, depicts a united but melancholy pair, the woman with her head resting wearily on her hand. The large painting *The Marimba* (1951) is unusually dynamic, carrying the abstract and cubist patterning further than in most of the series to express the rhythm of the music and the movement of the dance. A marimba is a drum, or a kind of xylophone, and the emphasis given to the hands outlined by the broad curves and circles, emanating from the large black head in the center, evoke the player's gestures.

By contrast, Figari's depictions of black subjects are explicitly placed within his memories and experiences of the history and culture of Uruguay and the Rio de la Plata region generally (in other words, including Argentina). Finally dedicating himself to painting in 1921, he wrote later: "Sustained entirely by my philosophical outlook, I occupied myself, more than in anything else, in reconstructing my memories of our traditions, a subject which was completely neglected at that time."[18] He painted the flat landscapes of the plains with the *ombu* and mahogany trees, the patios and estancias, and the people: white Creoles, Negroes, and Gauchos: American subjects. "I continue to think that those countries of America, our countries, have much art that has yet to be realized . . . We live besotted with the wonders of the old world, and this attitude has not accompanied the spirit of freedom and sovereignty that a deeply original creativity demands."[19]

He believed in the authenticity of his pictorial themes: "What is truly necessary is to choose very carefully the best path, the one that is the most direct and which connects us to our own setting instead of 'foreignizing' us, which would be snobbish and unwise

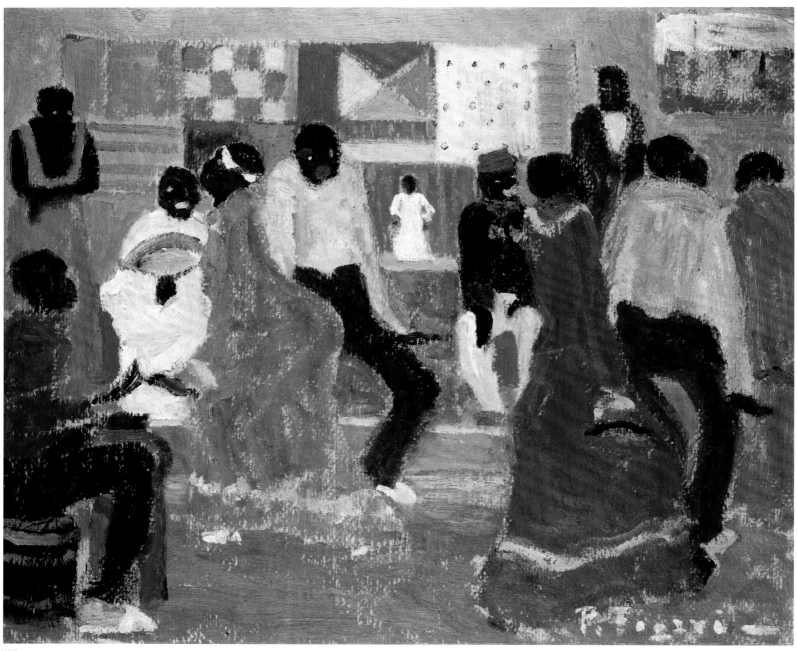

209

because there are so many beautiful things in our own homeland. Zuloaga and Bonnard used to tell me that I was quite fortunate to come upon such lovely pictorial themes."[20] But at the same time, he imbibed the primitivism prevalent in Paris at the time.

Figari was a successful lawyer, whose parents had emigrated from Italy; a member of the Uruguayan intellectual elite, he frequently occupied diplomatic posts even after ceasing to practice as a lawyer to paint full-time. Figari had little formal training as a painter, but he was an active promoter of art, even serving as director of the Escuela Nacional de Artes y Oficios from 1915–1917. He

traveled several times to Europe and spent nine years in Paris (1925–1933). His own account of his distinctive, rough, and blotchy style was that, lacking technical ability, he would be unable to express his imagination and therefore decided to set down as directly as possible his memories. It is quite plausible that the compositions are based on observations recollected later, though they also fall into very clear groups, which are deliberately contrasted with each other. For example, among the many scenes he painted of local dances are three that treat the main divisions of Rio de la Plata society: *El Tango,* in which the dancers are white; *Los mula-*

209 *tos,* with brown-skinned couples; and the *Candombe,* in which the dancers are black.

Figari's paintings of black life form a deliberate contrast with those of the white society in Uruguay, and both seem to belong to what was already in the 1920s a distant past. Jorge Luis Borges proposed that only new countries—like his own Argentina, or Uruguay—have a past, but that it is a past that its inheritors conspire to forget. "I spoke of Argentine memory and I feel that a sort of modesty veils that subject and that to insist on it too much is a betrayal. But in this house of America the men of all the nations of the earth have conspired to disappear in the new man, who is none of us as yet . . . It is a conspiracy of an unusual kind: a prodigal adventure of lineages, which seek not to last but to be finally unknown: bloods which seek the darkness."[21] Figari, Borges goes on, "is the pure temptation of this memory."

It is sometimes claimed that the Negroes whom Figari represented were communities of slaves who had escaped over the border from Brazil. Although these did play a role in the revival of the *candombe* dances, this claim overlooks the fact that slaves were imported into the Banda Oriental, as Uruguay was then known, from ca. 1750, and slavery was not finally abolished until 1846. The majority of the slaves came from Congo, Angola, and Mozambique.[22] One of Figari's favorite subjects was the *candombe;* this term refers both to the celebrations at the periodic gatherings in Montevideo, where the majority of the black population lived during the colonial era and into the nineteenth century, and to the dances of African origin. Catholic elements were incorporated into the *candombe,* which is closely related to and clearly the same term as Brazilian *Candomblé.* It was, "in its best period," celebrated every Sunday but also and especially on January 6, the Day of the Kings, when the back king/saint Balthazar was worshipped. The "kings,"

wearing top hats, would lead the parade and oversee the dances. Figari shows *candombe* scenes with black dancers accompanied by drums and white-clad statues of the saint on an altar. As distinct from the slave communities in Cuba and Brazil, who on the whole worked on the plantations and lived apart in barracks, in Uruguay many were household slaves and lived in relative proximity to the Creole families. In *Dulce de Membrillo* (n.d.) an elegant patio with 210 women, children, cats, and dogs symmetrically disposed is shared by the white family and the black servants. The main feature distinguishing the former from the latter are the fans and the huge head combs, which were in fashion in Argentina and Uruguay in the mid-nineteenth century. Although Figari's figures seem to be generic "black" or "white," they are often individualized in the sense of having a distinct character, revealed by a gesture or posture, or slightly exaggerated in a satirical or humorous direction.

Figari's paintings of Negro dances—*Candombe* or *Camba-cuá*—and those of white society emphasize the contrast between the freedom and liveliness, the joyous sensual movements of the former and the stiff formality of the latter. Behind this lies Figari's version of primitivism, the belief shared by many Western artists and intellectuals that European "civilization" had lost contact with the natural world, and its inhabitants were no longer capable of the straightforward, direct expression of feelings. In one of his stories, *Pajueranos,* a provincial couple is struck by the artificiality and decadence of Paris: "Things around here [in Paris] do not appear as natural as we show them."[23] Some of Figari's earliest paintings depict primitive man in unspoiled nature (Troglodyte series), an American version of Paul Gauguin's flight to the Marquesas Islands in the Pacific. In fact, despite his claim to be documenting his memories, Figari also offered, he said, "glimpses of reality more or less poeticised according to my personal manner of reacting."[24] Al-

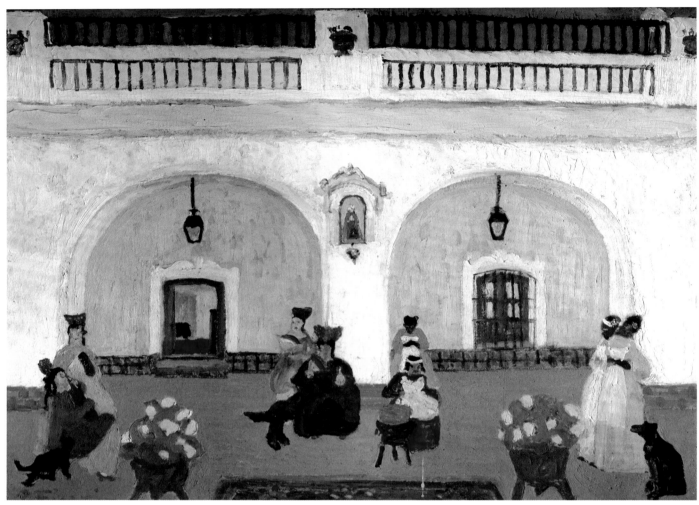

210

though the paintings bear traces of his evident admiration for the work of Vuillard and Bonnard (whom he knew in Paris), Figari kept his mark-making as direct and basic as possible, an effect emphasized by his choice after 1921 to paint on cardboard rather than canvas. This choice of medium absorbs the oil and allows the pigment to dry quickly. Sometimes part of the cardboard is left unpainted. The overall effect, notwithstanding the innate sense of color and composition, is as far as possible from academic realism.

When asked why he painted Negroes, he wrote: "I want to refer to man and in order to better do so, I take the Negro as my example, bearing in mind that we white men carry a black man, a very black man, within us—the same one who frequently suggests things that otherwise could not be suggested to a white man, without incurring the charge of irreverence."[25] If Figari's paintings reveal the importance of their black past to Uruguay and Argentina, they also carried in his eyes meditations on the human condition, on nature and civilization, in which images of the black, as well as their undoubted immediacy and realism, have a symbolic charac-

ter. It is interesting to compare his comment, quoted above, with Gilberto Freyre writing slightly later of Brazil: "Every Brazilian, even the light-haired fair-skinned one, carries out in him on his soul, when not on soul and body alike . . . the shadow, or at least the birthmark, of the aborigine or the Negro . . . In our affections, our excessive mimicry, our Catholicism, which so delights the senses, our music, our gait, our speech, our cradle songs—in everything that is a sincere expression of our lives, we almost all of us bear the mark of that influence."[26] Freyre's lyrical celebration of a multiracial nation is credited with changing the way both black and white Brazilians looked at themselves and each other, and in its specificity differs from Figari's generalized primitivism.

Cuba was the last Spanish-speaking territory to gain independence, in 1902, after decades of struggle in which free people of color and former slaves fought in the Cuban liberation army. A new colonial order in the 1880s had banned discrimination on grounds of skin color from all public places, but the still powerful Cuban elite, the sugarcane plantation owners and the periodic oc-

cupying forces of the United States, regarded the prestige of the colored veterans with alarm.[27] As we saw with the example of Panama at the beginning of this chapter, the legislation against discrimination that often accompanied independence in the Latin American nations did not prevent continuing prejudice, though at the same time there was considerable intermingling of color and races. Recuperation and reconciliation after centuries of bondage and the frustrations of emancipation were accelerated in the Caribbean through artists, poets, and writers such as Wifredo Lam, Aimé Césaire, and Nicolas Guillén who drew on Afro-Caribbean cultures and experience. As Robin Blackburn writes, "Cuban *santería,* Afro-Caribbean music and poetry or Brazilian *candomblé, capoeira* and carnival, Caribbean popular architecture, murals, kick-boxing and carnival, Haitian *meringue* music and *vodou* rites are still further expressions of this diasporic ferment."[28] In *Merengue* (1938), Jaime Colson (1901–1975, Dominican Republic) crowds the music-making and dancing figures into the foreground of the painting to enforce the point that this is a hybrid popular entertainment, mixing African, Spanish, and indigenous instruments—the drummer on the right, for example, is black.

The work of Wifredo Lam (Cuba, 1902–1982) is an extraordinary example of the two-way routes between modernism's love of African art and Afro-Caribbean Santeria. Lam was brought up in Sagua la Grande, a town in the middle of the sugar plantations; his father was Chinese, an educated man who died in 1926 at the age of a hundred and eight. His mother was predominantly black with some Spanish and Indian ancestors. Much is often made of the importance of his godmother, Mantonica Wilson, a Santeria healer who in her ritual practices always invoked Xango, ancestor of the Yoruba and god of thunder. As Lam said, as a child he attended ceremonies that had come from Dahomey or the Congo. However, he refused her invitation to succeed her and to inherit her accoutrements as healer and sorcerer. As he explained later, "I am neither a priest nor a believer in Afro-Cuban rituals: I have as much of the savage in me as I do the Cartesian, but the magical world that I lived as a boy in Sagua la Grande formed part of my childhood and my adolescence."[29] Lam went to Madrid on a scholarship in 1923; after the Spanish Civil War, in 1938, he finally reached Paris and met Picasso, who championed the young painter and introduced him to André Breton and the Surrealists. Pierre Loeb tells a story against himself of a visit to Lam's studio: needing to make some judgment about the work of this young, unknown painter, he remarked to Picasso that he was influenced by Negro art. "Picasso, furious, replies brusquely: 'He has the right, him. He is black!'"[30]

Lam forged a new pictorial expression from a position that was both inside and outside Afro-Cuban culture. While his earliest paintings occasionally depicted black subjects (for example, *The Couple* [1936]) his images of beings derived from and inspired by the African *orishas* break new ground. The paintings he did on his return to Cuba after seventeen years in Europe were a complex form of political and social protest. The first impression he had on returning to La Havana in 1941 was, he said, a "terrible sadness." "The whole colonial drama of my youth seemed to be reborn in me."[31] The poverty of the blacks was as abject as ever, as was discrimination, and the island was now a playground for rich tourists. "Havana at that time was a land of pleasure, of sugary music, rumbas, mambos and so forth. The Negroes were considered *picturesque.* They themselves aped the whites and regretted that they had not light skins. And they were divided—the blacks disowned the mulattos, while the mulattos detested their own skin because they were no longer like their fathers, yet were not white either."[32]

On the journey from Marseille to Cuba, Lam had spent time on

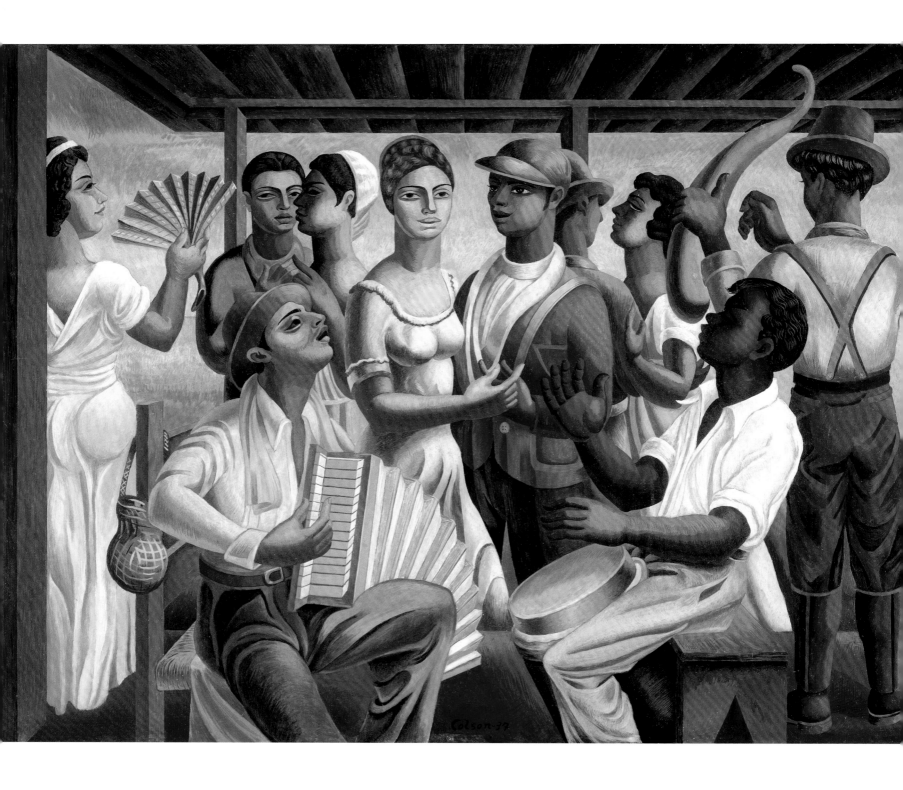

211 Jaime Colson. *Merengue*. 1938. Santo Domingo, Museo Bellapart.

212 Wifredo Lam. *The Jungle*. 1942/1943. New York, Museum of Modern Art.

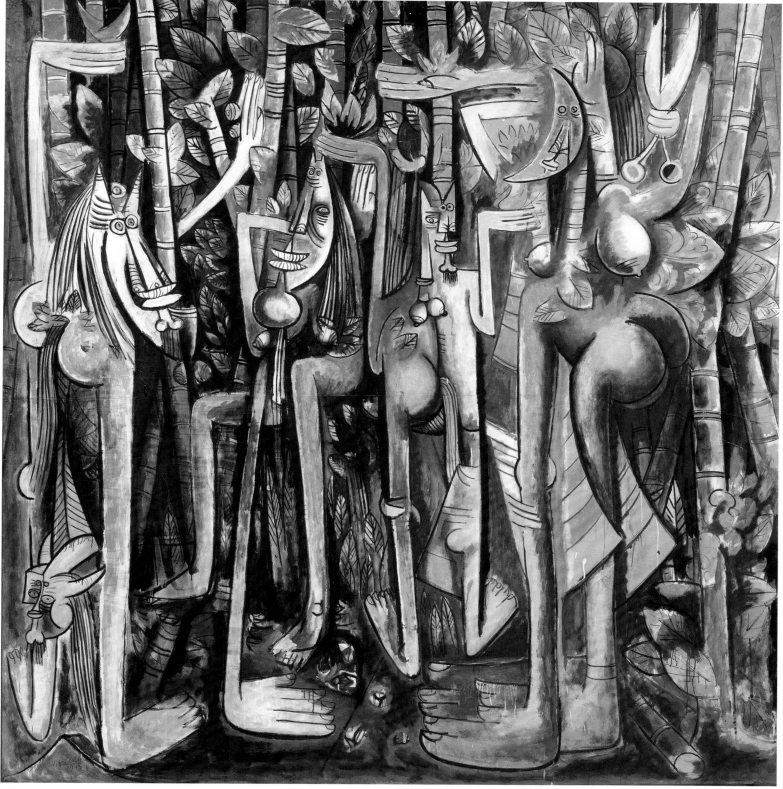

212

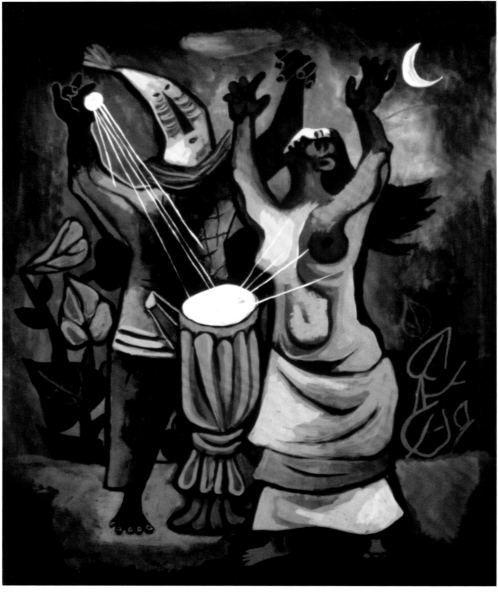

213

Martinique, where he and Breton met Aimé Césaire. The black poet's long poem "Cahier d'un retour au pays natal," translated into Spanish and published with illustrations by Lam in 1942, was a source of inspiration and encouragement for Lam. *The Jungle*, Lam's masterpiece, painted in less than three weeks between December 1942 and January 1943, is a response to the situation in Cuba:

> Poetry in Cuba then was either political and committed, like that of Nicolas Guillén and a few others, or else written for the tourists. The latter I rejected, for it had nothing to do with an exploited people, with a society that crushed and humiliated its slaves. No, I decided that my painting would never be the equivalent of that pseudo-Cuban music for nightclubs. I refused to paint cha-cha-cha. I wanted with all my heart to paint the drama of my country, but by thoroughly expressing the negro spirit, the beauty of the plastic art of the blacks. In this way I could act as a Trojan horse that would spew forth hallucinating figures with the power to surprise, to disturb the dreams of the exploiters.[33]

The Jungle sets up a dialogue with Picasso's *Demoiselles d'Avignon* (1907), transposing its five protagonists into a tropical setting. Pi-

casso's prostitutes, their pink bodies topped with alien heads (two Iberian stone heads, a black Gauguinesque profile, and two African masks), stare out at us, Medusa-like. Lam's life-size figures similarly confront us, with a mixture of lewd sexuality and the gaze of the ritual masks, with breasts and buttocks fragmented among the foliage and the canes. The woman on the right grasps a pair of scissors, her castrating gesture repeated more explicitly in another version of *The Jungle.* A comparison between *The Jungle* and Mario Carreño's *Afro-Cuban Dance* (1943) highlights Lam's achievement in inventing a black subject which is simultaneously critical and celebratory, angry but also humorous. *Afro-Cuban Dance,* with the bare-breasted dancer and the *diablito*—a popular figure in nineteenth-century *costumbrista* painting—still exoticizes its subject, by contrast with *The Jungle.* The challenge for Lam is to reveal the world of black Cuba but avoid the exotic and picturesque—as Césaire put it: "To create a world—is that a minor thing? . . . There, where the exotic inhumanity of a junk shop spread out its wares, to make a world appear!"[34]

Following this extraordinary, disturbing image, Lam developed hybrid figures that cross between animal and human realms, fusing "the natural and the fantastic, the physical and the spiritual."[35] Several carry titles linked to Santeria and its *orishas* and *loas,* including Malembo, the god of cross-roads (1943); Ogoun, patron of war; blacksmiths and iron workers, Yemaya and Eleggua. But the paintings are not representations of the deities. Lam does not use a specific symbology, and he remarked that placing the double-pointed staff, which is the symbol for Shango (Xangô), the god of thunder, in the upper-right-hand corner of *The Eternal Presence* (1945) was very unusual for him.

When André Breton met Hector Hyppolite at the Art Center in Port au Prince, where an exhibition of Lam's paintings was being installed, he asked the Haitian artist-priest his opinion of them. Hyppolite "affirmed a vigorous and deferential interest in them while still retaining a slight air of reserve because in his view it was 'Chinese magic' rather than the 'African magic,' which was, he implied, his own province of knowledge."[36] Lam was not, as he himself said, a believer or a practitioner. Hyppolite, in giving two-dimensional pictorial form (as opposed to three-dimensional or symbolic) to the voodoo deities for the first time, wanted to convey information, even to create icons. Mestre Didi (b. 1917) in Brazil, who like Hyppolite is a priest and religious authority, creates sculpture-constructions based on ritual objects, shells and pearls, and sacred materials including palm fibers. This is different again, as he is not interpreting or translating the *orishas* but making works associated with them. His religious society is organized around an ancestor cult—Egun in Yoruba culture—and elements of nature, in particular the palm tree.[37]

Lam's response to the world of the *orishas* is more personal and detached and is freely inventive. It was through Césaire, and through surrealism, that Lam recognized and in his own way conjured up magic: "Surrealism helped me to find an opening but I didn't paint in a surrealist manner although I gave a solution to surrealism . . . Here in Cuba there were things that were pure surrealism. For example, Afrocuban beliefs; in these you can see poetry preserved in its magical, primitive state."[38]

Lam created his own visual language in which, as in the striking image *I Am* (1949), he could express the complexity of his own identity. Seated upright in a chair against a glowing red ground is a hybrid horse-headed creature with horns and long green hair; encircling this creature is a pair of ghostly black arms, clasped on the lap of the seated figure but with no body, though there is a scrap of patterned cloth on one arm. The seated figure seems to have one

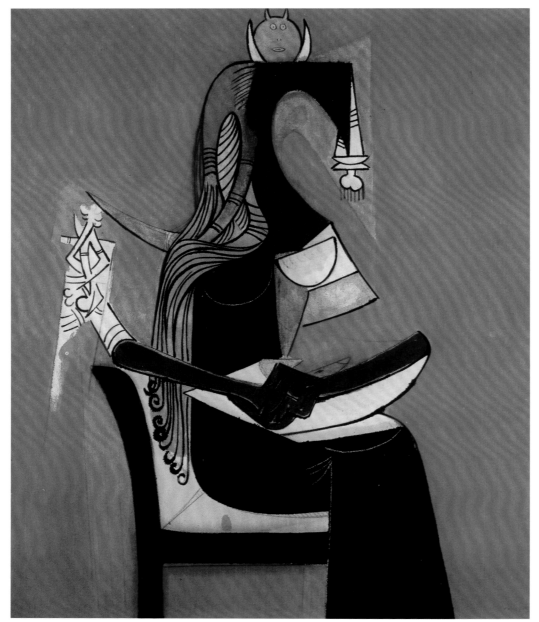

214

214 Wifredo Lam. *I Am*. 1949. Oil on canvas. Paris, Mme Fabri.

white breast, but there is also the outline of a male breast against the black. Perhaps this "couple," enigmatic as it is, is a self-portrait.

Afro-Cuban traditions and beliefs, and the secret societies that perforce were formed to sustain them in conditions of oppression and prohibition, have continued to interest artists in Cuba and elsewhere in the Caribbean. Belkis Ayón (1967–1999) was a Cuban graphic artist who made the myths and practices of the many syncretic Afro-Cuban religions, including Santeria, *Palo Monte, Abakuá,* and others, the focus of her images. She was especially fascinated by *Abakuá,* a mystery-guarding all-male secret society, which she researched through books and then through contact with its adepts. Originating in southern Nigeria and based on oral

traditions, *Abakuá* did not have specific visual imagery, so Ayón interpreted it in her own way. As the introduction to the catalogue raisonné of her work, *NKAME: Belkis Ayón* (2010) put it, "Belkis penetrated the ritual space as much as she was allowed to . . . As a result she created an impressive iconography, interpreting the religious myth from the standpoint of a black Latin female artist of the late twentieth century."[39] Although her images are deeply felt responses to the stories and to the rituals, they are not interpretations or presentations of them in the same sense that Hyppolite's are. Her figures, for example, often have no mouth, or the mouth is crossed out or barred, which could be her comment as a woman shut out from the male society of *Abakuá,* on its secrecy—a para-

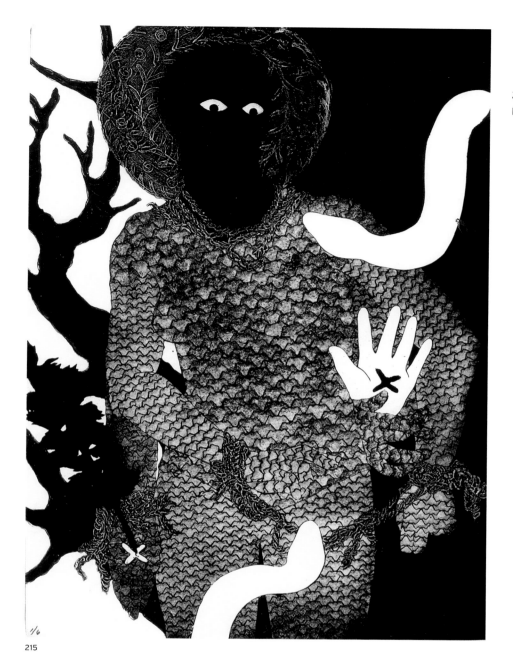

215

doxical comment, given the oral character of the traditions that underpin it.

Belkis Ayón's black-and-white prints were made during a time of shortages of all kinds of materials in post-Soviet Cuba, and she made her collagraphs, sometimes in quite large formats, by gluing together masses of small bits of paper, producing ridged and textured surfaces, on which she created striking contrasts in black and white. The figures in her scenes have black, white, or gray faces, as in *Consagración* (1991), which seems to be a comment on the racial mix in Cuba but may also have specific meaning in terms of the stories to which she alludes. In *The Sentence no. 1*, the white eyes in the black mouthless face, the white hand with the cross that

is both stigmata and "no entry," and the snake-phallic forms together with the detailed texture of the scaly body of the figure and its chains, produce a disquieting image that brilliantly encapsulates the speculative and critical eye with which Belkis saw and felt the fearful power of Afro-Cuban beliefs.

Changes in the nature of artistic practice over the course of the twentieth century, from the various kinds of nonobjective and abstract art to minimalism and conceptualism and art's extension into everyday spaces and activities, obviously involve the disappearance or rejection of the "image" as it is traditionally understood. How far the notion of the image of the black can be explored in nonfigurative or installation-type works is debatable, but I

216

would argue that a significant role is still played by African visual and cultural forms and ideas in work where there is no obvious representation of a black person. Very few of the modernist artists in Brazil in the first half of the twentieth century were themselves black, but it is interesting that two major abstract/constructivist artists of the second half of the century, Rubem Valentim and Emanoel Araujo, are of African ancestry. Rubem Valentim (1922–1991), a self-taught artist from Salvador, Bahia, incorporates signs and symbols of *Candomblé* into his paintings, such as *Composition* (1961). As the Brazilian art historian Paulo Herkenhoff said, "Valentim led Brazilian art to a new symbolic level and a new ethical plane . . . Xangô's double axe, which cuts from both sides, is the metaphor for an art conceived within Western constructivist mo-

dernity and genuinely incorporates Brazil's African roots."[40] The same form appears in Emanoel Araujo's *Totem de Xangô* (1981). Araujo, of Amerindian and Nago (Brazilian Yoruba) descent, translates into minimalist sculptural forms specific symbols of African religion, dance rhythms, and body gestures, but also sharp reminders of black suffering: "The history of slavery rages through the formalist rhetoric because we recognize the origin of the forms for these sculptures in the spur-shaped prongs attached to the collars designed for the punishment and identification as such, of captured runaway slaves."[41]

The "tropical" tendency in art has a long and diverse history in Brazil and the Caribbean, and it has been paradoxically involved, from its beginnings in the 1920s, with some of the most

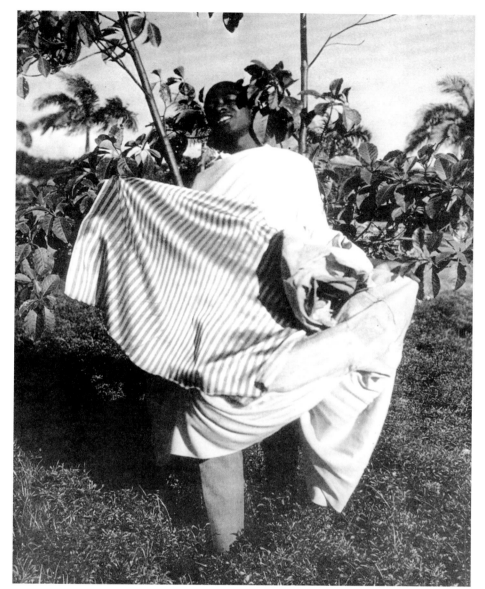

radical enterprises including performance, installation, and cinema. When Hélio Oiticica first presented his environment installation *Tropicália* in Rio de Janeiro in 1967, it seemed a startling departure from his earlier nonobjective works; with live parrots, plants, sand, and flimsy favela-type walls, it challenged the spectacular exotic but also the very idea of the image. As Oiticica wrote in the catalogue for his Whitechapel Gallery exhibition in London in 1969, "The problem of the image is posed here . . . in a context that is typically national, tropical and Brazilian."[42] Oiticica was in search of an "experiential" image as opposed to the purely visual "consumed" image. On the cover of the catalogue is a photograph of a young black man from the Mangueira favela in Rio de Janeiro, *Jerônimo, wearing Cape 5,* one of the *Parangolés* Oiticica devised as

a way to bring the color and structure of his earlier geometrical works and constructions alive. Jerônimo gives a "momentary, luminous smile" before he returns to the "horrific daily existence of poverty and violence that overshadows Brazilian culture."[43] In the *Parangolés,* in his environment *Tropicália,* in his "penetrable" cabin spaces *Eden,* Oiticica was exploring forms of experience and sensation beyond the straightforward two-dimensional image, and in doing so was profoundly influenced by the Mangueira favela and especially the samba. Describing the sensorial effects he sought in *Tropicália* and in *Eden,* and the radical principle of involving the spectator, inviting him or her to participate in the work, he wrote, "Rhythmic dance and music have been the main introduction to these convictions, for me: I want to come into the

whole of its acting area: social, psychological, ethical."[44] The *Paran-golés* were worn by the samba dancers at the first manifestation "with capes, tent, banners" in Rio's Museum of Modern Art in 1965. *Eden,* a "campus" of *Penetrables* and enclosures made specially for the Whitechapel show, had different components, some of which refer directly to *Candomblé:* in the titles such as the *Tia Ciata cabin,* and the *Iemanja Water Penetrable.*[45] The photograph of Jerônimo of Mangueira is significant as much for what it stands for as in its own right. It is in a sense a token, a document, a moment frozen from a much larger project, driven by a passionate desire to recognize and value the overlooked, marginal, and desperately poor inhabitants of the shantytowns such as Mangueira, and in doing so to resist continuing attempts to, as Gates put the point, "'whiten away' vestiges of African culture."[46] Oiticica is not singling out Jerônimo because he is black but because he comes from a world that he feels is fundamental to Brazil and "reveals the live potential of a 'culture in formation,'" which happens for complex reasons to be predominantly black. He reacted strongly against the view—held even by his friends within the avant-garde—that his work was becoming too folkloric. "Formulation of the idea of *Parangolé* in 1964: 'root, root', or the foundation of the root-Brazil, in opposition to the folklorisation of this 'root material'—the folklorisation is born from oppressive camouflage: 'to show what is ours, our values'—the excess of primitive art etc. *Parangolé* rebels, since 1964, against this oppressive folklorisation, and uses the same material which would formerly be folk-Brazil, as 'non-oppressive' structure."[47]

Over the course of the twentieth century, the nature of the image of the black in art from Latin America has undergone a profound shift; from being, as this phrase suggests, the passive subject of visual representation, the black has become an active and powerful force in the contested field of modern art, and black culture has joined forces with other currents in questioning traditional modes and materials of visual production.

13

NÉGRITUDE: CÉSAIRE, LAM, AND PICASSO

DAVID BINDMAN

Négritude was a Francophone literary and ideological movement initiated by the Senegalese Léopold Senghor (1906–2001), the Martinican poet Aimé Césaire (1913–2008), and the Guianan Léon Damas (1912–1978) when they were students in Paris in the early 1930s.[1] Their intention was to promote the idea of a black identity that spanned "the Black World," rejecting French cultural domination and colonialism in favor of a universal humanism of oppressed peoples. Césaire, after he returned to Martinique in 1939, retained close connections with French Surrealists, whom he admired for their assault on the restrictive forms of language that underpinned French hegemony. Martinique quickly became involved in the war, and despite being under Vichy control, became a refuge for artists and intellectuals from France, including André Breton and the painter Wifredo Lam (see chap. 12), both of whom did much for Césaire's reputation.[2] On his return to Paris after the liberation in 1944, Césaire was feted by French intellectuals, and met, possibly through Lam, Pablo Picasso, who had recently joined the French Communist Party.

Césaire's most famous poem, "Cahier d'un retour au pays natal" ("Account of the Return to My Native Land"), composed in 1939, is a passionate cry on behalf of

> those who invented neither gunpowder nor compass
> Those who tamed neither steam nor electricity

But who

> give themselves up to the essence of all things
> ignorant of surfaces but struck by the movement of all things
> free of the desire to tame but familiar with the play of the
> world.[3]

The poem looks forward, in complex and apocalyptic imagery that draws on his own experience of abject poverty and the history of Martinique, to a liberation not only of Africans and those of African descent but of all those humiliated and exploited by centuries of enslavement.

Much of Césaire's imagery in "Cahier d'un retour au pays natal" and his later poetry is conditioned by his experience of the extravagant tropical vegetation and occasionally volatile geology of Martinique. His poems are lush evocations of the "réel merveilleux"[4] of the Caribbean, but always confronting the painful inheritance of slavery. These he conveyed to Lam in person and in his poetry, and one can see in the latter's paintings, in the years following his arrival on the island, a shift from Picasso-like cubistic figures in relative isolation to the extraordinarily rich fusion of figures and plant life in such paintings as his masterpiece *The Jungle.*[5] The combination of human elements, suggestions of African masks, and the

see 212

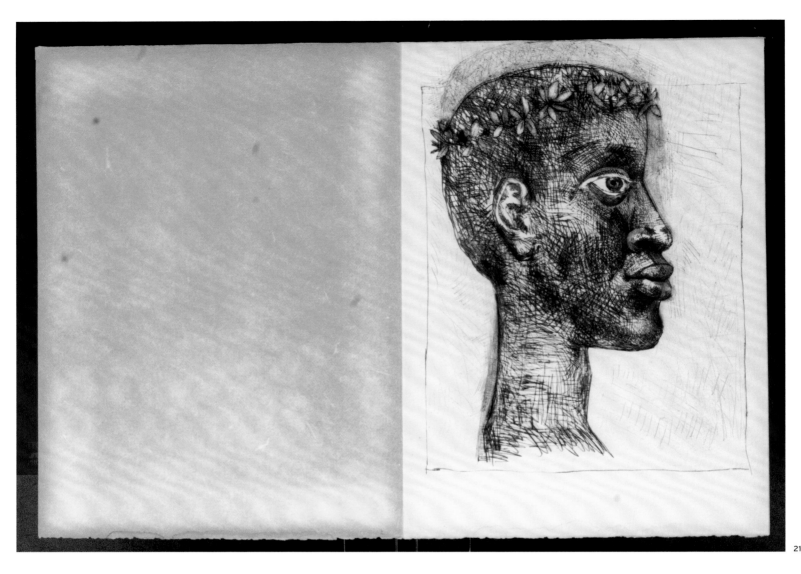

dense vegetation of Martinique provides a visual correlative to the rich imagery of Césaire's poetry, as was often remarked at the time.

The friendship between Césaire and Lam was lifelong, and on the latter's death in 1982 the poet wrote and published in *Moi, laminaire* ten poems dedicated to Lam's memory, derived from a series of his aquatints. They were prefaced by an account by Lam of his grandmother, a Santeria priestess, who "had the power to conjure up the elements . . . I visited her house filled with African idols. She gave me the protection of the gods: Yemanja, Goddess of the sea, Shango, god of war, companion of gun-Ferraille, god of the substance that gilds the sun each morning, always at the side of Olorun, the absolute god of the creation."[6] All of which suggests that Césaire encouraged Lam to look to his own African ancestry.

Picasso had known Lam since 1938 when the younger artist fell under the older artist's spell, as is evident in his paintings of that period. Picasso and Césaire met in 1944 or 1945 in Paris, and though they became firm friends, their artistic collaboration was based on only one project, the illustrated edition of the latter's series of poems, *Corps perdu,* published in 1950.[7] Nonetheless it was a particularly fruitful one, though the association between the famous and wealthy artist and the radical poet might seem surprising. The year 1950 is right in the middle of what John Richardson has called Picasso's "Mediterranean Years."[8] The catalogue of an exhibition of that name held in 2010 is filled with paintings of Arcadian scenes, the painter's wives, girlfriends, and family members, and photographs of his idyllic life in the South of France where he owned a number of properties. The fact that Picasso was openly a member of the French Communist Party since 1944 and throughout the period is not completely avoided, though almost all of the works he produced in support of the party are omitted. Richardson claims that he was drawn to the Communist Party as a kind of family, and not by a belief in Marxist ideology.[9] After all, how could a man so extravagant and full of animal spirits and joie de

218 Pablo Picasso. Frontispiece to Aimé Césaire's *Corps Perdu, African Head*. 1950. Cambridge, Mass., collection of Henry Louis Gates, Jr.

219 Pablo Picasso. Title page to poem *"Mot,"* Aimé Césaire's *Corps Perdu*. 1950. Cambridge, Mass., Houghton Library, Harvard University.

vivre support a party dedicated to antimaterialism and universal equality?

Yet as another exhibition of 2010, *Picasso: Peace and Freedom* at Tate Liverpool, makes clear, Picasso was far from being a lukewarm member of the party.[10] In reality he was its most active spokesman, ready to travel abroad to make speeches on its behalf, and he took up its campaigns with enthusiasm. He was also prepared to make art in support of them, showing "a boundless willingness to donate work, design posters, Christmas cards, silk scarves, and newspaper drawings." This is not to say that he was concerned with the finer points of Marxist doctrine or followed the party line at all times, yet as Lynda Morris and Christoph Grunenberg point out in the catalogue, "His involvement ranged from support for striking miners in northern France and financial and political assistance for Spanish Republicans in exile in Mexico and Hispanic America, to opposition to apartheid in South Africa. He travelled to and spoke at peace congresses in Poland, Italy and England. Picasso opposed racism, inequality and oppression in all its forms."[11]

While his main concern was with Spain under Franco's dictatorship, he had a strong interest in racial equality, supporting African, Jewish, and Muslim causes, and it is in the light of this that we need to look at his relations with Césaire. When they met toward the end of the Second World War Picasso was already sympathetic to anticolonialism. They were both members of the French Communist Party, and they went to the peace conference in Wroclaw in August 1948, visiting Auschwitz-Birkenau together.[12] They were also fellow travelers of surrealism—not actual members of the movement, but for Césaire surrealism was a way of accessing both his African and Caribbean heritage without resorting to colonial influences, as it had been for Lam.

The limited edition of *Corps perdu*, 1950, consists of loose sheets containing ten poems by Césaire, each illustrated by Picasso three times. There is a striking frontispiece of an African head in etching

220 Pablo Picasso. *Mankind Holding the Symbol of Peace*. 1958. Vallauris, Temple of Peace.

218 and drypoint, followed by ten sugar aquatints for the titles of the poems, and twenty engravings in illustration of them. The frontispiece is an idealized image of Césaire himself, with a laurel wreath around the top of his head, which invokes Sartre's identification of the poet as the "Orphée noir," identifying the poet with the mythical Orpheus, who charmed plants, rocks, animals, and men.[13]

This sense of the poet as someone who draws life from the lushness of nature and creates hybrid forms out of it is continued through Picasso's illustrations, where humans are shown as trapped within nonhuman forms, in ever-changing images of enslavement, not so much paralleling the text as weaving in and out of it. In the

219 first poem, "Mot," Picasso's title illustration is of a face expressively corroded by the aquatint, which illustrates, by contrast with the uplifting frontispiece of Césaire as creator, the theme of the poem, which is a poetic meditation on "le mot nègre" (the word negro), repeated as an incantation several times. The second image conjures up the often sinister interpenetration of humanity and nature in Césaire's poetry by showing two female creatures who are both flower and woman, referring perhaps to the lines

> le mot nègre
> sorti tout armé du hurlement

d'une fleur vénéneuse (the word negro sprung fully armed from the howl of a poisonous flower)[14]

The frontispiece etching for *Corps perdu* was reproduced and enlarged for the poster for the *Présence Africaine* Congress of 19–22 September 1956, which drew many writers from Africa and the Diaspora, and Picasso also made a design for the second congress in Rome 26 March–1 April 1959, incorporating an image of the *Races of the World*. This he subsequently developed for one of his last works, the end wall of the Temple of Peace in Vallauris, where 220 he returned to the traditional imagery, going back to the Renaissance via Linnaeus, of the Four Continents, represented here by four heads of different colors.[15]

The involvement with Césaire and his late exercises in the imagery of blacks make a fascinating contrast with Picasso's much earlier involvement as an avant-garde artist with African sculptures, described by Suzanne Preston Blier in chapter 6. This involvement was largely an aesthetic one; in the post–Second World War period, by contrast, he involved himself actively with the human rights of people everywhere, and especially those of African descent.

NOTES

ILLUSTRATIONS

INDEX

NOTES

Preface

1. Both archives can be consulted by the public by appointment, and the photographs can also be accessed on the Internet by subscription through ARTSTOR.

2. Grace Hadley Beardsley, *The Negro in Greek and Roman Civilization: A Study of the Ethiopian Type* (Baltimore, 1929), p. ix.

3. Alain LeRoy Locke, *The Negro in Art: A Pictorial Record of the Negro Artist and the Negro Theme in Art* (New York, 1968 [1940]).

4. Ibid., pp. 3, 138.

5. Ibid., p. 139.

6. As early as 1980, John Russell had, in commending "the exalted nature of [the project's] ambitions and . . . its beauty of presentation," already complained of "the august slowness of its fulfillment" (*New York Times,* 29 June 1980, p. 7).

7. See www.slavevoyages.org/tast/database/search.faces.

8. Barbara Johnson, *The Critical Difference: Essays in the Contemporary Rhetoric of Reading* (Baltimore, 1992), p. 3.

9. Paul Gilroy, *The Black Atlantic: Modernity and Double Consciousness* (Cambridge, Mass., 1993), 15.

10. See Henry Louis Gates, Jr., *The Signifying Monkey: A Theory of Afro-American Literary Criticism* (Oxford, 1988), pp. 127–69.

11. Christopher L. Miller, *Blank Darkness: Africanist Discourse in French* (Chicago, 1985), p. 10.

12. Isidore of Seville, *Etymologicae* XIV, 5.2.

13. Miller, *Blank Darkness,* p. 11.

14. Winthrop D. Jordan, *White over Black* (New York, 1977), p. 95.

15. Joshua Reynolds, *The Idler,* no. 82, 10 November 1759 (1816 ed.), p. 332.

16. See, for example, the full-length watercolor in the Museum of Fine Arts, Boston, 17.3103.

17. "And Miriam and Aaron spake against Moses because of the Ethiopian woman whom he had married: for he had married an Ethiopian woman."

18. Lionel Casson, *The Periplus Maris Erythraei: Text with Introduction, Translation, and Commentary* (Princeton, N.J., 1989).

19. David Brion Davis, *Challenging the Boundaries of Slavery* (Cambridge, Mass., 2003), p. 12.

20. Louise Levathes, *When China Ruled the Seas: The Treasure Fleet of the Dragon Throne, 1405–1433* (New York, 1994).

21. George M. Frederickson, *Racism: A Short History* (Princeton, N.J., 2002), pp. 27–28.

22. Charles Verlinden, *L'esclavage dans l'Europe médiéval,* 2 vols., Rijksuniversiteit te Gent. Werken; uitg. door de Faculteit van de Letteren en Wijsbegeerte, 119e, 162e afl. (Bruges, 1955, 1977).

23. M. I. Finley, "Slavery," *International Encyclopedia of the Social Sciences,* vol. XIV (New York, 1968), pp. 307–8.

24. G. W. F. Hegel, *Phenomenology of Spirit,* translated by A. V. Miller (Oxford, 1977), p. 111.

25. Ehud R. Toledano, "Representing the Slave's Body in Ottoman Society," *Slavery and Abolition* 23, no. 2 (August 2002): 58.

26. Orlando Patterson, *Slavery and Social Death: A Comparative Study* (Cambridge, Mass., 1982).

27. Peter Martin, *Schwarze Teufel, edle Mohren* (Hamburg, 1993), pp. 308–27.

28. Annette Gordon-Reed, *The Hemingses of Monticello: An American Family* (New York, 2008), p. 31.

29. Gretchen Gerzina, *Black London: Life Before Emancipation* (New Brunswick, N.J., 1995), pp. 88–89.

30. Edward Long, *The History of Jamaica, or, General Survey of the Antient and Modern State of That Island: With Reflections on Its Situation, Settlements, Inhabitants, Climate, Products, Commerce, Laws, and Government* (London, 1774), vol. II, p. 336.

31. Quoted in Guy C. McElroy, *Facing History: The Black Image in American Art, 1710–1940* (Washington, D.C., 1990), p. xxix.

Introduction

1. See Jean Devisse, "A Sanctified Black: Maurice," in *The Image of the Black in Western Art*, vol. II, pt. 1, pp. 139–94.

2. See Paul Kaplan, "Italy, 1490–1700," in *Image of the Black*, vol. III, pt. 1, pp. 158–65.

3. The third volume was to be carried out by Jacques Thuillier (1928–2011), but it did not appear.

4. *Image of the Black*, vol. IV, pts. 1 and 2 (1989; reprinted in an enlarged edition in 2012).

5. See Susan Earle, ed., *Aaron Douglas: African American Modernist* (New Haven, Conn., 2007), pp. 166–70.

6. See chap. 8.

7. See chap. 9.

8. Philip D. Morgan, *Slave Counterpoint: Black Culture in the Eighteenth-Century Chesapeake and Lowcountry* (Williamsburg, Va., 1998).

9. Thelma Golden, *Freestyle*, Exhibition catalogue, New York, Studio Museum in Harlem (2001), p. 14.

10. J. G. P. Delaney, *Glyn Philpot: His Life and Art* (Aldershot, 1999), p. 96.

11. She was more generally known as Petrine Archer-Shaw, but she specifically asked to be cited as Petrine Archer in this book.

1. Counteracting the Stereotype: Photography in the Nineteenth Century

1. The French inventor Nicéphore Niépce (1765–1833) produced the earliest extant photographic image, made by a camera obscura in 1827. After the death of Niépce, Louis Jacques Mandé Daguerre successfully fixed an image and announced to the Paris press his discovery.

2. Elizabeth Ewen and Stuart Ewen, *Typecasting: On the Arts and Sciences of Human Inequality: A History of Dominant Ideas* (New York, 2006), p. 161.

3. Harvey S. Teal, *Partners with the Sun* (Columbia, S.C., 2001), p. 28.

4. Ibid.

5. Brian Wallis, "Black Bodies, White Science: Louis Agassiz's Slave Daguerreotypes," in *Only Skin Deep*, ed. Coco Fusco and Brian Wallis (New York, 2003), p. 165.

6. Suzanne Schneider, "Louis Agassiz and the American School of Ethnoeroticism: Polygenesis, Pornography, and Other Perfidious Influences," in *Pictures and Progress: Early Photography and the Making of African American Identity*, ed. Maurice Wallace and Shawn Michelle Smith (Durham, N.C., 2003), p. 214.

7. Kellie Jones, "In Their Own Image," *Artforum* 29, no. 3 (1990): 135–36.

8. Carla Williams and Deborah Willis, *The Black Female Body: A Photographic History* (Philadelphia, 2002), p. 24.

9. Advertisement from the *Hartford Daily Courant* (8 October 1852).

10. http://teachingamericanhistory.org/library/index.asp?document=621.

11. Ibid.

12. Ibid.

13. "To Our Patrons," *Freedom's Journal* 1, no. 1 (16 March 1827), 1.

14. Winston James, *The Struggles of John Brown Russwurm: The Life and Writings of a Pan-Africanist Pioneer, 1799–1851* (New York, 2010).

15. Washington frequently photographed his female subjects holding a daguerreotype case. This one is similar to one that Augustus Washington used in his portraits in his Hartford studio.

16. Liz Wells, ed., *Photography: A Critical Introduction*, 2nd ed. (New York, 2000), p. 132.

17. James, *Struggles of John Brown Russwurm*, p. 79.

18. Washington, D.C., National Portrait Gallery, Augustus Washington website.

19. Ann Shumard, *A Durable Memento: Portraits by Augustus Washington* (Washington, D.C., National Portrait Gallery, 1999), n.p.

20. Miles Orvell, *American Photography* (New York, 2003), p. 31.

21. http://www.nhregister.com/articles/2012/05/03/news/doc4fa3291 6295d4141801838.txt

22. Laura Wexler, "A More Perfect Likeness: Frederick Douglass and the Image of the Nation," in Wallace and Smith, *Pictures and Progress*, p. 18.

23. Richard J. Powell, *Cutting a Figure: Fashioning Black Portraiture* (Chicago, 2008), p. 64.

24. Colin L. Westerbeck, "Frederick Douglass Chooses His Moment," *Selections from the Art Institute of Chicago: African Americans in Art* (Chicago, Art Institute, 1999), p. 161.

25. J. Saunders Redding, "Let Freedom Ring," in *Critical Essays on Frederick Douglass,* ed. William L. Andrews (Boston, 1991), p. 58.

26. Powell, *Cutting a Figure,* p. 67.

27. Ginger Hill, "Rightly Viewed," in Wallace and Smith, *Pictures and Progress,* p. 57.

28. http://www.metmuseum.org/Collections/search-the-collections/190035135

29. Eric Foner, *Forever Free: The Story of Emancipation and Reconstruction* (New York, 2006), p. 101.

30. Ibid., p. 102.

31. Nicholas Mirzoeff, in Fusco and Wallis, *Only Skin Deep,* p. 116.

32. Kathleen Collins, "The Scourged Back," in *History of Photography* 9, no. 1 (January–March 1985): 43–45.

33. Frederick Douglass Opie, *Hog and Hominy: Soul Food from Africa to America* (New York, 2010), p. 38.

34. Cultural historians W. Jeffrey Bolster and Hilary Anderson write that the basket was made "of either sea-grass, sweetgrass, or rush, [and] its coiled design and construction were clearly African in origin." W. Jeffrey Bolster and Hilary Anderson, *Soldiers, Sailors, Slaves, and Ships: The Civil War Photographs of Henry P. Moore* (Concord, N.H., 1999), p. 78.

35. Ibid., p. 81.

36. Carla L. Peterson, *"Doers of the Word": African-American Women Speakers and Writers in the North (1830–1880)* (New York, 1995), p. 40.

37. Deborah Gray White, *Ar'n't I a Woman?: Female Slaves in the Plantation South* (New York, 1985), pp. 161, 162.

38. Darlene Clark Hine, *Hine Sight: Black Women and the Reconstruction of American History* (Brooklyn, 1994), p. 64.

39. Peterson, *"Doers of the Word,"* p. 42.

40. W. E. B. Du Bois, "The Conservation of Races," in *Negro Social and Political Thought: 1850–1920,* ed. Howard Brotz (New York, 1966), p. 491.

41. Michael Bieze, *Booker T. Washington and the Art of Self-Representation* (New York, 2008), p. 132.

42. Ibid., p. 43.

2. Marketing Racism: Popular Imagery in the United States and Europe

1. One example of this is Jan Nederveen Pieterse, *White on Black: Images of Africa and Blacks in Western Popular Culture* (New Haven, Conn., 1992).

2. On the popularity of the golliwog in visual culture, see David Pilgrim, "The Golliwog Caricature," http://www.ferris.edu/jimcrow/golliwog/ (accessed November 5, 2012); and Robin Bernstein, *Racial Innocence: Performing American Childhood from Slavery to Civil Rights* (New York, 2012).

3. Jon Healey, "From Bedtime Story to Ugly Insult: How Victorian Caricature Became a Racist Slur," *Guardian* (5 February 2009).

4. Jean Michel Massing attributes this fable to Lucian in the Greek anthology. See Massing, "From Greek Proverb to Soap Advert: Washing the Ethiopian," *Journal of the Warburg and Courtauld Institutes* 58 (1995): 180–201; Karen Newman, "'And Wash the Ethiop White': Femininity and the Monstrous in *Othello,"* in *Shakespeare Reproduced,* ed. Jean Howard and Marion O'Connor (London, 1987), pp. 141–62; and Kim F. Hall, *Things of Darkness: Economies of Race and Gender in Early Modern England* (Ithaca, N.Y., 1995).

5. Anne McClintock, *Imperial Leather: Race, Gender, and Sexuality in the Colonial Contest* (New York, 1995); Anandi Ramamurthy, *Imperial Persuaders: Images of Africa and Asia in British Advertising* (Manchester, 2003).

6. On the international history of blackface minstrelsy, see Robert C. Toll, *Blacking Up: The Minstrel Show in Nineteenth-Century America* (New York, 1974); Michael Pickering, "Mock Blacks and Racial Mockery: The 'Nigger' Minstrel and British Imperialism," in *Acts of Supremacy: The British Empire and the Stage, 1790–1930,* ed. J. S. Bratton, Richard Allen Cave, Brendan Gregory, Heidi J. Holder, and Michael Pickering (Manchester, 1991), pp. 179–236; Eric Lott, *Love and Theft: Blackface Minstrelsy and the American Working Class* (New York, 2003); Sarah Meer, *Uncle Tom Mania: Slavery, Minstrelsy, and Transatlantic Culture in the 1850s* (Athens, Ga., 2005); and Derek B. Scott, *Sounds of the Metropolis: The Nineteenth-Century Popular Music Revolution in London, New York, Paris, and Vienna* (Oxford, 2008).

7. Henry Louis Gates, Jr., "The Face and Voice of Blackness," in *Facing History: The Black Image in American Art, 1710–1940,* ed. Guy C. McElroy (Washington, D.C.: Bedford Arts and the Corcoran Gallery of Art, 1990), pp. xxix–xlvi.

8. This description refers to the ca. 1871–1874 edition of *The Ten Little Niggers,* published in New York by the McLoughlin Brothers. For discussion of the games, songs, literature, and minstrel performances associated with *The Ten Little Niggers,* see Pieterse, *White on Black;* and Wulf Schmidt-Wulffen, *"Ten Little Niggers": Racial Discrimination in Children's Books* (Berlin, 2012).

9. Kyla Wazana Tompkins, *Racial Indigestion: Eating Bodies in the 19th Century* (New York, 2012).

10. For analyses of French colonial postcards, see P. Blanchard and A. Chatelier, eds., *Images et colonies: Nature, discours et influence de l'iconographie coloniale liée à la propagande coloniale et à la représentation des Africains et de l'Afrique en France, de 1920 aux Indépendances* (Paris, 1993); Christraud Geary and Virginia-Lee Webb, eds., *Delivering Views: Distant Cultures in Early Postcards* (Washington, D.C., 1998); and David Prochaska, "Fantasia of the Photothèque: French Postcard Views of Colonial Senegal," *African Arts* 24, no. 4 (October 1991): 40–47, 98.

11. Tanya Sheehan, "Looking Pleasant, Feeling White: The Social Politics of the Photographic Smile," in *Feeling Photography,* ed. Elspeth Brown and Thy Phu (Durham, N.C., forthcoming).

12. Leonard Rifas, "Ideology: The Construction of Race and History in *Tintin in the Congo,*" in *Critical Approaches to Comics: Theories and Methods,* ed. Matthew J. Smith and Randy Duncan (New York, 2011), pp. 221–34. The book was first published in 1931 and was revised in 1946 to remove references to Congo as a Belgian colony, but it retained racist stereotypes.

13. Christraud M. Geary, "Missionary Photography: Private and Public Readings," *African Arts* 24, no. 4 (October 1991): 48–59, 98–100.

14. Hans-Jörg Czech and Nikola Doll, *Kunst und Propaganda: im Streit der Nationen 1930–1945* (Dresden, 2007).

15. Adrienne Childs, "Sugar Boxes and Blackamoors: Ornamental Blackness in Early Meissen Porcelain," in *The Cultural Aesthetics of Eighteenth-Century Porcelain,* ed. Alden Cavanaugh and Michael E. Yonan (Burlington, Vt., 2010), pp. 159–77.

16. Reiko Tomii and Kathleen M. Friello, eds., *Fred Wilson: Speak of Me as I Am: the United States Pavilion, 50th International Exhibition of Art, the Venice Biennale, Venice, Italy* (Cambridge, Mass., 2003); and Peter Erickson, "Respeaking Othello in Fred Wilson's *Speak of Me as I Am,*" *Art Journal* 64, no. 2 (2005): 4–19.

17. Kenneth W. Goings, *Mammy and Uncle Mose: Black Collectibles and American Stereotyping* (Bloomington, Ind., 1994); and Larry Vincent Buster, *The Art and History of Black Memorabilia* (New York, 2000).

18. Michael D. Harris, *Colored Pictures: Race and Visual Representation* (Chapel Hill, N.C., 2003), p. 84.

19. Marilyn Kern-Foxworth, *Aunt Jemima, Uncle Ben, and Rastus: Blacks in Advertising, Yesterday, Today, and Tomorrow* (Westport, Conn., 1994); and M. M. Manning, *Slave in a Box: The Strange Career of Aunt Jemima* (Charlottesville, Va., 1998).

20. On the appropriation of Aunt Jemima and other racist stereotypes by twentieth-century African American artists, see Karen Dalton, Michael Harris, and Lowery Sims, "The Past Is Prologue but Is Parody and Pastiche Progress? A Conversation," *International Review of African American Art* 14, no. 3 (1997): 17–30.

21. Calvin Reid and Tony Shafrazi, *Michael Ray Charles* (New York, 1998).

22. Rachael Ziady DeLue, "Dreadful Beauty and the Undoing of Adulation in the Work of Kara Walker and Michael Ray Charles," in *Idol Anxiety,* ed. Josh Ellenbogen and Aaron Tugendhaft (Stanford, Calif., 2010), pp. 74–96.

23. Henry A. Giroux, "Benetton's 'World without Borders': Buying Social Change," in *The Subversive Imagination: Artists, Society, and Social Responsibility,* ed. Carol Becker (New York, 1994), pp. 187–207.

24. Dennis Rodkin, "How Colorful Can Ads Get?" *Mother Jones Magazine* 15, no. 1 (January 1990): 52.

25. See, for example, Barry Bearak, "Why Famine Persists," *New York Times Magazine,* 13 July 2003.

26. Arthur Kleinman and Joan Kleinman, "The Appeal of Experience; The Dismay of Images: Cultural Appropriations of Suffering in Our Times," *Daedalus* 125, no. 1 (Winter 1996): 1–23, 8; David Campbell and Marcus Power, "The Scopic Regime of 'Africa,'" in *Observant States: Geopolitics and Visual Culture,* ed. Fraser Macdonald, Klaus Dodds, and Rachel Hughes (London, 2010), pp. 167–98; and David Campbell, "The Iconography of Famine," in *Picturing Atrocity: Reading Photographs in Crisis,* ed. Geoffrey Batchen, Mick Gidley, Nancy K. Miller, and Jay Prosser (London, 2011), pp. 79–91.

27. Scott MacLeod, "The Life and Death of Kevin Carter," *Time Magazine* 144, no. 11 (12 September 1994): 70–73.

28. See the website of the Jim Crow Museum of Racist Memorabilia: www.ferris.edu/jimcrow/

3. Visual Culture and the Occupation of the Rhineland

1. John Phillip Short, *Magic Lantern Empire: Colonialism and Society in Germany* (Ithaca, N.Y., 2012), p. 15.

2. Ibid., p. 21.

3. Tina M. Campt, *Other Germans: Black Germans and the Politics of Race, Gender, and Memory in the Third Reich* (Ann Arbor, Mich., 2004).

4. Sally Marks, "Black Watch on the Rhine: A Study in Propaganda, Prejudice and Prurience," *European History Quarterly* 13, no. 3 (July 1983): 297–334.

5. Christine Rogowski, "The Colonial Idea in Weimar Cinema," in *German Colonialism, Visual Culture, and Modern Memory,* ed. Volker M. Langbehn (New York, 2010), p. 226.

6. David Ciarlo, *Advertising Empire: Race and Visual Culture in Imperial Germany* (Cambridge, Mass., 2011), p. 317.

7. Ibid.

8. Lora Wildenthal, *German Women for Empire, 1884–1945* (Durham, N.C.), p. 188.

9. Ciarlo, *Advertising Empire,* p. 318.

10. Jill Lloyd, *German Expressionism: Primitivism and Modernity* (New Haven, Conn., 1991), pp. 67–82.

11. Ciarlo, *Advertising Empire,* p. 82.

12. Brenda Farnell, "Theorizing 'the Body' in Visual Culture," in *Made to Be Seen: Perspectives on the History of Visual Anthropology* (Chicago, 2011), p. 138.

13. H. Glenn Penny, *Objects of Culture: Ethnography and Ethnographic Museums in Imperial Germany* (Chapel Hill, N.C., 2002), p. 42.

14. Lloyd, *German Expressionism,* pp. 67–82.

15. Cora Lee C. Gilliland, "Karl Goetz, Medalist: His Place within the History of Art," *Numismatist* 89, no. 3 (March 1976): 485.

16. Kirk Savage, *Standing Soldiers, Kneeling Slaves: Race, War, and Monument in Nineteenth-Century America* (Princeton, N.J., 1997), p. 9.

17. Kristina Van Dyke, "Body in Fragments: August 21, 2009–Febru-

ary 28, 2010," The Menil Collection, http://www.menil.org/exhibitions/BodyinFragments.php (accessed April 2012).

18. David and Constance Yates, "The Renaissance of the Cast Medal in Nineteenth Century France," David and Constance Yates, New York, 1997, http://www.dcyates.com/medals/article.htm (accessed April 10, 2012). Italics added.

4. Anthropology and Photography (1910–1940)

I am very grateful to my colleagues at the IBWA workshop at Cambridge, Mass., in April 2012, and to Tamar Garb, Chris Morton, and Leon Wainwright for their invaluable comments as this chapter took shape.

1. Allan Sekula, "'The Body and the Archive,'" in *The Contest of Meaning: Critical Histories of Photography,* ed. Richard Bolton (Cambridge, Mass., 1989), p. 345.

2. These tropes of the exotic and authentic are found in touristic picture postcards to this day.

3. The nineteenth-century photographic collection assembled by Alexander Agassiz at Harvard University's Peabody Museum, in Cambridge, Mass., is a particularly fine example of the latter process.

4. Andrew Zimmerman, *Anthropology and Antihumanism in Imperial Germany* (Chicago, 2001), p. 174.

5. It should be noted that these processes are not confined to the picturing of African cultures. For the most part, they are arguments grounded in the nature of anthropology itself and not in the perception of Africa as such. There are many other parts of the world where one might undertake such an analysis.

6. See Elizabeth Edwards, "Uncertain Knowledge: Photography and the Turn-of-the-Century Anthropological Document," in *Documenting the World: Photographic Media and the Scientific Record,* ed. Kelley Wilder and Gregg Mitman (Chicago, forthcoming).

7. Christopher Morton, "The Initiation of Kamanga: Visuality and Textuality in Evans-Pritchard's Zande Ethnography," in *Photography, Anthropology, and History: Expanding the Frame,* ed. Christopher Morton and Elizabeth Edwards (Farnham, England, 2009). Complicating the observer-participant, subject-object colonial relations, the initiate was Kamanga, Evans-Pritchard's servant, and his ritual initiation was sponsored by Evans-Pritchard.

8. Manifested through the Carnegie-funded International Institute of African Languages and Culture founded in 1926.

9. Jack Goody, *The Expansive Moment: The Rise of Social Anthropology in Britain and America, 1918–1970* (Cambridge, England, 1995), p. 9.

10. John L. Comaroff, Jean Comaroff, and Deborah James, eds., *Picturing a Colonial Past: The African Photographs of Isaac Schapera* (Chicago, 2007), p. ix. This volume gives a lucid account of Schapera's work.

11. Jean Comaroff and John L. Comaroff, "Introduction: The Portraits of an Ethnographer as a Young Man," in ibid., p. 2.

12. Ibid.

13. Jean Comaroff, John L. Comaroff, and Deborah James, "African Images: The Photographs of Isaac Schapera in Bechuanaland and Elsewhere, 1929–1940," in ibid., p. 187.

14. Jean-Hervé Jezequel, "Voices of Their Own? African Participation in the Production of Colonial Knowledge in French West Africa, 1900–50" in *Ordering Africa: Anthropology, European Imperialism and the Politics of Knowledge,* ed. Helen Tilley and Robert J. Gordon, Studies in Imperialism (Manchester, 2007), p. 146.

15. For instance, Jomo Kenyatta trained as an anthropologist at the London School of Economics in the mid-1930s and used that knowledge and skill when leading Kenya to independence.

16. Ariella Azoulay, *The Civil Contract of Photography,* trans. Rela Mazali and Ruvik Danieli (New York, 2008), p. 11.

17. Christopher Morton, "Double Alienation: Evans-Pritchard's Zande and Nuer Photographs in Comparative Perspective," in *Photography in Africa: Ethnographic Perspectives,* ed. Richard Vokes (Woodbridge, England, 2012).

18. Christopher Morton and Gilbert Oteyo, "Paro Manene: Exhibiting Photographic Histories in Western Kenya," *Journal of Museum Ethnography* 22 (December 2009): 155–64.

19. For a letter from Kgosi (Chief) Linchwe II explaining the significance of the photographs and their relation with oral history, see Comaroff, Comaroff, and James, *Picturing a Colonial Past,* p. xv.

20. James Clifford, "On Ethnographic Allegory," *Writing Culture: The Poetics and Politics of Ethnography,* ed. James Clifford and George E. Marcus (Berkeley, Calif., 1986), pp. 98–121.

21. Ian Walker, "Phantom Africa: Photography Between Surrealism and Ethnography," *Cahiers d'Études africaines* 37, cahier 147, XXXVII-3 (1997): 637.

22. Clifford, "On Ethnographic Allegory," p. 44.

23. Duggan-Cronin's photographs remain keenly debated in southern Africa. See Michael Godby, "Alfred Martin Duggan-Cronin's Photographs for *The Bantu Tribes of South Africa* (1928–1954): The Construction of an Ambiguous Idyll," *Kronos: Southern African Histories* 36, no. 3 (November 2010): 54–83; Darren Newbury, *Defiant Images: Photography and Apartheid South Africa* (Pretoria, 2009), pp. 15–17; Tamar Garb, *Figures and Fictions: Contemporary South African Photography* (Göttingen, 2011), pp. 21–27 and references therein.

24. Schapera advised on the bibliography of Duggan-Cronin's 1928 Bavenda volume.

25. Godby, "Alfred Martin Duggan-Cronin's Photographs," 70–71.

26. Clifford, "On Ethnographic Allegory," p. 117; Michael Richardson, "An Encounter of Wise Men and Cyclops Women: Considerations of Debates on Surrealism and Anthropology," *Critique of Anthropology* 13, no. 1 (March 1993): 57–75.

27. See, for example, Paul Blanchard, Gilles Boëtsch, and Nanette Jacomijin Snoep, eds., *Human Zoos: The Invention of the Savage* (Paris, 2012).

28. Notably Michael Leiris, the Surrealist poet who became one of France's leading anthropologists. See Richardson, "An Encounter of Wise Men," p. 59.

29. Clifford, "On Ethnographic Allegory," p. 118.

30. Ibid.

31. James Clifford, *The Predicament of Culture: Twentieth-Century Ethnography, Literature, and Art* (Cambridge, Mass., 1988), p. 132.

32. Richardson, "An Encounter of Wise Men."

33. Walker, "Phantom Africa," pp. 637–39.

34. Clifford, *The Predicament of Culture,* p. 147.

35. Ibid.

36. Deborah Poole, "An Excess of Description: Ethnography, Race, and Visual Technologies," *Annual Reviews of Anthropology* 34 (2005): 160.

37. Walker, "Phantom Africa," p. 637.

38. Poole, "An Excess of Description," p. 160. Much artistic intervention into "anthropology" is grounded in this homology.

39. Duggan-Cronin's photographs have recently been endorsed as important cultural records by Nelson Mandela. See Godby, "Alfred Martin Duggan-Cronin's Photographs," p. 80.

40. Walter Benjamin, "The Task of the Translator," in *Illuminations,* ed. Hannah Arendt, trans. Harry Zorn (London, 1992), p. 76.

5. African Taxonomies: Displaying and Classifying Race

I am greatly indebted for conversations and other help to Petrine Archer, Mary Jane Arnoldi, Paul Kaplan, Elizabeth Edwards, Gail Feigenbaum, and Karen Stokes.

1. See David Bindman, *Ape to Apollo: Aesthetics and the Idea of Race in the 18th Century* (Ithaca, N.Y., 2002).

2. For Cordier, see Hugh Honour, *The Image of the Black in Western Art,* new ed., vol. IV, pt. 2 (Cambridge, Mass., 2012), pp. 106–11 and figs. 71–73; and the definitive work on the artist, Laure de Margerie and Edouard Papet, *Facing the Other: Charles Cordier (1827–1905), Ethnographic Sculptor,* trans. Lenora Ammon, Laurel Hirsch, and Clare Palmieri, Exhibition catalogue, Paris, Musée d'Orsay (Paris, 2004).

3. "My art incorporated the reality of a whole new subject, the revolt against slavery and the birth of anthropology" (Charles Cordier, *Mémoires et notes écrites par Charles Cordier, statuaire,* p. 10, cited in Margerie and Papet, *Facing the Other,* p. 15).

4. Ibid., pp. 20–26.

5. Ibid., p. 28.

6. Arthur, comte de Gobineau, *Essai sur l'inégalité des races humaines,* 4 vols. (Paris, 1853–1855).

7. For Herbert Ward, see Honour, *Image of the Black,* vol. IV, pt. 2, pp. 225–29 and figs. 168–70; Mary Jo Arnoldi, "Where Art and Ethnology Met: The Ward African Collection at the Smithsonian," in *The Scramble for Art in Central Africa,* ed. Enid Schildkrout and Curtis A. Keim (Cambridge, Mass., 1998), pp. 193–216; Hugh Marles, "Arrested Development: Race and Evolution in the Sculpture of Herbert Ward," *Oxford Art Journal* 19, no. 1 (1996): 16–28; and Kirsty Breedon, "Herbert Ward: Sculpture in the Circum-Atlantic World," *Visual Culture in Britain* 11, no. 2 (July 2010): 265–83.

8. See Marles, "Arrested Development," cited *supra,* n. 7.

9. See Herbert Ward, *A Voice from the Congo, Comprising Stories, Anecdotes, and Descriptive Notes* (London, 1910).

10. For a view of the Paris studio, see Honour, *Image of the Black,* vol. IV, pt. 2, p. 227, fig. 168.

11. Henry Field, *The Track of Man: Adventures of an Anthropologist* (London, 1955), p. 131.

12. See Marianne Kinkel, *Races of Mankind: The Sculptures of Malvina Hoffman* (Urbana, Ill., 2011), pp. 13–17.

13. Daniel J. Sharfstein, *The Invisible Line: Three American Families and the Secret Journey from Black to White* (New York, 2011).

14. Field, *Track of Man,* pp. 14–16.

15. Cole Douglas, *Franz Boas: The Early Years, 1858–1906* (Vancouver, 1999), pp. 195–96.

16. Vernon J. Williams, Jr., *Rethinking Race: Franz Boas and His Contemporaries* (Lexington, Ky., 1996), pp. 4–36.

17. Preface to Henry Field, *The Races of Mankind: An Introduction to Chauncey Keep Memorial Hall,* Field Museum of Natural History, Anthropology Leaflet 30 (Chicago, 1933), p. 6.

18. Field, *Track of Man,* p. 36.

19. Arthur Keith, *Ethnos; or, The Problem of Race Considered from a New Point of View* (London, 1931), p. 10.

20. Ibid., p. 10. See also Tracy Lang Teslow, "Reifying Race: Science and Art in *Races of Mankind* at the Field Museum of Natural History," in *The Politics of Display: Museums, Science, Culture,* ed. Sharon Macdonald (London, 1998), p. 63.

21. Keith in Field, *The Races of Mankind,* p. 8: "The eye at a single glance picks out the racial features more certainly than could a band of trained anthropologists, who depend on measurements to distinguish Negro, Indian, or Chinaman from European."

22. Kinkel, *Races of Mankind,* p. 29.

23. Arthur Keith, *An Autobiography* (London, 1950), pp. 552–53.

24. Teslow, "Reifying Race," pp. 60–61.

25. Bindman, *Ape to Apollo,* pp. 95–96.

26. Malvina Hoffman, *Heads and Tales* (New York, 1936), pp. 12, 155.

27. Los Angeles, Getty Research Institute, Malvina Hoffman Papers, Box 18h.

28. Henry Field, "The Unity of Mankind," *Polity* 2, no. 7 (April 1934): p. 103.

29. Kinkel, *Races of Mankind,* p. 9.

30. "Regarding the record cards with anthropological data, I remember a long time ago having written to say that I really could not fill out those cards the way they were printed. . . . My brain children are only to be looked at and not measured" (Malvina Hoffman to Laufer, 13 May 1933, Getty Research Institute, Malvina Hoffman Papers, 850042–3 Miscellaneous Correspondence ca. 1932–1935).

31. The account of the visit to Africa is virtually identical in both her autobiographies: *Heads and Tales* and *A Sculptor's Odyssey,* both of 1936.

32. Keith in Field, *Races of Mankind,* p. 9.

33. See Honour, *Image of the Black,* vol. IV, pt. 2, p. 242, fig. 181.

34. Field, *Races of Mankind,* p. 21.

35. This discussion of the Haardt expedition and the Mangbetu woman owes everything to Petrine Archer's Ph.D. dissertation, to which she kindly gave me access: "Negrophilia Paris in the 1920s: A Study of the Artistic Interest in and Appropriation of Negro Cultural Forms in Paris During That Period" (Ph.D. diss., University of London, 1994), esp. chap. 6.

36. Ibid., pp. 266–70.

37. Field, *Races of Mankind,* pp. 20–22.

38. Letter of 5 February 1944, in which Paul S. Martin, chief curator of anthropology, tells Hoffman about the changes of nomenclature he finds necessary.

6. Africa and Paris: The Art of Picasso and His Circle

1. Gertrude Stein, "Matisse and Picasso and African Art, 1906–1907" (1933) in *Primitivism and Twentieth-Century Art: A Documentary History,* Documents of 20th-Century Art, ed. Jack D. Flam, Miriam Deutch, and Carl Einstein (Berkeley, Calif., 2003), p. 35. See also Hilary Spurling, *The Unknown Matisse: A Life of Henri Matisse, the Early Years, 1869–1908* (Berkeley, Calif., 2001), pp. 371–72.

2. Stein, "Matisse and Picasso and African Art," in Flam, Deutch, and Einstein, *Primitivism and Twentieth-Century Art,* p. 35.

3. Jacob, in Hélène Seckel, with Emmanuelle Chevrière and Hélène Henry, *Max Jacob et Picasso,* Exhibition catalogue, Quimper, Musée des Beaux-Arts, 21 June–4 September 1994 (Paris, 1994), p. 232.

4. Carl Heinrich Stratz, *Die Rassenschönheit des Weibes* (Stuttgart, 1901).

5. Michael Hau, *The Cult of Health and Beauty in Germany: A Social History, 1890–1930* (Chicago, 2003), p. 83.

6. Michael Leja, "'Le vieux marcheur' and 'Les deux risques': Picasso, Prostitution, Venereal Disease, and Maternity, 1899–1907," *Art History* 8, no. 1 (March 1985): 66–81 plus 39 plates.

7. David Lomas, "A Canon of Deformity: *Les Demoiselles d'Avignon* and Physical Anthropology," *Art History* 16, no. 3 (September 1993): 424–46.

8. Allan Sekula, "On the Invention of Photographic Meaning," in *Thinking Photography,* ed. Victor Burgin, Communications and Culture (London, 1982), p. 87.

9. Anne Baldassari in Elizabeth Cowling, ed., *Matisse, Picasso,* Exhibition catalogue, London, Tate Modern, 2002, pp. 340, 342.

10. Ibid., pp. 340–41.

11. Anne Baldassari, *Picasso and Photography: The Dark Mirror,* trans. Deke Dusinberre, Exhibition catalogue, Houston, Museum of Fine Arts (Houston, 1997), fig. 57; Philippe David, *Inventaire générale des cartes postales Fortier,* pt. 1, *Sénégale—Guinée, 1900–1905* (Paris, 1986), t.1, pp. 3, 13.

12. Baldassari, *Picasso and Photography,* p. 54, fig. 57.

13. Anne Baldassari, *Dora Maar I Picasso, dodir pogledima = Dora Maar et Picasso, regards croisés,* Exhibition catalogue, Zagreb, Galerija Klovićevi dvori (Zagreb, 2004), p. 344.

14. Baldassari, *Picasso and Photography,* p. 72, and *Dora Maar I Picasso,* p. 346; Ellen McBreen, "The Pinup and the Primitive: Eros and Africa in the Sculpture of Henri Matisse (1906–1909)," Ph.D. diss., New York University, Institute of Fine Arts, 2007, p. 131.

15. Baldassari, *Picasso, photographe, 1901–1916,* Exhibition catalogue, Paris, Musée national Picasso, 1 June–17 July 1994 (Paris, 1994), p. 155, fig. 117; Baldassari, *Dora Maar I Picasso,* p. 346; McBreen, "The Pinup and the Primitive," p. 131.

16. Baldassari, *Dora Maar I Picasso,* p. 347.

17. McBreen, "The Pinup and the Primitive," p. 149.

18. Ibid., p. 131 n. 48.

19. Baldassari, *Dora Maar I Picasso,* p. 347 n. 15.

20. McBreen, "The Pinup and the Primitive," p. 47.

21. William Rubin et al., *Les Demoiselles d'Avignon* (New York, 1995), p. 64.

22. John Richardson, with collaboration of Marilyn McCully, *A Life of Picasso,* 3 vols. (New York, 1991–1996), vol. III, *The Triumphant Years, 1917–1932,* p. 15.

23. Rubin et al., *Les Demoiselles d'Avignon,* p. 133, figs. 32r and 32v.

24. Leo Steinberg, "Le bordel philosophique," in Hélène Seckel, gen. ed., *Les Demoiselles d'Avignon,* 2 vols., Musée Picasso Paris Series, 3, Exhibition catalogue, Paris, Musée Picasso, 26 January–18 April 1988 Musée Picasso Paris Series, 3 (Paris, 1988), vol. II, p. 52. Steinberg's "The Philosophical Brothel" was originally published in *Art News* 71, nos. 5 and 6 (September and October 1972), and in a revised English version of the same title in *October* 44 (Spring 1988): 7–74.

25. For related discussion, see Leja, "'Le vieux marcheur' and 'Les deux risques,'" pp. 65–68.

26. Raymond Corbey, "Alterity: The Colonial Nude," *Critique of Anthropology* 8, no. 3 (1982): 75–92.

27. See also Elizabeth Hutton Turner, "Who Is in the Brothel of Avignon? A Case for Context," *Artibus et Historiae* 5, no. 9 (1984): 145; and Robert S. Lubar, "Narrating the Nation: Picasso and the Myth of El Greco," in *Picasso and the Spanish Tradition,* ed. Jonathan Brown (New Haven, Conn., 1996), pp. 36–37, fig. 29.

28. Leo Frobenius, *Die Masken und Geheimbünde Afrikas,* Leopoldinisch-Carolinische Deutsche Akademie für Naturforscher, Nova Acta Leopoldina, vol. LXXXIV, no. 1 (Halle, 1898), fig. 9.

29. Laurence Madeline and Marilyn Martin, *Picasso and Africa* (Cape Town, 2006), p. 197.

30. Baldassari, *Picasso and Photography,* p. 50.

31. Natasha Staller, in Christopher Green, *Picasso: Architecture and Vertigo* (New Haven, Conn., 2005), pp. 67–68, n. 77.

32. Ibid., p. 78.

7. Encounters with the Image of the Black: The German and French Avant-Garde (1905-1920)

1. Alfred H. Barr, Jr., *German Painting and Sculpture* (New York, 1931), p. 10.

2. I acknowledge that the terms *primitivism* and *primitive art* are highly charged and problematic, burdened with an inherent Eurocentric system of thought that has been called into question by postcolonial theory. However, I follow other art historians such as Jack Flam and Reinhold Heller in occasionally employing these terms, and with respect to a "period" reception, as the most concise designation for the influence on Western thought and culture of arts and crafts beyond Europe, especially of Africa and Oceania, during the early twentieth century. Reference is also made to the term with respect to the Expressionist generation's search for indigenous "Germanic" roots, in short, a "domestic primitivism." The relationship between "exotic" and "domestic" forms, especially as far as the German avant-garde is concerned, is of interest here.

3. See Rose-Carol Washton Long, "Brücke, German Expressionism and the Issue of Modernism," in *New Perspectives on Brücke Expressionism: Bridging History,* ed. Christian Weikop (Farnham, 2011), p. 19.

4. Charles Haxthausen lamented the "cursory treatment" of the German Expressionists in the MoMA "Primitivism" exhibition. See Charles W. Haxthausen, "'Primitivism' in Twentieth Century Art. Detroit," *Burlington Magazine* 127, no. 986 (May 1985): 326. Even the catalogue (details below), which as Haxthausen stated was a "distinguished accomplishment," relegated all German artists (with the exception of Max Ernst) to one admittedly fine chapter by Donald E. Gordon in the second volume, whereas Gauguin, Matisse, and Picasso were each the subject of detailed individual studies in the first volume. Beyond its Paris-school bias, the exhibition also encountered much flak for obsessively exploring formal affinities between avant-garde art and African and Oceanic artifacts in a manner that effectively decontextualized the latter, an approach then questioned by postcolonial criticism. See the chapter "Histories of the Tribal and the Modern" in James Clifford, *The Predicament of Culture: Twentieth-Century Ethnography, Literature, and Art* (Cambridge, Mass., 1988), pp. 189–214. While there is no doubt that in the critical wake of the exhibition more sensitive inquiries were conducted that investigated the complexity of "primitivism," not least through interrogating the actual term, it should be observed that though MoMA's exhibition may have been too formalist in approach, the focus on affinities or parallels was something often emphasized in the primary documents of the artists themselves, and in this respect was historically accurate at least.

5. Sieglinde Lemke, *Primitivist Modernism: Black Culture and the Origins of Transatlantic Modernism,* W. E. B. Du Bois Institute Series (Oxford, 1998), p. 39.

6. Quoted in Jack D. Flam with Miriam Deutch, eds., *Primitivism and Twentieth-Century Art: A Documentary History,* Documents of Twentieth-Century Art (Berkeley, Calif., 2003), p. 27.

7. Ibid.

8. Ibid., p. 28.

9. Jack D. Flam, "Matisse and the Fauves" in *"Primitivism" in 20th Century Art: Affinity of the Tribal and the Modern,* ed. William Rubin, 2 vols., Exhibition catalogue, New York, Museum of Modern Art, 19 September 1984–15 January 1985 (New York, 1984), vol. I, p. 215.

10. Quoted in ibid., pp. 216–17.

11. D. H. Kahnweiler, "Negro Art and Cubism, 1948," in Flam with Deutch, *Primitivism and Twentieth-Century Art,* p. 284.

12. Ibid.

13. Leopold D. Ettlinger, "German Expressionism and Primitive Art," *Burlington Magazine* 110, no. 781 (April 1968): 191–92.

14. John Elderfield, *The "Wild Beasts": Fauvism and Its Affinities,* Exhibition catalogue, New York, Museum of Modern Art, 26 March–1 June 1976 (New York, 1976), p. 109.

15. Flam, "Matisse and the Fauves," pp. 215–19.

16. Ibid., p. 220. Derain's *Bathers* is in Prague, Národní galerie v Praze.

17. Ibid., p. 225.

18. See Timothy O. Benson, "Brücke, French Art and German National Identity," *New Perspectives on Brücke Expressionism,* ed. Christian Weikop (Farnham, 2011), pp. 31–56.

19. Wilhelm Friedrich Arntz, *Paula Modersohn und die Maler der "Brücke": Cuno Amiet, Erich Heckel, E. L. Kirchner, Otto Müller, Emil Nolde, Max Pechstein, Schmidt-Rottluff,* Exhibition catalogue, Bern, Kunsthalle, 3 July–15 August 1948 (Bern, 1948), p. 13.

20. Ernst Ludwig Kirchner, "Das Werk" in Lothar Grisebach, ed., *E. L. Kirchners Davoser Tagebuch: Eine Darstellung des Malers und eine Samm-*

lung seiner Schriften (Cologne, 1968), p. 84. [The German text is: "1903 hatte er im Ethnographischen Museum in Dresden die Schnitzereien der Neger und die bildlichen Darstellungen der Palaubalken gefunden und trotz des Spottes der eigenen Freunde als höche Kunstäusserung . . . erkannt. Er fühlt in ihnen eine Parallele seines eigenen Strebens."]

21. I would like to thank Silvia Dolz, curator of African art at the Staatliches Museum für Völkerkunde in Dresden, for providing me with this information.

22. See Peter Lasko, "The Student Years of the *Brücke* and their Teachers," *Art History* 20, no. 1 (March 1997): 61–99.

23. Paul Westheim, *Das Holzschnittbuch* (Potsdam, 1921), p. 164.

24. Ettlinger, "German Expressionism and Primitive Art," p. 192.

25. Ibid., p. 195.

26. Donald E. Gordon, "Kirchner in Dresden," *Art Bulletin* 48, no. 3/4 (September–December 1966): 354–55.

27. Donald E. Gordon, "German Expressionism," in *"Primitivism" in 20th Century Art,* ed. William Rubin, vol. II, p. 373.

28. Lucius Grisebach, *Ernst Ludwig Kirchner und die Kunst Kameruns,* Exhibition catalogue, Zurich, Museum Rietberg, 3 February–25 May 2008 (Zurich, 2008), p. 36.

29. Peter Howard Selz, *German Expressionist Painting* (Berkeley, Calif., 1957), p. 95.

30. Peter Howard Selz, "E. L. Kirchner's 'Chronik der Brücke,'" *Art Journal* 10, no. 1 (Autumn 1950): 50.

31. Wolfgang Henze, "Heckel," in *German Expressionist Sculpture,* ed. Stephanie Barron, Exhibition catalogue, Los Angeles, Los Angeles County Museum of Art, 30 October 1983–22 January 1984 (Chicago, 1983), p. 92.

32. Ibid., p. 93.

33. Heckel wrote to Mr. Laude, 18 December 1958: "Etwa 1906 entdeckten wir, das sind die Maler der -Brücke- im Ethnographischen Museum im Zwinger von Dresden zwischen sehr viel völkerkunchlichen Gegenständen Figuren und geschnitzte Balken aus der Südsee. Ich kann mich nicht erinnern, ob dort auch afrikanische Kunst mit wesentlichen Stücken vertreten war . . . Für mich ist der erste Eindruck, einer meiner plastischen Vorstellung ganz entsprechenden, eine aegyptische Holzskulptur, die ich etwa 1906 im Albertinum in Dresden sah. Hier war aus dem vollen Stamm mit einfachen Mitteln das Figürliche in voller Sinnlichkeit und trotzdem formal ganz gebunden, also nicht naturalistisch, sondern geheimnisvoll herausgearbeitet, wie auch bei der Südsee—und afrikanischen Plastiken, bei denen noch durch die Veränderung der Proportionen die Ausdruckskraft gesteigert schien." I would like to thank Renate Ebner and Hans Geissler of the Erich Heckel Stiftung for drawing my attention to this unpublished source from the Nachlass Erich Heckel and granting me permission to reproduce it here.

34. See Wolfgang Henze, "Die Genese der Brücke-Skulptur in Dresden—Ein Arbeitsbericht," in *Die Brücke in Dresden 1905–1911,* ed. Birgit Dalbajewa and Ulrich Bischoff, Exhibition catalogue, Galerie Neumeister, Staatliche Kunstsammlungen, 20 October 2001–6 January 2002, Dresden (Cologne, 2001), pp. 78–96.

35. William Stanley Rubin, "Picasso," in *"Primitivism" in 20th Century Art,* ed. William Rubin, vol. I, p. 288.

36. See Christian Weikop, "Karl Schmidt-Rottluffs Arborealer Expressionismus" in *Rosa. Eigenartig grün: Rosa Schapire und die Expressionisten,* ed. Sabine Schulze, Exhibition catalogue, Hamburg, Museum für Kunst und Gewerbe, 28 August–15 November 2009 (Hamburg, 2009), pp. 186–215.

37. Rubin, "Picasso," p. 285.

38. Ibid., p. 286.

39. Flam, "Matisse and the Fauves," p. 218. This point notwithstanding, Derain did supply woodblock prints in a primitivist style for an edition of Guillaume Apollinaire's *L'Enchanteur pourrissant* (1909). Derain was seemingly quite a Germanophile; an enthusiast for Friedrich Nietzsche and other modern German philosophers, he displayed works at Munich exhibitions held by the Neue Künstelervereinigung and Der Blaue Reiter in 1910 and 1912, respectively.

40. Emil Nolde, quoted in *Emil Nolde: Graphik: Aus der Sammlung der Stiftung Seebüll Ada und Emil Nolde,* Exhibition catalogue, Kiel, Schleswig-Holsteinischer Kunstverein, 19 October–30 November 1975 (Neukirchen über Niebüll, 1975), p. 19.

41. L. de Marsalle [E. L. Kirchner], "Über die plastischen Arbeiten von E. L. Kirchner," *Der Cicerone: Halbmonatsschrift für Künstler, Kunstfreunde und Sammler* 17, no. 13 (July 1925): 695–701.

42. Gordon, "German Expressionism," p. 387.

43. Wilhelm Valentiner, "Karl Schmidt-Rottluff," *Der Cicerone* 12 (1920). Quoted in Stephanie Barron, *German Expressionist Prints and Drawings: The Robert Gore Rifkind Center for German Expressionist Studies,* 2 vols. (Los Angeles, 1989), vol. 1, *Essays,* p. 39.

44. Quoted in Barron, *German Expressionist Sculpture,* p. 52.

45. Colin Rhodes, "Through the Looking-Glass Darkly: Gendering the Primitive and the Significance of Constructed Space in the Practice of the Brücke," in *Gender and Architecture,* ed. Louise Durning and Richard Wrigley (Chichester, 2000), p. 193.

46. Gordon, "Kirchner in Dresden," pp. 356–57.

47. See Peter Kropmanns, "The Gauguin Exhibition in Weimar in 1905," *Burlington Magazine* 41, no. 1150 (January 1999): 24–31.

48. André Salmon, "Negro Art," *Burlington Magazine for Connoisseurs* 36, no. 205 (April 1920): 165.

49. Carl Zigrosser, *The Expressionists: A Survey of Their Graphic Art* (New York, 1957), p. 9.

50. Jill Lloyd, *German Expressionism: Primitivism and Modernity* (New Haven, Conn., 1991), p. 87.

51. Robert Goldwater, *Primitivism in Modern Art* (New York, 1938).

52. See Pablo Picasso, "Discovery of African Art 1906–1907" in Flam, *Primitivism and Twentieth-Century Art,* pp. 33–34.

53. This letter is referred to in Hal Foster, "'Primitive Scenes,'" *Critical Inquiry* 20, no. 1 (Autumn 1993): 96.

54. I am indebted to Reinhold Heller for this observation, in correspondence with me 3 July 2012.

55. Reinhold Heller, "Die 'Brücke' und die zentrale Rolle der Primitiven," in *Brücke: Die Geburt des deutschen Expressionismus,* ed. Magdalena M. Moeller and Javier Arnaldo, Exhibition catalogue, Madrid, Museo Thyssen-Bornemisza, 1 October 2005–15 January 2006 (Berlin, 2005), p. 76.

56. See Rhodes, "Through the Looking-Glass Darkly," pp. 201–3.

57. The aggressive nature of this German colonialism would ultimately lead to a terrible massacre of the Khoikhoi people between 1904 and 1907.

58. Heller, "Die 'Brücke' und die zentrale Rolle der Primitiven," p. 76.

59. Tanja Pirsig-Marshall, "Die Brücke als Katalystor für Muellers Schaffen" in *Gruppe und Individuum in der Kunstlergemeinschaft Brücke: 100 Jahre Brücke: Neuste Forschung,* ed. Birgit Dalbajewa, Konstanze Rudert, and Aya Soika, Jahrbuch der Staatlichen Kunstsammlungen Dresden, Berichte, Beiträge 2005 (Dresden, 2007), p. 136.

60. *Paula Modersohn und die Maler der "Brücke": Cuno Amiet, Erich Heckel, E. L. Kirchner, Otto Müller, Emil Nolde, Max Pechstein, Schmidt-Rottluff,* Exhibition catalogue, Bern, Kunsthalle Bern, 3 July–15 August 1948 (Bern, 1948).

61. See Lloyd, *German Expressionism,* p. 39.

62. Jürgen Thiesbonenkamp, "Kameruns Erbe und Krise in Welthorizont," in Jürgen Thiesbonenkamp and Andreas-Martin Selignow, eds., *Interdisziplinare Afrikaforschung und neuer Afropessimismus: Symposion zum 70. Geburtstag von Heinrich Balz, 12–13 September 2008 Gellmersbach* (Berlin, 2009), pp. 65–82, esp. pp. 75–76.

63. See Rhodes, "Through the Looking-Glass Darkly," p. 195.

64. Gordon, "German Expressionism," p. 386.

65. See Christian Weikop, "Tropical Sun and Trophy Heads," *Art History* 26, no. 1 (February 2003): 130–34.

66. Fritz Richard Stern, *The Politics of Cultural Despair: A Study in the Rise of the German Ideology* (Berkeley, Calif., 1961), p. 134.

67. Emil Nolde, *Jahre der Kämpfe* (Berlin, 1934).

68. Ibid., quoted and translated in Flam with Deutch, *Primitivism and Twentieth-Century Art,* p. 53.

69. August K. Wiedmann, *The German Quest for Primal Origins in Art, Culture, and Politics 1900–1933: Die "Flucht in Urzustände,"* Studies in German Thought and History, vol. 16 (Lewiston, N.Y., 1995), p. 87.

70. Nolde, *Jahre der Kämpfe,* quoted and translated in Stephanie Barron, ed., *"Degenerate Art": The Fate of the Avant-Garde in Nazi Germany,* Exhibition catalogue, Los Angeles Museum of Art, 17 February–12 May 1991 (Los Angeles, 1991), p. 319.

71. His later apparent diatribe may have been designed to protect his work from the National Socialists by expressing his sympathies with their cultural policies. If that was the case, then it was doomed to failure as his work was featured more than any other artist in the "Degenerate Art" exhibitions of 1937–1938.

72. Gordon, "German Expressionism," p. 382.

73. Ibid., p. 384.

74. See Anita Beloubek-Hammer, Magdalena M. Moeller, and Dieter Scholz, eds., *Brücke und Berlin: 100 Jahre Expressionismus,* Exhibition catalogue, Berlin, Nationalgalerie, 8 June–28 August 2005 (Berlin, 2005), pp. 232–33.

75. Norbert Wolf, *Ernst Ludwig Kirchner, 1880–1938: On the Edge of the Abyss of Time* (Cologne, 2003), p. 67.

76. Joseph Masheck, "Raw Art: 'Primitive' Authenticity and German Expressionism," *RES: Anthropology and Aesthetics* 4 (Autumn 1982): 94.

77. Gordon, "German Expressionism," pp. 393–95.

78. See Jill Lloyd, "Emil Nolde's Still Lifes, 1911–1912: Modernism, Myth, and Gesture," *RES: Anthropology and Aesthetics* 9 (Spring 1985): 43 n. 20.

79. Katherine Kuenzli, "The Primitive and the Modern in the Blue Rider Almanac and the Folkwang," paper presented at the Blue Rider Centenary Conference, London, Tate Modern, 25 November 2011. Cited with permission of the author.

80. Carl Einstein, "Negerplastik," quoted and translated in Flam with Deutch, *Primitivism and Twentieth-Century Art,* p. 80.

81. See Uwe Fleckner, *Carl Einstein und sein Jahrhundert: Fragmente einer intellektuellen Biographie,* Deutsches Forum für Kunstgeschichte (Berlin, 2006), pp. 194–203.

82. See Carl Einstein, *Afrikanische Plastik* (Berlin, 1921), quoted and translated in Charles W. Haxthausen, "Bloody Serious: Two Texts by Carl Einstein," *October* 105 (Summer 2003): 112 n. 38.

83. Ibid.

84. Wyndham Lewis, "Note (on Some German Woodcuts at the Twenty-One Gallery)," *Blast: Review of the Great English Vortex,* no. 1 (20 June 1914): 136.

8. Negrophilia, Josephine Baker, and 1920s Paris

1. Janet Flanner, *Paris Was Yesterday 1925–1939,* ed. Irving Drutman (New York, 1972), p. xx. "She made her entry entirely nude except for a pink flamingo feather between her limbs; she was being carried upside down and doing the split on the shoulder of a black giant. Midstage he paused, and with his long fingers holding her basket-wise, around the waist, swung her in a slow cartwheel to the stage floor, where she stood like his magnificent discarded burden in an instance of complete silence.

She was an unforgettable female ebony statue. A scream of salutation spread through the theater."

2. "Vénus noire" was the fantasy title poet Charles Baudelaire gave to his long-standing creole mistress, Jeanne Duval, who features in works such as *Les Fleurs du Mal* and, especially, *Le Serpent qui danse.* Susan Schmid, describing Charles Baudelaire's exoticism, suggests, "Like other beholders of exotic womanhood, Baudelaire is fascinated by Jeanne Duval's appearance: her hair, her scent and her suppleness make her the archetype of the sexually exciting exotic woman who, conveniently, possesses hardly any individuality. He regards her as the personification of the animal-like, of the natural." See Susan Schmid, "'Black Venus': Jeanne Duval and Charles Baudelaire," *Erfurt Electronic Studies in English,* EEEE 2/97 (a journal archived by the Niedersächsische Staats- und Universitätsbibliothek, Göttingen).

3. Baker's transgressive style is vividly described by Brenda Dixon Gottschild where she literally demonstrates her posture and dance form, in *Josephine Baker: The First Black Superstar,* London: British Broadcasting Corporation (BBC) Resources aired October 2009, m. 12:30.

4. Cultural analyst Brent Hayes Edwards discussing Negrophilia and its relationship to Diasporic blacks in Paris questions its usefulness as a theoretical construct. Instead, Edwards inverts the term *crises nègres,* first used by Jacques Doucet as a commentary on Paris's infatuation with African culture, to show that the real crisis was that experienced by blacks as a result of their cultural dislocation and their inability to communicate their own sense of being modern to their white vanguard colleagues. Brent Edwards redefines *crises nègres* as "crises of representation: the modernity of black performance and expression [that] clashes with the mirage of a silent, distant 'ethnic' primitive." See Brent Hayes Edwards, "The Ethnics of Surrealism," *Transition* 78 (1998): 84–135, esp. p. 89.

5. W. E. B. Du Bois, "Criteria of Negro Art," an address in honor of Carter G. Woodson, 1926. See Henry Louis Gates, Jr., and Nellie Y. McKay, gen. eds., *The Norton Anthology of African American Literature,* 2nd ed. (New York, 2004), pp. 777–84.

6. A distinction was made between "hot jazz" and the melodic, "industrialized" sound of bands such as Paul Whitman and Jack Hylton, which were considered "insipid." It suited the avant-garde to view jazz as a bridge to Africa, and they stressed its innovation and primitivized qualities. See Robert Giffin, "Hot Jazz," translated from the French by Samuel Beckett, in Nancy Cunard, ed., *Negro, An Anthology,* edited and abridged, with an introduction by Hugh Ford (1934; New York, 1996), pp. 238–39.

7. Picasso and Stravinsky became friends in Naples, where Diaghilev's Ballets Russes also performed. For a discussion of the friendship between Picasso and Stravinsky that led to the creation of the ragtime-influenced works, see Carina Nandial, "Picasso and Stravinsky: Notes on the Road from Friendship to Collaboration," *Colloquy: Text, Theory, Critique,*

no. 22 (December 2011): 81–88. This journal is published at Monash University, Melbourne, Australia.

8. For a more detailed discussion about boxing and contemporary Negrophilia, see Petrine Archer-Shaw, "Negrophilia: A Double-Edged Infatuation," *Guardian* (London), 23 September 2000.

9. An evening of music and dance staged at the Théâtre des Champs Elysées by Paul Guillaume to accompany his *Première exposition d'art nègre et d'art océanien,* in 1919.

10. A dance choreographed by Jean Börlin, the star of the Ballets Suédois, inspired by African art and performed in 1919 at the Comédie des Champs Elysées. Later this dance would form the basis of a *ballet nègre* with the same name performed in 1929 at the Théâtre des Champs-Elysées. Paul Colin designed the costumes and poster for this later Ballets Suédois production.

11. Carl Einstein, *Negerplastik* (Leipzig, 1915).

12. Marius de Zayas, *African Negro Art: Its Influence on Modern Art* (New York, 1916).

13. Rosalind Krauss, "Giacometti" in *"Primitivism" in 20th Century Art: Affinity of the Tribal and the Modern,* ed. William Rubin, 2 vols., Exhibition catalogue, New York, Museum of Modern Art, 19 September 1984– 15 January 1985 (New York, 1984), vol. II, pp. 503–34.

14. For a critique of Bataille's methods, see Petrine Archer, "Negrophilia, Diaspora, and Moments of Crisis," in *Afro Modern: Journeys Through the Black Atlantic,* ed. Tanya Barson and Peter Gorschlüter, Exhibition catalogue, Tate Liverpool, 29 January–25 April 2010, pp. 26– 39.

15. These ideas ran contrary to the ideals and ambitions of black people themselves who, given half the chance, might have voiced their own motives. When the Panamanian boxer Al Brown was invited to participate in a fundraising gala at the Cirque d'hiver in 1931, he is reported to have said that he was "boxing to contribute to the success of the expedition and to increase knowledge and understanding of Africa." Yet even these progressive surrealists steeped in ethnographic theory and preparing for their Dakar Djibouti Expedition framed him as a type of modern black "primitive." See Brent Hayes Edwards, "The Ethnics of Surrealism," *Transition* 78 (1999): 82–135. Edwards labels this disparity between French Negrophilia sentiment and the motivations of black people as a "crise nègre"—a crisis of representation for blacks in the Diaspora.

16. Edwards, "Ethnics of Surrealism," p. 91.

17. For a comprehensive account of the black entertainment scene in Paris during this era, see William A. Shack, *Harlem in Montmartre: A Jazz Story Between the Great Wars,* Music of the African Diaspora, 4 (Berkeley, Calif., 2001).

18. For more about the nightlife and social makeup of these Diaspora communities, see Tyler Stovall, *Paris Noir: African Americans in the City of Light* (Boston, 1996).

19. Paulette Nardal, *La Dépêche africaine,* 30 May 1929, p. 3. My translation. She writes: "les noirs se sentent bien chez eux."

20. Madiana [Audré] Wardal, "The Biguine of the French Antilles" in Cunard, ed., *Negro: An Anthology,* pp. 245–46.

21. This type of rhetoric related to the rejuvenation of European bloodlines through a black other had its origins in European romanticism, according to Gobineau in the nineteenth century. See Arthur de Gobineau, *Essai sur l'inégalite des races humaines* (Paris, 1853–1855) (electronic document, Bibliothèque nationale de France, Paris).

22. Paul Guillaume, *Crisis* (June 1924): 80. As early as 1924, Guillaume would write: "Negro Art has a spiritual mission, it has the great honor to develop the taste, to stir the depths of her soul, to refine the spirit, to enrich the spirit of the imagination of this very Twentieth Century."

23. Iris Schmeisser, *Transatlantic Crossings Between Paris and New York: Pan-Africanism, Cultural Difference and the Arts in the Interwar Years,* American Studies Monograph Series, vol. 133 (Heidelberg, 2006), p. 60.

24. Paul Colin, *Le Tumulte noir* (Paris, 1927).

25. RIP, the pen name for French satirist and musical critic Georges Thenon (1886–1941).

26. For an article that provides an entertaining but also thorough examination of this portfolio and its various characters, see Karen C. C. Dalton and Henry Louis Gates, Jr., "Josephine Baker and Paul Colin: African American Dance Seen Through Parisian Eyes," *Critical Inquiry* 24, no. 4 (Summer 1998): 903–34.

27. Schmeisser, *Transatlantic Crossings,* p. 171.

28. For a complete record of this exhibition, see *Encyclopédie des Arts Décoratifs et Industriels Modernes au XIXème siècle en douze volumes* ([1827?]; reprint ed., New York, 1977).

29. Georges-Marie Haardt and Louis Audouin-Dubreuil, *La Croisière noire: Expédition Citroën Centre-Afrique* (Paris, 1927).

30. Petrine Archer-Shaw, "Negrophilia: French Avant-Garde in and Appropriation of Black Culture in the 1920s" (Ph.D. diss., Courtauld Institute, University of London, 1994).

31. The state organized the Colonial Exhibition of 1931 at which Josephine Baker was also a guest.

32. Schmeisser, *Transatlantic Crossings,* p. 167.

33. Marianna Torgovnick, *Gone Primitive: Savage Intellects, Modern Lives* (Chicago, 1990).

34. Henri Matisse, *Jazz* (Paris, 1947).

9. Afrophilia and Afrophobia in Switzerland and Germany (1916-1938)

1. Quoted in Wolfgang Henze, "Kirchner," *German Expressionist Sculpture,* ed. Stephanie Barron, Exhibition catalogue (Chicago, 1983), p. 116.

2. Ernst Ludwig Kirchner, *Davoser Tagebuch,* ed. Lothar Grisebach (Ostfildern, 1997), p. 219. [The German text is: "Ihre starken Gesichter, teils mit großen schwarzen Hüten bedeckt, formten sich aus den Tannen."]

3. L. de Marsalle [E. L. Kirchner], "Über die plastischen Arbeiten von E. L. Kirchner," *Der Cicerone* 17, no. 14 (1925): 695–701.

4. Wendy A Grossman, *Man Ray, African Art, and the Modernist Lens,* Exhibition catalogue (Washington, D.C., 2009), p. 35.

5. See Pablo Picasso, "Discovery of African Art 1906–1907," in *Primitivism and Twentieth-Century Art: A Documentary History,* ed. Jack D. Flam with Miriam Deutch (Berkeley, Calif., 2003), pp. 33–34.

6. Hugo Ball, *Flight Out of Time: A Dada Diary,* ed. John Elderfield (Berkeley, Calif., 1996), pp. 64–65.

7. Ibid., p. xv.

8. Hans Richter, *Dada: Art and Anti-art* (New York and Toronto, 1965), p. 20.

9. See Richard Sheppard, *Modernism-Dada-Postmodernism* (Evanston, Ill., 2000), p. 248.

10. Quoted in Maud Lavin, *Cut with the Kitchen Knife: The Weimar Photomontages of Hannah Höch* (New Haven, Conn., 1993), p. 163.

11. Maud Lavin, "Hannah Höch's *From an Ethnographic Museum,*" in Naomi Sawelson-Gorse, ed., *Women in Dada: Essays on Sex, Gender, and Identity* (Cambridge, Mass., 1998), p. 334.

12. Grossman, *Man Ray,* p. 64.

13. Matthew Biro, *The Dada Cyborg: Visions of the New Human in Weimar Berlin* (Minneapolis, 2009), p. 241.

14. See Sally Marks, "Black Watch on the Rhine: A Study in Propaganda, Prejudice and Prurience," *European Studies Review* 13 (July 1983): 297–334.

15. Grossman, *Man Ray,* p. 85.

16. Marilyn Wyman, "Irma Stern: Envisioning the 'Exotic,'" in *Woman's Art Journal* 2 (Autumn 1999): 18.

17. James Clifford, *The Predicament of Culture: Twentieth-Century Ethnography, Literature and Art* (Cambridge, Mass., 1988), p. 136.

18. See Susan Laikin Funkenstein, "A Man's Place in a Woman's World: Otto Dix, Social Dancing, and Constructions of Masculinity in Weimar Germany," in *Women in German Yearbook: Feminist Studies in German Literature and Culture* 21 (Lincoln, Neb., 2005), p. 182.

19. Ibid., p. 181.

20. Ivan Goll, quoted in *The Weimar Republic Sourcebook,* ed. Anton Kaes, Martin Jay, and Edward Dimendberg (Berkeley, Calif., 1994), p. 559.

21. Quoted in Peter Paret, *Berlin Cabaret* (Cambridge, Mass., 1996), p. 171.

22. Ibid.

23. Ibid.

24. Quoted in Sieglinde Lemke, *Primitivist Modernism: Black Culture and the Origins of Transatlantic Modernism* (Oxford, 1998), p. 103.

25. Katherine Tubb, "Sex and Race: Document versus Drama in the

Photography of August Sander and Marta Astfalck-Vietz" (paper presented at the "August Sander and Weimar Germany" conference, organized by Christian Weikop, Hawthornden Lecture Theatre, National Galleries of Scotland, 13 May 2011).

26. See Jill Lloyd and Michael Peppiatt, *Christian Schad and the Neue Sachlichkeit* (New York, 2003).

27. *Expressionism and Beyond: Fourteen Paintings from the German Art Collection at New Walk Museum and Art Gallery,* Leicester (Leicester, 2002), p. 61.

28. Quoted in Barbara Miller Lane, *Architecture and Politics in Germany 1918–1945* (Cambridge, Mass., 1985), pp. 156–57.

29. Erik Levi, "The Censorship of Musical Modernism in Germany, 1918–1945," in *Critical Studies* 1 (2004): 73.

30. See Stephanie Barron, ed., *"Degenerate Art": The Fate of the Avant-Garde in Nazi Germany,* Exhibition catalogue (Los Angeles, 1991). It is notable that at the time that the "degenerate art" exhibition was on tour in Germany, a show that denigrated the associations between modern German art and ethnographic sources, the Harvard art historian Robert Goldwater, who was Jewish, published his seminal *Primitivism in Modern Art* (1938), which, intentionally or not, served as some form of riposte.

31. Hans Weber, "Volkstum im Handwerk," in *Die Kunst im Deutschen Reich* 4, no. 4 (April 1940). Quoted in H. Lehmann-Haupt, *Art Under a Dictatorship* (Oxford, 1954), p. 132.

32. Susan Sontag, "Fascinating Fascism," *New York Review of Books* (6 February 1975), republished in Susan Sontag, *Under the Sign of Saturn* (New York, 1980), p. 88.

33. Ibid.

10. Painted Blacks and Radical Imagery in the Netherlands (1900–1940)

I want to use this modest place to express my deep gratitude for the help and support of many, especially Elizabeth McGrath, Johanna Fortuin, and Carl Haarnack.

1. For example: only around 1926 did the State Academy in Amsterdam engage black models for art students to practice on. In comparison, Belgian academies began this practice around 1850. See Esther Schreuder, "Black Is Beautiful, Black Is Hot: The Attraction of Black Culture," in *Black Is Beautiful: Rubens to Dumas,* ed. Esther Schreuder and Elmer Kolfin, Exhibition catalogue, Amsterdam, De Nieuwe kerk, 26 July–26 October 2008 (Zwolle, 2008), p. 111.

2. Data collected from kranten.kb.nl (digitized newspapers on Royal Library website) 13 July 2012: the years 1900 and 1909 show 2,939 hits for the word *neger*. For the years 1910–1919: 3,698 hits; 1920–1929: 7,096 hits; 1930–1939: 7,017 hits; 1940–1949: 1,881 hits. Other words are also in use between 1900 and 1940. For instance, *nikker, kaffer* (South Africa), and more, although in smaller numbers.

3. Jeanne Kloos-Reyneke van Stuwe, "Feiten en fantasieën. De zwarte magie," *De Nieuwe Gids* (July 1929): 114–20.

4. Leendert Jurriaan Jordaan, "Black Shadows," "Het Negernummer," *De Groene Amsterdammer weekblad voor Nederland,* no. 2759 (19 April 1930): 7. Jordaan is also the artist behind the cartoons on this page.

5. Albert Plasschaert, "Het Negernummer," *De Groene Amsterdammer.* The Dutch artists in the magazine are: Jan van Herwijnen, Wim Schuhmacher, Samuel Leser "Mommie" Schwarz, Else Berg, Kristians Tonny, Isaac Israëls, and cartoons by Johan Braakensiek, L. J. Jordaan, and Henri van de Velde. Two years later the children can enjoy the Negrophilia craze with *Het groote Negerboek.* In this book, naive and stereotyped stories abound about "little negroes and niggers" in Africa. They often look like cute little animals or creatures. Willy Schermelé, *Het groote Negerboek. Oorspronkelijke en bewerkte verhalen, sprookjes, fabels, versjes, grapjes, enz.* (Amsterdam, [1932]). In this book one can find such titles as: "Naar Nikkerland" (To the land of the Nikkers). In this case, the word is used more as a synonym for Negro. Willy Schermelé, the author, continued this popular theme in her work. Between 1930 and 1940, Schermelé also published: *Van Zwarte Peutertjes voor blanke kleutertjes* (From black toddlers to white toddlers; 1940), *Roettoet en andere Nikkertjes* (Blackface and other Nikkers; 1939), and *Versjes en prentjes van Zwarte ventjes* (Poems and images of black chaps; 1935). In 1939, Constance Egan's *Rustie Has a Holiday,* with illustrations by Schermelé, was published in London. After 1945 there are no known titles by Schermelé with a black subject, except the figure Zwarte Piet in the St. Nicolas story.

6. Sketchbooks with Ashanti dancers can be found in the collections of the Rijksmuseum in Amsterdam and the Gemeentemuseum, The Hague. Two drawings are in Otterlo, Kröller-Muller Museum, KM 120-798 recto, KM 128-798 recto. See also Schreuder, "Black Is Beautiful," pp. 116–17. Israëls not only drew and painted these Ashanti dancers, he also composed a series of attractive watercolors of a group of female Caribbean dancers.

7. Another signal is the increasingly popular cakewalk, as Jeanne Kloos also remarked in "Feiten en fantasieën" (see note 3 above). Around this time one could read in a Dutch newspaper the instructions for dancing the cakewalk (e.g., "Hoe de 'Cake-Walk' gedanst wordt," *Rotterdamsch nieuwsblad,* 5 March 1903). The cakewalk was invented by African Americans as a parody of white American folk and ballroom dancing. Exaggerated steps and movements are an important element in this dance. In 1903 the music was also printed in Amsterdam: *Eine vergnügte Neger-Hochzeit (Nigger Wedding/Noce de Negres), Humoristischer Cake-Walk von Rob. Vollstedt,* Op. 215 [Hamburg, 1903]), Collection Carl Haarnack. For more on the cakewalk, see Jan Nederveen Pieterse, *White on Black: Images of Africa and Blacks in Western Popular Culture* (New Haven, Conn., 1992), pp. 137–38.

8. Mondrian quoted in Carel Blotkamp, *Mondriaan: Destructie als*

kunst (Zwolle, 1994), pp. 164–66. (An English-language edition was published in 1995 under the title *Mondrian: The Art of Destruction.*) In Dutch: ". . . uiterst revolutionaire verschijnselen: zij zijn destructief constructief. Zij verwoesten den eigenlijken inhoud van vorm niet: zij verdiepen slechts vorm om hem hierdoor op te heffen tot een nieuwe ordening. Zij verbreken het bindende van: 'vorm als afzonderlijkheid' om universele eenheid mogelijk te doen zijn." See Nancy J. Troy, "Figures of the Dance in De Stijl," *Art Bulletin* 66, no. 4 (December 1984): 645–56.

9. See Van Dongen, *Danseuse Indienne (Hindoe danseres, Danseuse Hindoue, Indian dancer),* 1910–1911, oil/canvas, 100 × 81 cm, private collection. See Jean-Michel Bonhours and Nathalie Bondil, *Van Dongen,* Exhibition catalogue, Monaco, Nouveau musée national de Monaco, 25 June–7 September 2008 (Paris, 2008), p. 207.

In 1911 Van Dongen paintings appeared in Amsterdam in an exhibition of St. Lucas. He was ridiculed by the press. Sluyters defended Van Dongen and reviewed several paintings on view. One of them was a portrait of a black woman. Sluyters writes about this work: "Does anyone see, for example, that the *negress* (negerin) with the hat and white feathers is a mind-picture, and is not intended to show the quality of the feather on the hat? . . . It could happen that after you are observing the color, you will see that the form associated with the correct color and composition is very witty. It is possible that you finally see the mind-image of that woman, listening to the sound of colors" ("Van Dongen en de kritiek," *De Kunst Zaterdag,* 17 June 1911, no. 177, pp. 1–2).

10. Several dates can be found on this painting. The earliest is 1906, but that seems very early compared to his other work; 1910, or even 1914, seems more accurate. As Sluyters kept on working on this painting until 1947, it is not clear which parts are from which period.

11. Anita Hopmans, *Jan Sluijters, 1881–1951: Aquarellen en tekeningen,* Exhibition catalogue, Den Bosch, Noordbrabants Museum, 8 June–25 August 1991 (Zwolle, 1991), p. 31.

12. See, for example, *Largo II,* 1914, oil/canvas, 6.5 × 51.5 cm, in *Jan Sluijters: Schilder met verve,* Exhibition catalogue, Laren, Singer Museum, 31 January–25 April 1999 (Zwolle, 1999), p. 54, fig. 70.

13. Alternative title, *Neger tussen de gordijnen* (Negro in the curtains), oil/canvas, 1914, 105 × 74.5 cm, private collection. See Schreuder and Kolfin, *Black Is Beautiful,* cat. no. 94 and p. 300 (ill.), or see Rijksdienst Kunsthistorische Documentatie (RKD) site databank, no. 100421: *Jan Sluijters: Schilder met verve,* p. 48. Another version of this work is in The Hague Gemeentemuseum, inv. no. SCH-1980-0021; RKD no. 100371.

14. C. V. (Cornelis Veth), "De Neger van Jan Sluijters," *Elseviers Maandschrift* 24, no. 47 (January 1914): 537–38.

15. Just Havelaar, *Jan Sluijters, Afbeeldingen naar zijn oeuvre* (Amsterdam, 1919), p. 9.

16. In 1911 Kandinsky was part of the Moderne Kunstkring exhibi-

tion in de Stedelijk Museum. Sluyters and Mondrian were part of the organizing committee.

17. See, for instance, Paul Gauguin's *Vahine no te Tiare* (Woman with a flower), 1891, Copenhagen, Ny Carlsberg Glyptotek, MIN 1828. There is another known version by Sluyters, and a study; see RKD, no. 100746.

18. Havelaar, *Jan Sluijters,* 1919, p. 9.

19. The famous Johnson-Jeffries fight was billed as the "Battle of the Century" and took place in 1910. Van Dongen organized boxing matches in his studio. To him and his friends, all black boxers were stars. See Anita Hopmans, *De grote ogen van Van Dongen,* Exhibition catalogue, Rotterdam, Boymans van Beuningen, 18 September 2010–23 January 2011 (Rotterdam, 2010), p. 101.

20. Hopmans, *De grote ogen van Van Dongen,* p. 139, fig. 72, and p. 188. In this catalogue, the painting is dated earlier. The reason Hopmans gives is that Johnson was in Paris between 1913 and 1914, when this work may have been painted, and not in 1916 or 1919, as stated in much of the literature. In 1908 Van Dongen wondered how he would present himself: "as white negro, perhaps?" in Nathalie Bondil and Jean-Michel Bonhours, *Van Dongen,* Exhibition catalogue, Monaco, Nouveau musée national de Monaco, 22 January–7 September 2008 (Paris, 2008), p. T-9. The Van Dongen quotation in French reads: "Voulez-vous venir voir mes choses et être mon barman auprès du public? Le Surnom proposé, 'un nègre blanc.'"

21. L. J. Jordaan, "Jan Sluijters, politieke prent," *Openbaar kunstbezit* (1960), nr 4, p. 34a–b.

22. Many "revolutionary" artists and writers of that time, also Sluyters's colleagues Van Dongen and his friend and neighbor Picasso, were anarchists. "It was their anarchism that prepared Picasso and many in his circle to adopt anticolonial postures, which are abundantly evident in the political cartoons made by central modernist figures," writes Patricia Leighten. See Patricia Leighten, "The White Peril and L'Art nègre: Picasso, Primitivism, and Anticolonialism," in *The Art Bulletin* 72, no. 4 (December 1990): 611.

23. After the war, the magazine sympathized with the Russian Revolution and the anticolonial movement.

24. Text: Kurt Löb, *De onbekende Jan Sluijters: Boekgrafiek, oorlogsprenten, affiches, postzegels* (Utrecht and Antwerp, 1968), pp. 86, 105.

25. In the database of the RKD (Rijksdienst voor Kunsthistorische Documentatie), there are fifty-three scanned photographs of works by Sluyters with a black subject, including male and female nudes, male and female portraits, and male and female figure studies: http://website.rkd.nl/Databases/RKDimages. This figure is of a total of 1,932 digitized pictures of works by Jan Sluyters (in Dutch: Jan Sluijters).

26. Schreuder, "Black Is Beautiful," pp. 118–20; Jacqueline de Raad, "On 'Painting from Negroes' and Jan Sluijters' Favourite Model Tonia

Stieltjes," in ibid., pp. 126–35; Schreuder, "Negress with a Red Scarf (Tonia Stieltjes)/Recumbent Female Nude (Tonia Stieltjes)," in ibid., pp. 310–11; Raad, "Portrait of Mrs. S, or Negress in Black," in ibid., illus. p. 311, and illus. pp. 95, 96, 97; and "Staande negerin in rode blouse 1925," Jan Sluijters 1881–1957, Den Bosch, Exhibition catalogue, Haarlem, Noordbrabants Museum/Frans Halsmuseum, 1981, illus. p. 82.

27. Information about his letters on the website of the RKD (Rijksdienst voor Kunsthistorische Documentatie) in The Hague, http://www .rkd.nl. RKD nr 100430.

28. Bas C. van Lier, *Carel van Lier Kunsthandelaar, wegbereider, 1897–1945* (Bussum, 2003), p. 21.

29. Ibid., pp. 133–37. The exhibitions were called *Oude kunst uit Africa, Oude Japanse Netsuké's,* and *Oude Aziatische kunst.*

30. V. D., "F. W. van Yperen en Ronald C. Moody in de kunstzaal van Lier," *Algemeen Handelsblad,* 14 January 1938.

31. Lier, *Carel van Lier,* pp. 53, 55, 136; Cynthia Moody, "Midonz," *Transition* 77 (1998): 12.

32. She studied at the Weimar Academy, met Max Pechstein around 1917 in Berlin, and was one of the founders of the Novembergruppe in 1919. See Max Osborn, *Irma Stern: Mit einem Auzug aus dem "Tagebuch einer Malerin," Junge Kunst,* Vol. 51 (Leipzig, 1927); Claudia B. Braude, "Beyond Black and White: Rethinking Irma Stern," *Focus: Journal of the Helen Suzman Foundation, Johannesburg* 61 (June 2011): 45–59; Irene Below, "Irma Stern (1894–1966)—Afrika mit den Augen einer Weissen Malerin, Moderne Kunst zwischen Europa und Afrika—Zentrum und Peripherie und die Debatte um moderne Kunst in nicht-westlichen Ländern," *Kritische Berichte: Zeitschrift für Kunst- und Kulturwissenschaften* 25, no. 3 (1997): 42–68; Marilyn Wyman, "Irma Stern: Envisioning the 'Exotic,'" *Woman's Art Journal* 20, no. 2 (Autumn 1999–Winter 2000): 18–23, 35; Karel Schoeman, *Irma Stern: The Early Years, 1894–1933,* General Series/South Africa, no. 22 (Cape Town, 1994), p. 74. Schoeman: "As will be clear from the quotations from her diaries and other texts, Irma Stern was always aware of her African Heritage, but in the circumstances it had thus far been the subject of remembrance rather than experience, seen mostly at a distance and in retrospect in the framework of her life in Germany: her image of Africa was composed of memories, dreams and desires in uneven proportions, and to a certain extent it may be said to have developed into a private myth, its effect heightened both by the Expressionists' interest in the exotic and by the frustrations of her long confinement in wartime Germany." Marion I. Arnold, *Irma Stern: A Feast for the Eye* (Stellenbosch, 1995), pp. 13–14, 69.

33. Osborn, *Irma Stern,* p. 25, illus.

34. Schoeman, "Frau und Gegenwart," in *Irma Stern: The Early Years,* p. 86.

35. See, for example, Ralph Mercer and Lorenz Dittmann, eds., *Die*

Brücke in der Südsee: Exotik der Farbe, Exhibition catalogue, Saarbrucken, Saarlandmuseum, 22 October 2005–8 January 2006 (Ostfildern-Ruit, 2005).

36. Arnold, *Irma Stern: A Feast for the Eye,* p. 119, notes about the women of South, West, and Central Africa: "None of the models engage[s] directly with the viewer and all remain impassive under the artist's scrutiny."

37. Ibid., p. 97. Arnold suggests that the portraits are pretty much self-portraits. The works are more about her than about the people she depicts.

38. Below, "Irma Stern . . . Afrika," p. 49. Also, Braude, "Beyond Black and White," 58.

39. The renowned critic Albert Plasschaert on the exhibition at Van Lier: "In the work by Irma Stern, as she paints blacks and landscape away from Cape Town, you see no Cape painting but one of many copies of an international style of painting (there is still in the Negro Girls with red cloths certainly something of Gauguin's work in Tahiti). There is in this work a feminine trait." See "Werk van Irma Stern bij Van Lier," *Het Vaderland,* 4 March 1930.

40. Jos de Gruyter spent the first ten years of his life in Singapore and the Dutch East Indies (Indonesia). He was the director of the Groninger Museum between 1955 and 1963.

41. Jos. W. de Gruyter, "Irma Stern en Negerkunst bij van Lier," *Elseviers Maandschrift* 40, no. 79 (1930): 293–94.

42. "Kunst van de Nederlandse stam tentoonstelling van het A.N.V. in het Gemeentemuseum," *Het Vaderland,* 28 March 1936. Jan Sluyters was on the organizing committee.

43. Surinamese painter Leo Glans studied in the 1930s in Amsterdam. He had the misfortune to be infected with leprosy and lost the sight in his eyes in the early 1940s. Black South African artist Ernest Mancoba came to Paris in 1938. He would join the partly Dutch COBRA movement after the Second World War; Schreuder and Kolfin, *Black Is Beautiful,* pp. 122, 318; Esther Schreuder, "A Certain South Africanness," in *The Rainbow Nation: Contemporary South-African Sculpture/Hedendaagse beeldhouwkunst uit Zuid-Afrika,* ed. Dick van Broekhuizen, Jennifer Jansen, and Nelleke van Zeeland, Exhibition catalogue, The Hague, Museum Beelden aan Zee, 6 August–30 September 2012 (Zwolle, 2012), p. 37.

44. Langston Hughes is, for instance, mentioned at least seventy times during this period in the newspapers in the Netherlands.

45. Hans Ramsoedh and Peter Sanches, "75 jaar Wij slaven van Suriname: De turbulente biografie van een boek inleiding," *OSO–Tijdschrift voor Surinamistiek en het Caraïbisch gebied* 29, no. 1 (2010): 8. Robbie Aitken, "From Cameroon to Germany and Back via Moscow and Paris: The Political Career of Joseph Bilé (1892–1959), Performer, 'Negerarbeiter' and Comintern Activist," *Journal of Contemporary History* 43, no. 4 (October 2008): 597–616. The central figure in the dissemination of propaganda

and making contacts was Willi Münzenberg, a German who also maintained close contacts with the various Communist organizations in the Netherlands.

46. Alice Boots and Rob Woorman, "De Geschiedenis van een manuscript: De Wording van 'Wij slaven van Suriname' van Anton de Kom," *OSO—Tijdschrift voor Surinamistiek en het Caraïbisch gebied* 29, no. 1 (2010): 35; Magdeleine Paz is translated in Dutch. Magdeleine Marx, *Omdat ik zwart ben,* 2nd ed. (Amsterdam, 1933). The beautiful Dutch cover is by a person called "Mohr," collection of Carl Haarnack.

47. At least 435 news items on the Scottsboro Boys case in mainly communist newspapers in 1932, and at least 122 in 1933.

48. James A. Miller, Susan D. Pennybacker, and Eve Rosenhaft, "Mother Ada Wright and the International Campaign to Free the Scottsboro Boys, 1931–1934," *American Historical Review* 106, no. 2 (April 2001): 388.

49. Sybrand Hekking, "Cas Oorthuys: Fotograaf 1908–1975," *Geschiedenis van de Nederlandse fotografie* 2 (Amsterdam, 1982): 16.

50. Alice Boots and Rob Woortman, *Anton de Kom: Biografie 1898–1945/1945–2009* (Amsterdam, 2009), pp. 137–38.

51. Hans Ramsoedh and Peter Sanches, "75 jaar Wij slaven van Suriname, De turbulente biografie van een boek inleiding," *OSO—Tijdschrift voor Surinamistiek en het Caraïbisch gebied* 29, no. 1 (2010): 6–18.

52. Kees Broos, *Piet Zwart 1885–1977,* Exhibition catalogue, The Hague, Gemeentemuseum (1973; reprint ed., 1982), p. 60; Hekking, "Nieuwe fotografie" in *Geschiedenis van de Nederlandse fotografie,* p. 19.

53. Boots and Woortman, *Anton de Kom,* p. 197. In a photograph taken from De Kom in the same period, standing between other unemployed, De Kom looks very neat. Possibly Piet Zwart wanted to emphasize the proletarian in De Kom? A picture of De Kom by C. A. J. van Angelbeek is in the Stadsarchief, Amsterdam, no. 10013: Collectie C. A. J. van Angelbeek (illus. on website: www.beeldbank.amsterdam.nl).

54. Susan Campbell, "'Black Bolsheviks' and Recognition of African-America's Right to Self-Determination by the Communist Party USA," *Science and Society* 58, no. 4 (Winter 1994/1995): 440–70.

55. The painting led a hidden life until the late 1990s when the curators of the exhibition Magie en Zakelijkheid wanted to show this work as a textbook example of new objectivity. After much searching, it was recovered in the room of a fellow working at the Stedelijk Museum in Amsterdam. The painting adorned the cover of the Magie en Zakelijkheid exhibition catalogue, then served in the Amsterdam Museum for a long time as an illustration of the arrival of people from Surinam to the Netherlands. At the exhibition *Black Is Beautiful, Rubens to Dumas* in 2008, it was a press and crowd favorite. See Ype Koopmans and Carel Blotkamp, eds., *Magie en zakelijkheid: Realistische schilderkunst in Nederland 1925–1945* (Zwolle and Arnhem, 1999), cover illus. and p. 167; Ellen de Vries, *Nola*

Portret van een eigenzinnig kunstenares (Amsterdam 2008), illus. back cover, and illus. X; *Black Is Beautiful, Rubens to Dumas,* p. 306, illus.

56. Examples of Surinamese who took on American names: Saxophonist Arthur Lodwijk Parisius was renamed Kid Dynamite, Theodoor Kantoor was renamed Teddy Cotton, Frits Blijd named himself Freddy Blythe and Jimmy Blue (Rudie Kagie, *De eerste neger* [Amsterdam, 2006], p. 67), boxer Henri Sno renamed himself Henri Tiger Sno (ibid., p. 87). Lex van Spall named his band the Chocolate Kiddies (De Vries, *Nola,* p. 65). And clubs were called Kit Kat Cotton Club (Kagie, p. 85), the Negro Palace Mephisto, and Coconut-club.

57. De Vries, *Nola,* 146–47.

58. Poem by Nola Hatterman in Sranantongo: *Wan de:* Wan de mi sa dede / No wan sma sabi oten / En mi no sabi ope / Ma mi winsi taki / Te a da sa kon / Sranangron sa teki mi / En blaka anoe sa beri mi. In Dutch: Op een dag zal ik sterven / Niemand weet wanneer / En ik weet niet waar / Maar ik wens dat / Wanneer de dag daar is / Surinaamse grond mij zal opnemen / En zwarte handen mij zullen begraven. *De Westindiër,* January 1953, Myra Winter, "Een artistiek bemiddelaar tussen Nederland en Suriname," *Kunsten in beweging 1900–1980—Cultuur en Migratie in Nederland,* ed. Rosemarie Buikema and Maaike Meijer (The Hague, 2003); De Vries, *Nola,* p. 10.

11. The Image of the Black in Twentieth-century Anglo-Afro-Caribbean Art

1. Cuba and other Spanish-speaking islands are considered in chap. 12 of this volume.

2. With regard to the English-speaking Caribbean, the first publication to successfully document the art history of the region was Veerle Poupeye's *Caribbean Art,* a fairly specialized evaluation of art in the region that raised the bar for art books when it was published in 1998.

3. See Michel Rolphe Trouillot, *Silencing the Past* (Boston, 1995).

4. Stuart Hall, "Cultural Identity and Diaspora," in *Framework: The Journal of Cinema and Media,* no. 36 (1990).

5. Poupeye, *Caribbean Art,* p. 12.

6. Erica James, "Speaking in Tongues: Metapictures and the Discourse of Violence in Caribbean Art," *Small Axe* 16, no. 137 (March 2012): 119–43.

7. Annette Insanally, Mark Clifford, and Sean Sheriff, eds., *Regional Footprints: The Travels and Travails of Early Caribbean Migrants,* Sir Arthur Lewis Institute of Social and Economic Studies (Kingston, 2006), p. 10.

8. Felix Angel, ed., *Parallel Realities: Five Pioneering Artists from Barbados* (Inter-American Development Bank), 1999.

9. Allisandra Cummins, Allison Thompson, and Nick Whittle, *Art in Barbados: What Kind of Mirror Image?* (Kingston, 1999), p. 43.

10. Krista Thompson, *An Eye for the Tropics: Tourism, Photography, and Framing the Caribbean Picturesque* (Durham, N.C., 2006).

11. Kersuze Simeon-Jones, *Literary and Sociopolitical Writings of the Black Diaspora in the Nineteenth and Twentieth Centuries* (New York, 2010), p. 122.

12. *Magic Island* sensationalized the new ethnographic approaches promoted by field workers such as James Frazier, Marcel Mauss, and Claude Lévi-Strauss. But as cultural historian J. Michael Dash has noted, Seabrook seems to have been more concerned with protecting Haiti from cultural contamination than with seeing it develop as a modern nation. See J. Michael Dash, *Haiti and the United States; National Stereotypes and the Literary Imagination* (New York, 1988), p. 34ff.

13. Augustus John, *Autobiography* (London, 1975), pp. 293–302.

14. Ibid.

15. As previously noted in Petrine Archer, ed., *Fifty Years—Fifty Artists* (Kingston, 2002), p. 22.

16. André Breton and André Masson, *Martinique charmeuse de serpents* (Paris, 1972 [1947]).

17. André Masson, *La Memoire du Monde* (Geneva, 1974).

18. Aimé Césaire, *Cahier d'un retour au pays natal*, with an introduction by André Breton (Paris, 1947).

19. Kobena Mercer, "Cosmopolitan Contact Zones," in *Afro-Modern: Journey Through the Black Atlantic*, ed. Tanya Barson and Peter Gorschlüter, Exhibition catalogue, Tate Liverpool, 29 January–25 April 2010, p. 44.

20. Cummins, Thompson, Whittle, *Art in Barbados*, pp. 14, 16.

21. Anne Walmsley, Stanley Greaves, BOMB, no. 86 (Winter 2004): 38–45.

22. For a more complete and compelling reading of Marcus Garvey's aesthetic, see Robert Hill, "Making Noise Marcus Garvey Dada, August 1922," in *Picturing Us: African American Photography and Identity*, ed. Deborah Willis (New York, 1995).

23. Robert Hill, ed., *The Marcus Garvey and Universal Negro Improvement Association Papers*, vol. 5, pp. 603, 625.

24. A word popular among the Rastafari community to suggest their understanding of black culture. The word is most often used to celebrate April 21 annually, in honor of Haile Selassie's visit to Jamaica in 1966.

25. Veerle Poupeye, "Osmond Watson: Defining Painter and Sculptor of Modern Jamaican Culture," (London) *Guardian* (1 December 2005): 38.

26. Paul Gauguin stayed in Martinique from April to June of 1887. He had gone in search of exotic landscapes but left after falling sick. Later he would settle in Tahiti, where he created a body of work more in keeping with his "primitive" ideas. See Paul Gauguin, *Noa Noa: The Tahitian Journal* (New York, 1920).

27. As evidenced in Esther Chapman's play "The West Indian" (1936). See Petrine Archer-Straw, "Cultural Nationalism and Its Development in Jamaica, 1900–1944," M.A. thesis, University of the West Indies, 1986, p. 124.

28. For a detailed account of the significance of the Manleys and their home at Drumblair, see Rachel Manley, *Drumblair: Memories of a Jamaican Childhood* (Kingston, 1996).

29. Geoffrey Maclean, "The Art of Trinidad and Tobago," *Season of Renewal: Celebrating 50 years of Independence and Caribbean Partnership*, Exhibition catalogue, UWI Museum, Mona, Jamaica, 7 June–11 June 2012, p. 75.

30. Mercer, "Cosmopolitan Contact Zones," p. 41.

31. Cultural theorist Stuart Hall has discussed the problems of this type of synthesizing in relation to Jamaica's coat of arms. See Stuart Hall, "Negotiating Caribbean Identities," *New Left Review* 1, no. 209 (January–February 1995): 5.

32. Like *Negro Aroused*, this work was purchased for the National Collection by patrons concerned for its posterity. A limited-edition print of the painting was made as part of a fundraising campaign to acquire the work. Conversation with Valerie Facey, Manor Park, Kingston, 22 May 2012.

33. The Art Foundry, *Lips, Sticks and Marks*, Exhibition catalogue, 23 August–25 October 1998, St. Philip, Barbados. Exhibition co-curated by artists in the show. Artists included Annalee Davis, Alida Martinez, Irenee Shaw, Joscelyn Gardner, Osaira Muyale, Roberta Stoddart, Susan Dayal.

34. See my own "Paradise, Primitivism and Parody," in Okwui Enwezor, Carlos Basualdo, Ute M. Bauer, *Creolite and Creolization, Documenta 11-* Platform 3, Kassel, 2002.

35. Annie Paul and Krista A. Thompson, "Caribbean Locales/Global Artworlds," *Small Axe*, no. 16 (vol. 8, no. 2) (September 2004): viii.

36. Gerard Aching, *Masking and Power: Carnival and Popular Culture in the Caribbean* (Minneapolis, 2002), p. 4.

37. Ibid., p. 17.

38. Leon Wainwright, "Aubrey Williams: A Painter in the Aftermath of Painting," *Wasafiri* 24, no. 3: 65–79.

39. Ibid.

40. Leon Wainwright, "Aubrey Williams: Atlantic Fire," in *Aubrey Williams: Atlantic Fire*, Exhibition catalogue, National Museums Liverpool and October Gallery, ed. Reyahn King, London, 2010, pp. 46–55.

41. For the Afro-Cobra movement, see *Image of the Black in Western Art*, vol. V., pt. 2, Adrienne Childs.

42. Annie Paul, "Subjects Matter: The Repeating AlterNATIVE and the Expat Gaze," *Arts Education for Societies in Crisis*, ed. Rawle Gibbons and Dani Lyndersay (St. Augustine, Fla., 2007), pp. 31–53.

43. See Petrine Archer, *New World Imagery: Contemporary Jamaican Art,* Exhibition catalogue, London, South Bank and Touring, 1996.

44. Artist's statement taken from her website, http://www.joscelyn gardner.com/

45. See, for instance, Louis Chude Sokei, "Post-Nationalist Geographies: Rasta, Ragga, and Reinventing Africa," in *African Arts* 27, no. 4 (Autumn 1994): 80–96; and Deborah Thomas, *Modern Blackness: Nationalism, Globalization and the Politics of Culture in Jamaica* (Durham, N.C., 2004).

12. The Image of the Black in Latin America

1. "South America," which was originally proposed as the remit for this chapter, although conveniently neutral, does not include México, which is part of North America, or Central America and the Antilles. The term "Latin America" was long assumed to have originated in French foreign policy, seeking to justify the French intervention in México in the 1860s, claiming that France and México belonged to the same "Latin race."

2. See Aims McGuinness, "Searching for 'Latin America': Race and Sovereignty in the Americas in the 1850s," in *Race and Nation in Modern Latin America,* ed. Nancy P. Appelbaum, Anne S. Macpherson, and Karin Alejandra Rosemblatt (Chapel Hill, N.C., 2003), pp. 88–107.

3. See McGuinness, ibid., for a fuller account, including the "Watermelon" incident.

4. See Henry Louis Gates, Jr., *Black in Latin America* (New York, 2011).

5. Paul Gilroy, *The Black Atlantic: Modernity and Double Consciousness* (London, 1993).

6. Jean Franco, *The Modern Culture of Latin America: Society and the Artist* (London, 1967).

7. Robin Blackburn, *The American Crucible: Slavery, Emancipation and Human Rights* (New York, 2011), p. 473.

8. Gates, *Black in Latin America,* p. 28.

9. Ibid., p. 45.

10. Maraliz de Castro Vieira Christo, "Algo além do moderno: a mulher negra na pintura brasileira no início do século XX," *19&20* 4, no. 2 (April 2009) ("Au dela du moderne: la femme noire dans la peinture bresilienne au debut du XXieme siècle," 2008), http://www.dezenovevinte.net/obras/obras_Maraliz.htm.

11. Emanuel Araujo, *A mão brasileiro* (São Paulo, 1988). Published on the centenary of the abolition of slavery in Brazil, this book is the fruit of many decades of research by Araujo, who built up an unrivaled collection of images of the black in Brazil. See also Edgard Vidal, "Trajectoria de una obra: 'A Negra' (1923) de Tarsila do Amaral: Una revolucion icónica," http://cral.in2p3.fr/artelogie/spip.php?article79, accessed 16 March 2011.

12. The *orishas* are intermediary spirits, forces of nature that can be appeased by sacrifice. Although names and terms vary according to the different African origins for the religious practices conserved and embellished in slave communities in Brazil, Cuba, Haiti, and elsewhere, there are many elements in common.

13. Quoted in "Introduction: Modernism and the Black Atlantic," in *Afro-Modern: Journeys through the Black Atlantic,* ed. Tanya Barson and Peter Gorschlüter, Exhibition catalogue, Tate Liverpool, 29 January–25 April 2010, p. 8.

14. Oswald de Andrade, "Pau-Brasil Poetry," in Dawn Ades, *Art in Latin America* (London, 1989), p. 311.

15. Ibid.

16. Richard Gott, Guayasamín obituary, *Guardian* (20 March 1999).

17. José Camon Aznar in his monograph *Oswaldo Guayasamín* (Barcelona, 1981) speaks of the drama of Spanish America "with its Amerindians, its half-castes and its Negroes," p. 169.

18. Pedro Figari, "Autobiographical Notes Written in a Diplomatic Agenda," in Samuel Oliver, *Pedro Figari* (Buenos Aires, 1984), p. 23.

19. Quoted in Marianne Manley, "Intimate Recollections of the Rio de la Plata," *Paintings by Pedro Figari: Intimate Recollections of the Rio de la Plata,* Exhibition catalogue, New York, Centre for Inter-American Relations, 5 March–19 May 1986, p. 21.

20. *Seis Maestros de la Pintura Uruguaya,* Exhibition catalogue, Buenos Aires, Museo Nacional de Bellas Artes, 15 September–15 October 1987, p. 152.

21. Jorge Luis Borges, "Figari," in Samuel Oliver, *Pedro Figari* (Buenos Aires, 1984), p. 9.

22. Alicia Haber, "Vernacular Culture in Uruguayan Art: An Analysis of the Documentary Function of the Works of Pedro Figari, Carlos Gonzalez and Luis Solari," Occasional Papers, Latin American and Caribbean Center, Florida International University, 1982.

23. Ibid., p. 7.

24. Pedro Figari, letter to Salterain, 6 January 1933 (Paris), quoted in Manley, *Intimate Recollections,* p. 14.

25. Figari, letter to Salterain, 28 May 1932, quoted in Manley, *Intimate Recollections,* p. 14.

26. Gates, *Black in Latin America,* p. 43.

27. Blackburn, *The American Crucible,* p. 470.

28. Ibid., 476.

29. "No soy ni babalao ni creyente de los ritos afro-cubanos: tengo tanto de salvaje como de cartesiano, pero aquel mundo mágico que viví de niño en Sagua la Grande formó parte de mi infancia y de mi adolescencia." Antonio Nuñez Jimenez, *Wifredo Lam,* Editorial Letras Cubanas (Havana, 1982), p. 67.

30. Pierre [sic], "Wifredo Lam," *Tropiques* 6/7 (February 1943): 61–62.

31. Max-Pol Fouchet, *Wifredo Lam* (Barcelona, 1989), p. 187.

32. Ibid.

33. Ibid., p. 192.

34. "Créer un monde est-ce peu de chose? . . . Là où s'étageait l'inhumanité exotique du magasin de bric à brac, faire surgir un monde!" Aimé Césaire, "Introduction à la poésie nègre américaine," *Tropiques* 2: 42. See Dawn Ades, "Wifredo Lam and Surrealism," in *Wifredo Lam in North America,* ed. Curtis Carter, Exhibition catalogue, Milwaukee (Marquette University), The Patrick & Beatrice Haggerty Museum of Art, 11 October 2007–21 January 2008, for a more detailed discussion of Césaire, Lam, and Surrealism. Later, Lam dissociated himself from Césaire's *négritude,* adopting rather René Menil's position that this had become a dangerously reductive ideology inverting black and white values. Responding to the accusation of "black racism," Lam replied, "It's a false accusation. They say that because I don't paint like a European, because I try to paint with the idiosyncrasy of my people. The personages in my paintings are neither white nor black, they lack race. I am not in agreement with the doctrine of *négritude* either. It is not a matter of race, but of the class struggle." "Mi pintura es un acto de descolonización." Entrevista con Wifredo Lam (interview with Wifredo Lam), Gerado Mosquera, *Exploraciones en la plastica cubana* (Havana, 1983), p. 189. Lam's position here is in line with the Cuban Communist Party.

35. Whitney Chadwick, "Surrealist Hybridity and Wifred Lam's *Deity,*" *The Colour of My Dreams: The Surrealist Revolution in Art,* Exhibition catalogue, Vancouver Art Gallery, 28 May–25 September 2011, p. 199.

36. André Breton, "Hector Hyppolite," *Surrealism and Painting* (New York, 1972), p. 311.

37. *Magiciens de la terre,* Exhibition catalogue, Paris, Centre Pompidou, 18 May–14 August 1989, p. 131.

38. Mosquera, "Mi pintura," in *Exploraciones,* p. 189.

39. *NKAME. Belkis Ayón,* project director Katia Ayón, authors José Veigas, Cristina Vives, David Mateo, Lázaro Menéndez (Madrid, 2010).

40. Paulo Herkenhoff, "Constructive Congá: Rubem Valentim," [2006] quoted in "Introduction: Modernism and the Black Atlantic," *Afro-Modern: Journeys Through the Black Atlantic,* ed. Tanya Barson and Peter Gorschlüter, Exhibition catalogue, Tate Liverpool, 29 January–25 April 2010, p. 15.

41. George Nelson Preston, *Emanoel Araujo: Brazilian Afrominimalist,* Preface by P. M. Bardi (São Paulo, 1987), p. 43.

42. Hélio Oiticica, untitled statement in *Hélio Oiticica,* Whitechapel Art Gallery, 1969, n.p. Reprinted in *Oiticica in London,* ed. Guy Brett and Luciano Figueiredo (London, 2006). Oiticica's term *Tropicália* was appropriated by poets and musicians including his friends Caetano Veloso and Gilberto Gil in the popular movement Tropicalismo.

43. Paulo Venancio Filho, "Tropicália, Its Time and Place," in *Oiticica in London,* p. 30.

44. Hélio Oiticica, "Eden," *Hélio Oiticica,* Whitechapel Art Gallery, 1969, n.p.

45. Michael Asbury, "This Other Eden: Hélio Oiticica and Subterranean London," in *Oiticica in London,* p. 37.

46. Gates, *Black in Latin America,* p. 48.

47. Oiticica quoted in Guy Brett, "Recollection," in *Oiticica in London,* p. 14.

13. *Négritude:* Césaire, Lam, and Picasso

1. For a comprehensive account of *Négritude,* see the Stanford Encyclopedia of Philosophy online: plato.stanford.edu/entries/negritude/

2. Daniel Maximin, *Césaire et Lam: Insolites bâtisseurs* (Paris, 2011), pp. 6–7.

3. Translation by John Berger and Anna Bostock, Aimé Césaire, *Return to My Native Land* (Harmondsworth, 1970), pp. 74–75.

4. Alejo Carpentier's words, in Anne Egger, ed., *Césaire & Picasso: Corps Perdu Histoire d'une rencontre* (Paris, 2011), p. 10.

5. Max-Pol Fouchet, *Wifredo Lam* (Barcelona, 1986), p. 29.

6. Maximin, *Césaire et Lam,* pp. 62–83.

7. Aimé Césaire, *Corps perdu, gravures de Pablo Picasso* (Paris, 1950).

8. John Richardson, *Picasso: The Mediterranean Years, 1945–1962,* Exhibition catalogue, London, Gagosian Gallery, 2010.

9. Ibid., pp. 11–12.

10. Lynda Morris and Christoph Grunenberg, eds., *Picasso: Peace and Freedom,* Exhibition catalogue, Tate Liverpool, 2010.

11. Ibid., p. 12.

12. Egger, *Césaire & Picasso,* pp. 18–19.

13. Ibid., p. 21.

14. Ibid., n.p.

15. Ludwig Ullman, *Picasso und die Krieg* (Bielefeld, 1993), p. 423.

ILLUSTRATIONS

P. 1 Anonymous. Portrait of Malik Ambar. Southern India (Dekkan, Amednagara), 1610–1620. Opaque watercolor and gold on paper. 36.7 × 23.9 cm. Boston, Museum of Fine Arts, Ross-Coomaraswamy Collection, 17.3103. © 2010 Museum of Fine Arts, Boston.

1 Aaron Douglas. *Aspects of Negro Life, The Negro in an African Setting.* 1934–1935. Mural painting. New York, New York Public Library, Schomburg Center. Aaron Douglas/© Art and Artifacts Division, Schomburg Center for Research in Black Culture, The New York Public Library. © Heirs of Aaron Douglas/VAGA, NY/DACS, London 2013.

2 Aaron Douglas. *Aspects of Negro Life, An Idyll of the Deep South* 1934–1935. Mural painting. New York, New York Public Library, Schomburg Center. Aaron Douglas/© Art and Artifacts Division, Schomburg Center for Research in Black Culture, The New York Public Library. © Heirs of Aaron Douglas/VAGA, NY/DACS, London 2013.

3 Aaron Douglas. *Aspects of Negro Life, From Slavery Through Reconstruction.* 1934–1935. Mural painting. New York, New York Public Library, Schomburg Center. Aaron Douglas/© Art and Artifacts Division, Schomburg Center for Research in Black Culture, The New York Public Library. © Heirs of Aaron Douglas/VAGA, NY/DACS, London 2013.

4 Aaron Douglas. *Aspects of Negro Life, Song of the Towers.* 1934–1935. Mural painting. New York, New York Public Library, Schomburg Center. Aaron Douglas/© Art and Artifacts Division, Schomburg Center for Research in Black Culture, The New York Public Library. © Heirs of Aaron Douglas/VAGA, NY/DACS, London 2013.

5 Glyn Philpot. *Portrait of Henry Thomas.* 1930s. Oil on canvas. London, Daniel Katz Collection.

6 Glyn Philpot. *Naked Figure from Behind.* 1930s. Oil on canvas. London, Daniel Katz Collection.

7 Joseph T. Zealy. Portrait of Jack (Driver), Guinea, Plantation of B. F. Taylor, Esq. 1850. Daguerreotype. Cambridge, Mass., Peabody Museum of Archaeology and Ethnology, Harvard University. Courtesy of the Peabody Museum of Archaeology and Ethnology, Harvard University, 35-5-10/53043_60742037.

8 Joseph T. Zealy. Portrait of Drana, country born, daughter of Jack. 1850. Daguerreotype. Cambridge, Mass., Peabody Museum of Archaeology and Ethnology, Harvard University. Courtesy of the Peabody Museum of Archaeology and Ethnology, Harvard University, 35-5-10/53041_60742035.

9 Joseph T. Zealy. Portrait of Jem. 1850. Daguerreotype. Cambridge, Mass., Peabody Museum of Archaeology and Ethnology, Harvard University. Courtesy of the Peabody Museum of Archaeology and Ethnology, Harvard University, 35-5-10/53047_60742041.

10 Carrie Mae Weems. *From Here I Saw What Happened and I Cried:* 1. "From Here I Saw What Happened and I Cried." 1995–1996. Toned gelatin silver print. C-print with sandblasted text on glass. 26 3/4 × 22 3/4 in. From an original daguerreotype taken by Joseph T. Zealy, 1850. New York, Museum of Modern Art. Gift on behalf of the Friends of Education of the Museum of Modern Art. Courtesy of the artist and Jack Shainman Gallery, New York.

11 Carrie Mae Weems. *From Here I Saw What Happened and I Cried*: 2. "You Became a Scientific Profile." 1995–1996. Toned gelatin silver print. C-print with sandblasted text on glass. 26 3/4 × 22 3/4 in. From an original daguerreotype taken by Joseph T. Zealy, 1850. New York, Museum of Modern Art. Gift on behalf of the Friends of Education of the Museum of Modern Art. Courtesy of the artist and Jack Shainman Gallery, New York.

12 Carrie Mae Weems. *From Here I Saw What Happened and I Cried*: 3. "A Negroid Type." 1995–1996. Toned gelatin silver print. C-print with sandblasted text on glass. 26 3/4 × 22 3/4 in. From an original daguerreotype taken by Joseph T. Zealy, 1850. New York, Museum of Modern Art. Gift on behalf of the Friends of Education of the Museum of Modern Art. Courtesy of the artist and Jack Shainman Gallery, New York.

13 Carrie Mae Weems. *From Here I Saw What Happened and I Cried*: 4. "An Anthropological Debate." 1995–1996. Toned gelatin silver print. C-print with sandblasted text on glass. 26 3/4 × 22 3/4 in. From an original daguerreotype taken by Joseph T. Zealy, 1850. New York, Museum of Modern Art. Gift on behalf of the Friends of Education of the Museum of Modern Art. Courtesy of the artist and Jack Shainman Gallery, New York.

14 Carrie Mae Weems. *From Here I Saw What Happened and I Cried*: 5. "& A Photographic Subject." 1995–1996. Toned gelatin silver print. C-print with sandblasted text on glass. 26 3/4 × 22 3/4 in. From an original daguerreotype taken by Joseph T. Zealy, 1850. New York, Museum of Modern Art. Gift on behalf of the Friends of Education of the Museum of Modern Art. Courtesy of the artist and Jack Shainman Gallery, New York.

15 Augustus Washington. Unidentified woman, believed to be Sarah McGill Russwurm, sister of Urias A. McGill and widow of John Russwurm. 1854. Daguerreotype, sixth plate, hand-colored. Washington, D.C., Library of Congress, Prints and Photographs Division, LC-USZ6-1949.

16 Augustus Washington. Urias Africanus McGill (ca. 1823–1866), merchant in Liberia, born in Baltimore, Maryland. 1854. Daguerreotype, sixth plate, hand-colored. Washington, D.C., Library of Congress, Prints and Photographs Division, LC-USZ6-1948.

17 Unknown artist. Frederick Douglass. Ca. 1855. Daguerreotype. 2 3/4 × 2 3/16 in. (7 × 5.6 cm). New York, Metropolitan Museum of Art. The Rubel Collection, Partial and Promised Gift of William Rubel, 2001 (2001.756). © 2013. Image copyright The Metropolitan Museum of Art/Art Resource/Scala, Florence.

18 McPherson & Oliver and William D. McPherson. Private Gordon: "The Scourged Back." 1863. Albumen print carte de visite. Mount: 3 15/16 × 2 3/8 in. (10 × 6 cm). New York, International Center of Photography, purchased with funds provided by the ICP Acquisitions Committee, 2003. Entered into the Daniel Cowin Collection. Accession no. 183.2003.

19 Henry P. Moore. "Sweet Potato Planting." James Hopkinson's Plantation photographer. 1862. Albumen print. Washington, D.C., Library of Congress, Prints and Photographs Division, LC-DIG-ppmsca-11398.

20 Unidentified photographer. Sojourner Truth (1797–1883). "I Sell the Shadow to Support the Substance." 1864. Albumen print carte de visite. 4 × 2 3/8 in. (10.2 × 6 cm). New York, International Center of Photography, purchased with funds provided by the ICP Acquisitions Committee, 2003. Entered into the Daniel Cowin Collection, 182.2003.

21 Page from Florence Upton, *The Adventures of Two Dutch Dolls and a Golliwogg*. 1895. Cambridge, Mass., Houghton Library, Harvard University.

22 A. & F. Pears Limited. Advertisement for Pears' Soap, British. Ca. 1880s. Color lithograph. 23 cm. London, Wellcome Library, Ephemera Collection, EPH161:4.

23 *All Coons Look Alike to Me*. 1896. Illustrated sheet music cover. Chicago, M. Witmark & Sons. Providence, Brown University Library, African-American Sheet Music Collection.

24 *Types africains. Concours de sourires*. French. Ca. 1920. Photolithograph. Postcard Collection—French West Africa. New York, Photographs and Prints Division, Schomburg Center for Research in Black Culture, The New York Public Library, Astor, Lenox and Tilden Foundations.

25 *Alligator Bait*. Postcard, American. Ca. 1920. Chromolithograph. Private collection.

26 Gino Boccasile. *Italia liberata,* Italian poster. 1944. Offset print. 36 × 28.5 cm. Berlin, Deutsches Historisches Museum.

27 Blackamoor Figures. Late 19th century. Italian, painted and gilt wood and metal. 24 × 7 3/4 × 6 7/8 in. (61 × 19.7 × 17.5 cm). Houston, Museum of Fine Arts, the Rienzi Collection, gift of Mr. and Mrs. Harris Masterson III. MFAH Number: 96.1127.1.

28 Advertisement for Aunt Jemima Pancakes, American. Ca. 1951. Offset print.

29, 30 J. E. Stevens. *Jolly Nigger Bank.* 1896. American, cast iron mechanical bank. Collection of Henry Louis Gates, Jr.

31 Oliviero Toscani. 1989. Advertisement for Benetton. Oliviero Toscani Studio.

32 Kevin Carter. *Famine in Sudan.* Color photograph. 1 March 1993. © Kevin Carter/Sygma/Corbis.

33 *Simplicissimus*. Cover from 27 Nr. 45, Simplicissimus from 5.2.1923. Page 629, Weimar, Klassik Stiftung Weimar.

34 Josef Steiner. *50 Wilde Kongoweiber Männer und Kinder in Ihrem Aufgebauten Kongodorfe.* 1913. Lithograph. 72 × 89.5 cm. Berlin, Deutsches Historisches Museum. Josef Steiner/Deutsches Historisches Museum.

35 Karl Goetz. *Die Wacht am Rhein/Die Schwarze Schande.* 1920. K262 obverse and reverse. Cast bronze. Courtesy of Henry Scott Goodman (www.karlgoetz.com).

36 Karl Goetz. *Die Wacht am Rhein/Die Schwarze Schande.* 1920. K262a reverse. Cast bronze. 58.3 mm. Courtesy of Henry Scott Goodman (www.karlgoetz.com). Karl Goetz. *Die Wacht am Rhein/Die Schwarze Schmach.* 1920. K263 reverse. Cast bronze. Courtesy of Henry Scott Goodman (www.karlgoetz.com).

37 Karl Goetz. *Die Wacht am Rhein/Die Schwarze Schande.* 1920. K264 reverse. Cast bronze. 57.2 mm. Courtesy of Henry Scott Goodman (www.karlgoetz.com).

38 J. E. Middlebrook (?). Portrait, Zulu woman, South Africa. Ca. 1890. Oxford, Pitt Rivers Museum, University of Oxford. © PRM 1998.193.36.

39 Anonymous postcard. Senegal. Ca. 1905. Oxford, Pitt Rivers Museum, University of Oxford. © PRM 1998.209.9.7 [B9.9.g].

40 R. S. Rattray. Women preparing pottery clay. Asante, Ghana. 1921–1932. Oxford, Pitt Rivers Museum, University of Oxford. © PRM 1998.312.48.1.

41 E. Evans-Pritchard. Sequence from witch doctor *(abinza)* initiation series. Zande Yambio region, Southern Sudan. 1927–1930. Oxford, Pitt Rivers Museum, University of Oxford. © PRM 1998.341.208.3, 1998.341.333.2, 1998.341.208.2.

42 Isaac Schapera. Women threshing corn, Kgatleng, Botswana. 1920–1930. © Royal Anthropological Institute of Great Britain and Ireland, London [RAI 4052].

43 Isaac Schapera. Small girl at play, building a miniature house. Kgatleng, Botswana. 1920–1930. © Royal Anthropological Institute of Great Britain and Ireland, London [RAI 3898].

44 E. Evans-Pritchard. Mekana, son of elite local man, Ongosi, and Evans-Pritchard's Zande servant. Yambio region, Southern Sudan. 1927–1930. Oxford, Pitt Rivers Museum, University of Oxford. © PRM 1998.341.370.

45 Charles W. Hobley. Man, possibly Ondun, chief of the Kaiulu Luo clan. Kisumu, Kenya. 1902. Oxford, Pitt Rivers Museum, University of Oxford. © PRM 1998.209.45.6 [B9.45.f].

46 A. M. Duggan-Cronin. Venda girls filling granaries. Southern Africa. Ca. 1920. Kimberley, A. M. Duggan-Cronin/McGregor Museum. © A. M. Duggan-Cronin/McGregor Museum.

47 A. M. Duggan-Cronin. Venda women going to draw water at the Mutshindudi River. Southern Africa. Ca. 1920. Kimberley, A. M. Duggan-Cronin/McGregor Museum. © A. M. Duggan-Cronin/McGregor Museum.

48 Marcel Griaule. "Masque 'jeune fille,'" Dogon, Mali. Mission Dakar-Djibouti. Ca. 1931–1933. 11.4 × 14.5 cm. Frame: 22.5 × 29.5 cm. Precedent collection: Paris, Musée de l'Homme-Photothèque. Unité patrimoniale: Iconothèque, Inv.: PP00030602. © 2012. Musée du quai Branly, Photo Marcel Griaule/Scala Archives, Florence.

49 R. S. Rattray. Group portrait of the Queen Mother of Tafu and her family. Asante, Ghana. Ca. 1927. Oxford, Pitt Rivers Museum, University of Oxford. © PRM 1998.312.47.1.

50 Charles Cordier. *African Venus.* Baltimore, Walters Art Museum/Bridgeman Art Library.

51 Herbert Ward. *Distress.* Bronze. Washington, D.C., Smithsonian National Museum of Natural History, catalogue no. E323734.

52 Field Museum, Sample anthropometric form given to Malvina Hoffman, for Bushman from the Kalahari Desert, working for Ringling Barnum and Bailey's Circus. 1929. Los Angeles, Getty Research Institute, Malvina Hoffman papers.

53 Malvina Hoffman. *The African Race.* From group of *Three Great Races,* symbolizing the Unity of Mankind. Bronze. Chicago, Field Museum of Natural History. © The Field Museum no. MH0062.

54 Malvina Hoffman. *Shilluk Warrior from the Upper White Nile.* Bronze. Chicago, Field Museum of Natural History. © The Field Museum no. MH89C.

55 Malvina Hoffman. *Negro Dancing Girl of the Sara Tribe.* Bronze. Chicago, Field Museum of Natural History. © The Field Museum no. MH2.

56 Malvina Hoffman. *Mangbetu Woman.* Bronze, from photograph taken for Malvina Hoffman. Chicago, Field Museum of Natural History. © The Field Museum no. MH14A. (Photograph in Du Bois Institute, Harvard University.)

57 Anonymous. Photograph of Mangbetu woman, taken on the Haardt expedition. 1925. Los Angeles, Getty Research Institute, Malvina Hoffman papers, Box 66. Los Angeles, Getty Research Institute, Malvina Hoffman papers. The Getty Research Institute, Los Angeles (850042).

58 Pablo Picasso. *Les Demoiselles d'Avignon.* 1907. Oil on canvas. New York, Museum of Modern Art. Museum of Modern Art, New York, USA/Giraudon/Bridgeman Art Library/© Succession Picasso/DACS, London 2013.

59 Vili figure. Republic of Congo. 19th century. Wood. France, private collection. Courtesy Archives H. Matisse.

60 Henri Matisse. *Still Life with African Sculpture.* 1906. Oil on canvas. Private collection. © Succession H. Matisse/© DACS 2013.

61 Pablo Picasso. Study for *Les Demoiselles d'Avignon.* 1906. Paris, Musèe Picasso. © Succession Picasso/RMN-Grand Palais/All Rights Reserved/© DACS 2013.

62 Composite of images of African masks from Leo Frobenius's *Die Masken und Geheimbünde.* 1898. London, British Library. British Library Ac.2871.

63 Pablo Picasso. *Three Figures Under a Tree.* 1907. © Succession Picasso/RMN-Grand Palais/René-Gabriel Ojéda/© DACS 2013.

64 Photographs of Africans. Top row left: Edmond Fortier. "Les Bobos." Postcard. 1906. Paris. (© RMN-Grand Palais/Michèle Bellot). Top row, center: Basuto Woman. From Carl Heinrich Stratz, *Die Rassenschönheit des Weibes* (1906), p. 138 and fig. 76 (British Library Shelfmark no. Cup. 351/429). Top row, right: "Deux jeunes filles Targui," (Two Targui women). Photograph clipped from the review *L'Humanité féminine* (5 January 1970) by Henri Matisse. Paris, Henri Matisse Archives. Photograph © Henri Matisse Archives. Bottom row, left: *"Helle und Dunkle"* (Light and Dark skin). From Carl Heinrich Stratz, *Die Rassenschönheit des Weibes* 1911 (1921), p. 29 (British Library Shelfmark no. Cup. 820.c.24)

and fig. 14. Bottom row, center: From Carl Heinrich Stratz, *Die Rassenschönheit des Weibes* (1907), p. 148, p. 83 "Ashanti" (British Library Shelfmark no. Cup. 351/429). Bottom row, right: "Zulu Girls." From Stratz (1907), p. 132 (British Library Shelfmark no. Cup. 351/429) and fig. 73 (British Library Shelfmark no. Cup. 351/429).

65 Pablo Picasso. "Deux nus." Study for *Two Women*. 1906. Private collection. © 2013 Edouard Malingue Gallery/© Succession Picasso/DACS, London 2013.

66 Pablo Picasso. "La Danse barbare." Study for *Salomé and Herod*. 1905. Chicago, private collection. Private collection/Photo © Succession Picasso/Christie's Images/Bridgeman Art Library/© DACS 2013.

67 Composite. Top row left: Dahomey Amazon in Rev. R. J. Wood, *The Uncivilized Races, or Natural History of Man* (1870, London), p. 637, California Digital Library. Top row right: "The Amazon." Frontispiece for Richard Francis Burton, *A Mission to Gelele, King of Dahome,* vol. 1 (London, 1863), Burtoniana.org. Bottom row: Mme Crampel. "Aduma [Gabon] Tamtam." From Harry Alis, "Pays des Fans," *Tour du Monde* (1890), 2nd s. p. 323. Republished in Leo Frobenius, *Die Masken und Geheimbünde* (1898), Yale University Library.

68 Pablo Picasso. *Parody of Olympia*. Self-portrait with Sebastià Junyer and nude. 1901–1903. Paris, private collection. The Athenaeum/© Succession Picasso/DACS, London 2013.

69 Vallotton. *Le Blanche et la noire*. 1913. Winterthur, Villa Flora. Reto Pedrini Zürich/Hahnloser/Jaeggli Stiftung, Winterthur.

70 Pablo Picasso. *Child Beside a Hut with Palm Tree*. 1905. Marina Picasso collection. © Succession Picasso/DACS, London 2013.

71 Pablo Picasso. *Seated Negro*. 1906. Ink sketch. Zurich, Bollag collection. Zurich. © Succession Picasso/DACS, London 2013.

72 Pablo Picasso. *La Parisienne and Exotic Figures*. 1906–1907. Paris, Musée Picasso. © Succession Picasso/DACS, London 2013.

73 Pablo Picasso. *Standing Figure with Raised Arms*. 1906–1907. Pencil, pen, and red ink. Màlaga lettering. © Succession Picasso/RMN-Grand Palais/All Rights Reserved. © DACS 2013.

74 Cover of the exhibition catalogue *Cubism and Abstract Art,* showing Alfred H. Barr, Jr.'s chart of the progression of modernism. 1936. © 2013. Digital image, The Museum of Modern Art, New York/Scala, Florence.

75 Pablo Picasso. *Bust of a Man*. 1908. Oil on canvas. 62.2 × 43.5 cm. New York, Metropolitan Museum of Art. Accession no. 1996.403.5. © 2013. Image copyright The Metropolitan Museum of Art/Art Resource/Scala, Florence/© Succession Picasso/DACS, London 2013.

76 Maurice de Vlaminck. *Bathers*. 1908. Oil on canvas. 88.9 × 115.9 cm. Switzerland, private collection.

77 Henri Matisse. *Reclining Nude I (Aurora)*. 1907. Bronze. 13 9/16 × 19 5/8 × 11 in. (34.3 × 49.5 × 28 cm). Baltimore, The Baltimore Museum of Art, The Cone Collection, formed by Dr. Claribel Cone and Miss Etta Cone of Baltimore, Maryland. The Baltimore Museum of Art, The Cone Collection, formed by Dr. Claribel Cone and Miss Etta Cone of Baltimore, Maryland, © 2013 Succession H. Matisse/DACS. Photo: © 2013, courtesy of The Baltimore Museum of Art.

78 Erich Heckel. *Standing Child* (Stehendes Kind). 1910/1911. Woodcut printed in green, red, and black on paper. 37.47 × 27.46 cm. Los Angeles, The Robert Gore Rifkind Center for German Expressionist Studies, Los Angeles County Museum of Art. Accession no. M.82.288.370b. © 2013 Los Angeles County Museum of Art (LACMA)/Scala Archives, London/© DACS 2013.

79 Ernst Ludwig Kirchner. *Program of the Künstlergruppe Brücke (Title vignette)*. 1906. Woodcut. Image: 7.5 × 4.2 cm; sheet: 21.7 × 17.5 cm. Davos, Kirchner Museum Davos. Photo László Tóth © 2013. Photo Scala, Florence/BPK, Bildagentur für Kunst, Kultur und Geschichte, Berlin.

80 Workshop of the Fungom Region, Cameroon. *Bowl with figures* (Schale mit Figuren). 19th century. Wood. H: 35 cm. Zurich, Völkerkundemuseum der Universität Zürich. Accession no. 10087. © Völkerkundemuseum der Universität Zürich.

81 Ernst Ludwig Kirchner. *Program of the Künstlergruppe Brücke (manifesto text)*. 1906. Woodcut. Image: 15.1 × 7.5 cm; sheet: 28.8 × 22.2 cm. New York, Museum of Modern Art. Gift of J. B. Neumann. Accession no. 479.1941.2. Photo László Tóth © 2013. Photo Scala, Florence/BPK, Bildagentur für Kunst, Kultur und Geschichte, Berlin.

82 Erich Heckel. *Bearer* (Trägerin). 1906. Painted alder wood sculpture. 34.7 × 5.1 × 8.9 cm. Hamburg, Museum für Kunst und Gewerbe. Accession no. C 6/80. © DACS 2013.

83 Pablo Picasso. *Caryatid*. 1907. Oak, partly painted. 80.5 × 24 × 20.8 cm. Paris, Musée Picasso. Accession no. MP238. © Succession Picasso/RMN-Grand Palais/Béatrice Hatala/© DACS 2013.

84 Ernst Ludwig Kirchner (?). Ca. 1911. Five wood sculptures by Erich Heckel, photograph. Hemmenhofen, Nachlaß Erich Heckel.

85 Pablo Picasso. *Dryad*. 1908. Oil on canvas. 185 × 108 cm. St. Petersburg, State Hermitage Museum. Hermitage, St. Petersburg, Russia/Bridgeman Art Library/ © DACS 2013.

86 Ernst Ludwig Kirchner. *The artistes Milly and Sam in Kirchner's atelier, Berliner Straße 80, Dresden*. 1910/1911. Glass negative. 13 × 18 cm. Davos, Kirchner Museum Davos. Accession no. 2./2PI.

87 Ernst Ludwig Kirchner. *Nelly and Sidi Heckel (Riha) dancing in Erich Heckel's atelier, Dresden*. Ca. 1910/1911. Glass negative. 13 × 18 cm. Davos, Kirchner Museum Davos. Accession no. 1./5P.

88 Carl Marquardt's *Schaustellung "Das Sudanesendorf" in the Dresdner Zoologischen Garten,* Female Group. 1909. Postcard. Dresden, Archiv Zoo Dresden.

89 Ernst Ludwig Kirchner. *Negro Dancer* (Negertänzerin). 1909/1910. Oil on canvas. 81 × 95.5 cm. Bern, collection of Eberhard W. Kornfeld. Peter Willi/Bridgeman Art Library.

90 Ernst Ludwig Kirchner. *Negro Dancer* (Negertänzerin). 1909/1910.

Oil on canvas. 170 × 94 cm. Erstein, Musée Würth. Accession no. 7986. akg-images.

91 Ernst Ludwig Kirchner. *Portrait of a Woman* (Frauenbildnis). 1911. Oil on canvas. 117.79 × 87.94 cm. Support: 46 3/8 × 34 5/8 in. (117.79 × 87.94 cm). General Purchase Funds, 1957. © 2012. Albright Knox Art Gallery/Art Resource, NY/Scala, Florence.

92 Ernst Ludwig Kirchner. *Milly Sleeping* (Milly schlafend). 1910–1911. Oil on canvas. 64 × 90.5 cm. Bremen, Kunsthalle. Foto: Lars Lohrisch/© Kunsthalle Bremen.

93 Otto Mueller. *Negro with a Dancer* (Neger und Tänzerin). 1903. Oil on canvas. 91 × 65.5 cm. Private collection. akg-images.

94 Ferdinand von Řezníček. *Tête-à-tête.* Illustration in *Simplicissimus* 5, no. 35 (1900): 280. Herzogin Anna Amalia Bibliothek/Klassik Stiftung Weimar.

95 Paula Modersohn-Becker. *Kneeling Mother and Child* (Kniende Mutter mit Kind an der Brust). 1906/1907. Oil on canvas. 113 × 74 cm. Berlin, Nationalgalerie, Staatliche Museen Preussischer Kulturbesitz. akg-images.

96 Workshop of the Babanki-Tungo Region. *Leopard Stool* (Leopardenhocker). 19th century. Abachi wood. H: 35 cm. Chur, Bündner Kunstmuseum.

97 Ernst Ludwig Kirchner. *Three Nudes* (Drei Akte). 1911. Woodcut. 20.7 × 25.7 cm. Darmstadt, Hessisches Landesmuseum Darmstadt.

98 Ernst Ludwig Kirchner. *Fruit Bowl* (Obstschale). 1911. Wood painted black. H: 28.5 cm. Bern, collection of Eberhard W. Kornfeld.

99 Ernst Ludwig Kirchner. *Female Nude in Tub* (Weibliche Akt im Tub). 1911. Oil on canvas. 76 × 70 cm. Kiel, Kunsthalle zu Kiel. akg-images.

100 Ernst Ludwig Kirchner. *Interior II* (Interieur II). 1911. India ink, pen, and brush. 33.5 × 28.5 cm. Berlin, Brücke-Museum.

101 Ernst Ludwig Kirchner. *Crouching Woman* (Hockende). 1910. Wood with paint. 32.7 × 17.5 × 14 cm. Moritzburg, Sammlung Hermann Gerlinger. Klaus E. Göltz/Stiftung Moritzburg-Kunstmuseum des Landes Sachsen-Anhalt.

102 Emil Nolde. *Mulatto.* 1913. Cambridge, Mass., Harvard Art Museum, Busch-Reisinger Museum. Accession no. BR54.117. © Corbis/Nolde Stiftung Seebüll.

103 Mother and Child Figure, North Yoruba, Nigeria. 19th century. Wood. Berlin, Ethnologisches Museum, Staatliche Museen Preussischer Kulturbesitz, III C27073.

104 Emil Nolde. *The Missionary* (Der Missionar). 1912. Oil on canvas. 79 × 65.5 cm. Private collection. © Corbis/Nolde Stiftung Seebüll.

105 Emil Nolde. *Man, Woman, and Cat* (Mann, Frau, und Katze). 1912. Oil on canvas. 67 × 52.8 cm. Neukirchen, Stiftung Seebüll Ada und Emil Nolde. Erich Lessing/akg-images/ © Nolde-Stiftung Seebüll.

106 Detail of king's throne (Königsthron), Bamun, Cameroon. 19th century. Wood, glass, cowry shells. H: 175 cm. Berlin, Ethnologisches Museum, Staatliche Museen Preussischer Kulturbesitz. Accession no. III C33341. ullstein bild/akg-images.

107 Karl Schmidt-Rottluff. *Four Evangelists: Matthew, Mark, Luke, and John* (Die vier Evangelisten). 1912. Hammered and painted tin. Panels: 42.5 × 33 cm. Berlin, Brücke Museum. Accession no. 95–98/75. Brücke Museum, Berlin/© DACS 2013.

108 Ernst Ludwig Kirchner. Cover page of the *Chronicle of the Artists' Group Brücke.* 1913. Woodcut. 45.7 × 33.2 cm. Private collection. Interfoto/Alamy.

109 Ernst Ludwig Kirchner. *The Drinker; Self-Portrait* (Der Trinker; Selbstbildnis). 1914–1915. Oil on canvas. 118.5 × 88.5 cm. Nuremberg, Germanisches Nationalmuseum. Germanisches Nationalmuseum, Nuremberg (Nuernberg), Germany/Bridgeman Art Library.

110 Ernst Ludwig Kirchner. *Schlemihl in the Solitude of His Room* (Schlemihl in der Einsamkeit des Zimmers), Print IV of the Schlemihl cycle. 1915. Color woodcut. 33 × 21.5 cm. Kiel, Kunsthalle zu Kiel. akg-images.

111 Karl Schmidt-Rottluff. *Blue Girl's Head with Hanging Braids* (Blauer Mädchenkopf mit hängenden Zöpfen). 1917. Blue-tinted wood. H: 32 cm. Whereabouts unknown. Image taken from Wilhelm Niemeyer, "Von Wesen und Wandlung der Plastik," *Genius; Zeitschrift für werdende und alte Kunst,* 1:1 (1919): 86. Universitäts- und Stadtbibliothek Köln, GENIU_0001/© DACS 2013.

112 Karl Schmidt-Rottluff. *Christ* (Kristus). 1918. Woodcut on woven paper. 71.12 × 53.34 cm. Berlin, Brücke Museum. Erich Lessing/akg-images/© DACS 2013.

113 Herbert Garvens. Title page to the exhibition catalogue *Schmidt-Rottluff Negerkunst.* 1920. Hannover, Kestner-Gesellschaft. Schleswig-Holsteinisches Landesmuseum. © 2013 DACS.

114 Paul Colin. *La Revue Nègre au Music-hall des Champs-Élysées.* 1925. Poster. akg-images/© ADAGP, Paris and DACS, London 2013.

115 Poster announcing the fight between Jack Johnson and Arthur Cravan in Madrid. 23 April 1916. London, the British Library, YC.2002.a.9402.

116 Fernand Léger. *The Creation of the World.* 1923. Pen and gouache. © 2013. Digital image, The Museum of Modern Art, New York/Scala, Florence. © ADAGP, Paris and DACS, London 2013.

117 Constantin Brancusi. *White Negress.* 1923. Veined marble. H: 24.8 cm. Philadelphia, Philadelphia Museum of Art, Louise Arensberg Collection. 1950. Philadelphia Museum of Art, Pennsylvania, PA, USA/The Louise and Walter Arensberg Collection, 1950/Bridgeman Art Library/© ADAGP, Paris and DACS, London 2013.

118 Man Ray. *Noire et blanche* (II). 1926. Photograph. Man Ray Trust. Jerusalem, The Israel Museum/Gift of Moshe Kaniuk/Bridgeman Art Library/© Man Ray Trust/ADAGP, Paris and DACS, London 2013.

119 Page with *Bessie Love's dance troupe in Broadway Melody (1929)* and *Schoolchildren from Bacouya, Bourail (New Caledonia).* From *Documents* 1929, no. 4. London, British Library P.P. 1927.bbe.

120 Miguel Covarrubias. *Jazz Baby.* Ca. 1925. Graphite, crayon, and watercolor on paper. Signed. 11 × 8 7/16 in. Courtesy of Michael Rosenfeld Gallery LLC, New York, NY.

121 P. Bosse. *Visitez le Pavillon des Tabacs/Exposition Coloniale.* 1931. 57 × 78 in. (145 × 198 cm). Paris, A.M.I. Image courtesy of Swann Galleries.

122 Paul Colin. "An elegant Josephine in banana skirt." From *Le Tumulte noir* portfolio. 1925. 47.5 × 32. Kharbine-Tapabor/Collection IM/Art Archive/© ADAGP, Paris and DACS, London 2013.

123 Jean Dunand. *Josephine Baker.* Ca. 1927. Lacquer and gold. Private collection. Bridgeman Art Library.

124 Alexander Calder. *Josephine Baker 1 (Danse).* 1926. Wire. Paris, Musée national d'Art Moderne Centre Georges Pompidou. © Calder Foundation New York/ADAGP/Centre Pompidou, MNAM-CCI, Dist. RMN-Grand Palais/Georges Meguerditchian/DACS London.

125 Henri Matisse. *The Negress.* 1952. Collage on canvas. Washington, D.C., National Gallery of Art. © Succession H. Matisse/DACS 2013. Photo: © 2013 Ailsa Mellon Bruce Fund/National Gallery of Art.

126 Ernst Ludwig Kirchner. *Stool I* (Stuhl I). 1921. Swiss pinewood painted with oxblood. 88 × 49 × 54 cm. Bern and Davos, collection of Eberhard W. Kornfeld. akg-images.

127 Marcel Janco. *Invitation to a Dada Evening.* 1916. Charcoal. 73 × 55 cm. Zurich, Kunsthaus Zürich Grafische Sammlung. Photo Kunsthaus Zürich. © ADAGP, Paris and DACS, London 2013.

128 Marcel Janco. Untitled (*Mask for Firdusi*). 1917–1918. Painted board and twine. 79 × 48 cm. Antwerp, collection Sylvio Perlstein. © ADAGP, Paris and DACS, London 2013.

129 Hannah Höch. *Negro Sculpture (Negerplastik).* 1929. Collage and gouache on paper. 26 × 17.50 cm. From the series *Out of an Ethnographic Museum* (Aus einem ethnographischen Museum). Edinburgh, Scottish National Gallery of Modern Art. Accession no. GMA 3987.

130 Hannah Höch. *The Sweet One* (Die Süsse). 1926. Photomontage with watercolor. 30 × 15.5 cm. From the series *Out of an Ethnographic Museum* (Aus einem ethnographischen Museum). Essen, Museum Folkwang. © DACS 2013.

131 Olaf Gulbransson. *The Black Occupation* (Die schwarze Besatzung). Illustration in *Simplicissimus* 25, no. 11 (9 June 1920): 168. Weimar, Herzogin Anna Amalia Bibliothek/Klassik Stiftung Weimar © DACS 2013.

132 Hannah Höch. *Love in the Bush* (Liebe im Busch). 1925. Photocollage on paper. 23 × 21.6 cm. From the series *Out of an Ethnographic Museum* (Aus einem ethnographischen Museum). Private collection. Photo: The Modern Art Museum of Fort Worth, Texas.

133 Irma Stern. *Umgababa.* 1926. Oil on canvas. 91.4 × 152.4 cm. Cape Town, Irma Stern Museum. © The Irma Stern Trust, DACS 2012.

134 Otto Dix. *To Beauty* (An die Schönheit). 1922. Oil on canvas. 140 × 122 cm. Wuppertal, Von der Heydt-Museum. akg-images. © DACS 2013.

135 Kees van Dongen. *Josephine Baker at the Negro Ball* (Josephine Baker au Bal Nègre). 1925. Watercolor. 71 × 48 cm. Belgium, collection of André Van Breusegem. Sheldon Art Gallery/© ADAGP, Paris and DACS, London 2012.

136 Photograph of Josephine Baker in her banana skirt at the Theater des Westens in Berlin. 1928. The curtain was drawn by Benno von Arent. Image from *Das Theater,* December 1928. ullstein bild/akg-images.

137 Rolf Nesch. *Negerrevue.* 1930. Colored etching and aquatint. 44.8 × 33.5 cm. London, Prints & Drawings, British Museum. Accession no. 1981, 1107.9. © 2013 Private Collections Images, London/Photo Scala, Florence.

138 August Sander. *Circus Workers* (Zirkusarbeiter). 1926–1932. Photograph, gelatin silver print on paper. Artist Rooms, Tate and National Galleries of Scotland. Lent by Anthony d'Offay. © Die Photographische Sammlung/SK Stiftung Kultur - August Sander Archiv, Köln/VG Bild-Kunst, Bonn and DACS, London 2013.

139 Christian Schad. *Agosta, the Winged Man, and Rasha, the Black Dove* (Agosta, der Flügelmensch, und Rasha, die schwarze Taube). 1929. Oil on canvas. 190 × 80 cm. London, Tate Modern, long-term loan from private collection. akg-images/© Christian Schad Stiftung Aschaffenburg/VG Bild-Kunst, Bonn and DACS, London 2013.

140 Ernst Neuschul. *Negro Mother* (Negermutter). Ca. 1931. Oil on canvas. 100.5 × 65.5 cm. Leicester, Leicester Museums and Galleries, New Walk Museum and Art Gallery. Accession no. F453.1978. Photo © Leicester Arts & Museums/Bridgeman Art Library/© DACS 2013.

141 *Jonny spielt auf.* 1938–1939. Poster and brochure, National Socialist image for the *Degenerate Music* (Entartete Musik) exhibition in Düsseldorf, Weimar, Munich, and Vienna. Berlin, Deutsches Historisches Museum. Accession no. R 92/715. Berlin, Deutsches Historisches Museum.

142 Frans Masereel. *Jazz.* 1931. Woodcut. Saarbrücken, Frans-Masereel-Stiftung. © DACS 2013.

143 Rudolf Hermann. *Degenerate Art (Entartete Kunst).* 1938. Poster/placard, lithograph printed in black, green, and orange on woven paper. 117.48 × 82.23 cm. Los Angeles, Robert Gore Rifkind Center for German Expressionist Studies, Los Angeles County Museum of Art. Accession no. M.2003.115.28. © 2013 Digital Image Museum Associates/LACMA/Art Resource NY/Scala, Florence.

144 Photograph of a visitor to the Degenerate Art exhibition (Entartete Kunst Ausstellung) in Berlin. 1938. Works by Karl Schmidt-Rottluff and Emil Nolde can be clearly identified. München, Bildarchiv Süddeutscher Verlag.

145 Leni Riefenstahl. *Libestans.* 1975. Dye-destruction print, mounted on card, flush-mounted on aluminum. 42.2 × 57.2 cm. Reproduced in Leni Riefenstahl, *The People of Kau* (New York, 1976). © Leni Riefenstahl.

146 L. J. Jordaan. *Black Shadows.* Netherlands, 1930. "Het Negernummer," *De Groene Amsterdammer weekblad voor Nederland,* nr 2759, 19 April 1930, p. 7. Amsterdam, Netherlands Amsterdam Groene Amsterdammer. Photo Atlas van Stolk, Rotterdam.

147 Isaac Israëls. Ca. 1900. The Hague, collection Gemeente Museum Den Haag Ashanti sketchbook—1935-0061. Collection of the Gemeentemuseum Den Haag.

148 Jan Sluyters. *Green Dancer/Dancing Negress*. Ca. 1910. Oil on canvas. 76.5 × 69 cm. Private collection, Family Sluijters. The Hague, Rijksbureau voor Kunsthistorische Documentatie/Netherlands Institute for Art History.

149 Jan Sluyters. *Negro in Jungle*. 1915. Oil on canvas. 150.5 × 121 cm. Utrecht, Collectie Centraal Museum; inv.nr. 26336 Image and copyright Collection Centraal Museum, Utrecht.

150 Kees van Dongen. *Jack Johnson*. Ca. 1914. Oil on canvas. 130 × 81 cm. Monaco, collection Palais Princier. Archives du Palais Princier, Monaco/Ch. Franch-Guerra © ADAGP, Paris and DACS, London 2012.

151 Jan Sluyters. *Oorlogken is jarig* (*Little War's First Birthday*). 31 July 1915. Lithograph. 28 × 36 cm. Amsterdam, *De Nieuwe Amsterdammer* nr 31. International Institute of Social History (IISG, Amsterdam).

152 Jan Sluyters. *League of Nations, Colonies, and Labor Movement*. 1919. 30.5 × 44 cm. Amsterdam, *De Nieuwe Amsterdammer* nr 217. International Institute of Social History (IISG).

153 Jan Sluyters. *Portrait of Tonia Stieltjes*. 1922. 103 × 81 cm. Baarn, private collection. Rijksbureau voor Kunsthistorische Documentatie/ Netherlands Institute for Art History.

154 Irma Stern. *Three Swazi Girls*. 1925. Cape Town, Irma Stern Museum. Photo Irma Stern Museum, Cape Town/© The Irma Stern Trust, DACS 2012.

155 Cas Oorthuys. *Adekom, Scotsborough, Negro Number. Links Richten*. 1932. Photomontage print. 24.5 × 15.7 cm. Amsterdam, collection of Carl Haarnack. Collection of the Gemeentemuseum Den Haag/© DACS 2013.

156 Cas Oorthuys. *AF/Afweerfront*. Afweerfront nr 1932 nr 5. International Institute of Social History (IISG, Amesterdam).

157 Piet Zwart. *We slaves of Suriname*. 1934. Photomontage. The Hague, Gemeentemuseum Den Haag, inv 0757387 Tek -1970-0459/© DACS 2013.

158 Piet Zwart. *Portrait of Anton de Kom*. 1933. Negative. Rotterdam, Fotomuseum. Nederlands Fotomuseum, Rotterdam/© DACS 2013.

159 Nola Hatterman. *On the Terrace, Jimmy van der Lak*. 1930. Oil on canvas. 100 × 90 cm. Amsterdam, collection Stedelijk, Museum Amsterdam. Stedelijk Museum Amsterdam Inv SB 6390.

160 Edouard Duval-Carrie. *Retable des 9 Eslaves*. 2008. Central panel. Little Haiti, Miami, collection of the artist. Courtesy of the artist.

161 Alex Burke. *The Spirit of the Caribbean*. 1999. Various fabrics and other materials. Dimensions variable. Paris, collection of the artist.

162 Leah Gordon. *Mulâtre* from the *Caste Series*. 2010. London, Riflemaker Gallery. Leah Gordon/Riflemaker Gallery, London.

163 Kathleen Hawkins. *Plantation Workers on Their Way Home*. N.d. Watercolor. 34.4 × 25.5 cm. Barbados, Barbados Gallery of Art.

164 Golde White. *Black Man in a Cap*. N.d. Oil on canvas. 50 × 40 cm. Washington, D.C., private collection.

165 Edna Manley. *Eve*. 1929. Wood (mahogany). H: 213.36 cm. Sheffield, Graves Art Gallery. Photo Courtesy Graves Art Gallery Sheffield, UK.

166 Ronald Moody. *Midonz* (goddess of transmutation). 1937. Large elm. UK, private collection, Cynthia Moody. Courtesy Ronald Moody Estate/© Tate London, 2013.

167 Philip Moore. *1763 Monument*. 1976. Bronze. 10.1 m. Georgetown, Guyana. Photo © Phillip and Sue Williams.

168 Osmond Watson. *Peace and Love*. 1969. Kingston, National Gallery of Jamaica. Photo Frank Marzouca/Courtesy Osmond Watson Estate, published with permission.

169 Albert Huie. *The History Lesson*. 1943. Kingston, private collection, Judy Ann MacMillan. Judy Ann MacMillan/Albert Huie Studio.

170 Karl Broodhagen. *Patricia*. N.d. Terra-cotta. H: 43.2 cm. Collection of the artist. National Art Gallery Committee Secretariat, Ministry of Community Development & Culture.

171 Hector Hyppolite. *Black Magic* (Magique Noir). Ca. 1946–1947. Oil on board. 25 1/2 × 37 1/2 in. (64.77 × 95.25 cm). Milwaukee, Museum of Milwaukee. Gift of Richard and Erna Flagg M1991.127. Photo Efraim Lever.

172 Kapo (Mallica Reynolds). *Revival Goddess Dinah*. Ca. 1968. Lignum vitae. 78.7 cm. Kingston, National Gallery of Jamaica. Photo Franz Marzouca/Courtesy Mallica Reynold Estate.

173 Ivan Payne. *Maube Seller*. N.d. Mahogany. H: 37.6 cm. Kingston, private collection, Elombe Motley. Courtesy Elombe Motley.

174 Honore Chosrova. *Séance*. 1988. Photo courtesy Gerry L'Etang.

175 Christopher Gonzales. *Mountain Head* (Woman of Zion). 1980. Kingston, private collection, Mrs. Sheila Graham. Photo Franz Marzouca.

176 Max Taylor. *Love and Responsibility*. 1997. Private collection. Photo Smith & Benjamin Art & Design.

177 Khokho (Joseph René-Corail). Untitled. 1963. Photo courtesy Renée-Paule Yung-Hing.

178 Stanley Greaves. *The Annunciation*. From the *There's a Meeting Here Tonight* series. 1993. Barbados, private collection. Courtesy of the artist.

179 Everald Brown. *Victory Over Satan*. 1968. Jamaica, Private collection.

180 Karl Parboosingh. *Ras Smoke I*. 1972. Kingston, National Gallery of Jamaica. Photo Franz Marzouca.

181 Ras Ishi Butcher. *Blazin 1*. 2003–2004. Mixed media. 121 × 152.4 cm. Barbados, private collection. Photo courtesy Crawford Billings Associates.

182 Georges Liautaud. *Danbala*. Ca. 1959. Metal. Milwaukee, American Folk art, Milwaukee Museum of Art. Milwaukee Art Museum, Gift of Richard and Erna Flagg M1991.168/Photo credit Efraim Lev-er.

183 Brent Malone. *Junkanoo Ribbons*. 1984. 84 × 76 cm. Oil on canvas. Kingston, National Gallery of Jamaica. Photo Franz Marzouca/Courtesy of the Brent Malone Estate.

184 Barrington Watson. *Mother and Child*. 1958. Oil on canvas. Kingston, National Gallery of Jamaica. Photo Franz Marzouca.

185 Alexandre Bertrand. Untitled. N.d. Oil on canvas. Photo courtesy Gerry L'Etang.

186 Boscoe Holder. *Untitled Male Nude.* N.d. Reproduced courtesy of Christian Holder, the Artist's Estate/VW (VeneKlasen/Werner).

187 Aubrey Williams. *Revolt.* 1960. 134–165 cm. Georgetown, Castellani House. Photo National Gallery of Art, Castellani House. © Estate of Aubrey Williams. All rights reserved, DACS 2013.

188 LeRoy Clarke. *In the Maze, There Is a Thin Line to My Soul.* 1986. Port of Spain, Trinidad, collection of the artist. Courtesy of the artist.

189 Omari Ra. *Bois Caiman's Foreign Policy Retro Reconstruction Globe Shrugged.* 2004. Mixed media on cloth. Two panels: each 256.5 × 147 cm; two panels: each 241 × 121 cm. Kingston, collection of the artist.

190 Chris Cozier. *The Castaway* (from the *Tropical Night* series) (detail). 2006–Present. Photo courtesy of the artist.

191 Albert Chong. *Seated Presence.* 1992. Colorado, collection of the artist. Reproduced in *Ancestral Dialogues: The Photographs of Albert Chong* (Los Angeles, 1994). Photo courtesy of the artist.

192 Joscelyn E. Gardner. *Veronica Frutescens* (Mazerine) (from the series *Creole Portraits*). 2009. Hand-painted stone lithograph on frosted myl. 91.4 × 61 cm. Photo courtesy of the artist.

193 Roberta Stoddart. *Earl* (from the series *In the Flesh*). Private collection, Port of Spain, Trinidad, W.I., 2006.

194 Ebony G. Patterson. *Di Real Big Man.* 2010. Mixed media hand-embellished photo tapestry with garlands on wallpaper. Variable dimensions. Kingston, collection, National Gallery of Jamaica. Image courtesy of the artist and Monique Meloche Gallery.

195 Anonymous. *Allegory of the Departure of Dom Pedro II After Independence.* 1890. 82 × 103 cm. São Paulo, Fundação María Luisa e Oscar Americano.

196 R. Brandão Cela. *The Abolition of Slavery.* 1938. Fortaleza, Academia Cearense de Letras.

197 Modesto Brocos. *The Redemption of Cain.* 1895. Rio de Janeiro, Museu Nacional de Belas Artes. akg-images.

198 Tarsila do Amaral. *A Negra* (Black Woman). 1923. 100 × 80 cm. São Paulo, Museu de Arte Contemporanea de Universidade de São Paulo. akg-images.

199 Armando Vianna. *Nettoyant les métaux de cuisine.* 1923. Photo Humberto Nicoline/Acervo do Museu Mariano Procopio-MAPRO.

200 Tarsila do Amaral. *Carnaval em Madureira.* 1924. 76 × 64 cm. São Paulo, private collection. Getty Images.

201 Cândido Portinari. *O Mestiço.* 1934. 81 × 65 cm. São Paulo, Pinacoteca do Estado.

202 Cândido Portinari. *O Lavrador de café.* 1939. 100 × 81 cm. São Paulo, Museu de Arte de São Paulo. Museu de Arte de Sao Paulo/© DACS 2013.

203 Cândido Portinari. *Navio Negreiro.* Sold at Christie's May 2012. Photo © Christie's Images/Bridgman Art Library/© DACS 2013.

204 Manuel Mendive. *Barco negreiro.* 1976. Casein and carving on wood. 102.5 × 126 cm. Havana, National Museum of Cuba.

205 Emiliano Di Cavalcanti. *Cinco moças de Guaratinguetá.* 1930. 97 × 70 cm. São Paulo, Museu de Arte de São Paulo. De Agostini Picture Library/akg-images/© DACS 2013.

206 Lasar Segall. *Bananal* (Banana plantation). 1927. 87 × 127 cm. São Paulo, Pinacoteca do Estado. Museu Lasar Segall/Pinacoteca do Estado de Sao Paulo.

207 Diego Rivera. *The Liberation of the Peon.* (1923–1924). Mural. 4.38 × 3.48 m. Mexico City, Ministry of Education. Instituto Nacional del Bellas Artes/Fundación Diego Rivera/Banco de México. © 2013 Banco de México Diego Rivera Frida Kahlo Museums Trust, Mexico, D.F. / DACS.

208 Oswaldo Guayasamín. *The Lovers.* Negro theme from Huacayñán series. 1950. 98 × 67 cm. Barcelona, Fernando Rivière collection. Fundacion Guayasamin.

209 Pedro Figari. *Candombe.* N.d. 62 × 82 cm. Private collection. Superstock Inc.

210 Pedro Figari. *Dulce de Membrillo.* N.d. Oil on cardboard. 60 × 81 cm. Album/Prisma/AKG-images.

211 Jaime Colson. *Merengue.* 1938. Oil on board. 52 × 68 cm. Santo Domingo, Museo Bellapart. Photo courtesy Museo Bellapart.

212 Wifredo Lam. *The Jungle.* 1942/1943. New York, Museum of Modern Art. © 2013. Digital image, The Museum of Modern Art, New York/Scala, Florence/© DACS 2013.

213 Mario Carreño. *Afro-Cuban Dance.* 1943. Washington, D.C., AMA, Art Museum of the Americas, Organization of American States.

214 Wifredo Lam. *I Am.* 1949. Oil on canvas. 124.5 × 108 cm. Paris, Mme Fabri.

215 Belkis Ayón. *The Sentence no. 1.* Havana, National Museum of Fine Art. Photo José A. Figueroa/Courtesy Belkis Ayón Estate.

216 Emanoel Araujo. *Totem de Xangô.* 1981. Inox steel. 1.80 × 60. Private collection. (Formerly: Collection of Antonio Gidi).

217 Hélio Oiticica. *Jerônimo, wearing Cape 5.* 1965. Photograph. Desdemone Bardin. Projeto Hélio Oiticica/Desdemone Bardin.

218 Pablo Picasso. Frontispiece to Aimé Césaire's *Corps Perdu, African Head.* 1950. Cambridge, Mass., collection of Henry Louis Gates, Jr. Etching and drypoint. Photo W. E. B. Du Bois Institute for African and African-American Research/© Succession Picasso/DACS, London 2013.

219 Pablo Picasso. Title page to poem *"Mot,"* Aimé Césaire's *Corps Perdu.* 1950. Cambridge, Mass., Houghton Library, Harvard University, fTyp 916.60.2720. © 2013 Succession Picasso/Houghton Library Houghton fTyp 916.60.2720.

220 Pablo Picasso. *Mankind Holding the Symbol of Peace.* 1958. Vallauris, Temple of Peace. © 2013 Succession Picasso/White Imagess/Scala, Florence/© DACS 2013.

INDEX

Page numbers in italics indicate illustrations. Page numbers in italics and in parentheses indicate details of illustrations.